RUBENS AND HIS CIRCLE

STUDIES BY JULIUS S. HELD

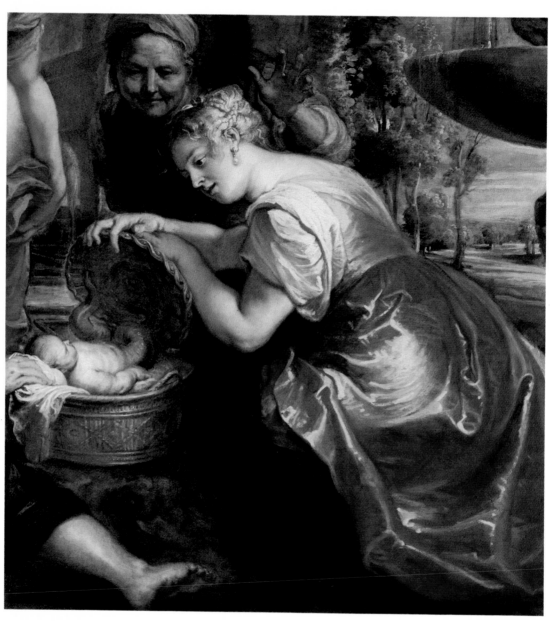

XIV.2 Peter Paul Rubens,
The Daughters of Cecrops Discovering the Young Erichthonius (fragment)

RUBENS
AND
HIS CIRCLE

Studies by

JULIUS S.
HELD

EDITED BY · ANNE W. LOWENTHAL · DAVID ROSAND · JOHN WALSH, JR.

PRINCETON UNIVERSITY PRESS · PRINCETON, NEW JERSEY

COPYRIGHT © 1982 BY PRINCETON UNIVERSITY PRESS
PUBLISHED BY PRINCETON UNIVERSITY PRESS, PRINCETON, NEW JERSEY
IN THE UNITED KINGDOM: PRINCETON UNIVERSITY PRESS, GUILDFORD, SURREY

ALL RIGHTS RESERVED
LIBRARY OF CONGRESS CATALOGING IN PUBLICATION DATA WILL BE
FOUND ON THE LAST PRINTED PAGE OF THIS BOOK

PUBLICATION OF THIS BOOK HAS BEEN AIDED BY FUNDS FROM PRIVATE DONORS AND
A SUBSIDY FROM THE SAMUEL H. KRESS FOUNDATION

THIS BOOK HAS BEEN COMPOSED IN LINOTRON GARAMOND
CLOTHBOUND EDITIONS OF PRINCETON UNIVERSITY PRESS BOOKS
ARE PRINTED ON ACID-FREE PAPER, AND BINDING MATERIALS ARE
CHOSEN FOR STRENGTH AND DURABILITY

PRINTED IN THE UNITED STATES OF AMERICA BY PRINCETON
UNIVERSITY PRESS, PRINCETON, NEW JERSEY

CONTENTS

CONTENTS

EDITORS' FOREWORD

SCHOLARS of art tend to establish, unwittingly perhaps, a special publicly acknowledged relationship with the masters they have studied. Such certainly is the case of Julius Held, whose name, more than that of any other student of Peter Paul Rubens, has come to be associated with that of the great Flemish painter. In several major books and a long series of articles Held has introduced us to the remarkable range of experience encompassed by the art of Rubens—along the way coming himself to know the master ever more intimately and thereby reinforcing our equation of their two names.

Significantly, two of Held's books deal with aspects of Rubens' creative procedure: *Rubens, Selected Drawings* (1959), and *The Oil Sketches of Peter Paul Rubens* (1980). Dealing with categories of pictorial preparation, each of these studies establishes the critical foundations for approaching the whole interrelated complex of art historical problems—from authenticity and dating to function and stylistic development—inherent in every work of art, problems awaiting definition before resolution. Typifying the method or style of Held himself, these books move well beyond their catalogue structures to become profound studies of the creative processes of the artist, processes that are shown to involve iconography as well as composition, idea as well as material, intellect as well as eye.

This same expansiveness informs Held's shorter studies—his articles and lectures—on Rubens and other masters, such as the ones on Jacob Jordaens and Anthony van Dyck that are reprinted here. Generally focusing initially on a particular image and setting out to explore its dimensions of meaning, these pieces offer models for the student on several levels. Whether the starting point involves a problem of connoisseurship or iconography, of style or history, the issues are defined with precision and clarity—but also with a certain undisguised pleasure. The end of scholarship, however, is not the attribution or the dating per se, nor the identification of subject matter. Held's concern is with meaning in its broadest sense, that is, meaning as comprehending everything we want to know about a work of art, from its conception and gestation to its reception and "post-natal career." In this way the history of collecting assumes its rightful place alongside the history of critical appreciation in the definition of the contexts of meaning.

The interpretation of a work of art involves a shuttling back and forth in time, an acknowledgment of the tension between meaning then and now, between the impact of

an object on its initial audience and its effect upon us. As Held himself demonstrates by example, we begin with our own experience of an image and constantly balance and correct our perceptions against the controls of historical knowledge. Held's scholarship is always informed and guided by that deep sense of personal commitment that can only serve to expand the range of experience in the object of his study.

Whether he is reading the Bible with Rembrandt or Ovid with Rubens, Held's interpretation of an image is born of a feeling for the life embodied in both text and image and is molded by the conviction of the artist's basic intelligence and humanity as interpreter. The humanism of Held's critical approach is predicated on such a fundamental empathy with the art he is studying and the life it implies. We may—without his express permission—borrow Held's own stricture (with which he opens "Rubens' *Het Pelsken*") and apply it in the most positive way to him: the scholar's writings do indeed "throw a light on the personal interests and idiosyncrasies" of the art historian himself. Those of us who were privileged to hear Julius Held in the lecture hall or seminar room learned the truth of this dictum as he brought to life for us those images that so inspired and moved him, instructing us in the ways of art and of life. We learned to listen to the understated speech and read the halting gestures of Rembrandt's creatures and to feel the true passion in the heroic gestures of Rubens' *dramatis personae*.

Behind our gathering together a selection of Held's essays, which complements his *Rembrandt's* Aristotle *and Other Rembrandt Studies* (1969), lies a desire to share that experience with a larger circle—and, indeed, younger generation—of students. Julius Held dedicated that volume of Rembrandt studies to his students at Barnard and Columbia, at a time when the very special relationship between teacher and student was being put to a severe test. We, his students, would now like to express our appreciation by dedicating the present volume to the master himself on his seventy-fifth birthday.

While the articles reprinted here appear essentially in their original form, this is in many respects a new edition. The resetting of type made it possible not only to correct typographical errors but also to make other changes for the sake of accuracy, clarity, and consistency. Thus we have brought locations up to date wherever possible, confined documentation to footnotes, added and deleted illustrations, and made minor editorial emendations. Rewriting and deletion of passages have, however, been minimal, and all substantive additions to both text and footnotes appear within square brackets or are otherwise clearly designated.

The choice of articles was made jointly by the author and editors. Prompted by Held's reflections on the genesis and sequence of his interests, we have arranged the studies in order of their publication, so that they take on a biographical significance: the opening article, on the Boston *King of Tunis*, was Held's first publication on Rubens.

This project was supported by a generous grant from the Samuel H. Kress Foundation

and funds from private donors. Our warmest thanks go to the Kress Foundation, and especially to Mary M. Davis, as well as to the Luis A. Ferré Foundation, the Armand Hammer Foundation, Alice M. Kaplan, Jan and Oskar Klein of Central Picture Galleries, Clyde Newhouse of Newhouse Galleries, Eugene V. Thaw of E. V. Thaw and Co., and Virginia Bloedel Wright. Claudia Fogelin provided much appreciated help as research assistant and typist, and Ethan Matt Kavaler prepared the index. The list of Held's publications was based on one compiled by Edith Howard. We should also like to thank the publishers, museums, and collectors who permitted us to reprint material and illustrate works of art while waiving reproduction fees—a contribution of no little importance. Specific acknowledgments appear at the beginning of each study and also in the list of photograph credits that appears at the end of the book.

Finally, we would like to express our gratitude to Christine K. Ivusic of the Princeton University Press; her initial enthusiastic response to this project and her subsequent encouragement and guidance only increased the pleasure of our editorial labor.

ANNE W. LOWENTHAL
Barnard College, Columbia University
DAVID ROSAND
Columbia University
JOHN WALSH, JR.
Museum of Fine Arts, Boston

PREFACE

THE initiative for the present publication came from three of my former students. They also suggested that I add some remarks about the papers selected for inclusion, all limited to the field of Flemish seventeenth-century art, which has occupied me more often than others have done. I realized soon, however, that this suggestion implied—although that may not have been its intention—an effort on my part to reflect on my approach to art history in general; and this inevitably posed the question whether there might be a common denominator to all my studies, or at least the more serious ones. Art historians tracing the careers of individual artists proceed on the assumption that their works are related to one another and that to a greater or lesser degree the personality of the artist should be manifest in all of them. The scholar's activity is surely less governed by personal impulses than is the artist's, but he, too, cannot jump over his shadow. By training and by inclination he will be attracted to particular problems. He will ask one kind of question in preference to others. His very choice of fields of study may be prompted by attitudes and tastes of which he may not even be conscious. And just as the artist, no matter how original his work, is indebted to models given to him by tradition, or followed by him in a conscious process of selection, so the historian of art is subject to influences that show in his method and are revealed in his style.

At the time when I was ready to think of art as an activity worthy of historical study rather than of practice (as I had known it since childhood), the German inflation was at its height. A nightmare for the natives, the period was a bonanza for foreigners who had "Devisen"—currencies unaffected by devaluation. It so happened that I made the acquaintance of some very distant Dutch relatives who had come to a well-known German watering place to live like lords; and they invited me to spend some time with them in Holland. When I took up the invitation—I think it was in 1923—it did not diminish my happiness in seeing the world "outside" when I discovered that at home the "Devisen-Millionaires" lived in very modest circumstances. After more than half a century, I still remember the intensity of physical and intellectual delight that buoyed me during the weeks of that visit. For the first time I saw the sea, that fearsome expanse of gray water rolling in foam-crested waves against the shore at Scheveningen. There were the lush pastures sustaining large herds of cattle under a sky not limited, as in the region where

I had grown up, by mountains rising on all sides. And after years of culinary restraint, I gorged myself on sandwiches of roast beef and cheese, and drank countless glasses of rich milk. But more than the good life, it was the museums, the Mauritshuis and the Rijksmuseum above all, that made these weeks an enchantment which has remained with me ever since. What I had seen outside in that blessed land I recognized, transformed and purified, in the paintings of the Dutch masters of the seventeenth century.

I assume it was at that time that the points governing the tracks of my career were shifted toward the art of the Netherlands. Academic influences reinforced the directions taken, but some years went by before my view encompassed the art of Flanders as well. The taste for the Dutch masters had come naturally; that for Rubens had to be acquired. I believe it was Oskar Fischel who opened my eyes for Rubens in the lectures he gave in the old Kaiser-Friedrich Museum in front of the master's paintings, some of which are now but cherished memories for the dwindling number of those privileged to have seen them before their destruction. When the topic of my dissertation induced me to follow physically as well as mentally Dürer's trip to the Netherlands, it was Antwerp, the city Dürer had made his headquarters four hundred years before, that attracted me most. There I became aware of how much of Flemish art, despite wars, fires, and iconoclasm, was still in place, in contrast to Holland where it was largely sequestered in museums. I was still uneasy in the presence of Rubens; thus, when I pondered which direction to take after finishing my dissertation, I turned to the earthy, uncomplicated, and crudely humorous Jordaens rather than to Rubens. Yet although I spent much time and effort collecting the material for a major publication on Jordaens, in the end he was good only for a number of articles. Largely responsible for my not going on with this project was my growing disenchantment with the artist who later in life had failed to fulfill the great promises he had given in his youth. And as Jordaens' star waned, Rubens' began to rise.

I myself was now engaged in activities which could not fail to affect my work as a scholar. Looking at it in retrospect, I realize that much of my published work has been tied to my career as teacher. Not only did some questions and ideas, later elaborated in formal studies, come to me in the classroom or in the give and take of seminars; but also, when I put pen to paper, I was still guided to some extent by the teacher's desire to bring his students close to the artists discussed, and as much as possible to unlock for them the meanings encapsulated in their works, taken both as personal statements and as historical documents. My earliest publications admittedly came before I had started formal teaching, which I did only in this country. Yet part of my training toward curatorial work in museums involved "educational" activities, such as guiding groups of visitors through the various sections of the Berlin collections, among them the Pergamon Museum with its celebrated altar—a work of an ancient "Baroque" that could not help but reinforce my admiration for the great master of the Flemish Baroque. As a guide, I learned how difficult it is to find the right words in order, if not to match, at least not to debase the works I wanted to explain. Forced later to do the same, both in speaking and writing, in a foreign

tongue, I always remained conscious of the dangers of glib generalizations that only too often slip into interpretations of works of art. And I am sure I have offended students more than once when I censured them for neglecting plain words in favor of the fancy vocabulary they had picked up from criticism read and lectures attended. Wölfflin is supposed to have said, "Woe to the art historian whose words come easily."

Although the studies here assembled belong to only a relatively narrow field—albeit a major one—of my interests, they show clearly what seems to have been characteristic of much of my published work. If the chief divisions of scholastic philosophy were still applicable to the writings of present-day scholars, my studies would be classified as related, if only marginally so, to the nominalist school, rather than the realist. With rare exceptions, the point of departure of my investigations was either a single work of art, or possibly a small group of them. The "substantive reality" that I primarily aimed to examine was almost always a concrete and unmistakable *thing*, not the ideas or ideologies current at a given time.

More often than I should like to admit, my curiosity was triggered by chance encounters. When in the late 1930s a striking portrayal by Rubens of a handsome African prince emerged from the John Wanamaker collection at Lindenhurst and passed through the New York art market (it soon entered the Boston Museum of Fine Arts), I was not only fascinated by the pictorial splendor of the work but also moved by the noble bearing the artist had given to his model. It seemed almost imperative to ask who that model may have been. To my surprise, it turned out that the picture had not been done from life but was the paraphrase of a sixteenth-century portrait which was in Rubens' own collection. And a comparison with that work (known from a print) shows that Rubens had given to the Moorish prince a dignity he had lacked in the presumably more exact likeness of the older picture.

In another case I was prompted to investigate a problem of authenticity when the appearance of a hitherto unknown work of art on the market affected me with the kind of irritation I would expect a scientist to feel when encountering an unwelcome reaction in a familiar experiment. The picture—four heads of a Negro—had been bought at a London auction for nearly one million dollars. It was not this exorbitant price that provoked me but the fact that in quick succession the painting had been attributed to Van Dyck, Jordaens, and Rubens. In my subsequent study of the case, I found a particular pleasure seeing that it was possible to clear up the problem satisfactorily through the application of some plain common sense.

A third one of these studies grew from what I can only call a textbook example of serendipity. As I was standing in Leningrad in front of Rubens' sketch for an engraving in memory of Charles de Longueval, Count of Bucquoy, a ray of sunlight fell on the painting through one of the windows of the Hermitage (oh, those blessed old buildings that still have windows!); and in this truly heavenly illumination I noticed that there was a tiny inscription on the panel that had apparently never before been read. Moreover, it

was not Rubens' own but the engraver's, who signed it with his familiar monogram. This *document trouvé* provided the opportunity to examine anew one of the strangest events in Rubens' life, the danger to, and possibly attack on, his life by Lucas Vorsterman, his engraver.

In studies like these, the work of art served, in the manner of launching pads, to start an inquiry that proceeded to explore problems at best tangentially related to it. In others the work of art held the center of interest throughout, and every avenue explored led back to it, revealing additional aspects of its meaning. The works I so investigated were generally canvases of high visibility, such as Van Dyck's *Portrait of Charles I* in the Louvre, Rubens' portrait of *Hélène Fourment in a Fur Coat* in Vienna, and Jordaens' *Portrait of His Family* in Leningrad. All of them seemed to me to present problems that previous scholarship on Flemish art had disregarded or not even recognized as such. Why, for instance, should Van Dyck himself refer to the portrait of the king as "Le Roi à la Ciasse"? There was no visible reference to hunting in the work, and modern authors were more interested in spinning out romantic associations than in following up such a curious "clue." The painting known as "Het Pelsken" was generally thought to have owed its origin to an accidental glimpse Rubens had of Hélène going to, or coming from, the bath, wrapped in a fur coat, despite the fact that we know nothing about the bathing customs in Rubens' household, while everyone of course knew that a nude in a fur wrap had been painted by Titian and that Rubens had made a copy of it. And in the Jordaens painting, which so obviously included a self-portrait of the young artist surrounded by what most likely were members of his family, a correct identification of the sitters had eluded previous interpreters because they had neglected to pay attention to one essential detail, the child-angels flying above the scene.

If these papers were concerned with the iconography of portraiture in its broadest sense, in other studies I turned to the more conventional task of identifying or at least clarifying the subject matter of narrative subjects previously misinterpreted. Two of the papers here reprinted concern subjects derived from Ovid's *Metamorphoses*, probably the most popular of mythological texts, frequently illustrated before. In both studies—twenty-five years apart—I was able to observe what I found to be true also in other examples of Rubens' work, that he enriched his interpretation of a particular event by basing it on more than one passage from the poet's work. It happened in his painting of *Achelous' Banquet*, where he included in the main story from Ovid's Book 8 a fitting detail from Book 9. Even more revealing is what he did in the painting of the *Daughters of Cecrops*, since his allusion to a later event can alone explain the absence of any reference to the ensuing tragedy that had puzzled previous observers.

The longer I occupied myself with Rubens, the more I came to admire the range and depth of his interests, chief among them his study of classical antiquity, in its literary as well as its artistic manifestations. Thus I was delighted when, alerted by Karel Boon, I was able to make known a hitherto unknown group of splendid drawings of ancient

sculpture, including four studies after the Laocoön group, thereby providing a broader base than existed before to gauge the intensity of Rubens' preoccupation with ancient art.

The discovery in Avery Architectural Library at Columbia University of a modest drawing for an epitaph prompted me to investigate a heretofore neglected side of the master's activity, his designs for sepulchral monuments. Related to this line of inquiry were two later papers (here condensed into one) in which I approached the problem of Rubens' illustrations of books, above all his designs for title pages. This study, in fact, was the outcome of a seminar conducted in the graduate program at Williams College, and the preparation, with the help of the students, of an exhibition of that material. The books themselves, as one might expect, were a great help in deciphering allegorical conceits no longer familiar. It was also a nearly contemporary book on the training and care of horses which provided a clue for the seemingly arbitrary inclusion of an ancient deity in Jordaens' illustration of a Flemish proverb.

During the preparation of larger publications, I occasionally encountered problems requiring argumentation too long to fit into the main text and too essential for the study of the work in question to be banished to a footnote. This was the case with Rubens' splendid sketch at Glynde Place which Oliver Millar had published without, however, explaining why some parts of the sketch had been painted upside down. When it dawned on me that this reversal made excellent sense, relating as it does to the manner in which the finished paintings were to be seen on the ceiling, I also realized that five of the nine large canvases on the ceiling of the Banqueting House had been wrongly installed; to be seen as Rubens had intended them to be seen, they had to be turned around by 180 degrees. This change was in fact made a few years after my article appeared.

In a similar way, the question as to what iconographic tradition was represented by a Rubens sketch (stolen in 1933 from the Brooklyn Museum and never found) led me to what appears to have originally been a Protestant theme that had been incorporated in the imagery of the Counter-Reformation.

The final article selected for this publication is about a work which intrigued me for reasons that had nothing to do with its aesthetic appeal, admittedly small. Yet the pictorial catalogue of the collection of Cornelis van der Geest, by Willem van Haecht, is of considerable interest, first because of the personality of the collector, a friend and patron of Rubens, and also as a document reflecting the local pride felt in Antwerp in Rubens' time, in the achievements made, and the social position attained, by Flemish and particularly Antwerp artists. That Van der Geest appears to have owned a most curious painting by Jan van Eyck—now lost—required a separate investigation, which, among other things, led me to the widespread custom of the ritual ablution of brides before the wedding and its possible appearance in a well-known painting by Memling. Further research, made after the publication of that article (1957), is here presented for the first time, including the discovery in the Antwerp archives that Van der Geest was born twenty years earlier than had hitherto been thought.

As I contemplate this group of essays on Flemish painting, it occurs to me that a fitting subtitle of the publication might have been "occasional papers." They originated haphazardly, and all had a limited aim; nor do they jell into a coherent image of Flemish seventeenth-century art. What I hope they do is convey a particular and, in its limitations, valid attitude toward the study of works of art. Some of my studies have occasionally been compared to detective work. I do accept the analogy insofar as it refers to a method of the most exacting observation of all the evidence presented by the work of art. This includes also the study of iconography, a study which was greatly stimulated in me by my acquaintance with the work of the "Warburg Circle"; like most contemporary art historians, I am particularly indebted to Erwin Panofsky, but I have learned much also from conversations with Rudolf Wittkower and with Meyer Schapiro, for many years my colleagues at Columbia University. Yet my first professional training, which carried over into much of my later work, was in the activity commonly referred to as connoisseurship. Although thematically confined, this collection, I believe, exhibits with sufficient clarity the connoisseur's desire to anchor a given work of art in time and space. I am convinced that any broader historical construct runs the danger of error, if the basic data of the works involved have not been securely established.

That does not mean that I eschew all speculation. There are limits to what we can know. Max J. Friedländer used to say, "Wir sind ja nicht dabei gewesen . . ." ("After all, we were not present when . . ."). Provided we remain conscious of the hypothetical nature of any inferences we are drawing, I believe in the historian's right to ponder the motivations and the nature of the various human interactions involved in the creation of works of art. I realize, for instance, that in my piece on Rubens and Vorsterman, I went out on a psychological limb. Yet by not speculating on the sources of the tension between the two artists, I feel I would have been guilty of historical pusillanimity. Is it perhaps permissible to say that in such situations even a mistaken psychology might be better than no psychology at all?

It is fitting that the majority of studies here gathered are dedicated to the genius of that master who dominated, if not actually epitomized, the Flemish school of the seventeenth century: Peter Paul Rubens. Two other painters also make an appearance—Anthony van Dyck and Jacob Jordaens—both artists presenting in their work well-defined personalities. Yet their work would not have been what it was had they not received, and assimilated, the impact of Rubens' presence. Fromentin had seen this clearly when he said, speaking of Van Dyck, that "in spite of his personal genius, his personal grace, his personal talent," he "would be inexplicable if we had not before our eyes the solar light from which issue so many beautiful reflections." Yet the historian must beware of the danger of hero-worship, which might well prevent him from distinguishing with any degree of clarity the satellites coursing around the central star. Thus at various times I have turned my attention to these minor bodies in the constellation of Flemish art, such as Abraham Janssens, Theodoor van Loon, Otto van Veen, Jacob van Oost, Jan Boeckhorst, Antoon van den Heuvel, and Lucas

Franchoys the Younger. By clarifying their oeuvres, we may occasionally purify the work of the master from unwarranted attributions, as in the case of a sketch of St. Michael (Detroit) which had been published several times with critical superlatives as the work of Rubens but actually turned out to be by Franchoys. Despite some progress in this direction, the field is by no means closed; a younger generation of scholars may yet reap ample rewards by taking over the plow that the hands of the older generation are forced to relinquish.

As I close these rather personal reflections, I am conscious of the debt of gratitude I owe the three younger scholars who not only encouraged me to put them into words, but without whose initiative, attention, and plain hard work this publication would never have been possible. When Anne Lowenthal, David Rosand, and John Walsh conceived the idea of thus honoring me on my seventy-fifth birthday, they may not have realized how much time and effort would have to be invested by them in this project. May the result be worthy of, and reward them for, their labors.

JULIUS S. HELD
July 1979

LIST OF ILLUSTRATIONS

(XIII) The *Four Heads of a Negro* in Brussels and Malibu

(XIV) The Daughters of Cecrops

(xv) Rubens and the Book

RUBENS AND HIS CIRCLE

RUBENS' *KING OF TUNIS*
AND VERMEYEN'S
PORTRAIT OF MŪLĀY AḤMAD

IN HIS critical catalogue of Rubens' oeuvre, Max Rooses lists two paintings which figured in Rubens' estate after his death, where they were described as follows: *Twe portretten van een Koning van Thunis naer Antonius Moro* (Nos. 148-149).[1] Without any definite clues, Rooses hypothetically identified one of these paintings with a panel that had been in the Wellesley gallery, had passed from there into the collection of the Marquis du Blaisel, and had finally been sold with the Secretan collection in 1889.[2] The location of this picture was no longer known to Rooses when he published his book in 1892. However, the painting can now be identified as the *King of Tunis* (Fig. I.1), recently acquired by the Museum of Fine Arts, Boston, and formerly in the collection of John Wanamaker at Lindenhurst, where, although catalogued,[3] it seems to have remained for years almost completely forgotten. Not only are the measurements and the description in perfect agreement, but the catalogue of the Lindenhurst collection also refers to Lord Wellesley and the Marquis du Blaisel as the previous owners.

It is difficult to describe adequately the powerful impression this painting makes upon the beholder. Before a landscape in which the light blue sky, the rosy gray of the ruins, and the dull green of the fields predominate, towers the figure of the African in three-quarter length. He is clad in a somber, dark olive tunic enlivened by a vermilion tassel, a yellow and light crimson sash, and another similarly colored band hanging across the lower right arm. These colors are subordinate to and dulled by the large areas of extraordinarily sparkling white in the turban and other parts of the costume. The color scheme culminates in a most fascinating manner in the face, where the almost metallic bronze of

Reprinted by permission of *The Art Quarterly*, III, 1940, pp. 173-181.

the skin is suddenly pierced by flashing white highlights in the eyes, the true focal points of an amazing composition. The principal color arrangement is modified and animated in two ways: first, by the insertion of smaller patches of different color into the larger fields (copper-colored streaks in the turban, and blue, red, and white dots in some small figures in the background) and second, by the glittering play of lights and shadows which in turn endow the forms with an almost aggressive plasticity.

The fascination of the portrait is not due alone to its formal and coloristic qualities. One is drawn to study the features of this obviously noble Moor, where determination and animal menace seem to be strangely paired with sadness, even melancholy. Who was this man and where was his home? In what way is he related to the horsemen in the background or to the ancient ruins of an aqueduct?[4] These questions, fortunately, can be answered in detail, and with these answers the genesis of Rubens' painting can be clarified in a rather surprising way.

The painting, as we have seen, was connected by Rooses with two pictures which were described in the inventory of Rubens' own estate as portraits of a king of Tunis, after Antonio Moro. Such "copies" by Rubens after sixteenth-century paintings are not unusual.[5] However, it is difficult to relate the text of the inventory to our picture. Not only has no painting by Antonio Moro been preserved which could have served as a model, but the entire composition with a landscape as background and the intense psychological tension on the face finds no parallel in Moro's work. We would have to assume either that Rubens dealt rather freely with his model or that the note in the inventory is mistaken, at least about the name of the artist whose work Rubens followed. That this might be true could be inferred from another record which tells us that in the inheritance of the Antwerp painter and dealer Herman de Neyt, who died in 1642, there were two pictures described as follows: *Den Moor van Meester van Aelst, met Tunis achter.—Den vader vanden voors (chreven) Moor die Keyser Carel te voet valt.*[6] Here again we have the reference to Tunis, and this time we can pretty safely say who the figures were, although the pictures themselves are no longer known. Their titles quite obviously allude to one of the most famous military exploits of the sixteenth century, the punitive expedition to Tunis made by Charles V in 1535. The year before, Mūlāy Ḥasan, Berber king of Tunis, had been driven out by Khair al-Din (Barbarossa), famous corsair and vassal of the Turkish sultan. Mūlāy Ḥasan fled to Spain and implored the help of Charles V, who responded gladly. In a widely heralded "crusade" (and with superior military power) he conquered Khair al-Din and Tunis, and reinstated Mūlāy Ḥasan, not without obliging him to pay for the imperial favor with yearly tributes.

It is possible, although there is no way of proving it, that the "King of Tunis" which served as Rubens' model was one of these pictures, and hence not by Moro but by Pieter Coecke van Aelst. Yet again there is a difficulty. Pieter Coecke is well known for his famous trip to Constantinople in 1533. A series of woodcuts was published from the designs which he made on this trip, and for years to come his name was connected with

anything that smacked of the Orient. There is no document, however, which tells us that he was ever in Tunis. All the authors who maintain that he was there have as their only piece of evidence the two pictures which we just mentioned—described as his work more than a hundred years after the probable date of their execution.

Yet, we do know of an artist contemporary with Moro and Coecke, who was in Tunis, and who had even taken actual part in that expedition of 1535. His name was Jan Vermeyen. He had been commissioned to make designs for tapestries commemorating the event and affirming the role of Charles V as protector of Christianity. The cartoons for ten of these tapestries are still preserved in Vienna. However, the name of their original designer was soon forgotten. [The set of twelve tapestries is still in Madrid.] The name of Vermeyen scarcely occurs in seventeenth-century or later writing, and his rediscovery was one of the more spectacular feats of recent art history.[7] His portraits had been identified with Moro, among other painters, and many of his etchings and tapestry designs show close stylistic parallels with the work of Pieter Coecke. We would indeed have little reason to be surprised if seventeenth-century critics mistook his works for those of either Coecke or Moro.

There actually are two works by Vermeyen in which the King of Tunis, Mūlāy Ḥasan, and his son Mūlāy Aḥmad are depicted. One is a woodcut, correctly attributed to Vermeyen by Steinbart,[8] in which the characteristics of his style can still be observed despite the coarse execution by the woodcutter. The other is one of Vermeyen's beautiful though rather rare etchings, the portrait of Mūlāy Aḥmad (Fig. I.2).[9] This etching suddenly takes us back to Rubens' painting, for it corresponds with Rubens' design in almost every detail, except for one significant difference: it shows the composition in reverse. Since Rubens had no reason at all to go to the trouble of reversing the design, we conclude that he did not work from the etching but that both the etching and Rubens' painting were made from the same prototype—most likely a painting of Mūlāy Aḥmad by Vermeyen. We are justified in such an assumption because it is known that in another instance (with the portrait of Erard van der Marck) Vermeyen made an etching after his own painting. As a matter of fact, it was this instance that gave the first clue to a reconstruction of Vermeyen's work as a painter of portraits.[10]

Moreover, there is internal evidence that the etching shows the composition in reverse. Mūlāy Aḥmad holds the scabbard in his right hand, which is unnatural since he would normally not use his left hand to draw the sword. One has only to compare this position with Rubens' picture to become aware of its awkwardness.

One might perhaps ask if the original from which the etching was copied could not have been by another artist. However, all circumstances speak against such an assumption, particularly the fact that the design is closely related to other works of Vermeyen, especially the self-portrait of the artist preserved in the engraving by Jan Wiericx in Van Mander's book on the lives of Flemish and Dutch painters.[11]

We are, then, quite justified in assuming that there existed in the seventeenth century a painting by Vermeyen, the design of which is preserved in his own etching and in a

"copy" by Rubens. This painting, now lost, is perhaps identical with the portrait of a "King of Tunis" attributed to Moro which in turn is perhaps the same as that in De Neyt's collection which was then believed to have been done by Pieter Coecke.

For the identification of the lost Vermeyen portrait with the latter picture we can put forth another reason. De Neyt's picture is described as having a "view of Tunis" in the background. Vermeyen's etching indeed contains buildings of unmistakably African character in front of the ruins of the aqueduct. The aqueduct itself, however, is the most telling feature. Southeast of Tunis, near the river Medjerda, there are still today the imposing ruins of one of the most famous aqueducts of antiquity, which connected Zaghwan with Carthage, a distance of over 132 kilometers. Although much of it has been destroyed there are still a number of parts preserved, consisting of a double row of arches such as we see in the background of Vermeyen's etching and of Rubens' painting.

Mūlāy Aḥmad appears in the etching as a fairly young man. The painting from which it was copied was most likely done in 1535, when Vermeyen was himself in Africa. At any rate, it must date from before 1542, the year in which Mūlāy Aḥmad became king of Tunis himself, since the inscription calls him only "princeps Africanus Filius Regis Tunisiae." What we know of him is not exactly engaging. When his father made a trip to Europe in 1542 to make another plea for support, Mūlāy Aḥmad used his absence to establish himself as ruler. When the father rushed home, he was faced by his son with the choice between lifelong incarceration and blinding; he preferred blinding. Precariously tacking between the Spaniards and the Turks, Mūlāy Aḥmad retained his power until 1569, when he, too, fled to Spain. Nothing further is known about him.[12]

Such was the man whom Rubens painted in the Boston picture. We may be sure that he knew precious little about the historical Mūlāy Aḥmad. To him, the king of Tunis was probably just the hero of a romantic tradition, one of the African natives who had made common cause with the most Catholic emperor Charles V in his struggles against the Turks. There is a grandeur and dignity in his work which he alone could have added, since it is not found in the etching which is presumably a faithful reproduction of Vermeyen's paintings. Rubens "corrected" the proportions of his dusky prince by elongating his body so that the arms have their natural length and are not crowded as in Vermeyen's etching. He also eliminated as too confusing most of the small figural detail in the background. How much his color scheme owes to his model, we are, of course, in no position to say. But we may be sure that the brilliance of coloring, the freedom of sparkling highlights, and the sweep of the brushstrokes derive from the overflowing temperament of Rubens alone.

This leads to the question of when in his career Rubens may have painted the portrait. Since Vermeyen's picture appears to have been in the Netherlands, Rubens could have made his "copy" only after his return from Italy in 1609. Everything, indeed, points toward the years immediately after this date, years in which the fiery temperament of the master streamed almost unchecked into his paintings. One of the works which he executed

in this period was the large *Adoration of the Magi*, now in the Prado. It was ordered by the city council of Antwerp in 1609 and was executed in the course of the year 1610. It is well known that the picture was enlarged and in parts painted over by Rubens at a later period, but the original state can still be made out from the sketch which Hofstede de Groot published,[13] and which is now in the museum at Groningen. In this sketch we find our "King of Tunis" again, right in the center, in the role of King Balthasar. The color of his dress is light and he has donned a sparkling golden mantle, but these differences do not alter the essential similarity, especially in the face with its intense glance from the corner of the eyes. If nothing else, this recurrence would prove that Rubens was familiar with Vermeyen's painting in 1609. The loose, impetuous "bravura" style of the brushwork in the Boston picture would in my opinion also fit best into this period.

As one might expect, the Groningen sketch is not the only picture in which Rubens made use of his study after Vermeyen. We find the head alone, unmistakable with the large round turban, the white neck piece and the same turn of face and eyes, in the *Adoration of the Magi* of Malines Cathedral (1617-1618), again in the role of Balthasar.[14] This discovery proves that Rubens, rather than dressing up a Negro model which he could have studied from life, was satisfied with "copying" from one of his own earlier pictures, which in turn was again not made from life but from an old painting. From this incident we get a fair idea of Rubens' working methods. The astonishing thing about them is not that he was so economical of his material or that he was unafraid to repeat a design, to "quote" from his own or from pictures of other masters. What really amazes the modern beholder is Rubens' ability to combine with this talent for economic organization that of burning up all traces of his methodical execution in the fire of his pictorial fantasy. No matter how often he may have repeated himself or others, each work bears the imprint of his own originality.

POSTSCRIPT (1980)

In my catalogue raisonné of Rubens' sketches in oil (Princeton, 1980, p. 600), I returned to the problem of the Boston painting and wrote that its connection with the *Adoration of the Magi* of 1609 appears to me less close than I stated in 1940. I now prefer a date of 1613-1614 for that "dignified portrayal of the Moorish prince."

NOTES

1. Max Rooses, *L'Oeuvre de P.-P. Rubens*, Antwerp, 1892, IV, nos. 1067-1068. We quote the text of the inventory from J. Denucé, *Inventories of the Art Collections in Antwerp in the 16th and 17th Centuries*, Antwerp, 1932, p. 63.

2. Rooses: "Provient: Gallery Wellesley. Fut retenu à 6000 francs dans la vente du marquis de Blaisel (Paris 1870); dans la seconde vente du marquis de Blaisel (Londres 1872) il fut retenu à 150 livres sterling. Il fut vendu avec la collection Secretan en 1889, mais ne figura point au catalogue." (The latter information is incorrect. The painting is described in the catalogue of the Secretan sale under no. 159.)

3. No. 246, "Un Bey de Tunis," panel, 39 × 28½ inches.

4. Rooses mistakenly thought them to be the ruins of the Colosseum, from which he concluded that Rubens painted the picture in Rome.

5. There are painted copies after Massys, Key, Bruegel, and Titian, not to mention his many drawings after works of ancient and Renaissance art.

6. See Denucé, *Inventories*, p. 101.

7. For the latest discussion of his life and work see M. J. Friedländer, *Die altniederländische Malerei*, Leyden, 1935, XII, p. 157. [See now Max J. Friedländer, *Early Netherlandish Painting*, trans. Heinz Norden, New York, 1965, XII, p. 85-89, 129-130, 132, and 141.]

8. *Marburger Jahrbuch für Kunstwissenschaft*, VI, 1931, p. 100.

9. See A. E. Popham, *Oud-Holland*, XLIV, 1927, p. 174, no. 14. Copies in Berlin and Paris. The inscription reads: "MVLEI AHMET PRINCEPS AFRICANVS FILIVS REGIS TVNSI." The Arabic inscription on the coat of arms in the upper right corner is the Islamic proclamation of faith: "There is no god but Allah and Muhammed is the prophet of Allah" (information kindly given by the late Professor Richard Ettinghausen).

10. See Otto Benesch, "Jan Vermeyen als Bildnismaler," *Münchener Jahrbuch*, 1929, p. 204.

11. Reproduced in Hymans' and Floerke's edition of the *Schilderboeck*.

12. For these and other dates see E. Mercier, *Histoire de l'Afrique septentrional*, III, 1891, and C. Julien, *Histoire de l'Afrique du Nord*, Paris, 1931.

13. "Eine unveröffentlichte Farbenskizze aus der Frühzeit des P.P. Rubens," *Pantheon*, 1928, p. 36.

14. Reproduced in Rudolf Oldenbourg, *Rubens: Des Meisters Gemälde*, Klassiker der Kunst, Stuttgart, 1921, p. 163.

JORDAENS' PORTRAITS
OF HIS FAMILY

THE *Family Group* in the Hermitage at Leningrad (Fig. II.1)[1] has for a long time been known as one of the outstanding works of Jacob Jordaens. Two very important questions about the picture, however, have not yet been answered convincingly: who are the persons portrayed in the work, and in what year was it done?

If one follows the modern critical literature on the painting one finds that the majority of the critics seem to be agreed on an approximate dating. Buschman, Rooses, Oldenbourg, Bode, and Zoege von Manteuffel[2] consider it to be an early painting with dates varying slightly between 1616 and 1620. The date 1616 is also accepted by the authorities of the Hermitage, judging from the label on the painting itself. Only Fierens-Gevaert and Drost[3] give a later date.

At the outset, and judging solely on the basis of a general idea of Jordaens' development, the thesis of the earlier date would appear more plausible. Although the painting is covered today by a heavy yellow varnish which tends to soften the contrasts of color, one can easily observe stylistic features peculiar to Jordaens' earliest works, as they were well described by Burchard.[4] The coloring of the flesh with cool blue and violet shades is used a good deal and is just as characteristic as the wavy modeling and the application of the pigments in a loose and spotty manner, especially in the highlights. There is, furthermore, the extreme lack of spatial freedom and clarity. It is this crowdedness which many writers, beginning with Waagen,[5] criticized as one of the chief weaknesses of the work. In fact, it would hardly be possible to account in a rational manner for the bodies of all the figures around the small table. The heads are arranged like beads on a string, and only in front of the table do the figures have a fair amount of space in which to move. Yet, just in these

Reprinted by permission of *The Art Bulletin*, XXII, 1940, pp. 70-82.

parts there seem to be traces of *pentimenti*. Although even a study of the original painting as it now appears in the gallery failed to reveal the exact amount of overpainting, it can easily be seen that a part of the robe of the boy with the dog, the dog itself, and the right foreground corner, as well as parts of the dress of the little girl on the mother's lap, show traces of later changes. Except for these parts, the stylistic character of the painting is unaltered and suggests an early date, although it is impossible to make a more exact statement at this point.

With regard to the identity of the family, we find the earliest suggestion on Watson's mezzotint, made shortly before 1779, where the family is called that of Rubens. This mistaken title, under which the painting seems to have passed in the Walpole collection and also in the Hermitage, was first repudiated by Waagen and later unanimously by modern critics. Yet the theories with which later writers tried to replace the old tradition were just as unsatisfactory, save in one respect. Buschman, Haberditzl, and Van Puyvelde[6] believed that the family was that of Adam van Noort, Jordaens' teacher and father-in-law, and that the young man in the left foreground was Jordaens himself. While this last observation is correct, as we shall see later, the identification of the other figures cannot be accepted. First, it would be impossible to account for all the other figures as members of Van Noort's family (a fact which prompted Buschman to assume that Jordaens arbitrarily combined members of his own family with that of his teacher), and second, there is no similarity between the man holding a wineglass in the Leningrad picture and the well-known likeness of Van Noort as it appears in Hendrick Snyers' engraving, Van Dyck's etching, and Jordaens' own portrait of his father-in-law in Berlin.[7] Fierens-Gevaert's theory, that this elderly man is Jordaens himself, is not only in disaccordance with the presumed date for the picture, but is also unconvincing in any comparison with the well-known features of Jordaens as preserved in various monuments (Fig. II.2). In addition, this theory fails to identify any of the other persons portrayed.

No wonder that most scholars preferred to leave open the somewhat embarrassing question as to who is represented in the Leningrad painting. And yet an answer to it can be found, once a preliminary problem is settled which, strangely enough, has never been seen as such, namely, how large was the family we see in the picture, making, of course, the natural assumption that the painting is a portrait of a *family*.[8]

If we look at the painting again, we see first the two parents. There can be little doubt that the man with the wineglass is the father, the woman in the right foreground with the baby on her lap, the mother. Of the other figures, the woman in the right background would seem to be a maidservant and hence does not belong to the family proper. Her dress is much simpler than that of the others, and by carrying a dish of fruit she is characterized as of lower social rank. Thus, there remain eight persons whom we would have to consider as the children of the couple. Three of them, obviously, are boys. One, in the center of the picture, next to the father, might be either a boy or a girl. The rest clearly are girls.

This statement, however, does not take into account the three little angels which hover right above the heads of the family. They seem to have a definite significance in the picture,

since their presence is not entirely unnoticed. The two children in the center look up at them with a rather solemn, by no means playful or surprised expression, while one putto directs their eyes with a pointing gesture toward heaven and another spreads his hands in benediction. The three angels who seem to be in such close contact with members of the family obviously deserve an explanation. So far only Buschman has ventured to give one, suggesting that being *liefdegoodjes* ("cupids"), they might symbolize "domestic happiness" (*huiselijk geluk*). This theory, however, is at best a guess and has no analogy in the iconography of the period.

Nevertheless, by study of other paintings of this type we can clarify the meaning of the putti. For while their appearance in a group portrait of a family is perhaps a strange feature to the modern eye, it is by no means unusual in the seventeenth century. And wherever they appear, they have only one meaning: they represent the souls of children who had died earlier. For people to whom life after death was a certainty, and who believed that their deceased children lived on as little angels, the rendering of these children in a portrayal of the entire family was only a natural expression of piety and parental love. The following examples of such pictures may be noted here: the family of Pieter Stalpert (1645), by Jan Mytens; the family of Willem van Kerckhoven (1652), by the same artist, both pictures in the Gemeente Museum in The Hague; a painting by Juriaan Ovens, in Rotterdam,[9] with the family of H. Matthias, where one of the living children points toward the three deceased ones who hover above holding wreaths in their hands;[10] and a painting of 1634 by Thomas de Keyser in the Van Alen collection, London,[11] where it is the father who points toward three deceased children, "die als nackte Engelchen in den . . . Wolken umherflattern"![12] This painting, incidentally, contains the portrait of a nurse as well as those of the parents and five living children. There is, finally, a painting by Wybrand de Geest, of 1656,[13] with three little angels in the air, one of whom can be definitely identified as a deceased child. A document quoted by Bauch[14] is a valuable seventeenth-century confirmation of the point in question.

We would seem to be well justified, from this evidence, in taking the three little angels in the Leningrad picture also as the representations of departed children, an assumption which enables us to understand the exchange of glances between them and some of the living members of the family. We would then have to account not for only eight but for eleven children of the two parents.

This observation immediately opens up a fresh opportunity for the identification of the family. For we know, thanks to Génard's studies of documents,[15] that Jordaens' own parents had eleven children. They were

Jacob, the painter, born 1593	Madeleine, born 1603
Anne, born 1595	Elisabeth, born 1605
Marie, born 1596	Abraham and Isaac, twins, born 1608
Anne, born 1597	Susanne, born 1610
Catherine, born 1600	Elisabeth, born 1613

In this list the names Anne and Elisabeth each appear twice. For this fact there can be only one explanation, which is corroborated by the custom of the time to give the name of a departed child to the next born of the same sex: Anne I had died before 1597, when Anne II was born; Elisabeth I, before 1613, the date of the birth of Elisabeth II. Hence the evidence of the list alone would suggest a family of nine living children and two who had died. If the Leningrad picture represents the family of Jordaens' parents, as we believe it does, we would have to assume that a third child had died before it was painted. According to Génard, we know sufficient facts of the later life of Jordaens' brothers and sisters to establish with certainty that Anne II, Catherine, Madeleine, Abraham and Isaac, and Elisabeth II survived at least beyond the middle of the 1620s,[16] in other words beyond the time when the picture presumably was painted. The children of whom no later records exist are, as we would expect, Anne I and Elisabeth I, and besides these two, Marie and Susanne. Taking as negative evidence the fact that none of the girls born later was given her name, we surmise that Marie, born in 1596, survived the perils of childhood, at least beyond 1613. Hence, only Susanne remains of whom we know nothing. We assume, hypothetically, that she died early.

In comparing the record of Jordaens' brothers and sisters with the evidence of the Leningrad picture, one is struck by one point of correspondence: the distribution according to sex. In both families we have one grown-up son and two considerably younger boys. In fact, we have very little difficulty in identifying—still tentatively—each child in the picture with one of Jordaens' brothers and sisters. The youngest, on the mother's lap, would of course be Elisabeth II, the two boys in front, Abraham and Isaac. The young woman beside the mother would be the oldest daughter, Marie. Next to her, looking up to the angels, we would recognize Anne II (and her solemn glance would be particularly justified, as she bears the name of one of the departed), whereas the girl who looks over her mother's shoulder would be Catherine. The child next to the father, whose sex was hard to determine from the painting alone, would be Madeleine. In the young man with the lute, to the left, finally, one would have the self-portrait of the artist.

As we saw in the beginning, this last point would not represent a new observation. It has been suggested before by other writers, and can easily be established through a comparison with other portraits of Jordaens. In our case, however, this identification assumes a special significance, for once it is made certain, it automatically provides the clinching argument for the thesis proposed.

There are several portraits of the master for comparison. None of them shows him as young as the Leningrad picture. All the more striking, therefore, is the similarity of the features with the well-known engraving by Peter de Jode, done from a self-portrait which Glück believes to have found in a painting which in 1934 belonged to Tomas Harris, London.[17] This similarity has been observed by Buschman and others, as we have mentioned above. It cannot, in my opinion, possibly be denied. We have the same large, dark eyes and high brows, the short nose with rounded tip and wide nostrils, the full sensuous

mouth, the square chin. For the few differences, the considerable interval of time between the two pictures is explanation enough. The same result can be derived from the engraving by Vorsterman after Van Dyck's portrait of Jordaens, where even the form of the ear is strongly reminiscent of the Leningrad picture. Of all the supposed youthful self-portraits of Jordaens, the one in the painting under discussion corresponds more closely than any other to the contemporary engravings.[18]

It may be noted here, however, that on the basis of the engravings and also of the Leningrad picture, at least one more self-portrait can be recognized with reasonable certainty. It appears in the beautiful family portrait in the Prado which Hymans[19] quite rightly took for a portrait of Jordaens, Catherine van Noort, and their eldest daughter, Elisabeth; the girl with a fruit basket, naturally, is a maid (Fig. II.3). This contention was contradicted by Rooses,[20] with insufficient reason. A comparison with Jordaens' likeness as it appears in the Leningrad picture will suffice to prove the intrinsic sameness of the features, although the master had in the meantime grown the moustache which we know also from the engravings. It is, perhaps, not by chance either that the man in the Madrid painting holds a lute just as does Jordaens in the Leningrad picture. Since the age of the little girl in the Prado painting can be estimated to be about four or five years, the date of the picture would be about 1621-1622, as Jordaens' daughter Elisabeth was born in 1617.

The Leningrad picture must, of course, have been painted considerably before this time. Its actual date can indeed be fixed within a fairly narrow space of time, once the question of the identity of the family is settled. The daughter on the mother's lap, Elisabeth, was born in August 1613. As she seems to be at least one year old, although hardly more than two, a date for the painting of about 1615 would be the most likely. In this year the twins Abraham and Isaac were seven years old, Madeleine twelve, Catherine fifteen, Anne eighteen, Marie nineteen, Jordaens himself twenty-two. Their likenesses in the picture would seem to support such a dating.

At this point an unexpected difficulty seemed to perturb the smooth flow of an apparently simple demonstration. According to Génard,[21] Jordaens' father died in 1613. If the picture was painted in 1615, as everything would indicate, it is disturbing, to say the least, to find him still among the living, especially since the deceased children had been painted as little angels. The author admits that he first tried to explain the strange fact by a somewhat tortuous hypothesis. The solution, however, was quite simple—and in complete accord with the thesis proposed. While checking a different problem in Rombouts-van Lerius' edition of *De Liggeren*, the writer came across a footnote (p. 444) according to which Jordaens' father had died not in 1613, as Génard says, but August 5, 1618, and was buried three days later. Confronted with the choice between the awkward date of 1613 and the welcome one of 1618, the writer turned to two Antwerp specialists, M. J. Ernalsteen, Archiviste de la Cathédrale d'Anvers, and M. J. Denucé, Archiviste de la Ville d'Anvers, for help. The answer from both was as hoped for: Jordaens' father died indeed only in

1618,[22] and the date of 1613 was due either to an error in reading on the part of Génard, or, much more likely—considering Génard's reliability—to a printer's mistake which escaped the attention of the proofreader. Instead of the date of the death of Jordaens' father presenting an obstacle to our theory, the theory contributed to the uncovering of a printer's error, thus providing a measure for its own dependability.

The date 1615 which can be assigned to the Leningrad picture was important in Jordaens' life in another way. He received the freemastership in the Guild of St. Luke in that year. Although previously no painting was known which could have been dated so early, we have theoretically been prepared to find pictures of this date since Burchard published his important article in 1928. Burchard actually put together a group of works which he believed were done between 1615 and 1618, without however being able to advance a definite date for any one of them. This situation has since been considerably changed. In 1936, Van Puyvelde[23] published a picture by Jordaens which was signed and dated 1617. More recently, this author was able to describe a *Holy Family with Shepherds*, signed and dated 1616.[24] With a date of 1615 established for the Leningrad group portrait, we are in possession of at least one work for each year from 1615 to 1618. Under these circumstances the question arises whether Burchard's approximate dates might not need a further revision.

One of Burchard's most striking arguments, apart from style, was the observation that Jordaens, who from all appearances was a rather precocious artist, must have done a considerable number of works from the time of his acquisition of the freemastership on. Burchard might even have gone further. Jordaens was born in 1593. At fourteen he entered the studio of Van Noort. Without pressing the point, we would be justified in expecting paintings by Jordaens even as early as 1612, when he was nineteen years old.[25] (Of Rembrandt's preserved oeuvre, the earliest works were executed by the nineteen-year-old artist, while Van Dyck at this age had a full measure of production behind him.)

According to Burchard[26] one of the earliest paintings is the *Holy Family* in Brussels (Fig. II.4). In comparing this work with the Leningrad picture, we find obvious similarities in the rendering of the draperies (for instance in the figures at the left), the drawing of hands, the modeling of faces, or the treatment of the foliage in the background. There is a similarity in the choice of colors, and a related lack of spatial clarity, especially with regard to the figure of St. Joseph. Moreover, we find an almost repetitious arrangement in the group of two embracing children, the happily watching mother, and a fourth figure—in Brussels, St. Joseph, in the Leningrad picture, Catherine—who looks down over her shoulder. And yet, in the face of such similarities, the Leningrad picture clearly impresses us as the more advanced of the two. There is a greater gift for psychological animation of the faces, a maturer technique, and a sureness of anatomical construction which is absent in the other painting. In the Brussels canvas the head of the Infant Jesus seems to be almost detached from the rather clumsily drawn body.

If these observations are evaluated chronologically, one must come to the conclusion

that the Brussels *Holy Family* should be dated even before 1615 and hence would come rather close to the date of 1612, prior to which no paintings by Jordaens can reasonably be expected. In this problem, our newly-won knowledge about the Leningrad picture proves to be of value. One can hardly deny a certain likeness between the figure of Jesus in the Brussels picture and the boy in the foreground of the Leningrad family portrait, as if the same model had been used, though younger by a couple of years. Is it not a rather tempting conjecture to assume that the models for the two boys in the Brussels picture were Jordaens' own little brothers, Abraham and Isaac, when they were about four years of age, in other words, about 1612? The Virgin in the Brussels picture looks, of course, too young to be considered an actual portrait of Jordaens' mother; yet her features are definitely related to those of Jordaens' mother as portrayed in the Leningrad painting, and it is perhaps permissible to assume that Jordaens in depicting the Mother of God was guided by the image of his own mother.

As one result of the foregoing discussion, it would appear that the large and still-growing group of Jordaens' "earliest" works can probably be distributed over roughly six years of intense creative activity (1612-1618). Several of the paintings which were published by Burchard in all likelihood belong to the period before 1615 (as for instance his Figs. 3 and 11). The task of charting the artist's development during these years still remains to be done, a task which will provide the opportunity of checking the reliability of the deductions made in the present study.

After this article had gone to press, Margaretta Salinger of the Department of Paintings of the Metropolitan Museum of Art called my attention to a passage in the notebook of George Vertue which deals with the Leningrad group portrait and has the distinction of being the earliest literary reference to this picture. Vertue saw the painting in 1722 and made a short note of it in his diary (London, British Museum, Add. MS 23076). The most amazing aspect of this oldest record connected with the picture is the fact that the identity of the sitters, as we tried to establish it, was still known at that time! The passage, as published in the *Walpole Society,* XXII (*Vertue Note Books*, III), 1933-1934, p. 9, reads as follows:

"1722 [V. 4. B. M. 11]: at Mr. Walpoles a fine large picture of Jordaens of Antwerp his father & Mother & family. painted as I suppose by his own picture in his juvinile days."

We see that at the time of Vertue's visit to the Walpole collection—forty-four years after Jordaens' death—the essential facts about the identity of the persons portrayed were still available. They were forgotten when Watson made his mezzotint, shortly before 1779. Somewhere in the middle of the eighteenth century, through error or neglect, some of the essential data about the picture drifted below the level of historical consciousness, to be replaced by guesses and vague conjectures. In this instance, it was possible to re-establish that lost knowledge; yet, how infinitely larger is the number of cases where we are no longer able to salvage truth from under the heaps of oblivion.

One of the former theories about the Leningrad group portrait maintained that it combined members of Jordaens' own family with those of the family of his father-in-law, Adam van Noort. While this opinion is refuted simply by the establishment of the true identity of each figure, it seems desirable to devote additional study to the question of the actual appearance of the people who were supposedly rendered in the picture, especially Jordaens' wife, Catherine van Noort, and their children. It seems tempting, furthermore, to see if any of the persons depicted in the Leningrad picture appears again in other works of the master.

Since no documentary evidence is available as an answer to these problems, one must proceed on the basis of comparison of likenesses. It is obvious that such an endeavor is extremely delicate and leads to difficulties of a peculiar nature. If a painter portrays a person several times over an interval of many years, it is only natural that the pictures will differ, due to the aging of the model as well as to changes in the style of the artist. Theoretically, one may admit that a wide margin must be left for such variations, especially where the interval of years is very long. This liberal attitude, however, runs the danger of defeating its own ends, since any identification loses conviction with every "allowance" made for aging or changes of "interpretation." Another difficulty, which plays an important role in our case, most commonly arises where the pictures are not meant to be "portraits" in the proper sense of the word. Hélène Fourment, for instance, most likely served time and again as model for the Madonna or for a "Venus," just as Hendrickje Stoffels may have been the model for a "Bathsheba" or a "Juno." But are we entitled to take these pictures as valid documents for the actual appearances of the wives of Rubens or Rembrandt? Since such pictures were not painted with the purpose of portraying a definite person, the artists were free to take liberties with their models, emphasizing certain traits, suppressing others. Moreover, it should be remembered that many artists have preferences for certain types and are inclined to stylize their models in a definite manner. Cranach's "mongolian" eyes, Van Dyck's "greyhound" slimness may serve as points of illustration. Hence we must guard against the danger of interpreting similarities as proofs of the identity of the model, whereas they may actually be due to a process of stylization in harmony with the artist's subsconscious "guiding image."

Keeping in mind all these possibilities of fallacies, one can approach only with hesitation the problem of identifying members of Jordaens' family in figural compositions and portraits by the master. And yet, it seems to us not only a legitimate curiosity to concern oneself with this question, but also that the results are rewarding insofar as they throw light upon the artist's stylistic development, the chronology of his works, his working methods, and his inherent aesthetic ideals.

One of the most prominent figures in the Leningrad picture is Jordaens' mother, Barbara van Wolschaten. Since she had married in 1590, she could hardly have been much less than about forty-three to forty-five years of age at the time the picture was painted, nor

much more either, considering that she lived for another forty years, until 1655. She seems to have spent her later years as a member of Jordaens' household, and it would be surprising had she never again figured in any of Jordaens' pictures. There is indeed a type of elderly woman frequently found in works of the late 1630s and the 1640s whose features could be interpreted as those of the aging mother of the painter. The pictures are the well-known humorous scenes illustrating either the proverb "Soo d'oude songen, soo pepen de jongen" (As the old cock crows, so chirp the young), for instance the Antwerp picture of 1638; or the celebration of Epiphany. This old woman, with heavy-lidded eyes and a hooked nose, is used only in "respectable" roles, and never in undignified situations. Since we know definitely that in the same type of pictures Jordaens occasionally depicted himself, either as a merry bagpiper or as a gayly shouting companion, and that his father-in-law, Adam van Noort, quite obviously served as a model for the hale and hearty grandpa, it would not be surprising to find his mother also in the merry crowd. Yet the similarities of this model with Jordaens' mother, as we know her from the Leningrad picture, are not sufficiently strong to raise this identification beyond the stage of mere conjecture.

This is not the case with another picture which can claim to be a portrait of Barbara van Wolschaten. It is the beautiful portrait of a woman in Antwerp (Fig. II.5)[27] whose features are similar in every respect to those of the mother in the Leningrad painting. It looks almost as if the same sketch, the same study from nature, had been used for both pictures, or that one was actually painted from the other. This is all the more surprising as the Antwerp picture, to judge from its style, must have been done considerably later than that in Leningrad. The subdued warm glow of the colors would place it at least in the 1630s, if not later.

How can we explain such a strange fact, that the same model should appear younger in the later of two portrayals? An easy way out would be to assume that the Antwerp picture is not a likeness of the painter's mother but of one of his sisters, for instance of the oldest, Marie, who indeed in the Leningrad picture looks very much like her mother. That would, however, not explain the curious agreement in the position of both heads, which are seen in the identical three-quarters profile view and with the same inclination toward the right shoulder. If one studies the Antwerp portrait more closely, one can find a certain discrepancy between the head and the position of the rest of the body. The carriage of the head and the direction of the glance do not quite harmonize with the apparent occupation of reading a book. One has only to cover up the head to see how different a position the arms and bust alone suggest. All this would indicate that the picture was not done from nature but was "composed" with a special purpose or for a special occasion. What this may have been is left to our speculation, but it seems to be more easily explainable if we assume that it is a portrait of Jordaens' mother. Perhaps one of the children desired to have her portrait without the traces of age. Perhaps Barbara wanted her own portrait in such a fashion—since it is a common experience for elderly people to like themselves

pictured in their prime. We shall probably never know, but we can be convinced that the apparent contradiction of the evidence of the Leningrad and the Antwerp paintings is by no means beyond comprehension.

In the endeavor to establish the identity of Catherine van Noort, the best starting point seems to be the family group in the Prado (Fig. II.3). We have seen that through the proper interpretation of the Leningrad picture, new support could be derived for the often pronounced—and occasionally contradicted—theory that the Prado family is Jordaens himself, his wife, and their eldest daughter. There is no likeness of Catherine van Noort which is better established than that in the Prado canvas.[28]

Catherine van Noort, from the evidence of the Prado painting, was hardly beautiful. Her narrow, oval face is dominated by a long nose without a noticeable indentation at the bridge and with a thick, slightly pendent tip. The eyes are small and imbedded in a shallow field under high and well-rounded brows. The distance from nose to mouth is short, the chin long. In addition to the full though short lips, this gives to the mouth a peculiarly pursed expression. There can be little doubt that we find the identical face in the role of the Virgin Mary in the *Holy Family* [formerly] in the Booth collection in Detroit [and now in the Detroit Institute of Arts].[29] The picture has been dated around 1615-1617 by Burchard.[30] Jordaens had been married to Catherine in 1616. Their first child was born on June 26, 1617. It is tempting to think that the painting represents a record of his early family life, and it is perhaps not by chance that the figure of Joseph in the same picture is again based on the appearance of Adam van Noort, as can easily be seen from a comparison with those representations of this artist which have been mentioned above. He naturally looks considerably younger here than in the other paintings, since in 1617 he was only fifty years old.

The easily recognizable face of Catherine van Noort appears again in the charming *Holy Family* which Burchard also published as an early work (Fig. II.6)[31] and of which he himself owned a second, slightly changed version. This is perhaps the most appealing rendering of Jordaens' wife in any of her husband's paintings, as her homely features are transfigured, as it were, by the radiant expression of the happiness of motherhood. There are few works in Jordaens' oeuvre of equal intimacy and tenderness. It is based on an iconographical type which was particularly frequent during the first half of the sixteenth century (Gossart, Joos van Cleve),[32] but which is reinterpreted here with captivating freshness and personal candor.

A further confirmation of our identification of Catherine van Noort in early paintings of the master may be found in a hitherto unpublished sketch in a private collection in Brussels (Fig. II.7). Judging from its style, especially the choice of colors with preference for a warmer scale, combined with a fairly *pastose* and patchy modeling, one can easily date it somewhere about the middle of the 1620s. It is obvious that this sketch was made from the same model as the paintings which we have just seen. But beyond this, the Brussels sketch has such an air of unconventional casualness, not to say privacy, that even without

any previous considerations one would involuntarily suspect a close personal relationship between the painter and his model.

This very sketch, in turn, forms an important link to some other paintings in which we now can recognize with great certainty the features of Catherine van Noort. The most important is a large painting in the Metropolitan Museum, New York, with the inscription RADIX SANTA ET RAMI, Rom. II:16 (Fig. II.8).[33] This work represents two phases in Jordaens' development and, fortunately, in a combination which allows us to separate one from the other without difficulty. An examination of the painting[34] showed clearly that the original panel has been added to considerably at the bottom and at the left.[35] Only the four figures to the right belong to the early period of the master and would point stylistically to the middle of the 1620s. The rest, together with the inscription which with its exact reference to the Bible is so characteristic for Jordaens' late works, was executed much later and dates most likely from the 1650s. The Virgin belongs to the early part of the picture and is so closely related to the Brussels study of Catherine van Noort that we are not only facing the same model, but also in all probability the Brussels study was actually used for the Virgin of the New York picture. If this be accepted, we can use this observation in turn for a confirmation of our dating, which so far has been based only on stylistic comparisons. Catherine's features are slightly more rounded than in the earlier pictures, including the Prado family group, but one would hesitate to assume an interval of more than about five years between the two works. This again would point toward 1625 or shortly thereafter.

One can further recognize Catherine as model for the Virgin of a painting in the National Gallery, London (No. 3215), where she is shown receiving a visit from Zacharias, Elizabeth, and St. John. This painting, with its strong contrasts of light and dark, harks back to the "Caravaggesque" phase of Jordaens' development, but was probably done not much before the New York picture.

Considering the relative frequency of Catherine van Noort's appearance in paintings dating from the first ten years of the marriage, one should expect to be able to identify her also in paintings of a later date. This, however, is not the case. Various factors may be responsible for her apparent disappearance. Jordaens' style, first of all, developed in the direction of a more generalized treatment, especially in his female types, so that frequently the women in his pictures—unless they are old and have heavily-lined features—look more or less like variations of one and the same type. Another factor may be found in such external changes as fashion may have caused, particularly changes of hairdress. In most of the early pictures Catherine wears her hair smoothly brushed back. No such type appears later, when fashion required a well-dressed woman to wear her hair fluffy and curly and fringed above the forehead.

Some writers have professed to recognize Catherine van Noort also in the figure of the young mother who frequently appears in Jordaens' paintings of banqueting and merry-making, for instance in the centrally-placed figure of the Antwerp *Soo d'oude songen* and the

Louvre *The King Drinks*. Yet it seems rather difficult to follow this opinion. The main argument against it is found in the fact that Catherine, by the time these pictures were painted, was about fifty years old, while the model in question looks considerably younger. The only positive argument that could be voiced in favor of this theory is a reference to a painting in Besançon in which the same woman is seen embraced by a man who unmistakably has Jordaens' own features. This painting[36] has traditionally been called *The Painter and His Wife*, so that, if tradition were reliable, the woman would be Catherine van Noort. Unfortunately, as we have seen, such traditional titles of pictures are but rarely correct. A well-known picture [now in a private collection in New York] has also been commonly referred to as *The Painter and His Wife*, although in that case there is not the slightest doubt that the title must be inexact.

The New York canvas (Fig. II.9) shows an old man looking at the beholder with a sly grin, while a young girl feeds a plum to a parrot which the old man holds on his hand.[37] The subject no doubt is a satirical comment on the folly of love according to the traditional type of the "Ill-Assorted Couple." Surprisingly in such a subject, the young woman quite obviously is depicted with a certain sympathy; it is as if one could feel the fondness with which Jordaens tried to bring out the youthful charm of her features. This impression is perhaps not quite unfounded. The same face, rendered with equal tenderness, appears at the same time (about 1640) in the previously mentioned Louvre version of *The King Drinks*. There are still other pictures in which one can recognize the same model. We have no definite clues as to the identity of the girl, but if we look about in Jordaens' own family circle there is only one person who might possibly have served as model—his eldest daughter Elisabeth, who, born in 1617, by the time these pictures were painted was a young woman of about twenty or twenty-five years. Indeed, if one compares the coy girl from the Louvre picture with the smiling child from the Prado group portrait (Fig. II.3) one can find remote similarities, perhaps without too much wishful conjecture.

This brings us to the last question: is it possible to identify any of Jordaens' children in the paintings by their father? Jordaens, in contrast to his father, had only three children, Elisabeth (June 26, 1617), Jacob (July 2, 1625), and Anna Catherina (October 23, 1629). Elisabeth remained unmarried and died in her father's house the same day as Jordaens himself, presumably in an epidemic. Jacob was still alive in 1650, when he signed a picture (now in Amiens). It is not known when he died. Anna Catherina married Jan Wierts, and resided with her husband in The Hague. Hence all of them lived long enough for us to expect them to appear in the paintings of their father, especially if one considers that Jordaens—like Rubens and Rembrandt—was in the habit of choosing models from his own family circle.

Yet, so far as we can see, the clues as to the representations of any of Jordaens' children give a certain probability only in the case of his son. What his youngest, Anna Catherina, looked like we are unable to say, unless we want to engage in empty speculation; and with regard to the eldest, Elisabeth, even the few observations which we have made are uncertain

enough. To be sure, there is no definite, well-established portrait of Jacob Jordaens the Younger, either. Yet we can, at least, put forward a theory which we hope is fairly plausible.

In the collection of Alfons Cels in Brussels there were two paintings, obviously companion pieces, of an unusual shape. Both measure 190 by 89 cm. and contain a few full-length figures in a somewhat summary style. They look like decorative pieces, reminding one, in fact, of certain decorative schemes found in Veronese's wall decorations in the Villa Giacomelli at Maser.[38] Fortunately we can identify these paintings with two pieces which originally belonged to the estate of Jordaens himself and which appear as numbers 102 and 105 in the catalogue of his belongings. These were certainly, as Rooses has already suggested,[39] part of the decorative scheme of the artist's house. The building, which still stands in part, had been erected by the artist between 1639 and 1641. The paintings made for its decoration most likely date from the same period, and the style of the pictures from the Cels collection agrees with this date. In one of them, incidentally, we recognize the face of Adam van Noort, depicted very much as in the Antwerp *Soo d'oude songen* of 1638.

The other painting (Fig. II.10)[40] shows a youth with a dog entering through a door and lifting his hat in salutation. A girl, perhaps a maid, stands behind him.[41] This boy has definitely portrait-like features. We see a striking irregularity of the shape of the eyes and the right brow drawn higher than the left. The apparel of the boy is that of a member of the well-to-do middle class. The long, loose hair, hanging far down over the shoulders, was becoming the fashion in the Netherlands just about 1640, probably under the influence of English society, where it appears commonly during the 1630s. (For a parallel in Holland, see Frans Hals's portrait of a young painter, 1640, now in the Louvre.)

In 1640, Jordaens' son was fifteen years old, and since the boy in the painting would correspond to such an age, one might consider the possibility that we have here a portrait of Jacob Jordaens the Younger. This theory finds support in the observation that there exists a portrait study of the same boy at a much more tender age. This picture[42] shows a child of about five or six, holding a pomegranate. It obviously belongs to those studies which—like the Brussels study of Catherine van Noort (Fig. II.7)—by their very informal character suggest a family-member as the most likely model. No commission for a formal "child portrait" could have been filled by such a work. This quality, in addition to the necessary assumption that Jordaens must have been in contact with the child for at least ten years, after which he gave him a prominent place in the pictorial decoration of his own dwelling, in our opinion speaks strongly in favor of the theory proposed. The date of the Cels picture, incidentally, is further confirmed by the earlier study of the same boy, the style of which points toward a date in the late 1620s or about 1630.

If this view is correct, it is not surprising to find the same boy, though idealized and prettified, in the role of the Infant Jesus in a composition of the *Holy Family*, which is known in several versions, the best of which [is now in the Southampton Art Gallery].[43] The connection is so obvious that it hardly needs discussion. We now consider the identification of this boy with Jacob Jordaens the Younger as sufficiently certain to make use

of it in order to date the *Holy Family* about 1628, which is a welcome addition to the badly limited store of dates that can be assigned to works of Jordaens in the period between 1615 and 1640.

One more study of a child, through its most casual informality, requires discussion in this connection. This most delightful little picture, quite unknown and never published, is in a private collection in Amsterdam (Fig. II.11).[44] We see a baby, not more than a year old, in his high chair, sucking his index finger, obviously waiting for his meal. The artificial light comes sharply from the left and below. In its glow we discern an upper lip higher on the right side just as in the Paris study, and a "lifted" right eyebrow just as in the Cels picture. We admit that this is not enough to prove that this also is a "portrait" of the younger Jordaens. But there is little doubt in my mind, considering similar examples in seventeenth-century painting, that we have here a study made from one of the artist's own children. In this case one has the choice between Jacob and Anna Catherina; we are inclined to prefer the former—especially as the emphasis upon a stunning and unusual light effect would speak for an earlier date.

The concept one forms of Jordaens from all these observations is that of a real "family man" who derived pleasure and artistic inspiration from the close relationship with his next of kin. Such a character seems to be particularly fitting for a man whose art is so full of a plain, healthy vitality, and, placed as it is historically between the aristocratic verve of Rubens and the bohemian vulgarity of Brouwer, represents so clearly the sober instincts, the bourgeois morality, and the prosaic ideals of the Flemish middle classes.

NOTES

1. Hermitage, no. 6 (652). Canvas, 178 × 138 cm. In the eighteenth century the painting belonged to the collection of Sir Robert Walpole, 1st Earl of Orford, at Houghton, Norfolk. When Sir George Walpole, 3rd Earl of Orford (1730-1791), sold the collection to the Empress Catherine II of Russia in 1779, the picture came into the Imperial Russian collections and has been part of the gallery of the Hermitage ever since. It was reproduced—not very skillfully—by James Watson in the famous series of mezzotints made of the masterpieces of the Walpole collection, and in a lithograph by E. Huot in Gohier-Desfontaines' *Galerie Impériale de l'Ermitage*, St. Petersburg, 1845-1847. It has been mentioned and described in most of the larger publications on Jordaens and has been illustrated repeatedly. [See, for example, Michael Jaffé, *Jacob Jordaens 1593-1678*, exhibition catalogue, Ottawa, National Gallery of Canada, 1968-1969, no. 3.]

2. P. Buschman, *Jacob Jordaens*, Amsterdam, 1905, p. 84; Max Rooses, *Jacob Jordaens: His Life and Work*, trans. E. C. Broers, London, 1908, pp. 52-53; Rudolf Oldenbourg, *Die flämische Malerei des XVII. Jahrhunderts*, Berlin, 1922, p. 111; Wilhelm von Bode, *Die Meister der holländischen und flämischen Malerschulen*, 4th ed., Leipzig, 1923, pp. 409-411; Zoege von Manteuffel, in Thieme-Becker's *Allgemeines Lexikon der bildenden Künstler*, XIX, 1926, p. 153.

3. H. Fierens-Gevaert, *Jacob Jordaens*, Paris, 1905, p. 107; Willi Drost, *Barockmalerei in den germanischen Ländern*, Wildpark-Potsdam, 1926, p. 99.

4. Ludwig Burchard, "Die Anfänge des Jacob Jordaens," *Jahrbuch der preussischen Kunstsammlungen*, XLIX, 1928, p. 207.

5. G. F. Waagen, *Die Gemäldesammlungen in der Kaiserlichen Eremitage zu St. Petersburg nebst Bemerkungen über andere dortige Kunstsammlungen*, Munich, 1864, p. 155.

6. Buschman, *Jordaens*, p. 84; F. M. Haberditzl, "Die Lehrer des Rubens," *Jahrbuch der Kunstsammlungen des allerhöchsten Kaiserhauses*, XXVII, 1907, p. 181; Leo van Puyvelde, *Trésor de l'art flamand*, Paris, 1932, I, pp. 84-85. Van Puyvelde mentions the Leningrad picture in connection with a group portrait in Cassel, which he regards as of the family of Adam van Noort. In an effort to make the Leningrad picture fit the family of Van Noort, Van Puyvelde resorts to the impossible assumption that two of the figures are maidservants—without, however, saying

which two. Furthermore, he boldly assigns the date 1612 to the picture but neglects to tell the reader that Van Noort's *youngest* child, Martin, born in March 1601, by that time would have been eleven years old, which would hardly agree with the appearance of the baby on the mother's lap! We do not need to mention after this that there is not the slightest facial resemblance between any of the figures in the Leningrad picture and those in Cassel. For the latter see pl. XLVII in the *Trésor*, or Rooses, *Jordaens*, p. 157.

7. The easily recognized image of Adam van Noort occurs in many works by Jordaens, four of which are reproduced in Julius S. Held, "Malerier og tegninger af Jacob Jordaens i Kunstmuseet," *Kunstmuseets aarsskrift*, XXVI, 1939, Figs. 24-27.

8. The writer knows of no case where in this type of picture members of different families are portrayed, so that Buschman's *"Verlegenheitslösung"* is most unlikely from this point of view also. One can, in addition, call attention to the fruit which is placed so conspicuously on the table in the very center of the composition. It seems to have puzzled one commentator, but it is easily recognized as a pomegranate. This fruit, in the hieroglyphic language of the period, was considered a symbol of unity. We find, for instance, in Cesare Ripa, *Iconologia* (Venice ed., 1645, p. 101): "I pomi granati presso à gl'Antichi significauano Concordia, perchè tali deuono estere gl'animi concordi, e in tal vnione tra se stessi, come sono le granelle di questi pomi, dalla quale vnione nasce poi l'abbondanza che è il neruo di viuere politico, e Concorde."

9. Reproduced in Harry Schmidt, *Jürgen Ovens: sein Leben und seine Werke*, Kiel [1922], no. 22.

10. [Fig. 4 of the original version of the present study.]

11. Reproduced in A. Bredius, *Amsterdam in de XVII eeuw*, The Hague, 1897, p. 22.

12. Rudolf Oldenbourg, *Thomas de Keyser's Tätigkeit als Maler*, Strassburg, 1911, p. 40.

13. Reproduced in Kurt Bauch, *Jakob Adriaensz Backer*, Berlin, 1926, pl. 6.

14. Ibid., p. 61, note 35: "A° 1656. Den 22 September geleevert het overleden kint van den Heere P. van Harinxma tot 30-0-0 [should probably be read 36-0-0!] het panel 1-16-0. Het selfde kint te weten Jon' Julius Botnia van Harinxma *als een vliegende Engel in de lucht van't groot stuk geschildert* 6-0-0 = 43-16-0. Bekenne van dese bovenstande somma in danke voldoen en betalt te sijn. V. de Geest 1656." Bauch's belief that all three angels were added to the picture in that year (while the rest of the painting dates from 1654) finds no support in the text of the document. It says clearly that only one child was added in that year. The other two most likely had been painted with the rest of the picture in 1654, and the pointing finger of the child standing at the left probably calls attention to them. We therefore assume, as the only conclusion possible, that

Julius Botnia van Harinxma had been born between 1654 and 1656 and had died in infancy, thus prompting the parents to have him added as a little angel to the two others who had died previously.

15. J. P. Génard, "Notice sur Jacques Jordaens," *Messager des sciences historiques*, Ghent, 1852, pp. 203 ff.

16. Anne married in 1625, Catherine became "Religieuse," Madeleine "Béguine," Abraham joined the Augustinian order of monks, Isaac married in 1625, and Elisabeth became "Béguine" in 1632.

17. Gustav Glück, "Selfportraits by Van Dyck and Jordaens," *Burlington Magazine*, LXV, 1934, pp. 194 (illus.), 201.

18. [An excellent self-portrait of Jordaens, probably from the 1630s, was at De Boer in Amsterdam in 1949 (Fig. II.2); it may be identical with a painting listed by Leo van Puyvelde, *Jordaens*, Paris, 1953, p. 207 (canvas, 66 × 56 cm.).]

19. *Biographie nationale de Belgique*, X, 1889, pp. 515-533.

20. *Jordaens*, p. 52.

21. *Inscriptions funéraires et monumentales*, Antwerp, 1860, I, p. 240.

22. I owe to M. Ernalsteen an exact transcription of the text in the church records, as follows:

Rekeninge ende bewijs . . . Kersmis a° XVJ^c seventhien ende eijndende kersmis achthien.

. .

Ontfanck vanden rechten vanden kercklijcken a° 1618 de prochie suijwaert, Pastor Jaspar Estricx.

. .

8 aug. Jacques Jordaens 16-6

(Receipt over 16 guilders 6 stuivers for the burial taking place August 8, 1618; the records run from Christmas 1617 to Christmas 1618.)

23. Leo van Puyvelde, "Jordaens's First Dated Work," *Burlington Magazine*, LXIX, 1936, p. 225.

24. Julius S. Held, "Unknown Paintings by Jordaens in America," *Parnassus*, XII, 1940, p. 26.

25. In the sale of Thoré (Bürger), Paris, 1892, a picture by Jordaens figured under the title "Portrait of Catherine van Noort, 23 years of age." Since Catherine van Noort was born in 1589, four years before Jordaens, this painting would have to have been done in 1612, if the title were correct. The picture has gone through several hands and at present [1940] is owned by Lady Speyer, New York. Unfortunately, the identification of the model with Catherine van Noort is entirely arbitrary, and the painting obviously dates from a much later period of the artist's life.

26. "Die Anfänge des Jacob Jordaens," p. 213.

27. Antwerp, Musée Royal, no. 222, formerly in the collection of v.d. Hecke Baut de Rasmon.

28. If one follows the literature, one frequently finds the

same figure referred to as "the master's wife" and also "the master's daughter." Many such statements are most likely based on the perennial belief that a painting gains in favor—and value—if "human interest" can be attached to it. See also note 25.

29. [Jaffé, *Jordaens*, no. 8.]

30. "Die Anfänge des Jacob Jordaens," p. 216.

31. Ibid.

32. See Max J. Friedländer, *Die altniederländische Malerei*, VIII p. XXXVII (Gossart), and IX, pl. XXXVIII (Joos van Cleve). The position and attitude of the baby in Jordaens' work distinctly recalls those found frequently in earlier compositions of the nursing Madonna type, with the breast here replaced by an apple.

33. Another version of the same composition exists in Munich in the Alte Pinakothek (formerly Schleissheim), in which the group of the Virgin and Joseph is practically identically rendered. The Munich picture (reproduced in Oldenbourg, *Die flämische Malerei*, p. 108) is probably only a second version, but it is important because it gives an idea of what the Metropolitan Museum panel looked like before it was enlarged.

34. The writer wishes to thank H. B. Wehle, Curator of Paintings, for his kind assistance in this examination.

35. For other changes of similar nature in Jordaens' oeuvre, see Julius S. Held, "Nachträglich veränderte Kompositionen bei Jacob Jordaens," *Revue belge d'archéologie et d'histoire de l'art*, III, 1933, I, pp. 1-10.

36. The Besançon picture probably is only an old copy of an original which at the present time is no longer known.

37. The girl originally held cherries, over which the artist later painted the plum, as can be clearly seen in the painting. Rooses was probably correct in pointing to a Flemish metaphorical expression which called old men who are unduly interested in young girls "cherry-pluckers" (*Kreekenplukker*). [The painting was cleaned by Gabrielle Kopelman in 1979, at which time it was discovered that the stone architectural framework was a later addition. The picture was engraved—with stones—by S. Couzeau in 1771. The stonework has been removed, revealing a simple rectangular opening, so that the couple now seems to be looking into a room from out of doors. The original canvas was also found to have been enlarged with several strips. The outermost of these have been removed, reducing the measurements to 33¼ × 31¼ inches.]

38. See, for example, Giuseppe Fiocco, *Paolo Veronese*, Bologna, 1928, figs. 47 and 50.

39. *Jordaens*, p. 188.

40. [The painting was sold at Sotheby's, London, June 30, 1971, lot no. 26, and again on October 24, 1973, lot no. 37.] The third painting by Jordaens in the Cels collection, a picture of the *Satyr and Peasant*, is now in Göteborg, Sweden.

41. A drawing for this picture is preserved in the Albertina, Vienna (no. 8463; reproduced in J. Meder, *Handzeichnungen alter Meister aus der Albertina*, N. F. 1922, Taf. 36). It was engraved in the eighteenth century by A. Bartsch.

42. [Formerly] Paris, collection J. v. Stchoukine. Exhibited 1905, no. 85. [Now Brussels, coll. John Nieuwenhuys. See Jaffé, *Jordaens*, no. 40.]

43. [Formerly] London, A. Tooth and Sons, Ltd. On panel, 41 × 29 inches. Another version is in the C. Y. Palitz collection, New York [1940]. [Jaffé, *Jordaens*, no. 39.]

44. Coll. José Vigeveno. Canvas, 38 × 28 cm.

ACHELOUS' BANQUET

Dat 'er veele zyn, die de fabelen van Ovidius van buiten kennen, stellen wy vast; maar van binnen zeer weinig. 't Is meest uit de printboeken en niet in de grondtext, dat men tegenwoordig zoekt. (That there are many who know the fables of Ovid from the outside we admit; but few from the inside. At present one looks more into the illustrated editions than into the text.) Gerard de Lairesse, Het Groot Schilderboek, Amsterdam, I, 2, p. 124 (edition of 1740).

EVERY student of the art of the Renaissance and the Baroque is familiar with the amazing popularity of Ovid's *Metamorphoses* in these times. A steadily growing literature points out how indispensable a knowledge of Ovid is to anyone who wants to understand the subject matter of a majority of the mythological stories of that period. Thanks to Henkel's valuable and thoroughgoing study,[1] we are also aware of the fact that fixed iconographic traditions of Ovidian subjects were established chiefly by the illustrations in a few outstanding editions of the *Metamorphoses*. Any study in this field serves, indeed, only to bear out the observation of Gerard de Lairesse that many artists of his time knew hardly more of Ovid's fables than what they saw in illustrated editions. But if this state of affairs appeared to Lairesse as a cause for lament, it turns out to be a great help to the modern scholar who is interested in iconographical studies. It is actually by virtue of the illustrated editions of the *Metamorphoses* that we can establish with certainty the meaning of a subject which seems to have been fairly popular with leading Flemish artists of the seventeenth century.

[Prominent in the galleries of Flemish paintings at the Metropolitan Museum of Art in New York is a fairly large panel by Rubens which, when it was acquired in 1945 as a gift from Alvin and Irwin Untermyer in memory of their parents, was] generally known as *The Feast of the Gods* (Fig. III. 1).[2] The painting shows in the center a group of nude men seated around a table which is covered with edibles, mainly seafood. Fish and shells cover the ground in front and the walls of the cavernous structure behind and above the figures. There are nymphs with a cornucopia, a naiad and a triton, carrying more crustacea at the

Reprinted by permission of *The Art Quarterly*, IV, 1941, pp. 122-133.

left, and at the right servants attending to the drinking vessels. In the center of the picture is a reclining bearded man, adorned with the wreath of reed associated commonly with an ancient river god. He is pictured, it appears, in the midst of a narrative which seems to refer to something outside the cave. His left arm points out toward the river in the distance, and his story is followed by the others with keen attention, even amazement, mingled in some with doubt. One is reminded of the disciples and their reaction to Christ's announcement of his betrayal in most of the presentations of the Last Supper since Leonardo. This concentration, even tenseness, in the faces, the obvious distinction between narrator and listeners, would seem to indicate that the subject is something more clearly defined than just a "Feast of the Gods"—not to mention the fact, otherwise rather strange, that no female deity takes part in the banquet.

The subject of this scene is, indeed, quite definite. It is taken from a story in the eighth book of the *Metamorphoses*, verses 547-576. Here we read how Theseus, returning from Crete with his friends, is stopped by the river Achelous, swollen high by torrential rains. The river god advises the hero against a crossing and invites the group to dwell with him until the rains have subsided. Theseus, in a wonderfully laconic retort, accepts "both—advice and hospitality."

They go into Achelous' house, a cave made of hollowed pumice and tuff, the ground of which is covered with moss. Shells, alternating with corals, cover the ceiling. Theseus and his friends—of whom Pirithous, "Ixion's son," and the elderly Lelex are mentioned by name—sit down to a meal. Barefooted nymphs wait on them. After the wine has been served in precious cups, Theseus gives the cue for a story by asking for the name of an isle which can be seen outside the cave. Achelous obliges by telling the story of the transformation of the five Echinades into as many islands because they had neglected to invite him to a party. He goes on to relate—obviously enjoying this chance to talk about the past—how Perimele, to whom he had done violence, was thrown into the water by her infuriated father; but Neptune, upon Achelous' entreaties, had changed her also into an isle, which the river god continues to embrace forever.

It is easy to see that Rubens' painting fits this story well enough. The setting—painted in Jan Brueghel's delicate and meticulous workmanship—corresponds clearly with Ovid's description, although its neat arrangement of shells seems more typical of a baroque "cabinet of curiosities" than of the cavern of a fabulous river god. The main actors of the story are also easy to identify: the bearded man in the center as Achelous, the hero in front of the table as Theseus, at whose feet weapons and shield suggest his mission, and the youth who looks at him questioningly as his beloved Pirithous. It remains doubtful which is Lelex, "animo maturus et aevo,"[3] although we may assume that his is the head at Theseus' left. Particularly interesting is the introduction of the cornucopia at the left, for it proves how well Rubens knew his Ovid. When Achelous had finished his story, Lelex told the strange fate of Philemon and Baucis, whereupon Achelous continued with the story of Proteus and Mestra and in the ninth book went on to tell of his battle with

Hercules in which he lost one of his horns. This same horn, which the nymphs had filled with fruits and flowers, is then brought in by a nymph "dressed like Diana" and a servant with her hair hanging down on both sides, who offer the guests these fruits of autumn as an ending to their meal.[4]

Although it would appear that all the elements of the Ovidian story are present and no reasonable doubt can be entertained about the subject, it seems advisable to check the interpretation by reference to the iconographic tradition of representing this scene. We find indeed that far from being unique with Rubens, this story is frequently illustrated in sixteenth- and seventeenth-century editions of the *Metamorphoses*.

It seems to be found first in a French translation of 1539, entitled *Les XV liures de la Metamorphose D'ouide (Poete treselegāt)* . . . *traduictz de Latin en Francoys*. According to Henkel,[5] three designers collaborated in the illustration of this book. The woodcut accompanying the story of Achelous' banquet is obviously executed by the artist whose work Henkel described as "coarse, mechanical and uninteresting." In fact, it is almost impossible to connect the clumsy little print with a definite moment or aspect of the story. The meal scene at the left is vaguely reminiscent of the banquet, while the right half is related to the story of Perimele, whom Achelous kept floating until Neptune had listened to his prayer. Actually, it is very probable that the woodcut was never designed to fit the story, for if we thumb through the whole edition we find that the same block has been used no fewer than four other times[6] and—what is worse—in no case fits the text any better. We cannot help suspecting that the woodcut actually was made for a different book and was used rather indiscriminately by the publisher of the 1539 Ovid wherever there was a remote similarity to the text. The somewhat antiquated style of the design would also argue for such a theory.

Profoundly different is the case of the famous Lyon edition of 1557 and all its descendants. Our observations can only corroborate Henkel's emphatic eulogy not only of the quality of its woodcuts but also of their notable role in the development of Ovid illustration. In Bernard Salomon's woodcut indeed are found for the first time the essential elements of the story as we know it from Rubens' picture (Fig. III.2).[7] There is the hollowed-out rock with wide openings, the party of men assembled around a table within, and one of them pointing out toward the water. At the right we see two nymphs carrying food and wine. The woodcut differs from Rubens' work in that it depicts not only the storyteller and his audience but the content of his narrative as well. In the background at the extreme left may be seen Hippodamas in the act of throwing his daughter Perimele from a rock, and below it Achelous who holds the girl in his arms while turning to Neptune in his chariot. Although smaller, this part of the picture is the true center of interest to which the scene in the cave is definitely subordinated as incidental. The attention of all the figures is focused on the events outside, as if they saw them actually taking place and not only in their imagination, however much stimulated by Achelous' vivid narrative.

The combination in one picture of events of different degrees of reality—one actual and

present, the others past and only evoked in a narrative—has, of course, an inherent weakness
if judged for its dramatic unity. Salomon's woodcut makes Theseus and his friends eye-
witnesses as it were of events which had occurred long ago. There was, of course, nothing
unusual about this method of illustration. Moreover, Salomon's version remained the
prototype for all future illustrations of Achelous' banquet in printed editions of the *Meta-
morphoses*. As late as 1732, in the Amsterdam edition of that book, illustrated by Picart
and others, we find a print in which both the meal scene and the story of Perimele are
combined, the latter being almost identical to its rendering in Salomon's woodcut (Fig.
III.3). In the eighteenth-century engraving, however, the cave of Achelous clearly dominates
the scene, whereas Perimele's history is told on a minute scale far in the distance; in fact,
it remains unobserved by the people in the foreground and is even technically beyond their
field of vision because of the large pillar of rocks which forms a part of the entrance to the
cave. By giving emphasis to the meal scene and to the individual characterization of the
people participating in it, the later draughtsman follows an arrangement which we first
found with Rubens, but he does not understand the intentions which guided the Flemish
master. For it is in comparison with the traditional illustration of the story that one becomes
fully aware of the significance of Rubens' version.

It seems that Rubens, in his efforts to bring to life and to visualize convincingly the
mythological subject, became conscious of the necessity of distinguishing clearly between
the two parts of the story. To him, as a man of the Baroque, the unity of action was just
as essential as that of space, long recognized before. Thus he limited himself to one part
of the narrative; he concentrated on the foreground, even to the extent of letting Jan
Brueghel lavish all his virtuosity on incidental details, and showed nothing but the river
and a piece of land in the distance. Little may he have suspected that with just this logical
clarification of the picture's story he contributed largely to hiding its true meaning from
later generations. There were not enough "clues" left to identify the figures, and as *The
Feast of the Gods* it made its way through the world.

Nor was it alone in this fate. Rubens' younger fellow-countryman Jacob Jordaens treated
the same subject in a drawing, depicting also nothing but the scene in Achelous' cave.[8]
The subject of this drawing, too, has been unidentified until now. The original belongs
to the Albertina and was published once in Muchall-Viebrook's *Flemish Drawings*[9] under
the title *Mythological Subject (Jupiter and Mercury Visiting Peasants?)* (Fig. III.4). Considering
the plainness of the setting and the restricted number of figures, it would seem that
Jordaens followed Salomon more closely than Rubens. He also, however, omitted the
Perimele incident and gave only the scene of the banquet. We see Achelous at the right,
two nymphs next to him, and to the left Theseus with the elderly Lelex behind the table
and the youth Pirithous in front of it. The figures, it is true, have no classical proportions
nor do they strike heroic poses. One can understand how it was possible to think of them
as peasants, especially if one sees how much they resemble actual peasant types in Jordaens'
early pictures of the *Satyr and Peasant* (for instance the one in Kassel), not to mention the

obvious compositional similarities in such pictures. Yet there is no room for doubt that we have actually the Ovidian story in this drawing. Not only is the cave a telltale feature but so are the pointing hands and particularly the intentness which all figures show in looking toward something outside to which the speaker on the right is referring. Although there is actually not much formal similarity between Rubens' painting and Jordaens' drawing, it is notable that both depict only Achelous' banquet. Since a coincidence would be rather unlikely it is justifiable to ask which picture was done first in order to establish the priority of this approach to the subject.

The date of the Rubens fortunately can be determined with fair accuracy. Most experts are agreed in dating it around the middle of the second decade of the seventeenth century.[10] The comparative opaqueness of the modeling of the flesh, certain awkward poses, and the lack of a general rhythmic correspondence of movement are indications that it is prior to the typical products of the second half of the 1610s, when Rubens' design of groups became increasingly fluent and his color more transparent. However, there is an opportunity to fix a *terminus post quem*: the figure of Theseus himself—if he can be recognized in the hero in the left foreground—is represented in a pose which is often met with in Rubens' work. Its first appearance is in a drawing for the famous *Baptism of Christ*[11] done for the church of S. Trinità in Mantua. Except for the hands, the pose of the man in the center is identical with that of Theseus. This figure was not taken over into the finished version of the composition, now in Antwerp. Yet Rubens was much too economical to discard such a figure entirely. He used it the next time for a St. Sebastian in a study for the All Saints composition for the Breviarium Romanum which was commissioned in 1612.[12] Here even the arms are practically identical with those of Theseus.[13] A third time we meet with the same figure in a sketch for an altarpiece which he never finished.[14] All these examples agree with one another and are unlike the Theseus in the [Metropolitan Museum] picture in one respect—they show the figure turned to the left while Theseus is seen in reverse, turned to the right. Yet it is just this difference which links up Theseus with the St. Sebastian of Theodor Galle's engraving from the Breviarium Romanum, which was made from the Vienna drawing and published in 1614. It is only reasonable to assume that in planning the design of the [New York] picture Rubens made use of Galle's engraving which conveniently reversed one of Rubens' own drawings. Galle's engraving was hardly done much before the date of publication. The margin left for the dating of the [New York] picture is hence rather narrow: not before 1614 (assuming that Galle's engraving was not finished long before publication) and not much later than 1615 (for the stylistic reasons mentioned before).

As to Jordaens' drawing, it certainly belongs to his early period with its somewhat broad use of the pen and wash. We know that Jordaens was active around 1615 and perhaps even before that date,[15] but the Vienna drawing probably was not done as early as that. We have, in fact, an additional monument which enables us to give it a more precise date. Many years ago there was on the Berlin art market a sketch which at that time was called

School of Rubens and to my knowledge has never before been associated with Jordaens. This hitherto unpublished painting (Fig. III.5)[16] shows, however, so clearly all the characteristics of Jordaens' style that it can be attributed to this master without lengthy proof. It represents a type of study which, while not unique with Jordaens, is found several times in his work:[17] two detailed sketches of the same head, seen in different poses, or from different angles, juxtaposed but independent of each other. In this case it is a bearded man in two profile views, once looking down to the right, once looking to the left. It is done in a very coarse, opaque and yet "porous" manner, with vigorous, curvilinear brushwork, and with such a handling of light and dark that the effect of bright sunshine is suggested.

These "sunny" sketches appear in Jordaens' career not before 1618-1620 and are most common in the 1620s, for example in his studies for the *Ferry* in Copenhagen and the Brussels *Fecundity*. This sketch, now, stands obviously in close relationship with the Albertina drawing. The right head of the sketch is practically identical in position and shape with that of "Theseus" in the drawing. The similarity is so striking that we must assume one of two things, either that Jordaens used for his drawing the sketch, which he had possibly done before and independently of it, or that he made the sketch later than the drawing as a more detailed preparation for a painting of the subject.[18] Both alternatives tend to date the Albertina drawing in the early 1620s rather than before.

We thus can say with fair certainty that Rubens' painting came first in order of execution and to him goes the credit for having made the iconographical innovation which we discussed. It is simply one more case in which Jordaens followed an iconographical formula of Rubens. Many more such examples can be pointed out, from the very beginning of Jordaens' activity (for instance the *Daughters of Cecrops*[19] of 1617 which is based on Rubens' painting of the subject in the Liechtenstein Gallery) until late in his career. Yet, Jordaens never copied Rubens slavishly. His Albertina drawing, although indebted to Rubens in a general way, has none of the heroic splendor, not to say elegance, of Rubens but instead is a striking example of that earthy, sometimes pedestrian, but always vigorous originality which is a characteristic of [the first decades of the younger artist's activity.]

ADDENDUM (1941)

In the last issue of *Oud Holland* (V, 1940, p. 145) which the author discovered only after finishing the foregoing article, J.B.F. van Gils published and interpreted correctly a painting by Jan Steen, in a private collection, as containing the story of Achelous' Banquet. Van Gils assumes that Steen used M. Bouché's illustration of that subject, printed in Du Ryer's translation of the *Metamorphoses* of 1677. Since we can show that the subject was frequently illustrated before, and as no close analogies exist between Steen's picture and the print, this assumption is not necessarily cogent. Bouché's print, however, is interesting in that it contains (with slight variations) the same arrangement as the engraving in Picart's publication (Fig. III.3) which obviously is merely a free copy from the 1677 edition.

NOTES

1. M. D. Henkel, *Illustrierte Ausgaben von Ovids Metamorphosen im 15., 16. und 17. Jahrhundert. Vorträge der Bibliothek Warburg*, 1926-1927, p. 58.

2. See catalogue of the S. Untermeyer sale, New York, Parke-Bernet Galleries, May 10-11, 1940, no. 52, for all the data on the picture. [Standing large and almost completely visible at the right foreground, Rubens' painting is depicted in an anonymous seventeenth-century gallery picture illustrating the Art of Painting; see Marcel de Maeyer, *Albrecht en Isabella en de schilderkunst*, Brussels, 1955, pl. VI. When De Maeyer published his volume, the gallery picture belonged to Count Yturbe, Anet, Normandy. Rubens' painting is amost certainly identical with a picture described by Michel in 1771 as owned by the Princess of Scalamare: "Acheloüs en Proteus met verscheidene Zeegoden aan tafel zittende: drie Nereïden bedienen dezelven met visschen en vruchten. Het grot, de visschen, vruchten en zeegewassen zyn van J. Breughel"; see J.F.M. Michel, *Historische levensbeschryving van Petrus Paulus Rubens, Ridder, Heere van den Steen etc.*, Amsterdam, 1774, p. 360. (In the first, French, edition of Michel's book, of 1771, the reference is on p. 316.) I learned from the MS of Margaretta Salinger's "Catalogue of the Flemish Paintings of the Metropolitan Museum of Art" that Michel's information was repeated by A. van Hasselt, *Histoire de P.-P. Rubens*, Brussels, 1840, p. 301, no. 780.]

3. Book VIII, p. 617

4. Book IX, pp. 90-92

5. Henkel, *Illustrierte Ausgaben*, p. 73.

6. Vol. I, p. 35; Vol. II, p. 13; Vol. III, pp. 34, 86.

7. Our reproduction is taken from the edition with Italian text, published in 1559, which Henkel (*Illustrierte Ausgaben*, p. 88, note 1) had not seen.

8. Another instance in which the same subject was illustrated occurs in the background of a painting in the storeroom of the Metropolitan Museum of Art (06.1039; canvas, 62¾ × 45⅛ inches). The foreground shows a large figure of a river god holding a tray with fish and lobsters. Another figure, half hidden in shadow, is next to him on the right. The scene of Achelous' banquet is very small in the distance, but sufficiently clear to be identified as such.

The painting is rather enigmatic, especially as the main figure appears to be a portrait. Stylistically the painting is closely related to Van Dyck and must have been done by a Flemish follower of that master.

9. T. W. Muchall-Viebrook, *Flemish Drawings*, London, 1926, no. 53.

10. Rudolf Oldenbourg, *Rubens: Des Meisters Gemälde*, Klassiker der Kunst, Stuttgart, 1921: 1615-1617; W. R. Valentiner, *An Exhibition of Sixty Paintings and Some Drawings by Peter Paul Rubens*, Detroit, 1936, no. 5: 1615-1617.

11. Louvre 20187; reproduced in Gustav Glück and F.-M. Haberditzl, *Die Handzeichnungen des P.P. Rubens*, Berlin, 1928, no. 50; see also *Jahrbuch der kunsthistorischen Sammlungen des allerhöchsten Kaiserhauses*, XXX, 1912, p. 264.

12. Albertina 338 (395); reproduced in Glück-Haberditzl, *Handzeichnungen*, no. 70.

13. We may add that the man who sits at the table opposite Theseus is identical in movement—although reversed—with Ixion in Rubens' picture of about 1615-1617 in the Louvre; he appears again as Adam in the panel with Adam and Eve in the Mauritshuis, The Hague, for which Jan Brueghel also did the landscape.

14. Museum Boymans-van Beuningen; reproduced in *Catalogue Rubens-Tentoonstelling*, Amsterdam, 1933, no. 10. [1979: I am no longer sure it was for an altarpiece.]

15. See "Jordaens' Portraits of His Family," in this volume.

16. I owe the photograph to the kindness of the late Prof. Paul J. Sachs, Harvard University. [The painting was bought in 1943 by the Staatliche Kunsthalle, Karlsruhe; see Jan Lauts, *Katalog. Alte Meister bis 1800*, Karlsruhe, 1966, p. 157, no. 2127.]

17. Other examples are in the museums of Nantes and Ghent.

18. The same head appears once more in Jordaens' work in another unpublished painting of Ulysses and Polyphemus in the museum at Moscow. [See Michael Jaffé, *Jacob Jordaens 1593-1678*, exhibition catalogue, Ottawa, National Gallery of Canada, 1968-1969, no. 53.]

19. See "The Daughters of Cecrops," in this volume.

JORDAENS AND THE EQUINE ASTROLOGY

ONE of the most charming pictures of Jordaens' middle period is a canvas in Cassel which illustrates the old proverb "The eye of the master makes the horse fat" (Fig. IV.1).[1] It shows the lord of a manor, a vigorous yet dignified gentleman, who looks with pride at a magnificent gray dappled horse which is shown to him by a Negro attendant. Behind the master is a lady, possibly his wife, although judging by her age she could even be his daughter. A second servant pours food into a trough. At the right, from behind a tree, Mercury watches the scene. That the subject indeed is the illustration of a proverb is shown by the fact that it appears also in a series of proverb tapestries made from designs by Jordaens, where it is actually inscribed with the Latin version of the proverb: "Oculus Domini Pascit Equum."[2] Nevertheless, this title has not been accepted for the Cassel picture by those who have written about it. As recently as 1938, Voigt in the catalogue of the Cassel Gallery listed the picture as follows: "Ein Mohr fuehrt seinem Herrn einen Hengst vor" and he added by way of explanation "Ein Pferdehandel, der unter dem Schutze des Merkur, des Gottes der Kaufleute, vor sich geht." The figure of Mercury, evidently, has been the reason why scholars have declined to accept the proverb as the sole title. His presence, indeed, needs an explanation. It is, however, obvious that the reference by Voigt to Mercury as god of merchants is but a vague guess for which support can be found neither in the visual evidence of the picture itself, which surely is not a horse deal, nor in the iconographic traditions of the seventeenth century. Yet even Rooses, who himself knew and made mention of the Frauenberg tapestry, seems to have hesitated to call the Cassel picture by its proper name. While I have not seen the tapestry myself, I consider it most likely that Mercury is present in it, too, since he appears, though on the other side of the

Originally published as "Jordaens and the Equestrian Astrology," in *Miscellanea Leo van Puyvelde*, Brussels, Editions de la Connaissance, 1949, pp. 153-156.

composition, in the cartoon for the tapestry—one of several cartoons by Jordaens preserved—in the collection of the Musée des Arts Décoratifs in the Louvre in Paris.

To anyone familiar with Jordaens' work, the presence of Mercury in scenes with horses should not come as a surprise. A few years after the proverb tapestries, Jordaens made the designs for another set, the—erroneously—so-called *Equestrian Education of Louis XIII*.[3] Here we find a typical riding academy, perhaps inspired by Pluvinel's famous work, showing many of the paces and jumps of a well-trained horse. In a number of these tapestries one can see Mercury, either leading a horse or watching its movement like a professional trainer. A characteristic example is Vienna no. 193 (Fig. IV.2), for which there exists a beautiful painted modello, enlarged at the left by the figure of a Negro attendant with dogs and a parrot, [formerly] in the Spencer Churchill Collection [and now in the National Gallery of Canada, Ottawa] (Fig. IV.3).[4] Here Mercury leads a nearly white horse while a figure in Roman armor with a feathered helmet seems to assist in the control of the reddish-brown horse in the center. The same heroic figure appears also in other pieces of this set of tapestries, prominently connected with the horses. With all the other figures wearing contemporary dress, he would be a rather strange character if he were only a riding master. Actually, his outfit and shape bring to mind immediately the figure of Mars as he commonly appears in seventeenth-century renderings.

Mercury and Mars as trainers and guides of horses—what other explanation can be found for this phenomenon than the astrological significance of these gods as planetary influences! As soon as one follows up this thought, the seemingly incongruous presence of Mercury and Mars in these scenes finds a simple explanation. The importance of astrological theories for the understanding of the art of the Renaissance and the Baroque has been demonstrated in recent years in many ways. However, while the theory of the influence of the heavenly bodies on the character, form, and color of human beings has by now become general knowledge, it seems to be less known that the same principles were also applied to the animal kingdom, especially to horses. Yet, one needs only to read "La Gloria del Cavallo," a veritable equine encyclopedia that the Neapolitan patrician and horse-fancier Pasquale Caracciolo compiled, and published in Venice in 1566, to see how important this subject was to the men of the Renaissance. After dealing thoroughly, though quite conventionally, with the theory of the four humors in its application to horses, Caracciolo turns to the influence of the stars and deals at length with this problem, quoting the various—and often enough contradictory—authorities on the subject.

Speaking of the planets, he says that all horses are subject to Mars, but are influenced by other planets, too, which determine for instance their colors. The colors of Mercury "according to Mesahala are [those] between white and black, while Alcabitius maintains that every color that is mixed and varied is mercurial." Mercury "produces the creature not too white nor very black, with high forehead, long face and nose and hoofs, with little hair on his cheeks and with beautiful eyes, not quite black. . . ." "In short, we can say that honeycolored, dusky, deercolored, tawny, and multicolored hair is a sign of mercurial

complexion and of intemperate qualities. If the planet meets with any adverse [zodiacal] sign, it makes the animal deceitful, disobedient, now timid, now bold, unstable and of varying intentions. But with a benign mixture he will make it docile, agile, cheerful, and fortunate." The color of Mars (as planet "hot, dry, choleric, malicious, and fierce") is "vermilion and fiery, therefore Alcabitius writes that Mars makes the animals red, with reddish hair, . . . bold, proud, enterprising, and smart. Gauricus, who affirms that he [Mars] makes them red, adds thin hair, small eyes, crooked teeth, normal stature, good flesh, [and says they are] cheerful but suspicious. Thus, properly, sorrel horses and those with burning hair are martial, exceedingly choleric, disdainful, restless, impatient, impetuous, rash, especially in the summer when, as says Aristotle, fire is added to fire. One must therefore treat them gently and refrain from irritating them more by beating them, as they all have tender skins."

It is easy to see that Mercury and Mars, under proper conditions, are very desirable planets to rule horses, and in Jordaens' *Riding Academy* they are indeed rendered like faithful grooms who watch over their charges with care and pride. Mercury generally attends to the gray and dappled horses while Mars is properly concerned with sorrel horses and bays. It is a mercurial, gray-dappled horse that is shown to his master in the Cassel painting, and it is obvious that Mercury looks benignly on this creature, which seems to have all the qualities that a good constellation is said to give: docility, agility, cheerfulness, and good luck. However, it is characteristic for the rational and practical manner of thinking of the seventeenth century, and especially of Jordaens, the typical middle-class philosopher, that the planetary influence has clearly been accorded second place. Mercury may determine the color of the fine animal and may be helpful in other ways, but it is "The eye of the master" which "makes the horse fat."

NOTES

1. The proverb is of Greek origin; see W. Gottschalk, *Die bildhaften Sprichwörter der Romanen*, 3 vols., Heidelberg, 1935-1938. Its English version, found also in other languages, was probably modeled on the biblical passage "The light of the eyes rejoiceth the heart; and a good report maketh the bones fat" (Proverbs 15:30). [Jordaens was of course familiar with Jacob Cats' collection of proverbs in *Spiegel van den ouden ende nieuwen tijt*, Dordrecht, 1635 (1st ed. 1632), which gave the proverb in this form (II, p. 79): "Het ooghe van den Heer dat maeckt de peerden vet/Het ooghe van de vrou dat maeckt de Kamer net."]

2. These tapestries were exhibited in 1905 as from the collection of Prince Schwarzenberg, Frauenberg, Bohemia, and were described by Max Rooses, *Jacob Jordaens: His Life and Work*, trans. E. C. Broers, London, 1908, pp. 182-184. Another, although incomplete and cut-up, set is preserved in the cathedral of Tarragona, Spain.

3. According to Heinrich Göbel, *Wandteppiche, I: Die Niederlande*, Leipzig, 1923, p. 336, a contract was made on July 30, 1652, between the firm of Reydams and Leyniers and Carlo Vinck for a set of "Grands Chevaux" for which Jordaens made the cartoons and which has come down in many copies, the best known of which are in Vienna; they were published by Ludwig von Baldass, in *Die Wiener Gobelinsammlung*, Vienna, 1920, III, nos. 188-195. There is no reason this series should be called—as it has been so far—the *Equestrian Education of Louis XIII*. Louis XIII (1603-1643) was already dead by the time this series of tapestries was designed. The title was probably transferred to the tapestries through a mix-up with another set that Göbel mentions (p. 323), listed in a royal French inventory as a Riding School "représentant les exercices de Louis XIII en manège, faite par Jean Geubels en 1626."

4. [The *Riding Academy with Mercury and Mars* (Fig. IV. 3) was acquired by the National Gallery of Canada, Ottawa, in 1965 (No. 14810). As no. 88, it served as the focal point of the large Jordaens exhibition in Ottawa in 1968 (catalogue by Michael Jaffé).]

ARTIS PICTORIAE AMATOR:
AN ANTWERP ART PATRON
AND HIS COLLECTION

ONE of Van Dyck's most sensitive and admired portraits shows the head of a man of advanced age, with slender and finely chiseled features (Fig. V.1).[1] From underneath a large forehead—made more impressive by the sparseness of the graying hair—he looks calmly and with a vague weariness at the beholder. If Van Dyck generally tended to stress sensitivity and refinement at the expense of physical vigor and a will to dominate, there is reason to assume that in this case the model met the artist more than half-way. Although Cornelis van der Geest was Dean of the guild of Antwerp merchants and himself a successful dealer in spices,[2] he seems to have been possessed by one overriding passion: art. He sponsored living artists and collected their works. He joined their professional organizations. He took an active interest in the decoration of churches and chapels. He also filled his house with works of art of past ages, and did his best to keep alive the memory of the men who had produced them. In all these activities he was guided by an unfailing sense of quality, and it is safe to say that he was one of the foremost connoisseurs of his age.

Indeed, in contemporary documents, Van der Geest is generally identified as a *maecenas* of the arts. In the records of the *Liggeren*, he is called *Kunstliefhebber* (amateur of the arts), and, on Paulus Pontius' engraving, he is more formally referred to as *Artis Pictoriae Amator*.[3] In 1630, he appeared as a witness in the well-known document drawn up by Rubens in favor of Willem Panneels.[4] Here he is described as *vir honestissimus, mercator perbrobus, et antiquitatum amator studiosissimus*. Shortly after the death of Van der Geest, in 1638, Rubens published the engraving of the *Elevation of the Cross*, painted by him between 1610 and 1612 for the St. Walburgis church, of which Van der Geest had been *kerkmeester* (warden). This engraving was inscribed with the surely well-deserved eulogy: "To Heer Cornelis van

Reprinted by permission of the *Gazette des Beaux-Arts*, L, 1957, pp. 53-84.

der Geest, the best of men and the oldest of friends, in whom ever since youth he [Rubens] found a constant patron, and who all his life was an admirer of painting, this souvenir of eternal friendship is dedicated, intended to be presented in his lifetime. Engraved after the picture in the church of St. Walburgis, the idea of which he was the first to conceive and which he supported so zealously."[5] Again ten years later, in 1648, in Fickaert's *Metamorphosis*,[6] a monograph on Quentin Massys and one of the first examples of a book dedicated to a single artist of the past, Van der Geest is introduced as *Liefd weerdigh Liefhebber en Kender van de Edele Schilderkonst*—a statement which is also interesting as an early instance of the term *Kender* (connoisseur) of art.

Van der Geest's appearance is known to us not alone from the painting in London. Van Dyck also made a drawing of him which is now in the Nationalmuseum in Stockholm, and Pontius engraved it in the print to which we have referred before. In addition, Van der Geest figures as the host in the painting by Willem van Haecht in which Archduke Albert and Archduchess Isabella are shown visiting his house.[7]

It is possible to add to these portraits of Van der Geest one which is somewhat out of the way, and inconspicuously placed at that. His face appears in a little-known painting in the church of St. Gommarus at Lier, near Antwerp, on an altar dedicated to the titular saint and standing in the northern transept.[8] The architectural and sculptural parts of the altar, the work of Hans van Mildert, have been dealt with by scholars concerned with this interesting artist.[9] The paintings, however, remained practically unnoticed until quite recently when Lugt published a drawing which, like the corresponding part of the altar, is a work of Frans Francken the Younger.[10] It illustrates the incident when St. Gommarus tied together with his belt and thus restored a tree which his men had cut down on the property of a neighboring peasant (Fig. V.2). The belt of St. Gommarus was one of the chief local relics.[11] Lugt noticed that the major discrepancy between sketch and picture was the presence in the latter of a head which is clearly a portrait. He surmised that it might be the artist or the patron, but there is no doubt that it is a very good likeness of Cornelis van der Geest. The identity of the features—here almost melancholy in expression—with those of the London portrait is all the more welcome as this image does not seem to be derived from Van Dyck's work. Thus it serves as a check for the reliability of Van Dyck's interpretation and does credit—provided it is by him—to Frans Francken, by whom no other portraits are known. Behind Van der Geest there appears another head with strikingly individual features, but whether it too is a portrait, and if so of whom, I do not know.

There was good reason for including Cornelis van der Geest in this painting, even though he was not its donor. With the help of some hitherto unpublished documents and the works of local historians largely neglected by students of the history of art, the genesis of the altar and the circumstances which led to it can be reconstructed in considerable detail.

In 1580, in one of the last flare-ups of the iconoclastic disorders, the church of St. Gommarus was sacked by intruders from Antwerp led by Jan Junius de Jonge.[12] Many

works of art were destroyed, and the archives were scattered.[13] Among the losses was the high altar which had been painted by Abraham Janssens, perhaps the father of the younger Antwerp painter of that name. It was later replaced by a *Crucifixion* by Jacob Jordaens, which is now in the Cathedral at Bordeaux.[14] Other losses were gradually compensated for in the early seventeenth century. In 1612, Otto van Veen, who in that year resided in Lier as a fugitive from the plague that ravaged Antwerp, painted a triptych for the *Heiliggeest-meesters* (Regents of the Poorhouse) in memory of Elizabeth van Immerseel, a work which is still in the church.[15] A contract with Hans van Mildert to make another altar for St. Gommarus was drawn up in 1619, in the presence of Cornelis van der Geest. An old painting had been preserved for which the new altar was to provide a splendid frame. This altar was consecrated by Bishop Jan van Malderus on September 27, 1620.[16] Van der Geest may have been asked to serve as a witness because he was a personal acquaintance of Van Mildert. It is also possible, however, that he had family contacts with Lier. In the St. Gommarus church there is still a tombstone, dated March 9, 1624, in memory of a Cornelis Egbertus van der Geest; the name of one Jan van der Geest who was *schepen* of the city and county of Lier from 1627 to 1666 is still inscribed on colonettes.[17] The Immerseel family with which Cornelis van der Geest was related (see below) was also connected with Lier, as can be seen from the Immerseel altar by Otto van Veen.

Either late in 1626 or early in 1627, Van der Geest was again approached by the church wardens to help with the planning and to supervise the enlarging of the old panel and the addition of wings. The first payment for this commission was apparently made on April 29, 1627, but the work must have been begun considerably earlier since on May 2 the pictures had already arrived in Lier. Two artists shared in the commission: Frans Francken painted the outside of the wings, receiving 108 guilders for his work. Willem van Haecht, Van der Geest's special protégé, painted on the inside the pieces which were added to the old panels; for this slightly larger job he received 168 guilders; both artists were evidently paid at about the same rate. Forty-two guilders were paid to Jan Schut for gilding and painting the frame; Jan de Molin received two guilders and eight stuivers for a sketch "for the modification of some parts of the picture." Other small amounts were paid to carpenters for enlarging the old panels and for making the frames and the crates in which the panels were shipped; to the shippers Jan Visschers and Lisken de Winter, who transported the pictures by boat from Antwerp to Lier; and to some workers who carried them from the boat to the church and hung them. Besides their pay in money, the masters who had done "the picture and all the work in connection with it so praiseworthily" were treated in the traditional way with sixteen guilders twelve stuivers' worth of wine. Van der Geest, however, who had advanced the money, received on orders of the magistrate "for all his good services and the trouble which he had gone to . . . with the . . . painting which he had conceived and whose design he had helped to plan" half an *am* of Rhenish wine, worth fifty guilders. It is evident that he had well deserved being included in the Miracle of St. Gommarus.

What has happened to the old center panel, enlarged in 1627, I do not know. At present, its place is occupied by a reliquary and bust of St. Gommarus. The wings which are attached to the flanking columns are normally closed so that the outside with Frans Francken's painting is visible most of the time. On a few special holidays they are opened so that the paintings by Willem van Haecht may be seen.

These show a *Nativity* on the left and a *Presentation in the Temple* on the right side. A careful examination of the originals reveals the following situation: both paintings contain an old core, painted, to judge from the style, at the beginning of the sixteenth century. The old parts consist of two vertical boards, to which smaller pieces were added on three sides. They are flush with the additions on top and on the bottom where the wings were hinged to the center panel. One can distinguish the old boards from the later additions because they bulge slightly forward. Stylistically, the *Presentation* has kept its old character more nearly intact than the *Nativity* scene; the latter was evidently gone over thoroughly by Van Haecht. The additions by Van Haecht (which reach considerably into the old compositions) comprise in the *Nativity* the little angels above and the shepherds below; in the *Presentation*, the children in the foreground, and the architecture above the last window of the apse. He also painted, of course, the narrow strips which run down at the left in the *Nativity*, at the right in the *Presentation*.

Willem van Haecht's additions are apparently not original inventions, however. It is easy to see that the shepherds in the *Nativity* were copied from Otto van Veen's *Nativity* in the Maagdenhuis in Antwerp. It is very likely that the other sections are also derivative. The Annunciation scene in the book which the two children in the *Presentation* are holding has been done in Van Haecht's best copying manner. Thus the artist who so far has been known only as a painter of gallery pictures[18] and as the engraver of compositions by Bolognese artists, again reveals himself as a skillful copyist rather than an original mind in the only large scale work which can be attributed to him on the basis of documentary evidence.

A great deal has been written about Van Haecht's painting of Van der Geest's gallery since—when still in the collection of Lord Huntingfield—it first appeared at an exhibition at Burlington House in 1907. Yet, no systematic study has been made of all the objects and persons seen in it, and it is perhaps permissible in an article devoted to Cornelis van der Geest to make some further contributions to our knowledge of his collection and of the people who are here shown admiring it[19] (Fig. V.3); all the numbers and letters appearing in the following pages within parentheses refer to the photograph shown in this reproduction.

It is well known that the picture alludes to the famous visit of Archduke Albert and Archduchess Isabella (I) (H) to the home of Van der Geest in 1615,[20] when the latter supposedly turned down their request for a painting of a *Madonna* by Quentin Massys from his collection and—as Fickaert put it—"because of his egotism lost high favor." It has also

been pointed out that neither the people who are seen all over the picture nor the objects forming the collection could all have been there in 1615. Wladislas Sigismund of Poland (L) was not in Antwerp until 1624. Several of the pictures rendered were done in the 1620s, such as for instance the Wildens *Landscape*, now in Dresden (32), which dates from 1624; the *View of Antwerp* by Vrancx, in the Rijksmuseum (43) of 1622; not to mention Van Haecht's own *Danae* (31), which carries the date 1628. Thus, the painting of Van der Geest's gallery can be regarded neither as the rendering of a specific historical event—the visit of Albert and Isabella—nor as a faithful record of the contents or the arrangement of the collection at a given moment. It seems rather to be a condensation into one picture of Van der Geest's role in society and his activity as friend of the arts. This theme of the work reaches its climax in the grandiloquent pun on Van der Geest's name, inscribed above the door: *Vive L'Esprit.*

Examined from this point of view, the picture reveals a more complex structure and meaning than appears at first sight. That Van der Geest chose the incident of the showing of Massys' *Madonna* as the main action is probably due less to any pride at having refused to part with that treasure (provided Fickaert's story is indeed true and not, as seems to me more likely, apocryphal and derived from this very picture) than to Van der Geest's general interest in early Flemish painting and particularly in Quentin Massys. He owned three paintings by this master—the *Madonna* (29),[21] the *Portrait of a Man* now in Frankfurt (42), and a version of the *Paracelsus* (13)[22]—and, one year after his collection was painted by Van Haecht, he also caused the tombstone of Massys to be attached to the tower of the Cathedral and an inscription added to it in praise of the blacksmith turned artist.[23] His antiquarian interests also led him, early in 1613, to restore at his own expense the crypt under the church of St. Walburgis where, according to local tradition, the titular saint had retired to pray.[24] His concern for the old panel of St. Gommarus in Lier may be quoted as another example. If we examine his collection, we find that it contained a relatively large number of "primitives," or works copied from such earlier paintings. Besides the three paintings by (or after) Massys, he owned a *Portrait of Dürer* by, or more likely after, Tommaso Vincidor of Bologna (18);[25] *Landscapes* by Bruegel the Elder (1) and by Cornelis van Dalem (10);[26] a small French (?) *Portrait of a Woman* from around 1540 (27), admiringly looked at by Pieter Stevens; and, last but not least, the now lost painting by Jan van Eyck (38), to which I shall return.

Van der Geest was by no means the only Antwerp connoisseur of his time interested in art of the more distant past. Rubens' study of the early masters is too well known to require documentation, and Massys in particular enjoyed a special reputation, partly because of the "human interest" of his life, and partly as the "founder" of the school of Antwerp.[27] Van Haecht's painting may indeed contain (perhaps more implied than expressed) a flattering reference to Antwerp's role in the arts. Of the identifiable paintings, the majority seem to have been done by artists of the Antwerp school. Starting again with the three paintings by Massys, Bruegel, and Van Dalem, there were at least one by Floris (9); two

by Aertsen, who spent enough time in Antwerp to pass as a member of that school (6, 37); one by Van Noort (16);[28] two by Rubens (11, 15);[29] two by Brueghel the Younger (on the table); and one each by Snyders (30), Seghers (25), Vrancx (43), Van Balen (12), Simon de Vos (26), Jan Wildens (32), Neeffs (22), and Van Haecht (31). There are others which appear also to be products of the Antwerp school, although it is not certain who painted them: (8) Van Ertvelt (?); (24) [Marten Ryckaert (?)]; (39) Mostaert (?); (40) Verhaecht (?); (21) Coxie (?);[30] (36) Van Balen (?); (41) Francken (?) [but see below, Postscript]; and the little flower-piece in Isabella's hand, which looks like a Jan Brueghel or a De Gheyn. The interesting scene with the *Vision of St. Peter* (34) (Acts 10:11-16) appears to be Flemish, too, but I find it hard to make a more exact attribution. It might be a work by Coxie. Yet Van der Geest's interests, while clearly reflecting a strong local patriotism, were not narrow. He had two paintings by Elsheimer (17, 23), one or two by Rottenhamer (28, 33), [one by C. Cornelisz of Haarlem (4),] a few Italian pictures (2, 20, 35),[31] and a number of Flemish, Italian, and German drawings and prints (Dürer, Carracci).

The true range of Van der Geest's taste is perceived only if we turn to the other art objects which appear throughout the picture. On the table in the center stands a whole set of well-known bronzes by Giovanni da Bologna and his school;[32] to the same circle (Susini?) belong the two horses below the church interior by Neeffs (22) and the *Lucretia* below the Van Noort (16). The figure which is admired by two men near the window is by Giovanni da Bologna himself. There are the large copies, or casts, of classical and Renaissance statuary (one of which is a *Venus and Cupid* by Jörg Petel),[33] the ancient coins on the center table, and the two probably pseudo-classical reliefs on the table near the window. Above the door are the busts of Nero and Seneca.[34] Finally there are sundry majolica pieces, watches, armillary spheres, astrolabes, etc., and the chandelier with its gold and enamel work in the Floris style.

If the works of art in the painting show Van der Geest's activity as a collector, the live figures in the picture represent with perfect clarity the social circles with which he was in contact through his interest in art. It looks as if the grouping of these figures is not accidental. The group at the left, toward which Van der Geest turns, bowing respectfully, and whose attention he tries to direct to the Madonna by Massys, clearly consists of persons of high social rank (Fig. V.4). Besides Albert and Isabella, we find Geneviève d'Urfé, the widowed Duchess of Croy (F); Ambrogio Spinola (E); then Nicolas Rockox (C), burgomaster of Antwerp; and another man (D), whom Glück not too convincingly identified with Jan de Wouwere, the Antwerp magistrate and humanist. The lady to the left of Rockox (B) is probably the Comtesse d'Arenberg, on the evidence of a Pontius engraving of 1645 after Van Dyck.[35] To the right of Isabella we see Rubens, who as counselor and intimate of the Archduchess was clearly entitled to such a place (K). Then follow Wladislas Sigismund of Poland (L); Jan van Montfort, the master of the mint (M); and Van Dyck, from whose paintings most of the portraits in the picture were derived and who for that reason alone

(and also because he seems to have been particularly close to Van der Geest) deserved a place of honor (N). The woman at the left edge (A) remains unidentified.

Van der Geest himself (O) is the link to the next group, consisting of one woman and four men (Fig. V.5). The lady (P) has been identified by all previous writers as the wife of Van der Geest. Unfortunately for this theory, Van der Geest apparently remained a bachelor all his life. At least that seems to be the evidence of his will.[36] That Van der Geest's wife is not mentioned among the heirs would be insufficient proof, since she might have been dead in 1638 when the will was drawn up. Yet it is impossible that a man who made so sure that good works and a sufficient number of masses would be performed for the benefit of his soul would have completely neglected to remember the salvation of that of his wife. The same will, however, contains a clue to the identity of that rather formidable lady standing behind Van der Geest. After the listing of the various stepsisters (apparently by a marriage of his mother to a Van Immerseel), each of whom received a single gift of a thousand guilders, Van der Geest bequeathed an annual rent of two hundred guilders for her services to Mevrouw Catherine van Mokerborch, "staying at present with the testator," to be paid to the end of her life. It seems most plausible that this Catherine van Mokerborch was Van der Geest's housekeeper, all the more so as the bequest to her is followed by gifts to servants starting with "Barbara, the maid of the testator," who receives the single gift of four hundred guilders—a generous reward, but evidently much less than what Catherine van Mokerborch received, not to mention the fact that of the servants only the first name was given. (Unfortunately we are left to surmise the identity of a "certain woman and her children, widow of a certain gingerbread-baker," who received a single payment of twenty-five guilders.) We assume then that the stout woman in Van Haecht's picture is indeed Catherine van Mokerborch.[37]

Of the four men in this group, two can be identified with a good deal of certainty. To the extreme right is Pieter Stevens (T).[38] Leaning in the opposite direction, and looking at Giovanni da Bologna's bronzes, is probably Jacques de Cachiopin (R) who is known from Van Dyck's portrait (Glück 340) and Vorsterman's engraving (Wibiral 75). Both men were themselves famous collectors and it is interesting to note that the caption on Vorsterman's engraving of Stevens reads: *Amator Pictoriae Artis*, while almost the same formula appears on Cachiopin's portrait: *Amator Artis Pictoriae Antwerpiae*. Since Van der Geest, too, is referred to in this way (see above), the evidence seems to favor the assumption that this whole group of men is a group of collectors—perhaps including the man who kneels to examine Jan Wildens' *Hunter in the Snow*.[39] This theory would definitely exclude Glück's identification of the man next to Pieter Stevens with the painter Paul de Vos (S) which is not supported by any physiognomic resemblance.[40] Indeed, it is practically certain that we have here the same gentleman Van Dyck portrayed in a picture now in Windsor Castle (Glück 273), but who he may have been we do not know. He probably must be sought among Antwerp's collectors, where we must also look for the elderly man behind Catherine

van Mokerborch (Q) and perhaps also the kneeling man (U) who bears a certain resemblance to *L'Homme à la Pelisse* in Vienna.[41]

There is all the more reason to assume that a social and professional distinction was made among the various groups of people (faintly analogous to that of Raphael's *School of Athens*), for in the group at the right the three men whom we can identify with fair certainty are all painters (Fig. V.6): Jan Wildens (X),[42] Frans Snyders (Z), and Hendrik van Balen, standing next to Snyders and closest to the edge (AA).[43] In this group, I should like to include the young man who—alone of the actual portrait figures—is not placed inside the room, but modestly approaches from the outside (BB). I suggest that this is a self-portrait of Willem van Haecht, who in 1628 was thirty-five years old, which agrees well with the age of the young man. He wears long hair in the new fashion. That fashion favors Van Haecht, too, as he was indeed a "newcomer," having returned to Antwerp from Italy only a short while before. That he appears directly below Van der Geest's coat of arms and the inscription *Vive l'Esprit*, far from being accidental, gives further support to this theory, as Van Haecht was living with Van der Geest and was charged with keeping his collection. (He is not mentioned in Van der Geest's will of 1638, because he had died in 1637.)

There remain two groups of two men each in the rear of the room. They are examining pieces of sculpture, which was probably Van Haecht's way of showing that they were sculptors themselves. One of them might be Jörg Petel, pointing at his own work. Just as the painters, with the exception of Rubens and Van Dyck, were screened off from the "nobles" and the "collectors" by paintings, so the "sculptors" are also in separate spatial units and clearly subordinated to the more important figures. Thus there seems to be a close correspondence between the social hierarchy and the compositional plan of the work.[44]

We have seen before that the intention of the artist was not to paint a record of a specific scene, and it is evident that certain liberties were taken with the arrangement of the room. It is also evident, however, that a picture of this kind must include some features that make the identity of the locale unmistakable. It is impossible for us to check the details of the interior decoration, or the design of windows and the door, since Van der Geest's house, called "L'Empereur" and located in the Mattenstraat, was torn down in 1882-1883 when a whole section of the old town was razed to make place for new harbor installations. The room looks larger than even the most stately halls of old Antwerp houses, but it is a common experience with this kind of picture that proportions are distorted in favor of an impression of magnitude. If we make allowances for certain perspective distortions and for the tendency to show people smaller than they would actually have appeared, it is not impossible that the room is indeed a portrait of the "gallery" of Van der Geest. This room appears to have been located on the far side of a courtyard which one entered from the street through an archway and which was decorated with a fountain showing a large, baroque sculptural group. Given the actual location of Van der Geest's property in the Mattenstraat (Fig. V.7), the "gallery" must have been standing at the western end of the

property, with its windows opening upon the Scheldt River. This assumption is borne out by the painting where outside the windows we see boats sailing on a river.[45]

This view of the river is toward the north. Exactly opposite the windows, next to the door, there hangs Vrancx's painting of Antwerp harbor, seen toward the south. The painting has not only a very prominent place but is also rendered in incredible detail, as any comparison with its original, now in Amsterdam, will show (Fig. V.8). It is a picture of considerable topographic interest.[46] At the left is the *Porte du Werf*, built in 1579, demolished in 1810.[47] The steeple that appears above it is the old tower of St. Walburgis church, demolished in 1820, of which Van der Geest was warden and for which Rubens had painted, at Van der Geest's request, the triptych of the *Raising of the Cross*. The large structure in the foreground is the old crane (*La Grue*) which was built in 1546 and torn down in 1811. The view was taken from a spot only a few steps away from Van der Geest's house, and there is a certain logic in its hanging on the southern wall of the "gallery." The part of the *Werf* from which the view was taken may have been a favorite place of the great mechant. From here he could see some of the witnesses of Antwerp's former greatness in one of the most impressive skylines of his age. From faraway St. Michael's Abbey and the fortifications of Walskapelle on the western side of the Scheldt, the eye swept past the Fishmongers' Tower and that of the Cathedral to the places near to his home and close to his heart: the church of St. Walburgis and the gateway which led to it.

There may have been a special reason for showing this skyline under the very exceptional aspect of an extremely severe winter. The times when the Scheldt River froze over so that people could cross it were very rare. It had happened in 1564—when Bruegel seems to have made a record of it—and then again in 1608. The cold began on January 1 and lasted twenty-eight days. Van der Geest himself reported "ende was so cout, datmen t'Antwerpen over tscheldt liep." It so happened that this very year—1608—brought Van der Geest a high honor. He was elected Dean of the merchants' guild, the most important of all the guilds of Antwerp. The picture of the great freeze of 1608 thus evoked in him personal memories which must have been pleasant enough for a man who was not insensitive to the honors that came his way.

The two leading themes of the large painting by Van Haecht are thus summed up again in the little one by Vrancx. It alludes to Van der Geest's personal history and achievements. At the same time it expresses something of the pride and the deep affection which its owner appears to have felt for his native town.

It is evident from the foregoing that Van der Geest's collections and the circle of his friends and acquaintances hold an unusual interest for the historian of art. Not one of the works of art reproduced in the picture of his "Gallery," however, is likely to eclipse in importance the modest piece that hangs at the back of the room and which, ever since the appearance

of Van Haecht's painting, has been considered to be the record of a lost work of Jan van Eyck (Fig. V.9). Yet, while everyone so far has agreed on this fact, the picture has always been a source of embarrassment to the writers on Jan van Eyck because of its subject matter. To be sure, most writers remembered the description made by Fazio of a *Women's Bath* supposedly by Jan van Eyck, which this Italian writer saw in the collection of Count Ottaviano Ubaldini della Carda, but it was clear that Van der Geest's picture was very different from that described by Fazio.[48] Nevertheless, it was generally classified as an example of a lost category of "genre-paintings" by Jan van Eyck, even if few writers went so far as Winkler who considered it a kind of pornographic picture (like those that were later painted for Rudolf II of Hapsburg by such men as Spranger, Heintz, and others).[49] Only Friedländer, with his keen insight into the expression contained in works of art, found words which do justice to the character of the picture when he spoke of the *"sittsam feierliche Nebeneinander"* of the two women. He, as well as many other writers, felt reminded of the Arnolfini picture in London, but Friedländer made the additional and, it seems to me, important observation that a calculation of the picture's size makes it likely that it was of about the same dimensions as the London panel.[50]

The similarities with the Arnolfini panel are indeed striking and go much farther than has ever been pointed out. They concern not only the general plan of showing two standing figures in a relatively small chamber that receives its light from a window at the left, but also a great many specific items. In both pictures are found—and practically in the same spots—the little dog and a pair of wooden shoes. The window has the same shutters consisting of three parts of equal height (very different from any shutters found, for instance, in works of the Master of Flémalle and of Rogier); the ceiling has the same narrow and foreshortened beams. In both, a chest stands in front of the window and a bed appears at the right. Finally, in the background there is the same piece of furniture—a chair with a high back from the corners of which there rises a small carved figure; despite the smallness of Van Haecht's picture, there can be little doubt that even the ornamentation of the chair is identical. A convex mirror—although apparently not of the same shape as that of the Arnolfini picture—is seen at the left. The only major piece of furnishing of the London panel that is absent here is the chandelier, and its absence can be explained, as we shall see below. Even so, the impression is inescapable that the picture in Van der Geest's collection represented the same room as that which served as the setting for the Arnolfini portraits.

That room, as Panofsky has shown so convincingly,[51] was not a *chambre garnie quelconque.* It was the nuptial chamber, charged with symbolism, the fitting environment for the solemn moment in which the Lucchese merchant took his marriage vow. To assume that Jan van Eyck could have used the same room, down to almost the last detail, for an erotic genre piece amounts to accusing the artist not only of indelicacy but, contrary to all the evidence we have, of the grossest indifference to the poetic and symbolic significance of his settings. Whoever doubts the close connection of the two pictures is virtually forced

to assume that Van der Geest's painting was not by Jan van Eyck at all, but the work of an imitator, if not actually a forger, who used the setting and the compositional pattern of the Arnolfini panel for a subject of a very different nature. Yet, this theory is faced with formidable difficulties. Since the costume of the lady at the right is quite compatible with that worn in Jan van Eyck's time,[52] the later painter would not only have copied a setting by Jan, but would also have made an effort to keep the figures in the character of the early fifteenth century. I do not know any parallel for such a work. Furthermore, this artist— bent as he was on imitating a work of Jan van Eyck—would appear to have chosen a subject which has no parallel in all of Jan's work, even if we count the lost painting in Urbino which was clearly a very different piece. While it is correct that a Van Meegeren chose for his forgeries subjects which Vermeer practically never treated, the procedure of earlier forgers was less devious, since they did not have to take into account the subtle reasonings of professional art historians. In short, such a theory would gain for our problem nothing more than a wholly unnecessary increase in the number of unknowns. There are, of course, sixteenth-century *copies* after Eyckian works, and no one can say whether the picture in Van der Geest's collection was an original or a copy. But even if Van Haecht copied a copy, his picture would still be valuable as a record of a lost Van Eyck.

This Van Eyck, it must be repeated, cannot have been anything but a picture that had the closest possible connection with the Arnolfini painting. They belonged together like twins. Their size, composition, details, the very mood of the works, are too close to allow any other explanation.

Indeed, any study of the lost picture must lead us to the conclusion that it could not have been a *sujet de genre*. Two women are shown in the privacy of a bedroom, and the little dog is placed near the door as a guard against any intruder. One of the women is dressed in a very fashionable way, so much so, indeed, that one observer was forced to say that this "lady's maid" is "a very superior kind of maid indeed."[53] It seems pretty safe to say that she is not a servant at all. Her elaborate hairdo and kerchief, the elegant dress with its long skirt against which hang two bags, probably of keys, proclaim her as a lady in her own right with obvious signs if not of rank, certainly of wealth. Nor is she helping the other woman like the traditional bathing girls, or like the servant in Watteau's genre scene known as *La Toilette Intime*. She holds in her left hand a carafe with water; in her right hand she has an object which is not clearly visible but which might be a fruit. The other woman is completely nude, except for sandals. Only people thinking in terms of modern customs could imagine that a lady of the fifteenth century would strip like this as a matter of regular washing routine. Actually, the complete nudity of the woman suggests strongly that this is a ritualistic ablution. The position of her left hand with the towel—while ostensibly a functional one—carries also the age-old reference to purity and virginity.

Since we know that the Arnolfini picture is the record of a marriage ceremony, and since we have postulated a close connection between it and the lost picture, a study of

marriage rituals seems clearly indicated. Now, even the most perfunctory study of marriage customs reveals that a bath before, and sometimes also after, the wedding was not only taken as an act of common hygiene, but was also treated in almost all civilizations as an important ritual with its own sets of rules and taboos. It took either the form of a complete ablution or of a washing of parts of the body, particularly of the feet. It could be taken at home or in the public bath-house, and there are a good many late medieval ordinances which try to regulate these excursions, which sometimes seem to have degenerated into rather noisy public celebrations. The bath of the bride as a purification ritual usually preceded the putting on of the bridal gowns; a similar ceremonial was observed in the creation of a knight. Before his acceptance as a knight, the esquire had to take a bath and upon emerging from it would put on a new gown. In Germany it was customary for the bride to be accompanied by bridesmaids, the number of which varied but generally seems to have been more than one.[54]

The origins of the wedding bath may be connected with ancient fertility rites in which water often played an important part. Indeed, in some regions the water in which the bride had bathed was sprinkled either in the corners of the bridal chamber or over the bridal bed.[55]

Given this almost universal custom, it is tempting to assume that the lost Van Eyck was the rendering of a marriage bath, and to be exact, the marriage bath of Giovanna Cenami, the bride of Giovanni Arnolfini. This would explain without difficulty the identity of the setting, down to the presence of the same dog, who may have been a symbolic feature but also at the same time Giovanna's favorite pet, in accordance with that interesting fusion in the fifteenth century of symbolism and realism which has been pointed out by Panofsky, Meiss, and Schapiro.[56] It would also account for the absence of the chandelier which was introduced into the wedding scene to allow for the display of the wedding candle[57]—a feature which was obviously not needed, nor indeed proper, in the rendering of the wedding bath.

The rendering of a marriage bath, admittedly, may seem to be a strange subject for a painting even if we are aware that marriage baths were rituals of acknowledged importance in wedding ceremonies of all ages. If it were a unique case, the interpretation would have little chance of being accepted, although one could always point out that the Arnolfini double portrait itself is a very unusual work, which only recently again has been described by Baldass as "unique." However, Giovanna's purification ceremony is perhaps not such an isolated phenomenon in early Flemish painting as it may appear at first glance. Memling's *Bath of Bathsheba* in Stuttgart offers surprising parallels (Fig. V.10).[58] It, too, is a painting with two women, one nude, the other dressed, and the latter is hardly a maid, either. There is a bed in the right background, and a little dog is also present. Bathsheba's pose suggests again the idea of chastity.

Since Friedländer recognized that the upper left corner of the Stuttgart panel—which today is a relatively recent addition—originally consisted of a piece {formerly} in the

Epstein collection in Chicago [and now in the Chicago Art Institute], it cannot be doubted that the painting is indeed a Bathsheba.[59] For on that fragment appears the iconographically indispensable figure of King David. Nevertheless, any study of the iconographic tradition of the scene of David and Bathsheba—a very common subject in illuminated psalters, appearing generally in front of the sixth psalm—shows that the Stuttgart Bathsheba by Memling is a very unusual rendering of the subject.[60] Traditionally, Bathsheba is seen in a garden, either in or near a fountain or near a brook; she is often accompanied by one or two maids (or ladies), but they are standing in such a way that no obstacle is placed in the field of vision of David, who watches the nude figure from an open window. Occasionally he is shown handing to a messenger the letter which will summon the lady to his castle.[61] The only exception to this traditional pattern that I have been able to find (after checking about thirty-five examples in late medieval manuscripts) occurs in a miniature of a thirteenth-century manuscript in the Morgan Library (Ms. 638, fol. 41), where Bathsheba is shown taking her bath in a wooden tub, inside a building, accompanied by a maid-servant who carries water to her in a pail (Fig. V.11). Both figures are placed in a wide open window so that King David, looking on from the other side, has no trouble seeing the bathing beauty; indeed, he is gesturing commandingly to his servant to hasten the delivery of his message.[62]

Thus, Memling's placing of Bathsheba inside a house, while rather unusual iconographically, is not completely unknown in renderings of the scene before. Yet there are still features which make it, to say the least, a most extraordinary representation of the story. The very point of the narrative lies in the fact—a fact never disregarded in previous and contemporary renderings—that David was able to see Bathsheba as she took her bath: "and from the roof he saw a woman washing herself" (II Samuel 11:2). In Memling's picture Bathsheba, first of all, is not in the bath but leaving it; the "maid" is not assisting her as she washes herself but is holding up for her a white shift into which Bathsheba is slipping with great eagerness. Moreover, the maid's position, the placing of the shift, and the distance of both figures from the window make it practically impossible for David to get a glimpse of the nude woman; nor should we overlook the fact that over the large tub from which Bathsheba is emerging there is a kind of canopy which hid her while she took the bath beneath it. If Memling had nothing else in mind but the illustration of the story of David and Bathsheba, he certainly did his best to make it as unlikely as possible.

The whole case loses its strangeness, however, and indeed becomes fairly intelligible if we assume that besides being a Bathsheba, the picture was also the rendering of a marriage bath. The very precaution of the woman to remain unobserved, which makes it so exceptional as a Bathsheba scene, becomes meaningful if we consider the painting as the record of a ritual marriage bath; the white shift into which she is gliding is then the symbol of her new state of purity, and the prominence which is given in the picture to this object need not be explained as an emphasis on "genre" features. The same holds true for the introduction of a bed, which appears behind the canopied bathtub, and which has a more

appropriate place in the framework of a marriage ceremonial than in the context of the David and Bathsheba story, even though it ultimately played a role in that, too.

Perhaps more eloquent than any of the features quoted so far is one that we observe in the Chicago fragment. David, who is accompanied by a young attendant, is not holding a letter: in his left hand he holds a beautiful ring. While rings were often given to messengers as credentials[63] its prominence here suggests an additional meaning. If we interpret the picture as a reference to a marriage, and the main action as a marriage bath, the ring takes its place as the traditional symbol of fealty which the bridegroom gives to his bride in a legitimate wedding.

It might be asked why it was necessary to disguise a marriage bath by fusing it with the Bathsheba theme. The reason lies, most likely, in the function of the Stuttgart panel. It is a very large piece and there is little doubt that it formed originally the wing of a triptych; indeed, on its back there is still painted a figure which is frequently found on the outside of wings: an Eve, from a rendering of the Fall of Man. The style of this figure, however, is much later, dating it into the late sixteenth or early seventeenth century. Still, it may replace an earlier rendering of this subject, now lost.

A marriage bath as part of a religious triptych would obviously have been impossible; even a Bathsheba is a very unusual subject in this connection and it is not quite easy to say what scenes may have been rendered on the other panels. On the architecture represented in the Stuttgart panel, outside the window and below the alcove on which David appears, one recognizes the figures of Abraham raising his sword in the gesture of the Sacrifice of Isaac, and Moses with the tablets of the Law. Both figures—stressing most likely the idea of obedience to God's word—reinforce the character of the scene as one belonging to a religious context. The left wing (Bathsheba most surely was the right wing of the triptych) probably also contained an Old Testament subject. The center panel, on the other hand, would more likely have carried a subject from the New. There is, however, no typologically sanctioned relationship between a New Testament story and the Bathsheba incident.

The assumption that in Memling's picture we have a marriage bath in the disguise of a Bathsheba story tends to solve to some extent the iconographic difficulty of the picture. The wish to have a record of the ritual bath helps to explain the use of the biblical narrative which otherwise would hardly have appeared in such a place and on such a scale. In the combination of the two themes, the Bathsheba story itself had to be transformed to suit the emphasis on chastity which is entailed in the concept of the marriage bath. Indeed, it was only by joining the two subjects that they could be employed in the context of an altarpiece. Without the identification with a biblical character, the lady about to be married could never have been shown on this spot; conversely, the story of Bathsheba would not have been a fit subject if it had not been dignified by the elements proper for a marriage bath.

There arises, of course, the question, whether Jan van Eyck's lost painting was not a Bathsheba, too. If Memling could show the bath of Bathsheba in an interior, so could

have Jan van Eyck. Yet, this theory must be abandoned for the simple reason that one of the essential figures in the Bathsheba story is missing: there is no King David, and without him one cannot recognize the biblical narrative in pictures of bathing ladies. Unless one assumes that the painting in Van der Geest's collection originally was part of a diptych with the figure of King David on the other half, it cannot be interpreted in any other way than has been done above. The diptych theory is all the less acceptable as David would have had much too prominent a place—not to mention the fact that no such diptychs are known or are likely to have existed. On the other hand, there probably were other renderings of marriage baths which were depicted in terms of the Bathsheba story. Cranach's *Bathsheba* of 1526 in Berlin might very well be such a picture.[64] The two chief figures in that painting have such striking portrait character that one might hope to identify them with historical personalities; there was an engagement in 1526 between John Frederick the Magnanimous of Saxony and Sibyl of Cleves, but they were married only in 1527; besides, their features as we know them from other paintings are none too close to those of David and Bathsheba in the Berlin panel. It is likely, nevertheless, that one must look for the persons rendered among the high nobility, just as Memling's painting—if it is indeed the record of a wedding—must refer to an event in the highest layer of the Burgundian court society. The thorough fusion of the private and the public, the secular and the sacred spheres is certainly quite characteristic of these social circles.

There is one object in Jan van Eyck's marriage bath which deserves an additional comment. It is the mirror, which appears, although in a different shape and place, also in the Arnolfini picture. The mirror in that picture had primarily the function of showing the two witnesses who were present at the wedding, one of which was Jan van Eyck. It had to be placed in the center of the composition, between the two newlyweds, in order to accomplish this. Yet this compositional prominence lends to the mirror another role: it becomes itself a *witness* whose magic eye sees all the figures in the room and all their actions at the very moment in which they occur. In the Arnolfini picture, which renders the marriage *vow*, the mirror reflection of the solemn action is surrounded by scenes of the Passion—which provide a fitting framework for an event of sacramental character. The marriage *bath*, while no less solemn, could do without the religious allusion but it, too, had to be reflected in a mirror—a chaste and silent *witness* of the bride's act of purification.

If, then, these two pictures originally belonged together, we have to consider how they may have been combined. They could have formed pendants, existing independently although in close proximity to each other. It is not likely that they were hinged together to form a diptych. The most plausible arrangement seems to me that the marriage bath formed originally the cover of the Arnolfini panel. Such an arrangement is known to us from the Holzschuher portrait by Dürer in Berlin, which formed the bottom of a shallow box; a cover, equally painted, although not with a narrative scene, could be slid off and on by virtue of grooves in the side of the box.[65] If Van Eyck's marriage bath was painted on such a cover, it was probably on its underside, so that its face was normally down.

In the first record that we have of the Arnolfini picture, the inventory of the paintings of Margaret of Austria, made up in 1516, it is said that the arms of Don Diego de Guevara were "en la *couverte* du dit tableaul."[66] A marginal note, quoted by Brockwell, speaks of the addition of a fastener,[67] hence this cover is probably the same as that mentioned in the inventory of 1523 as "a deux feulletz" (or "con dos puertas"). In other words, the wedding bath was no longer connected with the Arnolfini picture at that time, although the presence of a cover is in itself highly significant. There is no proof, at any rate, that the cover of the sixteenth-century inventories was the original one. Indeed, the fact that these wings had the arms of Guevara on them argues against this assumption. We are thus free to consider the possibility that there existed another cover which was replaced by the wings with Don Diego de Guevara's coat of arms. The replacement of the original cover by a new one at the time the painting left the hands of Giovanna Cenami (who had survived her husband and who died only after 1489) makes much sense if we assume that it was the wedding bath which formed this original cover. Indeed, it may have been Giovanna herself who removed it and thus separated the two pictures. She may even not have been displeased by the thought that the very identity of the lady who was shown in the picture in that intimate moment might thus be lost to posterity. She could hardly have foreseen, though, that later generations would interpret the record of her chaste ablution in the presence of a friend (might this friend have been Margaret van Eyck?) as a picture painted for the pleasure of lustful eyes.

ADDENDUM (1957)

The foregoing study was finished substantially in 1951; since then Grossmann's interesting article on Cornelis van Dalem (mentioned above in footnote 26) appeared in which attention is called to the fact that Jan van Eyck's picture in the Van der Geest collection was later in that of Pieter Stevens and was sold with it on August 13, 1668; more important, still, Grossmann reprinted *verbatim* the text of the auction catalogue of 1668, which had never been published before. Since it is of great interest for the thesis presented in the previous paragraphs, this entry is here once more repeated: "De Jean van Eyck, num. 3. Le Bain très renomé, en lequel van Eyck a depeint le Pourtraict de sa femme nue et vétue, laquelle Piece a méritée autrefois avoir place dans le Cabinet du Duc Urbain Frederic II, selon le récit de Charles van Mander, Louys Guicciardini, & Vasari." The most important information that we gather from this catalogue entry is the fact that in the seventeenth century the painting was unquestionably accepted as a work by Jan van Eyck. That it was identified with the picture formerly in Urbino is easily explained since the only early source which had given a detailed description of that picture, Fazio, was evidently not known. The identification of both figures with Margaret van Eyck, however, is again of considerable interest. It projects into the fifteenth century a thematic idea which we associate more readily with Goya than with Jan van Eyck, but which evidently seemed to be not implausible

to a connoisseur of the seventeenth. While hardly acceptable, it proves at any rate that the clothed figure was not taken to be simply a maid, but that her lady-like character, on which part of my previous demonstration depends, was not lost on an observer who was still considerably closer to the times of Van Eyck than we are. And in calling her Jan's wife, the writer of the catalogue of 1668 may still have been repeating, however garbled, a tradition which had some truth in it. Even without knowing this text, I had toyed with the tempting idea that, just as Jan had been a witness at Arnolfini's wedding, Margaret had been the witness and assistant at Giovanna's solemn act of purification.

New light was thrown recently also on the personality of Catherina van Mokerborch (or Mockenborch) (see above). In his last will, made on July 11, 1637, Willem van Haecht left to Cornelis van der Geest some objects in silver and "the largest gallery-picture (*constcamere*) painted by the testator." Another gallery picture, with the story of Joseph and Potiphar's wife, he willed to Joris van Mockenborch. To Catherina van Mockenborch, his aunt (*moeyken*—a term which could also mean stepmother, or godmother, but in this context almost certainly signifies aunt), he left an annual income of forty guilders and a diamond ring, both of which should go, after her death, to his niece, Barbara Daep (see Leo van Puyvelde, "Willem van Haecht en zijn *Galerij van Cornelis van der Geest*," *Belgisch Tijdschrift voor Oudheidkunde en Kunstgeschiedenis*, XXIV, 1955, p. 159). Willem van Haecht's father, Tobias Verhaecht, the first teacher of Rubens, had indeed been married to a Susanna van Mockenborch, who—on the evidence of this will—was apparently the sister of Catherina van Mockenborch, the housekeeper of Van der Geest. This being so, Van der Geest's interest in Willem van Haecht is easy enough to understand—just as much as the prominent place accorded to Catherina van Mockenborch by her grateful nephew in the painting of Van der Geest's Gallery.

That this gallery picture was indeed the same one that Van Haecht willed to Van der Geest in 1637, as Van Puyvelde assumes, is not quite certain, though. Strictly speaking, the largest "*constcamere*" by Van Haecht is the painting in the Mauritshuis at The Hague (see above, note 18) which measures 105 × 149.5 cm., while the picture in the Rubenshuis measures 99 × 155 cm. It is not too likely anyhow that the painting which summed up Van der Geest's artistic and social activity, and in doing so assumed a unique place in the history of gallery pictures, should have entered his collection only through the bequest of its painter.

POSTSCRIPT (1979)

The stimulus for the foregoing paper had come from my observation of an unidentified portrait of Cornelis van der Geest in a painting at the St. Gommarus church in Lier. It gradually encompassed other aspects of Van der Geest's connection with the arts and artists of his time; the results of my studies were first presented in a public lecture given in Antwerp on January 25, 1953. Subsequent to the publication of my paper in 1957, other

studies have appeared (notably those by A.J.J. Delen and F. Baudouin[1]), but I, too, continued to be intrigued by the problems posed by Van Haecht's painting, and I am using this opportunity to make known some additional data pertaining to the theme of my 1957 paper.

One observation made by me soon after the publication was that the drawing depicting *Apelles Painting Campaspe in the Presence of Alexander the Great*, placed conspicuously on a table in the foreground of Van Haecht's picture, is still extant. Signed "Johan Wiricx inventor 1600," it belongs now to the Museum Mayer van den Bergh and it was subsequently published, on my urging, by J. de Coo, the curator of the museum (Fig. V.12).[2] De Coo recognized that the drawing had apparently belonged to Philips van Valckenisse, the father of the well-known and homonymous secretary of the city of Antwerp, in whose inventory it is described as "Figuere van naecte vrouwe die wtgeschildert wort met andere personagien" (the figure of a nude woman who is being painted, with other persons)—a good enough description of the drawing by someone (the notary P. Fabri) obviously unfamiliar with the subject.[3] De Coo's conclusion, however, that the drawing was "evidently made to be engraved" is hardly justified, since it was one of fifteen pieces in the collection of Van Valckenisse listed under the heading "Constige stucken gemaect by Jan Wiericx, metter pennen" (Artful pieces made by Jan Wiericx with the pen). In other words, it was made to be appreciated as a "Federkunststück"—a category of drawing "introduced in the Netherlands by the brothers Wierix"[4] and made most famous by the large-scale drawings of Goltzius. Another of the "constig" pen drawings in the collection of Van Valckenisse depicting Diana and Actaeon ("Figure van Acteon ende van naecte vrouwen op fontaine") turned up seven years later in the inventory of the estate of Nicolaas Cornelis Cheeus:[5] "Een schilderye gedaen metter pennen by Hans Wiericx, van Acteon ende Diana in ebbenhouten lysten."

There is reason to assume that Van der Geest acquired other items, too, when parts of the Van Valckenisse estate were offered for sale. (Some parts of the large estate were surely inherited by Van Valckenisse's son.) This may be true, for instance, for the "Twee gesneden manstronien in palmenhout in eben lysten" (two heads of men carved in palmwood, framed in ebony), since two such objects are seen on a table near the window in Van Haecht's painting; it would be a strange coincidence if two different pairs of such relief carvings of heads framed in ebony had been in Antwerp collections. (Needless to say, only relief carvings would be framed!)

While I had emphasized that Van der Geest had a strong preference for painters of the Antwerp school, I had not found a work by Otto van Veen among those depicted. Baudouin correctly pointed out that the *Last Supper* (41) was a work of that master,[6] and to this I am now tentatively adding the painting *Vulcan Forging the Armor of Achilles* (14). The subject is a relatively rare one in Flemish art,[7] yet a composition depicting Vulcan as blacksmith is twice listed in the inventory of Van Valckenisse, both times as a copy after Van Veen: "Een Vulcanus smedende gedaen na Octavio" and "Een Vulcanus op doeck, na

Octavio."[8] Van der Geest may have owned Van Veen's original, although one should not categorically exclude his having purchased one of the versions from Van Valckenisse's estate.

There are, in fact, other works that most likely came from this source. One is the still unidentified *Vision of St. Peter* (34) since this subject, too, was in Van Valckenisse's collection: "Schilderye van Sinte Peter siende tvisioen."[9] The older collection was particularly rich in paintings by Gillis Mostaert, among them both an original version and a copy of a *Flight into Egypt*.[10] The better one of the two may well be the hitherto anonymous *Flight into Egypt* in Van Haecht's painting (19); and Mostaert may also have been the author of the landscape with a burning city (39), a subject in which Mostaert specialized. We must always keep in mind, though, that some of these items may have been acquired by Van der Geest after they had gone through another collection; thus in the inventory of Jacques Snel (January 21, 1623) there is listed "Een stuck schilderye, Vlidinge van Egipten, met een blau binnenlyst ende buytenlyst, van Mostaert."[11] Even the Dürer engraving of a flagbearer (B. 87) placed next to Wiericx' drawing may have come from Van Valckenisse's collection, which contained a remarkably large group of prints by Dürer. That it is exhibited side by side with Wiericx' drawing may well be in recognition of the deceptively skillful copies Wiericx had made of Dürer's prints.

My old article can be amplified in some minor points. A painting of Venus and Cupid, probably the very same that stands in the center of the table in Van Haecht's picture, was for some time in the Van Berg collection in New York; and two small bronzes of rearing horses, like those seen just above the painting by Seghers (25) were in the M. Garbáty collection in White Plains, attributed to Tacca.

One curious fact, never commented upon, seems to be worthy of mention. Not only did Van der Geest not own a work of Jordaens, who by 1628 had been active for about fifteen years, but he was clearly not included among the artists present. To a man of the refined sensibility of Van der Geest, Jordaens' earthy art may well have been unacceptable.

As regards the personages assembled in Van Haecht's painting, my suggestion that they were divided by social rank as well as by profession or avocation has met with general approval; it also prompted Baudouin to identify the bearded man near the window looking at a sculpture by Giovanni da Bologna as Hans van Mildert, whose presence indeed one has a right to expect since Van der Geest patronized this prominent sculptor; his features are known from an engraving by Lucas Vorsterman, based on a portrayal by Van Dyck. My tentative identification of the man pointing at Petel's sculpture of Venus and Cupid with Petel himself has been confirmed by Schädler[12] as well as by Baudouin. The latter also pointed out that the presence of Van Dyck among the visiting dignitaries can easily be explained by the fact that by the time the picture was painted Van Dyck had received the title of court painter, just as had Rubens before him.

It was clearly too much to hope that Jan van Eyck's *Marriage Bath* would ever be found, and it has indeed not. Yet a curious piece of evidence has turned up—a small but clearly old copy of the lost painting. In the early 1950s it belonged to an English private collector

and was seen by Carl Nordenfalk (to whom I owe this information) when it was in the studio of Hans Hell, the restorer, in London. It is now in the Fogg Art Museum, Harvard University (Fig. V.13). It is unfortunately in a badly damaged condition but appears to be a most faithful copy of the lost original, to judge from a comparison with Van Haecht's record of the picture. In fact it might perhaps be more correct to say that the reliability of Van Haecht's copy is substantiated by the Cambridge panel, which certainly was copied from Van Eyck's original.

The most interesting and rewarding results of my later studies were related to the personality of the man who occupied the center of my interest, Cornelis van der Geest. What had hitherto been known about him had been summarized by A.J.J. Delen, who had evidently not done any archival studies of his own but had relied on previously published material, as I had myself in the 1957 article. It is to Delen's article that Baudouin referred in his study of the collection of Van der Geest.

In 1958 I took the opportunity of an unfortunately limited stay in Antwerp to conduct researches in the archives of the City of Antwerp. Examining the volumes recording real estate transactions, I obtained a good idea of the extent to which Van der Geest was involved in the purchase and sale of either actual real estate or of rental income based on such.[13] These were obviously preferred methods of investment, along with moneylending and occasionally even selling paintings. In connection with these studies I found that the year of Van der Geest's birth had been given wrongly in all previous publications. As recently as 1977, Baudouin still wrote that Van der Geest was born in 1575, "two years before his friend Rubens."[14] Yet Van der Geest was actually twenty-two years older than Rubens, having been born in 1555! According to a document of September 28, 1618,[15] Van der Geest and Jan-Baptista de Vos had received in 1617 from Tobias and Guilliam Verhaecht forty-two landscape paintings in oil, thirty with religious and twelve with secular subjects. Together with other merchandise they were sent to Ostend to be shipped to a Flemish businessman in St. Lucar and Seville. The Spanish buyer, Roman Perez, however, not only refused to take them at the price requested but also died soon thereafter, and in the document of 1618, Van der Geest and De Vos request the return of the pictures. These are the ages given of the four men involved: Tobias Verhaecht, about fifty-seven years old (he was, in fact, born in 1561); Willem (Guilliam) Verhaecht, twenty-five years old (he was born in 1593); Jan-Baptista de Vos, aged twenty-nine, and Cornelis van der Geest: sixty-three years old! It always had appeared to me unlikely that the man who had been one of Rubens' great patrons and was responsible for the first major commission Rubens received for an Antwerp church should have been hardly older than Rubens himself. Nor is this the only document that moves Van der Geest's birth back twenty years. As early as February 5, 1586, Van der Geest bought a rental income of 125 Karolusgulden on the house "Den Paternoster" in the Braderijstraat, and similar transactions involving real estate followed in 1593 and 1594. And still earlier, on September 7, 1583, Niclas de Ram, "koopman," and Jan van Wesenbeke, "notaris," declared that Cornelis Ver Geest [sic], son

of Jacques van der Geest and Margriet Pepersack, a young merchant, a bachelor of good reputation, and a native of Antwerp, had always been established and lived in Antwerp except that "some months ago" he made a trip to Spain for his affairs, but that he has never abandoned his Antwerp domicile since he has most of his merchandise in that city. It is obvious that such a document could not refer to a boy ten years old.[16]

If Van Dyck painted the London portrait of Van der Geest before he left for Italy, as is generally assumed,[17] the picture thus portrays a man of about sixty-five years, surely more in accord with his appearance in the painting than if he had been a man of forty-five or even forty-three (if one takes the date Martin gave of Van der Geest's birth—1577— the same as Rubens'!). He looks still older in the Stockholm drawing which Van Dyck probably made during his second Antwerp stay, in preparation for the project of the *Iconography*. (I should like to say in passing that Van der Geest probably played an active role in the genesis of Van Dyck's *Iconography*.) The trip to Spain undertaken in 1585, perhaps not the only one he made to that country, accords well with what we know about Van der Geest's business activities. The source of his wealth was the market dealing in the broad range of colonial produce. Relying on various historical studies, Baudouin gave a fairly comprehensive list of all the products imported and distributed by the so-called *kruydeniers*.[18] We know that Rubens' family was closely associated with the Antwerp traders of this commodity: his great-grandfather Pieter Rubens had been *kruydenier*, and his grandfather Bartholomew "apothecary," that is, a dealer in spices who also was entitled to dispense pharmaceutical products. To this must be added some rather involved but highly significant family relationships. After the early death of her husband, Rubens' grandmother Barbara Arents married Jan de Landmeter, a prominent dealer in spices for whom this also was a second marriage. From his first marriage, to Catharina Vervloet, De Landmeter had a daughter who married another *kruydenier* (also referred to as *olieverkooper*) Jan van Mockenborch; and one of the daughters of this marriage, Susanna, married Tobias Verhaecht and became the mother of Guillaume (Willem) van Haecht, the painter of the picture under discussion. It is worth noting that Tobias Verhaecht was evidently distantly related to Rubens—something we may call a "step-cousin" —which may help to explain why he was chosen to be Rubens' first teacher. Van der Geest, finally, was not only a member of this apparently closely interwoven circle of dealers in colonial produce by virtue of the nature of his business; he, too, had family ties with it. His mother Margriet Pepersack (a name hinting at forebears dealing in spices) was a stepsister of Elisabeth van de Vloet, or Vervloet, who in turn was surely related to Catharina Vervloet, the first wife of Jan de Landmeter and the grandmother of Tobias Verhaecht. In one document (September 27, 1594) recording the purchase by Van der Geest of a piece of land from Lanceloot van der Vloet, another member of that family, he is said to be the seller's nephew. He also willed 200 guilders to each of the daughters of Andries Vervloet, deceased, evidently another member of the family, although how he was related to Van der Geest, or the other heirs by that name, I do not know.[19]

In the light of these many cross-connections between the families of Rubens, De Land-meter, Van Mockenborch, Vervloet, and Van der Geest, involving in almost every generation second marriages of women as well as men (Rubens himself was twice married and had children from both wives), Cornelis van der Geest appears to us a peculiarly touching figure. Eminently successful as merchant, esteemed in professional organizations, renowned as collector, and generous as patron of artists, this pious bachelor projected outward, so it seems, the interest and warmth he might have lavished on a more intimate family circle. Without children of his own, he apparently assumed a fatherly role for many, among them the two greatest painters his beloved city of Antwerp had produced. Van Dyck left us his likeness, and it is a masterpiece. But no finer tribute to this remarkable man could have been paid than the inscription his greatest protégé put on the print he dedicated to his memory, quoted at the beginning of this study. Unparalleled in Rubens' writings, these words express a deeply felt affection and—beyond the grave—his lasting gratitude.

The widely accepted identification of the personages in Jan van Eyck's London double portrait with Giovanni Arnolfini and Giovanna Cenami has been rejected by Peter H. Schabacker in a study published in the *Art Quarterly*, 35, 1972, pp. 375-398. According to him, the marriage performed in the London panel is a morganatic one, meaning that the bride must have come from a social background inferior to the groom's—a condition which certainly would not apply to Giovanna Cenami, whose family was at least as distinguished as that of Arnolfini. (Morganatic marriages had certain restrictive legal consequences for the offspring and the administration of the estate.) Schabacker's chief, in fact his only, evidence is the joining of the groom's left hand to the right hand of the bride, which indeed is reminiscent of the procedure in morganatic marriages, commonly referred to as "left-handed marriages." Yet fascinating though this thorough discussion of morganatic marriages may be, little of it seems to me to be pertinent to or to reinforce Schabacker's basic proposition. By putting the entire emphasis on the joining of the hands (the *fides manualis*), Schabacker gives hardly any recognition to the groom's raised hand (the *fides levata*), the position of which appears to have been of particular concern to the artist: of the several changes of plan revealed by infra-red photography, the most substantial and in the context of the action most significant concerned the attitude of that hand. It appears that the artist took care to replace a rather casual gesture with one more clearly expressive of the sacred commitment of the matrimonial vow. In view of the evident concern the artist (and presumably his patron) had for the importance of the *fides levata*, a rather simple thought might help to explain the admittedly unusual (but by no means unique) joining of the groom's left hand with the bride's right. If the artist had rendered a conventional *junctio dextrarum*, the groom would have been forced to raise his *left* hand in his matrimonial vow—and *that* would indeed have been contrary to any tradition and legal practice, still in force today when any oath ritual opens with the phrase "raise your

right hand." To return to Van Eyck's picture, it seems that the position of the joined hands had indeed been modified so as to make clear that a degree of precedence was given to the groom's raised hand. The hands joined do not meet in an actual clasping; the young woman lays her hand trustingly and *palm up* into the hand of the bridegroom.

In his *Early Netherlandish Painting*, Panofsky already made a reference to H. Rosenau's study of 1942 in *Apollo*, XXXVI, 1942, pp. 125 ff., which had pointed out that "the somewhat unorthodox motif of the bridegroom's grasping the bride's right hand with his left is not infrequent in English matrimonial slabs" (Panofsky, p. 439, note 3 to p. 202). Thus neither the organization of the picture nor the pictorial traditions furnish compelling reasons to abandon the concept of a marriage between "ebenbürtige" partners. Yet there are, in fact, arguments against the interpretation of Jan van Eyck's work as depicting a morganatic ceremony. As Schabacker himself is aware, the practice of morganatic marriages was well known in, but also largely limited to, Germanic countries. He does not quote a single instance known of a morganatic marriage contracted in the Netherlands (or for that matter in France or Italy) in this period (or even later). Moreover, one wonders whether the performance of a morganatic marriage, legally a permissible but socially a less than creditable act, was ever formally depicted; and yet the author expects us to accept the thesis that it was here recorded by the most prominent artist of his country, in a painting of exquisite beauty, replete with subtle symbolism and historical references. Faced with the choice of taking Jan van Eyck's masterpiece as the record of a marriage between a socially prominent (although surely not aristocratic) man and a woman socially his inferior, or as the somewhat unorthodox, if perfectly understandable, portrayal of a marriage between social equals, I suspect that most people will prefer the second of these alternatives. And in that case nothing need prevent us from continuing to speak of it as the Arnolfini double portrait, even if we remain aware, with Martin Davies, former Keeper of the London National Gallery, of the likely, if still somewhat hypothetical, nature of the identification of the models with Giovanni Arnolfini and Giovanna Cenami.

In a subsequent article ("Jan van Eyck's Woman at her Toilet: Proposals Concerning its Subject and Context," *Fogg Art Museum Annual Report*, 1974-76, pp. 56-79), Schabacker denied that there was any connection between the London double portrait and the painting known from Van Haecht's picture of the collection of Van der Geest. In so doing, he stresses what I think are minor differences between the two interiors depicted, while playing down their obvious similarities. (He may be right, however, in thinking that the carafe in the hand of the clothed woman contains oil to anoint the body of the nude one, rather than water as I had stated in my article, and that the object in the other hand is not a fruit but some kind of equipment used in that procedure.) Instead he identifies the subject as the *Toilet of Judith* (*Vulgate*, X, 2-3), though he is aware of the fact that no other rendering of that subject is known from the fifteenth and sixteenth centuries. (With D'Hulst he assumes that it occurs in a drawing by Jordaens.) Judith's ablution, at any rate, was incidental to a complete change of clothing, as she took off the gown of goat's

hair and her widow's vestments (*abstulit a se cilicium, et exuit se vestimentis viduitatis suae*), placed a turban on her head, dressed herself in the vestments of her youth, putting on sandals, bracelets, clasps, earrings, rings, and adorning herself with all her jewelry (*imposuit mitram supercaput suum, et induit se vestimentis jucunditatis suae induitque sandalis pedibus suis, assumpsitque dextraliola, et lilia, et inaures, et annulos, et omnibus ornamentis suis ornavit se*). Yet in Van Eyck's presumed rendering of this incident there is a reference to neither the harsh widow's dress Judith took off nor the splendid apparel she put on. Realizing that "the context and function" of such a painting is "even more baffling than its subject," Schabacker proposes that it was painted for the private bathroom of Isabella of Portugal, made ready in 1430 in the Prinsenhof in Bruges prior to the arrival of the princess whom Philip the Good married in that year. Schabacker admits the hypothetical nature of his thesis; yet he apparently was not disturbed by the idea that Philip the Good ordered for the private rooms of his young bride a painting extolling a heroine who, after having washed herself and dressed fashionably, proceeded to cut off the head of the man whom she had first dazzled with the splendor of her appearance.

A still more radical reinterpretation of the London panel has been published by Zdzisław Kępiński ("Jan van Eyck: 'Małżeństwo Arnolfinich' czy 'Dawid i Betsabe,' " *Rocznik Historii Sztuki*, X, 1974, pp. 119-164, with a complete English translation). Considering the length and intricacies of Kępiński's text, I can offer no more than a brief comment on its main thesis.

Applying an admirable theological learning and a sophistication in argument worthy of a medieval scholar, the author concludes that the London picture depicts David's "second visit" to Bathsheba (II Samuel 24: "And David comforted Bathsheba his wife, and went in unto her, and lay with her: and she bare a son and he called his name Solomon: and the Lord loved him"). Aware of the portrait-like features and the contemporary dress of the couple, Kępiński explains them by suggesting that the picture renders not only a biblical scene but is also a self portrait of Jan van Eyck with his wife; he translates the inscription *Johannes de eyck fuit hic, 1434* as "Such was Jan van Eyck in 1434." The painting formerly in Van der Geest's collection, according to Kępiński, also depicts Bathsheba as she takes a bath; he identifies the white object lying on a chest at the left as the letter sent by David. (I remember it as a comb.)

The Arnolfini picture, admittedly, is unique in Flemish fifteenth century art, though some light, I believe, is thrown on it by Petrus Christus' painting of 1449 in the Lehman Collection. In presenting his startling thesis, Kępiński did not come to grips with the simple question why, and for what purpose, Jan van Eyck would paint himself and his wife in the guise of King David and Bathsheba, here extolled, as he thinks, as the ancestors of Christ. Nor does he say in what manner the "other" Bathsheba panel might have been connected with the London painting. Despite the author's great learning and the many interesting theological points he makes, I find his thesis basically improbable and still prefer by far Panofsky's rational explanation.

NOTES

1. London, National Gallery, no. 52. Panel, 37.5 × 32.5 cm. The picture was recently cleaned and later additions which had made it into a half-length figure were removed. [See now Gregory Martin, *National Gallery Catalogues, The Flemish School, circa 1600-circa 1900*, London, 1970, pp. 34-37.]

2. See E. Geudens, *Het Hoofdambacht der Meerseniers*, Antwerp, 1903-1904, passim. Van der Geest was a *Kruidenier-grossier*, that is wholesale merchant, in spices and other colonial products, one of the most lucrative branches of mercantile activity since the Middle Ages. The varied information contained in this book was not used in the last biographical sketch on Van der Geest to be published, the one by Florus Prims, in "De Zondagsvriend," March 11, 1937, p. 299. [For Van der Geest's age, see Postcript to this article.]

3. P. Rombouts and T. van Lerius, *De Liggeren*, Antwerp, 1872-1876, I, p. 579. Several other Antwerp citizens appear from the beginning of the seventeenth century as what may be called lay members of the artists' guild. In 1602, we find Peeter Peetersen, "Liefhebber der scilderyen"; in 1607, Jan Cooymans, "coopman ende liefhebber der scilderyen"; and in 1618, A. Loemans, "kunstliefhebber." Cornelis van der Geest is first mentioned in 1621-1622 and then regularly until 1627. He paid six florins as his annual dues, and variously two or four florins for the annual meal, depending on whether or not he attended. While the term *liefhebber* does not occur in guild records before 1600, it clearly refers to a social type which is of older origin. Vasari, in speaking for instance of Matteo Giustiniano, calls him "amatore de queste arti" (Milanesi, VII, p. 455); in 1582, Stradanus dedicated a series of prints, engraved by P. Galle, to "D. Iacobo Rauwardo, Summo picturae admiratori." We probably can assume that these men, like Van der Geest, were art collectors and patrons. One should keep in mind, however, that the phrase occurs in 1520 in the signature of an artist! Scorel signed the Obervellach altarpiece with this unusual statement: "Joannes Scorel hollandius pictorie artis amator pingebat anno a virginis partu . . . 1520" (Max J. Friedländer, *Die altniederländische Malerei*, XII, Leyden, 1935, pp. 124-126, and no. 298). It would be interesting to study the question whether the *liefhebbers* were also *marchands amateurs*; another question which could be investigated is when the term *amateur* was first applied to this social group, and when it acquired its present connotation, which is similar to "dilettante."

4. See Max Rooses and Charles Ruelens, *Codex Diplomaticus Rubenianus*, I, Antwerp, 1907, pp. 295-297.

5. "D. Cornelio van der Geest virorum optimo et amicorum vetustissimo suoque ab adolescentia perpetuo Fautori Artisque pictoriae summo dum vixit admiratori monumentum hoc aeternae amicitiae quod superstiti destinarat defuncto L.M.D.D.Q. Ex tabula Walburgensis Ecclesiae cuius ipse praecipuus Author et promotor fuit." See A. Rosenberg, *Die Rubensstecher*, Vienna, 1893, p. 138, note.

6. Franchoys Fickaert, *Metamorphosis ofte wonderbare Veranderingh' ende Leven vanden vermaerden Mr. Quinten Matsys Constigh Grof-Smit, ende Schilder binnen Antwerpen*, Antwerp, 1648.

7. [Formerly] collection of Mr. and Mrs. S. van Berg, New York [now Rubenshuis, Antwerp]. The painting is signed and dated 1628 on the picture in the center foreground showing *Danaë and the Shower of Gold*. While the signature is valid for the whole painting it claims specifically the Danaë picture for Van Haecht. See notes 18 and 19 below.

8. G. van Vugt, *St. Gummarus Autaer in de oud Collegiale Kerk te Lier*, De Vlaamsche School, 1865, p. 127, and A. Bergmann, *Geschiedenis der Stad Lier*, Lier, 1873. No mention of the altar is made in Stan Leurs and Jan Albert Goris' *Lier*, Ars Belgica, III, Antwerp, 1935, nor is it reproduced in this sumptuous work.

9. See Martin Konrad, *Meisterwerke der Skulptur in Flandern und Brabant*, Berlin [c. 1928], and T. Leyssens, "Hans van Mildert," *Gentsche Bijdragen tot de Kunstgeschiedenis*, VII, 1941, pp. 83 ff.

10. See F. Lugt, *Inventaire général des dessins des écoles du Nord, Ecole flamande*, Paris, 1949, I, no. 670, p. 64.

11. See Otto Baron de Reinsberg-Düringsfeld, *Calendrier belge*, Brussels, 1860-1862, II, p. 208.

12. This was probably the same Jan Junius de Jonge, a militant Calvinist and follower of William of Orange who, as burgomaster of Antwerp, made an unsuccessful attack on 's-Hertogenbosch in 1581. See A. J. van der Aa, *Biographisch Woordenboek*, IX, Haarlem, 1860, p. 245.

13. Of works dating from before 1580 still preserved in St. Gommarus, two very fine panels with the figures of Saint Sebastian and Saint Dymphna have not yet received proper attention. They have been attributed to Michiel Coxie and reproduced as works of this master by Leurs and Goris, *Lier*, pl. 79. Actually, they are signed with the characteristic monogram of Crispijn van den Broeck and dated 1573. They form an important addition to the work of this artist, hitherto far too little appreciated.

14. See Max Rooses, *Jordaens' leven en werken*, Amsterdam, 1906, p. 243.

15. According to the inscription on the altar, Elizabeth van Immerseel had given large gifts to the poor of Lier in 1507. She is presented as a model of charity, and the rich are admonished to follow her and thereby literally to "purchase paradise." The biographers of Otto van Veen (Z. von Manteuffel, in Thieme-Becker's *Künstler-Lexicon*, and L. van Puyvelde, in *Biographie Nationale de Belgique*) were unaware of Van Veen's presence in Lier or of the fact that the date

of the altar is known. For the chronology of Van Veen's work, this date is of considerable importance.

16. See Rombouts and Van Lerius, *Liggeren*, pp. 461-465, and G. van Vugt, *St. Gummarus*.

17. See also B. Stockmans, *Magistrat en Schependom der Stad Lier*, Lier, 1902, p. 72.

18. Besides the painting in the [Rubenshuis], three other gallery pictures have been attributed to Van Haecht: one, formerly in the Cremer Collection in Dortmund, known as the *Studio of Apelles* (J. Denucé, *Konstkamers*, Antwerp, 1932, p. 11), contains a number of works from Van der Geest's collection and has also the same *Danaë* by Van Haecht in the foreground; a somewhat larger variant of this theme is in the Mauritshuis in The Hague (Catalogue 1914, no. 266); the last one, attributed—less convincingly—to Van Haecht by S. Speth-Holterhoff (*Apollo*, Brussels, March 1942, p. 16) is in the collection of Mrs. Hardcastle, Hawkhurst, Kent.

19. For earlier literature on this picture, see Henri Hymans, *La Chronique des Arts*, March 1907, p. 99; E. Dillon, *Athenaeum*, London, January 1907, p. 109; W. Martin, *Bulletin van den Oudheidkundigen Bond*, 1908, p. 33; Gustav Glück, "Ein Studienkopf von Quentin Metsys," *Die Graphischen Künste*, XXXIV, 1911, p. 1 (reprinted in Gustav Glück, *Aus drei Jahrhunderten europäischer Malerei*, Vienna, 1933, with notes by F. Winkler, p. 325); F. Winkler, "Über die Galleriebilder des Willem van Haecht und Barent van Orley," *Mitteilungen aus den sächsischen Kunstsammlungen*, VII, 1916, p. 35; Gustav Glück, *Van Dyck, Des Meisters Gemälde*, Klassiker der Kunst, London, 1931, pp. xxi-xxii; Mary van Berg, *The Van Berg Collection of Paintings*, New York, 1947, pp. 14 ff.; *Pictures within Pictures*, exhibition catalogue, Hartford, Wadsworth Atheneum, 1949, no. 22. I am greatly indebted to Mr. and Mrs. S. van Berg for their most generous help in preparing this article and for providing me with a number of special photographs.

20. Regarding the date of this visit, one finds in the literature both August 15 and August 23, depending upon whether the authors relied on Van den Branden's *Geschiedenis der antwerpsche schilderschool*, Antwerp, 1883, or Fickaert, *Metamorphosis*. I owe to M. de Maeyer the information that August 23 is the more likely date since Albert and Isabella arrived in Antwerp only on August 15. (Since this was written, M. de Maeyer has published the results of his studies in his book, *Albrecht en Isabella en de schilderkunst*, Brussels, 1955.)

21. Friedländer, *Die altniederländische Malerei*, VII, no. 67, assumes that because of certain variations between the *Madonna* by Massys, now in Amsterdam, and the one appearing in Van Haecht's picture, there must have been another version which is no longer traceable. Since Van Haecht, as we can test in many cases (see for instance note 46), is highly reliable, and since Friedländer was able to

point out two copies after Massys which seem to have been derived from the "lost" version, his assumption is probably correct.

22. Friedländer, *Die altniederländische Malerei*, VII, no. 78. Van Haecht worked either from the Louvre version or one close to it, and not from the copy by Rubens in Brussels.

23. See P. Génard, *Anvers à travers les âges*, II, p. 512, with engraving by H. Brown. The text added in the seventeenth century reads: "Connubialis Amor de Mulcibre Fecit Apellem." The tombstone with a Flemish inscription, a skull, and three bare shields of the Guild of St. Luke is also shown. This stone had been in Van der Geest's house ever since the removal of the old monument from the small cemetery of Notre-Dame, in 1617.

24. Generally referred to as *Kelderke*, this crypt was dedicated to St. Peter and St. Paul (which may explain some of Rubens' interest in the church of St. Walburgis). It is not certain that its location corresponded with the actual crypt of St. Walburgis herself. Nothing remains today of either church or crypt, since the whole area was rebuilt in the early nineteenth century (see J. Linnig, *Album historique de la ville d'Anvers*, Antwerp, 1868, p. 35).

25. See Henri Hymans, *La Chronique des Arts*, March 1907, p. 99. Van der Geest may have owned Vincidor's original (which had been painted in October 1520 and then taken to Italy) or more likely a seventeenth-century copy of it. Such a copy, formerly given to Rubens, but now attributed to Van Dyck (canvas, 29¼ × 23¼ inches) was exhibited with the Duke of Bedford's collection at the Royal Academy of Arts in London in 1950 (E. K. Waterhouse, *Catalogue of an Exhibition of Paintings and Silver from Woburn Abbey*, lent by the Duke of Bedford, 1950, p. 17, no. 43. It did not figure in the Bedford sale of January 1951). The painting is known to me only from the text of this publication (which was brought to my attention by J. G. van Gelder), the author of which appears to be certain that it was this very picture which figured in Van der Geest's collection.

26. The Bruegel painting is also known from a drawing in Munich (see Charles de Tolnay, *P. Bruegel l'Ancien*, Brussels, 1935, p. 93, no. 44, fig. 192). Like other pictures of the collection of Van der Geest, this work, too, was later in the collection of Pieter Stevens. For the Van Dalem, see now F. Grossmann, "Cornelis van Dalem Re-examined," *Burlington Magazine*, XCVI, 1954, p. 42. This painting, too, was later in Stevens' collection.

27. That Massys was also highly appreciated in Antwerp in the late sixteenth century can be seen from the incident in 1577 when Marten de Vos successfully intervened in the threatened loss of Massys' large *Lamentation* in the Cathedral (see Carel van Mander, *Das Leben der niederländischen und deutschen Maler*, trans. H. Floerke, Munich, 1906, I, p. 139). See also Denucé, *Konstkamers*, p. 28, and below, note 38.

28. This panel, cut down at the top, is now [1957] in the collection of Mrs. Mary van Berg, New York.

29. Winkler made the suggestion that the *Portrait of a Man in Armor* (11) was copied from a lost Rubens. It has been overlooked so far that this picture still existed in the early eighteenth century when it was fully described in the collection of the Duke of Orléans (*Description des tableaux du Palais Royal dédiée à Monseigneur le Duc d' Orléans*, Paris, 1727, p. 206). It had earlier been in the possession of "Mylord Melfort." Strangely enough, it was at that time listed as a work of Jordaens, and it is cited as such in Rooses' book on that master (Antwerp, 1906, p. 297). The attribution to Rubens is more likely, however. The main figure seems to have been derived from Titian's portrait of Francesco Maria della Rovere, Duke of Urbino, Uffizi. (After completing this article I learned that the painting still exists in the collection of Lord Spencer at Althorp.) [1979: Actually there are two versions of this composition in existence; see this author's forthcoming catalogue of the seventeenth-century Flemish paintings in the Detroit Institute of Arts.]

30. The *Annunication* (21) is also still extant; I found it in the treasury of the St. Servatius Cathedral, in Maastricht. A painting similar to (36), but in reverse, is in St. Paul's, Antwerp. I owe a photograph of that picture to the kindness of Mlle E. Havenith.

31. *Judith Killing Holofernes* (17) is now in the collection of the Duke of Wellington, Apsley House, London (Heinrich Weizsäcker, *Adam Elsheimer, der Maler von Frankfurt*, Berlin, 1952, p. 100). *Ceres and Stellion* (23) is identical with the painting of this subject by Elsheimer in the Prado Museum (Catalogue, no. 2181). Both paintings are listed in Rubens' estate (Denucé, *Konstkamers*, p. 58, nos. 32 and 35). Rubens must have acquired them after 1628, when they were evidently still in Van der Geest's collection; he most likely bought them from Van der Geest's estate in 1638. It is, of course, quite possible that Van der Geest had made the original purchase on Rubens' advice, or even through him; in 1611, Rubens had expressed his regret that not a single painting by Elsheimer was in Flanders, and he suggested that Elsheimer's widow send a picture to Antwerp "where there is an infinite number of people who appreciate little things"; he also expressed his willingness to help her with all his might, even to the extent of making a down payment to her no matter whether the particular painting (a *Flight into Egypt*) was readily sold or not (letter to Johann Faber, January 14, 1611; see Max Rooses and Charles Ruelens, *Correspondance de Rubens et documents epistolaires*, VI, 1909, pp. 327-331). The *Last Judgment* (33) is now in Munich (Catalogue, 1936, no. 43; the painting is signed and dated 1598); the small painting of *Venus and Cupid* (?) on the table (28) might also have been a painting by Rottenhamer, to judge from its style.

The *Portrait of a Man in Armor* (2) is found also in the *Studio of Apelles* (see note 18); according to Wilhelm Suida (quoted in the exhibition catalogue at Hartford, see note 19) it is probably a work of D. Mancini, now in the Mauritshuis, at The Hague. The *Portrait of a Woman* (35) has been called a work of B. Licinio, which is probably correct. *Christ at the Mount of Olives* (20) may have been by Bassano.

32. Small bronzes by Giovanni da Bologna and his school were exceedingly popular objects with dealers and collectors—and with artists!—in the seventeenth century (see E. Tietze-Conrat, "Giovanni Bologna's Bronzes as Painters' Cribs," *Gazette des Beaux-Arts*, XXXI, 1947, p. 31). Several of them are listed in inventories (see Denucé, *Konstkamers*, p. 35, estate of Nic. Cornelis Cheeus, who died in 1621 and whose bronzes may have been acquired by Van der Geest; p. 135, estate of Jan van Meurs: "een Peerdekeh ent een stierken van Jean de Boloigne," etc.). See also J. Denucé, *Art Export in the 17th century in Antwerp*, Antwerp, 1931, pp. 241-252.

33. Among the copies done by a Rubens pupil which are now in the print room of the Copenhagen museum are two drawings in red chalk (Box III, figs. 85-86) which evidently reproduce the same group of *Venus and Cupid* as the one that formed part of Van der Geest's collection. According to K. Feuchtmayr (Gustav Glück, *Rubens, Van Dyck und ihr Kreis*, Vienna, 1933, p. 402), this group was a work of Jörg Petel; a small version in ivory, signed "Iorg Petle F., was reproduced in the *Burlington Magazine*, LIII, 1928, p. 249.

34. The Nero bust can be identified on the basis of Pontius' engraving of 1638, made from the design of Rubens (see Frank van den Wijngart, *Inventaris der rubeniaansche prentkunst*, Antwerp, 1940, no. 556).

35. Glück, *Rubens, Van Dyck und ihr Kreis*, p. xxii, identified the lady to the left of Rockox as Anna Maria de Camudio, the wife of F. de Boisschot (his figure 311). This identification is most doubtful; not only has the lady quite different features, but also her portrait by Van Dyck was not painted before 1630. As we have no evidence that Van Haecht made portraits independently, we would have to postulate an earlier portrait by Van Dyck of Anna Maria, an assumption which hardly seems justified.

36. The text of this unpublished document was transcribed for me by Prof. Dr. F. Blockmans, archivist of Antwerp. I am indebted to Mlle Havenith for obtaining it for me.

37. The name "Van Mockenborch" appears several times in the records of the merchants' guild; a Joris van Mockenborch was a dealer in colonial goods (*kruidenier*), like Van der Geest, and Catherine van Mokerborch may have been a relative of his and thus herself a member of a prominent family. See E. Geudens, *Meerseniers*, passim, and the postscript at the end of this article.

38. Pieter Stevens was one of the three executors of the

will of Van der Geest, and he seems to have been one of his closest friends. It was he who owned the famous *Madonna* by Massys after Van der Geest's death, together with two other works by or attributed to this master, a *Game of Cards* and a *Moneychanger with His Wife*. See Fickaert, *Metamorphosis*, p. 15; Fickaert's book was actually dedicated to Stevens. (See also Postscript.)

39. For the derivation of Watteau's signboard of Gersaint from Flemish gallery pictures, it may not be without interest that there is in that work also the motive of a kneeling figure examining a picture in the right half of the composition (observation by E. Panofsky).

40. *Rubens, Van Dyck und ihr Kreis*, p. xxii. For Paul de Vos' portrait, see Glück, 123, and Lommelin's engraving in Van Dyck's *Iconography*.

41. A. Rosenberg, *P.P. Rubens: Des Meisters Gemälde*, Klassiker der Kunst, Stuttgart, 1906, p. 58.

42. See the engraving by Pontius and the corresponding portrait by Rubens in the Metropolitan Museum, New York (Jan-Albert Goris and Julius S. Held, *Rubens in America*, New York, 1947, no. 27). The painting by Van Haecht was based on the Rubens portrait before it was changed by repainting.

43. This identification can be made on the basis of Pontius' engraving for the *Iconography* (Wibiral 42) and the portrait of Van Balen on his tomb in St. Jacques, Antwerp.

44. There still remain seven men and one woman whose features have not been found in paintings or prints, and—including these—eleven persons in all whose names still elude us. There are, in addition, two boys who are holding Massys' *Madonna*. It may be no more than an accident that they are standing in front of Rubens, but there is a remote possibility that they are meant to represent Rubens' two sons. The page in the left foreground is simply copied from the figure of Louis XIII as he appears in Rubens' *Coronation of Maria de' Medici* in the Louvre.

45. [For the location of Van der Geest's house, see A. Thys, *Historiek der Straten en openbare Plaatsen van Antwerpen*, Antwerp, 1893, frontis. Mlle E. Havenith, who had been helpful in the original research concerning Van der Geest's house, also brought to my attention a drawing, discovered by Prof. Couvreur, depicting a section of the old Antwerp quais which includes a view of Van der Geest's house (Fig. V. 7). The rear view of the house, as seen from the projecting area of the old *Werf*, gives a good idea of the impressive size of the building. Although a projecting wall hides a section at the extreme right, it was clearly a broad two-story building of eight window axes, two of which belong to a central section marked also by a high gable. A curious feature is a broad bay jutting forward from the lower story but with a floor level evidently considerably below that of the room behind it. As with other buildings fronting the river, the living quarters of Van der Geest's

house were protected against floods by a solidly constructed and windowless ground floor. The drawing confirms the statement that the Scheldt river must have been visible through the windows at the west. Yet it also provides sufficient evidence against the assumption that the room as rendered by Willem van Haecht may correspond to a "gallery" actually in Van der Geest's house. It is clear from the drawing that the house could not have had a room with three rows of high windows, as seen in Van Haecht's panel. Van der Geest's collection was probably dispersed all over the building, as was indeed the rule in other houses of Antwerp collectors. (I owe the permission to reproduce the drawing to Prof. Couvreur.)]

46. Another version of Vrancx's *View of Antwerp* is in the collection of Mr. and Mrs. S. van Berg, New York. It shows virtually the same view but an examination of Van Haecht's copy leaves no doubt that it was the Amsterdam version which he had before him.

47. For this and the following see especially Linnig, *Album historique*, A.J.J. Delen, *Iconographie van Antwerpen*, Brussels, 1930, and Geudens, *Meerseniers*, pp. 125 and 137.

48. See W. H. James Weale, *Hubert and John van Eyck*, London, 1908, pp. lxxiii and 175. S. Speth-Holterhoff, "Une Oeuvre disparue de Jean van Eyck," *Apollo*, Brussels, October 1941, p. 7, actually did identify Van der Geest's picture with that described by Fazio, a theory which is difficult in view of Fazio's detailed description. For this problem, see also Erwin Panofsky, *Early Netherlandish Painting*, Cambridge, 1953, I, pp. 361, note 25, 362, note 3.

49. F. Winkler, *Die altniederländische Malerei*, Berlin, 1924, p. 62: "Jan hat, um erotischen Neigungen seiner Auftraggeber zu genügen, wiederholt Badestubenbilder mit nackten Frauen gemalt, wovon eine Kopie auf einem Galeriebild des W. van Haecht . . . (zeugt)." It should be evident that Van der Geest's picture, whatever it was, was certainly not one of a *Badestube*. Nor does it correspond to the description which Beenken gave of it (*Hubert und Jan van Eyck*, Munich, 1941, p. 78): ". . . ein anderes zeigte eine einzelne Nackte die sich beim Waschen im Spiegel besah" (!). Recently Baldass (*Jan van Eyck*, London, 1952, pp. 84-86) discussed the picture much as Winkler had done: "It was probably painted for some princely patron and was obviously intended for a private cabinet.· Jan's masterly rendering of a female nude in the Ghent altarpiece may have evoked in some connoisseur the wish to possess a similar picture of a profane subject. . . . The patron evidently wanted not only a realistic representation of a female nude but also an equally realistic representation of the milieu." The closest analogy to the nude figure in Jan van Eyck's work, incidentally, is not in the Eve of the Ghent altarpiece but in the small Eve, in grisaille, on the

throne of the *Madonna*, in the altar of Canon van der Paele in Bruges.

50. *Die altniederländische Malerei*, I, 1924, pp. 113-114. Friedländer figured its size to have been about 90 × 60 cm. The measurements of the Arnolfini picture are 84.5 × 62.5 cm. Unfortunately, Van Haecht did not use a uniform scale for his "gallery." In general, he seems to have tended to make small pictures larger and large ones smaller. Baldass, *Jan van Eyck*, pp. 84-86, concluded on the basis of comparisons with other pictures that the lost painting was a little larger than the Arnolfini panel, but no such precise statement is possible. The height of the lost work could have been anywhere between 60 and 90 cm., and there is no reason it could not have been exactly as big as the London painting. It certainly had the same proportions.

51. Erwin Panofsky, "Jan van Eyck's Arnolfini Portrait," *Burlington Magazine*, LXIV, 1934, pp. 117 ff. Needless to say, the wildly arbitrary booklet by M. W. Brockwell, *The Pseudo-Arnolfini Portrait: A Case of Mistaken Identity*, London, 1952, has not produced a shred of evidence against Panofsky's demonstration. See also Panofsky's discussion in *Early Netherlandish Painting*, pp. 201-203 and passim.

52. While there is no exact analogy, most of the features of her costume, except perhaps the wide opening of the sleeves, can individually be accounted for in paintings of the period. In view of the great losses among early paintings, it would be rash to argue that because a certain costume feature does not occur in the monuments we know, it could not have existed at the time.

53. M. Conway, *The Van Eycks and Their Followers*, London, 1921, p. 71.

54. See Alfred Martin, *Deutsches Badewesen in vergangenen Tagen*, Jena, 1906, pp. 184 ff., "Das Hochzeitsbad"; also E. Westermarck, *The History of Human Marriage*, London, 1921, II, p. 503. For the ritual bath (*mikwaot*) in Jewish marriage rites, see *The Jewish Encyclopedia*, 8, 1944, pp. 342, 344, and 346 (Marriage Ceremonies). For the form of the ritual, see A. de Gubernatis, *Storia comparata degli usi nuziali in Italia e presso gli altri popoli Indo-Europei*, 2nd ed., Milan, 1878, p. 139; also Westermarck, *Marriage*, p. 503; and Martin, *Badewesen*, pp. 102 and 187. City ordinances of Nuremberg of the thirteenth and fourteenth centuries limit the number of bridesmaids to four (Martin, *Badewesen*, p. 184). See also A. Schultz, *Deutsches Leben im 14. und 15. Jahrhundert*, Vienna, 1892, p. 261.

55. See Sir James George Frazer, *The Golden Bough*, New York, 1935, II, p. 162; and Westermarck, *Marriage*, pp. 503 and 505.

56. Panofsky, "Van Eyck's Arnolfini Portrait," passim, and *Early Netherlandish Painting*, pp. 131 ff.; Millard Meiss, "Light as Form and Symbol in Some Fifteenth Century Paintings," *The Art Bulletin*, 27, 1945, pp. 175 ff.; and Meyer Schapiro, "Muscipula Diaboli: The Symbolism of

the Mérode Altarpiece," *The Art Bulletin*, 27, 1945, pp. 182 ff.

57. See Panofsky, "Van Eyck's Arnolfini Portrait," p. 102. For literature on the wedding candle, beyond that quoted by Panofsky, see Westermarck, *Marriage*, pp. 509 ff.; *Handwörterbuch des deutschen Aberglaubens*, VI, p. 152, and J. Schrijmen, *Nederlandsche Volkskunde*, Zutphen, 1930-1933, I, p. 291.

58. Baldass, *Jan van Eyck*, pp. 72, 85. Baldass considers the Stuttgart picture as one "derived" from the lost Van Eyck.

59. Friedländer, *Die altniederländische Malerei*, VI, 1928, p. 132, no. 97. The missing piece of the Stuttgart picture measures 27.8 × 20.3 cm., while the dimensions of the Chicago fragment are 25.4 × 19.7 cm. Moreover, the present insert of the Stuttgart panel, while transforming the setting from a colonnaded alcove to a large open terrace, shows King David in much the same way as he appears in Chicago. Whoever painted the insert evidently still had the original piece before him as model.

60. See G. Kauffmann-Gradmann, *Die Stuttgarter Gemäldegallerie*, Kassel, 1921: "Ein rätselhaftes Bild."

61. See, for example, the *David and Bathsheba* from the Hours of the Virgin, early sixteenth century, formerly in the collection of Mrs. Ethel Clarke, London, Fig. 13A in the original version of the present article.

62. This rendering of Bathsheba taking a bath near a window gains special interest in view of the fact that the Knight of La Tour-Landry in his famous book on feminine morals, written in 1371, tells the story this way: "This Bersabe dvelled before the paleis of Kinge David, and, as she kembed her hede atte a wyndow, the kinge perceived her. And she was right faire marveylously in every beauute . . ." (T. Wright, *The Book of the Knight of La Tour-Landry*, London, 1868, rev. ed. 1906, chap. LXXVI, p. 99). It is likely that the Knight based his version of the story on some such picture as that in Morgan Ms. 638, although the change from Bathsheba bathing to combing her hair may be his own variation on the biblical theme. At any rate both he and the illustrator of Morgan Ms. 638 stressed the fact that Bathsheba was easily visible from outside.

63. See T. Wright, *A History of Domestic Manners and Sentiments in England*, London, 1862, pp. 267-268.

64. See Max J. Friedländer and Jacob Rosenberg, *Die Gemälde von Lucas Cranach*, Berlin, 1932, p. 61, no. 173.

65. See *Beschreibendes Verzeichnis der Gemälde*, Berlin, Deutsches Museum, 1931, no. 557e. The original frame as well as the sliding cover (with the arms of the Holzschuher and Münzer families, as well as the date MDXXVI) are still preserved.

66. Weale, *Hubert and John van Eyck*, p. 70.

67. Brockwell, *The Pseudo-Arnolfini Portrait*, p. 37.

NOTES TO POSTSCRIPT

1. A.J.J. Delen, "Cornelis van der Geest, een groot figuer in de geschiedenis van Antwerpen," *Antwerpen*, V, no. 2, 1959, pp. 57-71. Frans Baudouin, *Rubens et son siècle*, Antwerp, 1972, pp. 191-203 (reprinted in *Pietro Pauolo Rubens*, trans. Elsie Callander, New York, 1977, pp. 283-301). (A study by N. de Poorter, of 1971, listed in the bibliography given by Baudouin in this publication, is not recorded in any bibliographical aid and could not be located in the United States.)

2. J. De Coo, "Nog Cornelis van der Geest, een tekening uit zijn verzamelingen, thans in het Museum Mayer van den Bergh," *Antwerpen*, V, 1959, pp. 196-199.

3. See Denucé, *Konstkamers*, p. 15.

4. E.K.J. Reznicek, *Die Zeichnungen von Hendrick Goltzius*, Utrecht, 1961, I, p. 77.

5. Denucé, *Konstkamers*, p. 30.

6. *Rubens et son siècle*, p. 294. The painting by Simon de Vos which Baudouin calls "A Merry Company" is actually depicting the parable of the Prodigal Son; on the frame of that picture four other scenes of the parable are depicted: the son taking leave from his father, chased from the bawdy house, guarding the swine, and welcomed by the father on his return.

7. Other examples dealing with that subject are known by Frans Floris and Hendrick de Clerck, as well as Maerten van Heemskerck. None of them resembles the picture reproduced by Willem van Haecht.

8. Denucé, *Konstkamers*, pp. 21 and 24.

9. Ibid., p. 20.

10. Ibid., pp. 23 and 25.

11. Ibid., p. 37.

12. Alfred Schädler, *Georg Petel, 1601/02-1634: Kritischer Katalog* (together with Karl Feuchtmayr, *Gesammelte Aufsätze*), Berlin, 1973, no. 4, pp. 85-87.

13. *Schepenregisters*, "Coopers en Comparanten." After locating the transactions in which Van der Geest was involved I received in 1959 summaries of the proceedings from Prof. Dr. F. Blockmans, archivist of the Stadsarchief. I have in my own files 156 summaries of such transactions, far too many to be discussed here, although one of them (see below) is of the highest importance for our knowledge of the great collector and art patron.

14. *Rubens et son siècle*, p. 286.

15. *Schepenregisters*, no. 530, F. & R. III, f310 recto.

16. For the transaction of 1586, see *Schepenregisters*, no. 386, M. & N. II, f63 verso-64 recto; for the declaration of 1585 see *Schepenbrieven*, no. 384, f45 verso. In the face of this incontrovertible evidence about the true age of Cornelis van der Geest, I am unable to explain how Delen, in his article in *Antwerpen* of 1959 (see above, note 1) could state that he was born on June 10, 1575; not only does Delen fail to cite any evidence for this date, but he also adds that "some maintain the year was 1577" (somigen beweren 1577), thus admitting himself an element of uncertainty about the correct date.

17. Gregory Martin, *National Gallery Catalogues: The Flemish School circa 1600-circa 1900*, London, 1970, p. 35.

18. *Pietro Pauolo Rubens*, pp. 40-41. In view of Van der Geest's interest in the Spanish trade, it is likely that he played an active role in the discussions about the gift, offered on September 1, 1612, by the Antwerp magistrate of Rubens' painting of the *Adoration of the Magi* (painted in 1609-1610) to Don Rodrigo Calderon, Conde de Oliva, a native of Antwerp and Ambassador Extraordinary of Spain. There had been considerable opposition to this donation on the part of the Antwerp merchants (*Meersche*), but they were outvoted and—possibly to mollify them—the gift was justified by the insertion in the document of the phrase that through this gift "de stadt soude mogen bekomen den stapele vande specerijen ende andere goeden uuyt Spagnien comende" (the city would become the principal market for spices and other goods coming from Spain).

19. The most generous individual donations—1000 guilders each—in Van der Geest's will were for his "stepsister" Margriete van Immerseel, wife of Adam Rademaecker; Catlijne van Immerseel, wife of Andries Hecx; Elisabeth van Immerseel, wife of Cornelis de Licht; the children of Anna van Immerseel; and Jan van Immerseel. The bulk of the estate was to be divided into three parts, to be given to Cornelis de Licht, Cornelis Hecx, and Adam Rademaecker, referred to as "his cousins." As executors he appointed Cornelis de Licht and Pieter Stevens. The will is preserved in the Stadsarchief, Notarissen, 2276, F. Ketgen, 1636-1642, f262 verso-265 verso.

LE ROI À LA CIASSE

WITH the *Mona Lisa*, the *Sistine Madonna*, and the *Nightwatch*, the portrait of Charles I in the Louvre belongs to that handful of pictures with which virtually everybody is familiar (Fig. VI.1).[1] It has been reproduced endlessly, from the engravings of the late eighteenth century to the halftones of modern schoolbooks. It appears with the same monotonous regularity in treatises on the history of England as in books on Flemish art. Charles Sterling called it, with a polite bow to Fromentin, "perhaps the most beautiful portrait by Van Dyck,"[2] and Mme Bouchot-Saupique spoke of it as "une des plus parfaites expressions de la peinture de toute une époche."[3] One should certainly expect that all the aspects of the picture had been thoroughly explored and that little is left for the modern critic except to share in the universal admiration which the portrait seems always, and deservedly, to have enjoyed.

Surprisingly, the literature on this famous work is rather skimpy. Although the picture has been described many times, these descriptions, by and large, are brief and sometimes misleading, and there are some questions that have never been asked at all.

In the present study I want to discuss some aspects of the interpretation of the work, to make suggestions as to its meaning and possible sources, and to indicate tentatively what may have been the reasons for its enduring popularity. No new contribution will be made to its date, generally accepted as 1635. No new finds have been made in archives. The considerable effect which the picture has had on contemporary and later artists such as Dobson, Sustermans, Quellinus, Carreño, Reynolds, Gainsborough, Goya, C. W. Peale, and even Prud'hon would form the theme of a separate and different investigation.

W. H. Carpenter was the first to identify the painting with one called "Le Roi à la Ciasse" and listed in a memorandum of 1638, presumably drawn up by Van Dyck himself.[4] Although this identification has never been formally challenged, it has not been accepted

Reprinted by permission of *The Art Bulletin*, XL, 1958, pp. 139-149.

by *all* writers. Charles Blanc makes no reference to it;[5] he describes Charles as "promenading in the woods." Guiffrey quotes the title but then goes on speaking of "the elegant simplicity of everyday dress."[6] Fromentin, Heidrich, Friedländer, Delen, Robb, Waterhouse, and Baldass completely ignored the old title,[7] as do most authors of books and catalogues on the collections of the Louvre.[8] M. Rooses put the words "Le Roi à la Ciasse" into quotation marks and parentheses,[9] thus indicating that he considered it a traditional label without serious significance. Michiels was the first to make use of the identification suggested by Carpenter, and his description, one of the longest in the literature, deserves to be quoted in full:

> It appears as if the monarch had lost his way during the hunt and, tired from a long ride, and not knowing where he was, dismounted from his horse. Two pages behind him hold the noble beast. The trees at the edge of the forest spread their shadows over the group. In the distance one sees the waves of a tranquil sea and a boat that moves away with full sails. The features of the hapless monarch express the moral weakness and the martial courage which formed in him such an interesting mixture. He looks at the beholder in an exquisite attitude, the right hand resting on the pommel of a large cane, the left hand on his hip. One might say that the artist foresaw the flight of the monarch and the hours of anguish which he had to pass at the shore of the Channel searching with his eyes for a vessel of rescue which could take him to France. Alas! the winds carry away that last hope. The sails become smaller and will soon disappear in the haze of the horizon.[10]

With the last passage Michiels alluded to an eighteenth-century opinion according to which the Louvre canvas illustrates the flight of Charles I. In the print of the painting that accompanies a chapter in F. A. David's *Histoire d'Angleterre*, the picture is actually entitled "Charles I. se sauve d'Amptoncourt."[11] Realizing that it was hardly possible for Van Dyck, who had died in 1641, to depict an event that took place in 1647, Michiels admitted that the old view had been erroneous. Yet he evidently could not free himself from sentimental associations caused by his knowledge of the later events of the king's life.

A reference to the king's fate indeed is one of the leitmotifs in descriptions of the Louvre canvas. Charles Blanc had struck this note when he said of his promenading gentleman that he carried with himself "sa mauvaise fortune et ses rêveries,"[12] a mood extending to the horse of which "l'oeil morne et la tête penchée *semble se conformer à sa triste pensée.*" Even the old notion of Charles' flight echoed in Blanc's text when he spoke of the ship which approaches the shore "comme pour emmener un fugitif." (In his description of the Windsor portrait, Blanc described Charles' face "serious and melancholy as always" and continued: "I do not know if the knowledge of history contributes to it, but one is persuaded to distinguish in the pallid features of this prince harbingers of his tragic destinies.")[13] Louis Gillet found Charles' expression in the Louvre painting both "rayonnante et triste."[14] Schaeffer, although taking a stand against romantic extremes, felt nevertheless that the

king looks "mit nachdenklicher Melancholie in die abendliche Landschaft."[15] Glück, too, describes Charles as looking out from the picture "mit fast trauriger Miene."[16] For Fierens-Gevaert, Charles was a "souverain nostalgique,"[17] and Delen climaxed it all when he said: "Ces yeux tristes et ces lèvres minces et austères disent tout le mystère de l'angoisse dévorante, du sombre pressentiment dans l'âme de ce roi fastueux mais malheureux qui bientôt [!] devrait expier sa faiblesse par la mort."[18]

The "gloomy" school of interpretation of the Louvre canvas (and occasionally of other portraits of Charles by Van Dyck) is too persistent a phenomenon not to require an explanation. Delen's phrase "ces yeux tristes," indeed, is strangely reminiscent of a famous line in Robert Browning's *Strafford* (II, 2) where Charles is described as "the man with the mild voice and the mournful eyes." Browning's image of the physical make-up of the king was probably derived from many portraits, the one in the Louvre surely among them; yet it is more than likely that he visualized him with "mournful eyes" because his mind was conditioned by two factors: one was the pervasive tendency of Romantic poetry and art to see a special beauty, if not a mark of distinction, in a melancholy bearing. Géricault's melancholy artist (Paris) and Delacroix's troubled Michelangelo (Montpellier) are as characteristic for this trend as Byron's *Sardanapalus* or Matthew Arnold's *Empedocles on Etna*.[19] The second factor, bearing more specifically on the theme of Van Dyck's portrait, was the revival of a tendency to stress Charles as a tragic figure.

It may be useful to remember that from the moment of his trial and execution Charles had been portrayed in diametrically opposed patterns. Those who were in sympathy with the Commonwealth referred to him as a tyrant who had fully deserved his fate. But to those who abhorred democracy and felt that monarchy was the only guaranty of a lawful government, he became the "Royal Martyr" (or the "blessed," or "glorious" one) and his execution—in the often repeated words of Edward Hyde, first Earl of Clarendon—the "execrable murder."[20] Five churches were dedicated to "King Charles the Martyr," and, in December 1660, Parliament passed a bill ordering the annual observation of his death as a day of fasting and penance.[21] The services of the day were printed in the Book of Common Prayer where they remained until 1859.

During the latter part of the eighteenth century the controversy had quieted down, but in the early nineteenth there was a strong revival of interest in the problems of the English revolution and the figure of Charles I. Various factors combined in this development. One was evidently the French Revolution, which again posed the problem of royal absolutism and popular representation, and in which again a legitimate monarch had been executed. One of the leading historians, and eventually a most powerful politician, François Guizot (1787-1874), whose father also had been a victim of the guillotine, published the first two volumes of his *Histoire de la Révolution d'Angleterre* in 1826-1827. In his preface he frequently coupled the two revolutions, discussing their similarities and differences and summing up with the significant statement "that the first would never have been thoroughly understood had not the second taken place."[22] Although he aimed at an objective view, his basically

conservative attitude (which after 1830 made him "the most determined foe of democracy")[23] is easily noticed in his account. He strongly attacks George Brodie, the author of a *History of the British Empire*, who "fully participates in all the prejudices, distrust, and anger of the bitterest puritans . . . while, to the faults and crimes of his party, he is wholly blind."[24] Guizot's detailed and often moving account of Charles' ordeals, trial, and death quickly became the standard text for Continental as well as English readers.[25]

Two years after Guizot's book there appeared the first volume of a five-volume biography of Charles I by Isaac D'Israeli, the father of the future Prime Minister.[26] D'Israeli, too, criticizes earlier historians unfriendly to Charles, among them Brodie ("a Scotch covenanter") and Mrs. Macauley ("a commonwealth lady") whose *History of England* had appeared in the years between 1763 and 1783 and had been partially translated into French by Mirabeau. For D'Israeli, Charles is a figure of tragic dimensions, comparable to the classical Oedipus.[27] There is more than rhetoric in his words when he sums up his introduction by saying: "Humiliated by fortune, beneath the humblest of his people, the King himself remained unchanged; and whether we come to reproach, or to sympathise, something of pity and terror must blend with the story of a noble mind wrestling with unconquerable fate."[28]

In 1813 the remains of Charles I were discovered in the tomb of Henry VIII in St. George's Chapel, Windsor. An account of this discovery was written on April 11 by Sir Henry Halford, the distinguished physician, and published in 1831;[29] the *New York Mirror* of October 22, 1831, reprinted the text with a woodcut of the king's head, under the heading "Curious Discoveries." Although the corpse was immediately reinterred, a lock from Charles' head was sent like a "relic" to Sir Walter Scott who placed it in his "musaeum."[30] The discovery of Charles' body too, may have contributed to bringing back into focus the pathetic end of the Stuart prince.

For the revival in some quarters of the old cult of Charles I, credit must be given to the growth of a historic Romanticism closely associated with the conservative trends of the age. Scott himself, though not sympathetic to Charles, had helped to make the age of the cavaliers appealing to the imagination (George Borrow called it later the "Jacobite Nonsense" of Scott). Plays about Charles had occasionally been written before, but in the early nineteenth century there was a sudden outburst of such dramatizations.[31] In 1818, Shelley began to think about a play on Charles I, but he left only a fragment when he died in 1822. In 1828 a tragedy about Charles was written by E. Cobham and two years later a German, E. Kaiser, also wrote a *Trauerspiel* with Charles as hero. This was followed in 1834 by a "historical tragedy" about Charles by Mrs. M. R. Mitford, in 1840 by another German *Trauerspiel* by Frans Bermoth, and in 1846 by the Reverend Archer T. Gurney's play *King Charles the First*. If we add to these Browning's *Strafford*, first produced in 1837, we find that in the space of twenty-two years no less than seven tragedies were planned or produced in which Charles figured prominently. After 1850 the number of plays dedicated to Charles' life declined, but six more were written between 1873 and 1908.[32]

Poets and novelists, especially those who for political or religious reasons leaned toward a conservative attitude, revived the very terms under which Charles had been venerated before. When Princess Charlotte died in 1817, Robert Southey devoted to her a *Funeral Song* in which he also evoked the memory of Charles ". . . whose tragic name / A reverential thought may claim. / That murder'd Monarch. . . ."[33] In 1828 (the year in which D'Israeli's book came out) the Reverend John Keble, who is credited with having started the Oxford Movement, added a poem about "King Charles the Martyr" to his *Christian Year*, the incredibly popular book of spiritual poetry that in Keble's lifetime alone saw ninety-five editions.[34] In this poem he apostrophized Charles with the frequently quoted lines: "Our own, our royal Saint"; and the Reverend Mr. Gurney again used the phrase "Royal Saint" in his play. The Tractarians indeed seem to have kept faithfully the solemn annual observation of Charles' death.[35]

How many more pious or sentimental references to King Charles may be found in early and mid-nineteenth century literature is impossible to say. A characteristic example, listed in Amy Cruse's book, is the passage from M. Yonge's *The Heir of Redclyffe* where its hero, Sir Guy Morville, says about the king: "How one would have loved him, loved him for the gentleness so little accordant with the rude times and the part he had to act—served him half like a knight's devotion to his lady-love, half like devotion to a saint."[36] And finally we should not forget the romantic pictures, distributed in innumerable prints, which showed some of the pathetic moments of the king's life, one particularly touching being his taking leave of his children.

Thus we see that in the beginning of the nineteenth century Charles once again assumed in many quarters a tragic and romantic aspect and that the emotional appeal of his fate was further strengthened by the significance his struggle had for the conservative political forces of the period. It is likely, therefore, that the "gloomy" interpretations of Van Dyck's Louvre portrait of Charles, and occasionally of other portraits of the monarch, appearing as they do among art historians shortly after the middle of the century, reflect a climate of opinion that had been formed in various political, literary, and religious circles during the preceding years.

Most modern writers do accept the identification of the king as being at the hunt, no matter how melancholy he may appear to them.[37] At first glance the painting itself hardly justifies this confidence. While Charles' costume is such as could conceivably have been worn by the king when hunting, it is most unlikely that it can be shown to have been worn *only* at such occasions. The evidence seems almost to point in the other direction: a walking cane does not seem to be a proper piece of equipment for a hunter; the silk jacket is rather unsuitable for the rough business of the hunt.[38] The equerry who holds the horse's bridle and the page who carries the king's mantle are surely normal company for a monarch on any outing undertaken on horseback, and nothing in their outfit or equipment

supports the thesis that we have before us an incident of the hunt. There is no reference anywhere to other hunters, to hounds, or to the prey itself. Nor is there any indication that the king has been separated from the rest of the company. Nothing seems to be further from the mind of the monarch, as we see him in Van Dyck's painting, than the pursuit of the stag.

Should we then give up the old theory that the painting in the Louvre is indeed the same picture that in the memorandum of 1638 figures as *Le Roi à la Ciasse*? I do not think so. It is necessary, however, to examine the question from a somewhat different angle.

Considering that it was painted at a time when painting in general, and portraiture in particular, were still apt to follow established patterns—though with variations—the Louvre painting of Charles I represents a rather unusual type. While the picture of a gentleman standing near his horse became common in later times, there are not many iconographic antecedents for Van Dyck's picture. The patterns of courtly portraiture, as found in the works of Titian and Rubens, did not include a formula comparable to Van Dyck's. The picture is not only more informal than the established types of state portraiture, but it also combines elements which were normally not seen together in this way.

Where a horse is present, the model is likely to sit on it; when he is on foot, he may have near him a dog, a member of his family, or a dwarf, but not a horse or a retinue like that seen in the Louvre canvas. A painting by G. B. Moroni, now in the Kress collection, is the only Italian example known to me in which a full-length figure is portrayed with a horse standing near him. Yet the similarity goes no further. The setting is completely different; of the horse, only the head is seen, appearing between the columns at the right. The man is in full armor and his stance is fairly conventional—and quite different from that of King Charles. No reference to Moroni's portrait is found in Van Dyck's Italian sketchbook. It is not very likely that Van Dyck ever saw it; in the genesis of the Louvre portrait, at any rate, it probably had no part.[39]

More important, I believe, is an English picture which exists in two versions, the better of which is in the Metropolitan Museum in New York (Fig. VI.2). (The other is in Hampton Court.) Painted in 1603, it shows Henry, Prince of Wales (1594-1612), at the age of nine standing triumphantly over the body of a dead stag. In the literature about this picture, there is some confusion as to what exactly is shown; one author said it is Henry represented cutting the throat of a stag.[40] Another describes Henry as "drawing" a sword, to cut off the stag's head.[41] Cust sees the prince "about to give the *coup de grâce* to a wounded stag."[42] Helen Comstock[43] and Elizabeth E. Gardner[44] alone of all authors described Henry correctly as sheathing his sword, but Comstock gives a rather fanciful description of the scene and Gardner cannot free herself from the notion of the *coup de grâce* which Henry supposedly has just administered.

To interpret correctly what goes on we only have to read the pertinent passage in the English edition of *Turbervile's Booke of Hunting*.[45] Speaking about "the Englishe manner, in breaking up the Deare" the author says (p. 134):

. . . oure order is that the Prince or chiefe (if so please them) doe alight and take assaye of the Deare with a sharpe knyfe, the whiche is done in this manner. The deare being layd upon his backe, the Prince, chiefe, or such as they shall appoint, commes to it: And the chiefe huntsman (kneeling, if it be to a prince) doth holde the Deare by the forefoote, whiles the Prince or chief, cut a slyt drawn alongst the brysket of the deare, somewhat lower than the brysket towards the belly. This is done to see the goodnesse of the flesh, and howe thicke it is.—This being done, we use to cut off the Deares heades. And that is commonly done also by the chiefe personage. For they take delight to cut off his heade with their woodknyves, skaynes or swordes, to trye their edge and the goodnesse or strength of their arme. {The head is then used to reward the hounds.}

If one examines the picture in the Metropolitan Museum more closely, one sees, although hidden under merciful retouches, a big gash in the deer's neck. This is certainly not a *coup de grâce* for a wounded animal, but a blow inflicted upon the dead deer in accordance with the customs of the hunt. Prince Henry, still a very young boy, after all, is satisfied with having opened by his blow the deer's neck. He is now indeed sheathing his sword, leaving the complete severing of the head to others. That the severing of the head was the ritualistic climax of the hunt of the stag (which in itself was the noblest—and most formalized—of all the hunts)[46] may be seen also from a woodcut in the English translation of Turbervile, here shown from the 1611 edition, where a prince has replaced—on a separate wood block—the princess who figured there originally; this is clearly a reflection of the change from the times of Queen Elizabeth to those of James I (Fig. VI.3). In this woodcut the prince receives from a kneeling gentleman the knife with which he cuts the stag's neck. It is quite possible that this plain woodcut served as the model for the painting of Prince Henry. The kneeling companion holding on to the stag, the horse in the background, held by the prince's equerry, the presence of hounds, and the reference to hunting in the background are sufficient to establish a connection between the works.

As far as I see there is no evidence that there existed a tradition of such hunting portraiture before 1603, which makes the influence of the woodcut on the painting all the more likely; between 1603 and 1635 (if that is the date of Van Dyck's picture) there were painted at least two more works that show variations on the theme of the prince at the hunt. In 1617 Paul van Somer painted his *Anne of Denmark* (1574-1619) at Hampton Court, in which the queen stands in a landscape in front of her horse which is held by a Negro groom; she is surrounded by hunting dogs but she is not herself engaged in hunting.[47] In 1626, George Geldorp painted the portrait of William the Second, Earl of Salisbury, at Hatfield, showing the spurred and booted gentleman in a landscape with a tiny stag hunt depicted in the distance.[48]

References to hunting are found in all these pictures, but they become successively weaker. While they have virtually disappeared from Van Dyck's work, it can still be

considered as a late representation of those portraits "à la chasse." Like them it shows the king on foot, out of doors, in a partly wooded setting. The groom with the horse standing behind the prince was a feature also in the hunting portraits of Prince Henry and Queen Anne. It is perhaps pertinent in this connection to point out that King Charles was the brother of Prince Henry (whose premature death alone forced Charles to take on the burden of rule) and the son of Queen Anne. Their portraits were of course constantly before Van Dyck's eyes. Thus it is easy to understand why he should have referred to his own picture as *Le Roi à la Chasse*, no matter how little it still retained of this context. To a noticeable degree, his painting does continue an established tradition, and the commission may well have specified that the king should be rendered as he would appear at a hunt. However that may be, we must admit that Van Dyck played down the reference to the hunt as an activity involving exercise, manipulation of weapons, and contact with hounds, let alone with dead animals. Instead, he stressed nobility of appearance and princely superiority. In view of these facts, it is appropriate to ask whether there were not other influences which contributed to the genesis of the painting. While the idea of the work may well have been derived from the English portraits discussed before, it is clear that there is no trace of any *formal* dependence. The unmistakable elegance and dignity of the picture—especially as regards the attitudes of, and the compositional relationship between, king and horse—have no parallel in the local tradition.

It has long been observed that for the pose of the horse Van Dyck made use of a motive which he had found in a work by Titian.[49] He drew the horse in one of the most beautiful pages of his Chatsworth sketchbook where it is indeed inscribed with the word "Titian" (Fig. VI.4). His actual source may have been a drawing, as Adriani says,[50] but it could just as easily have been one of the several versions of Titian's *Adoration of the Magi*, examples of which are in the Prado, in the Escorial, the collection of Arthur Sachs, and the Ambrosiana. What precisely the horse is doing in this pose had been interpreted in different ways, such as pawing the ground, licking or rubbing the knee, or chasing a fly; it certainly is not "kneeling down to allow the royal rider to dismount."[51] More important for our purpose is the observation that in Titian's picture the horse's motion is not only suggestive of a homage to Christ paid by the noble creature but that its erstwhile rider, the first king, who kneels in front of it, is evidently a portrait of a sixteenth-century nobleman, though no one, apparently, has identified the model.

Moreover, it has been suggested by Fischel that the pose of the horse is not even Titian's own invention but has a still nobler derivation.[52] It is, indeed, of classical origin. As far as we know, it appeared first on the West Frieze of the Parthenon, where the horse's head nearly touches the ground. Fischel thought that the source for Titian may have been a classical *carneol* such as he found in an example preserved in the Antiquarium in Berlin, in which a single horse is shown in a similar pose. He overlooked another possibility which involves a more readily accessible work. A horse in a very similar pose is attached to

Selene's chariot in sarcophagi illustrating the myth of Endymion.[53] A characteristic example, possibly the very one Titian had studied, was later embodied in the façade of the Casino Rospigliosi, built in 1607.[54] The horse, according to Robert, "impatiently rubs his mouth against his leg, and seems to paw the ground." One could also think that it chafes against the bit. The winged figure acting as groom is called *Aura* by Robert, but other interpretations have also been proposed.

It hardly needs stressing that an artist like Rubens was not likely to pass up a motif which, hallowed through its appearance on classical sarcophagi, had the additional sanction of having been used in a famous composition by Titian. As a matter of fact, the horse bending down appears in several of his compositions: it figures in the *Meeting of Abraham and Melchisedec*, one of the tapestries celebrating the Triumph of the Eucharist, designed for Isabella Clara Eugenia during the years 1625-1627;[55] with some modifications we see it also in the beautiful sketch of Briseis returned to Achilles which recently entered the Detroit Institute of Arts (designed probably toward 1630).[56] The most important example for our purposes, however, is found in one of the scenes of the Constantine cycle, which dates about 1622-1623. It is easy to see that all the main formal elements of Van Dyck's picture already occur in the composition, which is generally called the *Triumph of Rome*. In this composition Constantine stands near the right edge in the role of the victor, followed by his horse and a groom who is holding it. The arrangement of the Louvre canvas is particularly close to the Constantine group as it appears in a sketch formerly in the Cook collection and now in the Mauritshuis at The Hague (Fig. VI.5). I believe it is safe to say that while the general idea of rendering Charles "à la ciasse" came probably from a local tradition, the precise formal pattern was borrowed from Rubens' composition. Van Dyck was surely familiar with it even though he was already in Italy when Rubens painted the sketch. It is, above all, the relationship of the horse to the prince that is strikingly similar, a relationship in which the action of the horse—whatever its functional meaning—has been subtly employed to enhance the stature of the prince. In Titian's *Adoration of the Magi*, the bending down of the horse had only echoed the humble *proskynesis* of its master. With Rubens, and with Van Dyck who followed him, the horse's reverence brings out the grandeur of the monarch. It is interesting to see how Van Dyck developed this idea even further than Rubens had done. Not only the horse but also the attending figures are shorter than the king (who, as we know, was no more than five feet five inches tall). And whereas in Rubens' sketch the emperor is encumbered from all sides, in Van Dyck's canvas Charles stands clearly outlined against the open sky. Overhead, the branches of the trees form a veritable baldachin.

In taking over his basic compositional idea from Rubens' work, Van Dyck must have intended to incorporate into his painting the idea of triumph inherent in this design. Van Dyck's picture is certainly closer to those of military commanders overlooking a battlefield from an elevated vantage point than those of gentlemen taking their melancholy thoughts to the woods and fields. Charles admittedly seems to have little in common in his appearance with Rubens' Roman emperor. Instead of being sheathed in armor he is dressed in soft and

comfortable clothes. Where Constantine held a thunderbolt in his right hand—itself a symbol of apotheosis—Charles holds a cane. Yet in the hand of a seventeenth-century cavalier a cane is more than a mere utilitarian object. As late as the nineteenth century the walking stick distinguished the middle-class gentleman from the lower bourgeois or the worker. It is amusing to see that even though he is sitting down on the ground, one of the picnickers in Manet's *Déjeuner sur l'herbe* still holds onto his cane. Max von Boehn, in his book on accessories of fashion, devoted a whole chapter to the history of the walking stick, a descendant of the rods that are "the earliest symbols of sovereignty."[57] Walking sticks as objects of fashion make their appearance among the dandies of late feudal society, such as Charles V of France and King René. For a long time they remained the exclusive property of the upper classes, gradually becoming objects of great luxury. Costly canes grew fashionable precisely in the early seventeenth century. Louis XIV "never showed himself in public without a cane" and what is more, he put so much stress on this sign of distinction that commoners were forbidden to carry them. In the eighteenth century this rule was relaxed (it had, of course, never applied in other countries) and gentlemen began to make collections of canes. According to von Boehn, Rousseau had forty, Voltaire eighty, and Count Brühl all of three hundred canes, some with matching snuff boxes.

Henry IV of France "seems to have owned the first stick which could be classed as an article of luxury."[58] This is of considerable interest in our connection because it is in a portrait of this king by Rubens that we find one more analogy to Van Dyck's portrait of Charles I. If we compare the Louvre portrait of Charles with Rubens' King Henry in the picture of the Medici series where he receives, and examines with rapture, the portrait of his future queen (Fig. VI.6), we see an undeniable similarity in the way in which each holds a slender walking stick in his extended right hand. The king in Rubens' picture has been divested of his helmet and shield to express the idea that in this moment the power of love supersedes the cares of war (specifically the war Henry was then conducting against Savoy). Yet the presence of the various gods, and especially the personification of France, who, standing behind the king, shares in his admiration, makes it clear that here—as in all parts of the Medici cycle, the hero is rendered not as a private person but as the head of a state.[59] It is evident that in this context a cane that is no more than a walking stick would hardly have been given such prominence.

Charles I was obviously fond of canes, perhaps precisely because they combined conveniently princely dignity with comfort. That he adopted the fashion to wear a cane early may be seen from a portrait of the king by Daniel Mytens, painted in 1629, long before Van Dyck's arrival in London. Now in the Metropolitan Museum of Art, it portrays the king full-length. Although wearing riding boots, he stands indoors near a table on which are placed demonstratively the royal insignia of crown, scepter, and orb. The inscription underscores the formal character of the portrait by citing Charles' full title, not omitting his role as "Fidei Defensor." The king wears a sword at his side, and his right hand rests on a long, slender cane.

Charles' liking for canes as objects befitting both a monarch and a cavalier throws a curious light upon an incident that happened at the very end of Charles' life. From contemporary records in writing, as well as from one version of the painting by Edward Bower,[60] we know that Charles came to his trial carrying a cane (Fig. VI.7). This in itself is highly significant, since it is known that in his behavior Charles stressed deliberately the notion of royal prerogative and refused to recognize the authority of the court. Bower's painting depicts the king with his hat on, in accordance with the records which tell that Charles declined to take it off lest the gesture be construed as a sign of respect toward his judges. In his hand he holds the cane, a slim plain rod with a knob, made, according to most reports, of silver. During the first day of the trial (January 20), when "Mr. Cook, solicitor for the Commonwealth . . . offered to speak . . . the King, having a staff in his hand, held it up and laid it upon the said Mr. Cook's shoulder [another source says it was the arm] two or three times, bidding him 'hold.' "[61] Then, as another witness continues, "the head [of the staff] being Silver happen'd to fall off, which Mr. Herbert . . . stopp'd to take up, but falling on the contrary side, to which he could not reach, the King took it up himself. This by some was look'd upon as a bad Omen."[62] A contemporary magazine reports, after telling that the knob fell off, that "he stooping for it, put it presently into his pocket. This it is conceived will be very ominous."[63] A fourth witness tells "that the King himself thought the accident a bad omen, and that it was suspected that Hugh Peters had tampered with the cane."[64] (Hugh Peters is generally considered to have played a sinister role in the proceedings; he alone of all the regicides made a very miserable figure when he was to be executed in 1660.)

That Charles chose to bring the staff with him in the first place, and that he used it when he tried to stop the solicitor from presenting his charges, is suggestive of the fact that to him the cane represented one of the objects that signified his dignity and commanded respect. Still more revealing is the immediate reaction of all witnesses to the strangely meaningful incident of the falling knob. It surely would have been noticed even if the cane had been no more than an insignificant accessory of dress. But that Charles was disturbed enough to stoop to pick it up; that foul play was hinted at; that practically everyone saw in it an omen—all this seems to reinforce what we have assumed before: that to Charles and his contemporaries the cane was still invested with compelling associations of authority. In the light of what happened a few days later, the incident of the falling knob of a cane took its place among those symbolical portents, those signs in the sky and weird phenomena on earth, which to former ages had announced the doom of great kings.

Summing up, then, one can say that in Van Dyck's portrait of Charles I elements of two types of portraiture of historical personalities have been combined: on the one hand it is derived from the English type of the prince at the hunt, a tradition linked with behavior patterns of Renaissance nobility as embodied in the many treatises on the gentleman and his appropriate pastimes.[65] On the other hand it is connected with the concept of the absolute monarch symbolizing the State and the power conferred upon him as its

head. Charles appears in it both as the *cortigiano* and the *principe*. Indeed, it is the skillful blending of these two different elements that gives to the Louvre portrait its unique character and has contributed to its enduring success. Van Dyck created in it a new iconographic type which was followed by countless imitations. It certainly expresses well— as has always been felt—the character of Charles I, who also aimed at blending the two spheres of the cavalier and the monarch, though with less happy results. The only author who (perhaps without being aware of all the iconographic ramifications) expressed this idea with enviable lucidity is Ernst Gombrich. His one modest sentence is surely far and away the most penetrating comment on the picture that hitherto has been written. The picture, he says, "shows the Stuart monarch as he would have wished to live in history: a figure of matchless elegance, of unquestioned authority and high culture, the patron of the arts, and the upholder of the Divine Right of Kings."[66]

In the oeuvre of Van Dyck, at any rate, the picture represents the high watermark of sensitive historical interpretation. His other portraits of Charles I are much simpler in their meaning and, in general, adopt patterns which had become standard for royal portraiture, such as the equestrian portrait where the horse serves only as a grand base for the elevation of the ruler.

NOTES

1. Louvre, inv. no. 1967 (Inc. no. 1236). Canvas, 272 × 212 cm. Inscribed on a stone at the lower right: CAROLVS · I · REX · MAGNAE BRIT- / ANNIAE · &C; A · VAN DIICK · F. Ex coll.: Comtesse de Verrue; Marquis de Lassay; Comte de La Guiche; Madame du Barry; King Louis XVI (1775). According to Jacqueline Bouchot-Saupique (*La peinture flamande du XVIIe siècle au Musée du Louvre*, Brussels, 1947, p. 70), there exist more than thirty copies of this work. It was engraved by Robert Strange in 1782 (and rendered in many unimportant engravings and wood-engravings afterwards). Strange's engraving bears the following text: "Carolo I.ᵐᵒ MAGNAE BRITTANNIAE REGI, &c./Jacobus Hamiltonius, Marchio ab Hamilton, Sacri Stabuli Comes, adstat./E Tabula Antonii Vandiick Equitis, 8 pedes et 9 digitos alta, 6 pedes et 10 digitos lata, in Pinacotheca Regis Christianissimi conservata. Antonius Vandijck Eques pinxit. Robertus Strange delin.ᵗ atque sculpsit A.D. 1782." As far as I can see, Strange is the first source to identify the equerry with the Duke of Hamilton. On his authority, virtually all writers have accepted this identification. Only Paul G. Konody and Maurice W. Brockwell (*The Louvre*, London, 1905, facing p. 148) identified the equerry with M. de Saint-Antoine. This view is clearly untenable since the attendant in the Louvre portrait is obviously a different person from De Saint-Antoine, whom Van Dyck portrayed in an equestrian portrait of the same kind at Windsor (Gustav Glück, *Van Dyck: Des Meisters Gemälde*, Klassiker

der Kunst, London, 1931, p. 372). The identification of the equerry with Hamilton, however, is also open to serious doubt. James Hamilton, First Duke of Hamilton (1606-1649), was one of the great nobles of Charles's reign and heir to the throne of Scotland. Although he was closely allied with Charles from childhood, it is highly unlikely that he would have been included in the role of an equerry in a portrait of the king. It is true that in 1628, upon the death of Buckingham, he was appointed Master of the Horse (as well as gentleman of the bedchamber and a privy councillor). The Master of the Horse, far from being charged with holding the horse for the king on an outing, is actually "the third great officer in the British court. He has the management of all the royal stables and breed horses, with authority over all the equerries and pages, coachmen, footmen, grooms, etc. In state cavalcades he rides next to the sovereign" (*The Century Dictionary and Cyclopedia*, V, New York, 1906). There is not the slightest indication of high rank in Van Dyck's painting in the figure behind the king, indeed, half hidden by the king's horse. Furthermore, there is no compelling physiognomic likeness between the equerry in Van Dyck's painting and the features of Hamilton as we know them from Daniel Mytens' portrait of 1629 in the National Gallery at Edinburgh (Horst Gerson, *Van Geertgen tot Frans Hals*, Amsterdam, 1950, fig. 160) and Van Dyck's portrait in Hamilton Palace (KdK 463). Despite Strange's explicit statement, I believe the

identification of the equerry with Hamilton must be abandoned. For the time being, both the equerry and the page who carried the king's cloak must remain anonymous. (Charles Sterling informed me in a letter that he, too, has come to this conclusion. He also kindly supplied me with photos of the inscriptions.)

2. *Rubens et son temps*, exhibition catalogue, Paris, Musée de l'Orangerie, 1936, pp. 57-58, no. 31.

3. *La peinture flamande*, p. 70.

4. William Hookham Carpenter, *Pictorial Notices Consisting of a Memoir of Sir Anthony Van Dyck . . .*, London, 1844, pp. 66-67. While it is generally assumed that it was the king himself who crossed out Van Dyck's valuation of £200 and instead wrote £100 on the margin, Margaret Goldsmith (*The Wandering Portrait*, London, 1954, p. 39) avers that the corrections show the hand of Bishop Juxon, the Lord Treasurer.

5. Charles Blanc, *Histoire des peintres de toutes les écoles*, Ecole flamande, Paris, 1868, "Antoine van Dyck," p. 16. Needless to say, all earlier discussions of the portrait—for instance that of John Smith, *A Catalogue Raisonné of the Works of the Most Eminent Dutch, Flemish, and French Painters*, III, London, 1831, p. 39—make no reference to hunting at all.

6. Jules Guiffrey, *Sir Anthony van Dyck*, London, 1896, pp. 193-197.

7. Eugène Fromentin, *Les peintres d'autrefois*, Paris, 1876, p. 141; Ernst Heidrich, *Vlämische Malerei*, Jena, 1913, p. 75; Max J. Friedländer, *Die niederländischen Maler des 17. Jahrhunderts*, Berlin, 1923, p. 322, no. 129; A.J.J. Delen, *Antoon van Dijck*, Antwerp, 1947, p. 54; David M. Robb, *The Harper History of Painting*, New York, 1951, p. 509; Ellis Waterhouse, *Painting in Britain*, London, 1953, p. 48; Ludwig Baldass, "Some Notes on the Development of Van Dyck's Portrait Style," *Gazette des Beaux-Arts*, L, 1957, p. 270.

8. Armand Dayot, *Le Musée du Louvre*, Paris, 1912; Louis Demonts, *Catalogue des peintures*, III, Ecoles flamande, hollandaise, allemande et anglaise, Paris, 1922, p. 6; Eduard Michel, *La peinture au Musée du Louvre*, Paris, n.d., pp. 90-95; Georges Lafenestre, *Le Louvre*, Paris [1947], I, p. 27; René Huyghe, *Art Treasures of the Louvre*, New York, 1951, p. 162.

9. Max Rooses, *Art in Flanders*, New York, 1914, p. 231 and fig. 429.

10. Alfred Michiels, *Histoire de la peinture flamande*, VII, Paris, 1869, pp. 349-350. Large sections of this description were taken over verbatim by Michiels in his book on Van Dyck, first published in 1880 (2nd ed., 1882, p. 390). He eliminated, however, the sentence beginning "The features of the hapless monarch . . ." and inserted instead the following: "Les traits du malheureux souverain ont une expression remarquable de mauvaise humeur; dans son dépit, son oeil reste froid, morne, sans éclair de la haine

et des fortes résolutions; il souffre, il souffrira encore . . ., il ne se vengera pas!" And after the sentence that ends "the left hand on his hip" (la main gauche sur la hanche) he mentions the horse: "Son cheval, la tête basse, gratte du pied la terre avec impatience."

11. François-Anne David, *Histoire d'Angleterre*, II, Paris, 1786, p. 141, pl. XXVIII.

12. Blanc, *Histoire des peintres*, p. 16.

13. Ibid., p. 14.

14. Louis Gillet, *La peinture, XVIIe et XVIIIe siècles*, Paris, 1913, p. 100.

15. Emil Schaeffer, *Van Dyck: Des Meisters Gemälde*, Klassiker der Kunst, Stuttgart, 1909, p. xxxii.

16. Gustav Glück, *Van Dyck*, pp. xliii-xliv.

17. H. Fierens-Gevaert, *Van Dyck*, Paris, n.d., p. 94.

18. Delen, *Antoon van Dijck*, p. 54. It is significant for this trend of interpretation that Max Rooses, who in marked contrast to other nineteenth-century scholars describes Charles in the Louvre portrait as a "prince aimable, heureux et frivole" (*Les chefs-d'oeuvres de la peinture de 1400 à 1800*, Paris, n.d., I, p. 53), could not help introducing a "sad" interpretation into his analysis of the equestrian portrait of Charles, now in the National Gallery. Perhaps under the influence of Blanc's description of the Windsor portrait, cited above, he says that Charles "seems to turn his large listless eyes instinctively towards heaven with a tired and melancholy expression as if he were reading in the clouds his fateful end" (*Geschiedenis der antwerpsche schilderschool*, Ghent, 1879, p. 480). Pol de Mont, finally, speaks of "les enfants mélancoliques du roi" with references to the portraits by Van Dyck of Charles' children (*Antoine van Dyck*, Haarlem, 1906, Introduction). To him, however, almost all of Van Dyck's figures appear melancholy ("Quelle mélancolie dans les traits de tous ces visages"), but it is a "mélancolique souriante" which makes him think of Alfred de Musset and Heinrich Heine.

19. See also note 18.

20. Edward, Earl of Clarendon, *The History of the Rebellion and Civil Wars in England*, Oxford, 1826, VI, pp. 235-236. For the strong religious aspect of this worship of Charles' memory see, for instance, Luke Milbourne's Sermon preached at the Parish-Church of St. Ethelberga's in 1719 on the anniversary of Charles' death, which begins thus: "The Day is now return'd which has been set apart for many Years by Publick Authority, in which *Three guilty Nations* should in a more eminent manner humble Themselves before Almighty God, the terrible Avenger of the Blood that, next to the Crucifixion of the incarnate Son of God, the Sun ever look'd on, the impious Murder of *Charles the First*, once the lawful Sovereign of these Kingdoms, of precious and ever Blessed Memory." Luke Milbourne, *Ignorance and Folly put to Silence . . .*, London, 1719.

21. J. G. Muddiman, *Trial of King Charles the First*, Edinburgh and London [1928], pp. 188-189.

22. François Guizot, *History of the English Revolution of 1640*, 2 vols., trans. William Hazlitt, New York, 1846, I, p. xv.

23. *Encyclopaedia Britannica*, 11th ed., New York, 1910, XII, p. 706.

24. Guizot, *History of the English Revolution*, I, p. xvii. Brodie's *History of the British Empire* had been published in Edinburgh in 1822.

25. It is highly characteristic of Guizot's increasing conservatism that the relative objectivity of his attitude toward the English Revolution and Charles' execution gives way to a strongly partisan view in his *Discours sur l'histoire de la révolution d'Angleterre*, of January 1841, published in the 1850 edition of his *History of the English Revolution*. On p. 35 of that *Discours*, we find this revealing passage: "Et ce qu'on n'eût osé tenter contre le moindre des Anglais, on le faisait contre le roi d'Angleterre, contre le chef suprême de l'Eglise comme de l'Etat, contre le représentant et le symbole de l'autorité, de l'ordre, de la loi, de la justice, de tout ce qui, dans la société des hommes touche à la limite et réveille l'idée des attributs de Dieu!"

26. Isaac D'Israeli, *Commentaries on the Life and Reign of Charles the First, King of England*, London, 1828-1831.

27. Ibid., V, p. 472.

28. Ibid., I, p. 7.

29. The report was reprinted in Sir Henry Halford's *Essays and Orations*, London, 1842, p. 333.

30. H.J.C. Grierson, *The Letters of Sir Walter Scott*, London, 1932, III, p. 264. The letter is dated May 3, 1813, and is addressed to Scott's daughter.

31. See Reinhard Fertig, *Die Dramatisierungen des Schicksals Karls I. von England*, Diss., Erlangen, 1910.

32. Fertig lists dramas about Charles by W. G. Wills (1873); Arthur Gray Butler (1874), the first author to rescue Cromwell from the villain's role; Peter Lohmann, a German (1875); Mariano Aureli, an Italian (1875); and finally Siegfried Heckscher, a German (1908). Whether it is more than coincidence that four plays on Charles were published between 1873 and 1875, following by only a few years the deposition of Napoleon III and the establishment of a French Republic in 1871, I am unable to say.

33. Robert Southey, *The Poetical Works*, New York, 1850, p. 787.

34. *The Christian Year* appeared first in 1827. The poem on Charles I was added to the third edition.

35. See Amy Cruse, *The Victorians and Their Books*, London, 1935, p. 34. I owe to Mrs. Horace W. Chandler the reference to this book.

36. Ibid., p. 52.

37. Besides Guiffrey, Schaeffer, Fierens-Gevaert, Konody and Brockwell, Sterling, Glück, and Bouchot-Saupique, whose works have been listed before (notes 1, 6, 15, 17), we might mention further G. F. Waagen, *Handbuch der deutschen und niederländischen Malerschulen*, Stuttgart, 1862; F. Jos. van den Branden, *Geschiedenis der antwerpsche schilderschool*, Antwerp, 1883; H. Knackfuss, *A. van Dyck*, Bielefeld-Leipzig, 1902; Lionel Cust, *Anthony van Dyck*, London, 1905; F. M. Haberditzl, in Thieme-Becker, *Allgemeines Lexikon der bildenden Künstler*, X, 1914, p. 268; Willi Drost, *Barockmalerei in den germanischen Ländern*, Wildpark-Potsdam, 1926; Frank van den Wijngaert, *Antoon van Dyck*, Antwerp, 1943; Antonio Muñoz, *Van Dyck*, Novara [1941]; Leo van Puyvelde, *Van Dyck*, Brussels, 1950; Ernst H. Gombrich, *The Story of Art*, London, 1950.

38. Bouchot-Saupique, *La peinture flamande*, pp. 28 and 70, calls the outfit unequivocally a "costume de chasse."

39. The manner in which the horse is introduced next to a man in armor in Moroni's picture is reminiscent of renderings of St. George, such as the one in Pisanello's well-known painting in London. (I owe this observation to Professor Millard Meiss.)

40. Thomas Pennant, *Some Small Account of London*, 4th ed., London, 1805, p. 97. Pennant was speaking about the picture in Hampton Court. The Reverend James Dallaway in his notes to Walpole's *Anecdotes* (II, London, 1826, p. 7) repeats this statement.

41. The Reverend James Granger, *A Biographical History of England from Egbert the Great to the Revolution*, 3rd ed., London, 1779, I, p. 337.

42. Lionel Cust, "Marcus Gheeraerts," *The Walpole Society Annual*, III, London, 1913-1914, p. 28.

43. Helen Comstock, "The Connoisseur in America, Forty British Portraits," *Connoisseur*, CVI, July 1940, p. 28.

44. Elizabeth E. Gardner, "A British Hunting Portrait," *Bulletin of the Metropolitan Museum of Art*, January 1945, p. 113.

45. London, 1576; published in a second edition in 1611, and republished from this later edition in Oxford, 1908. There is some question as to whether Turbervile really was the author of the book that goes under his name. The answer to that question, however, has no bearing on our subject since the paragraph cited above was added by the English translator.

46. See W. R. Halliday, *A Short Treatise of Hunting by Sir T. Cockaine*, Oxford, 1932, Introduction.

47. See C. H. Collins Baker and W. G. Constable, *English Painting of the Sixteenth and Seventeenth Centuries*, New York, n.d., plate 37.

48. Ibid., plate 43.

49. Oskar Fischel, *Tizian: Des Meisters Gemälde*, Klassiker der Kunst, Stuttgart, n.d., p. 227.

50. Gert Adriani, *Anton van Dyck: Italienisches Skizzenbuch*, Vienna, 1940, p. 41, no. 27.

51. Robb, *Harper History of Painting*, p. 509. Du Gué Trapier in a recent article ("The School of Madrid and Van Dyck," *Burlington Magazine*, XCIX, 1957, p. 270) says that Charles "is ready to mount his white horse."

52. Oskar Fischel, "Wanderung eines antiken Motivs," *Amtliche Berichte aus den berliner Museen*, XXXIX, 1917, pp. 59-63.

53. See Carl Robert, *Die antiken Sarkophag-Reliefs*, III, Berlin, 1897, pls. XII, XIV.

54. Ibid., no. 39, p. 59.

55. For this series see Victor H. Elbern, "Die Rubensteppiche des kölner Domes," *Kölner Domblatt*, 1955, p. 43.

56. See Jan-Albert Goris and Julius S. Held, *Rubens in America*, New York [1947], no. 70.

57. Max von Boehn, *Modes and Manners: Ornaments . . .* , Toronto, 1929, chap. IV, pp. 94 ff. (trans. from *Das Beiwerk der Mode*, Munich, 1928, p. 97). For the meaning of rods in general and specifically the pastoral staff as the symbol of "authority of jurisdiction and rule," see A. Welby Pugin, *Glossary of Ecclesiastical Ornament and Costume*, London, 1868, pp. 212 ff. See also Charles Du Fresne, Sieur Du Cange, *Glossarium mediae et infimae latinitatis*, Graz, 1958 (reprint of the 1688 ed.), pp. 515-518, under "Baculus."

58. Von Boehn, *Modes and Manners*, p. 107.

59. See Otto Georg von Simson, *Zur Genealogie der weltlichen Apotheose im Barock*, Strasbourg, 1936, passim. For the classical sources of this figure, see F. M. Haberditzl, *Jahrbuch der kunsthistorischen Sammlungen des allerhöchsten Kaiserhauses*, XXX, 1912, p. 257.

60. There are two versions of Bower's portrait. One is in the collection of the Duke of Rutland at Belvoir Castle, the other in the National Portrait Gallery of Scotland at Edinburgh. It is only the latter that shows Charles holding the cane; in the portrait at Belvoir Castle his left hand is placed against his hip. On the basis of the photographs the Belvoir Castle portrait appears to be superior in quality. If the Edinburgh picture is a second version, or even a copy, the addition of the cane and its prominent place furnish striking evidence for the importance which this object had assumed during the trial.

61. Muddiman, *Trial of King Charles*, p. 77.

62. *Memoirs of the two last years of the Reign of that unparallel'd Prince, of ever Blessed Memory, King Charles I. by Sir Thomas Herbert and others*, London, 1702, p. 115.

63. Muddiman, *Trial of King Charles*, p. 77 (quoted from *The Moderate*, a periodical published by Mabbot).

64. This was reported by Sir Philip Warwick; see Muddiman, *Trial of King Charles*, p. 77.

65. See Ruth Kelso, *The Doctrine of the English Gentleman in the Sixteenth Century*, University of Illinois Studies in Language and Literature, XIV, Urbana, 1929. For the doctrine current in England at the time of Charles I, see Henry Peacham, *Compleat Gentleman* (1622; republished from the enlarged edition of 1634, with an introduction by G. S. Gordon, Oxford, 1906).

66. Gombrich, *Story of Art*, p. 302.

RUBENS' DESIGNS FOR SEPULCHRAL MONUMENTS

AMONG a collection of architectural drawings recently acquired by James G. Van Derpool of the Avery Architectural Library, Columbia University, is a drawing worthy of special interest (Fig. VII. 1).[1] It is a slight sketch,[2] with an old though certainly not contemporary inscription, "P. Rubens," in the lower lefthand corner. Whatever reason the unknown scribe had for putting Rubens' name on the sheet—whether he wanted to codify an old tradition or add permanence to his own attribution—there can be no doubt that he was perfectly correct. The drawing is indeed an original study by Peter Paul Rubens.

The object sketched by the master is evidently an epitaph, to be placed either against a wall, or, more likely perhaps, against a pier. In its center, left blank in the drawing, was to be a large tablet for the funerary inscription, framed by a classical molding enriched with an egg-and-dart motif. It was to rise from a rather heavily profiled socle that is supported on a double scroll. The shape of the inscription tablet is enriched at its upper end by projecting lateral "ears" which are supported by engaged Tuscan pilaster strips growing from elongated volutes. These volutes abut an outward sweep of the lateral enframement; the bottom line of the enframement breaks up in the center, thus adding to the effect of movement everywhere in evidence.

On top of the "ears," on either side, sit two nude child-angels in appropriately dejected attitudes, holding descending garlands like clusters of fruit; smaller garlands connect the lateral volute with the break in the bottom portion of the enframement. The angels turn their backs on a narrow block which rises between them and carries a segmental cornice. This in turn is decorated with a cherub's head and a small cartouche, the lower ends of which overlap the frame of the inscription tablet. Another block, narrower still, emerges

Reprinted by permission of *The Art Quarterly*, XXIII, 1960, pp. 247-270.

above the cornice and carries, as the crowning element of the whole design, a burning oil lamp, whose graceful form is echoed by its shadow cast against the wall.

Iconographically the design offers no problem. Garlands of fruits are traditional funerary motifs, suggestive of the sweet fruits of paradise. Child-angels and cherubs' heads were popularized in sepulchral monuments from the Quattrocento on. The burning lamp is a traditional symbol of human life, sanctioned by Cesare Ripa, and was a standard feature of tomb design, obviously representing in this context man's eternal life in Christ.

The drawing has been fully executed only on one side; at the right the artist was satisfied merely to indicate the outlines in a few lines, some done only in chalk. A similar economy, where the right side would have been only a symmetrical inversion of the left, is found in Rubens' sketch of the emblem of the Plantin Press in the Musée Plantin in Antwerp (Fig. XV.4).[3] We shall see below how many of the specific architectural and ornamental ideas of the one design can be identified in other decorative schemes of the master. Most important for the attribution, however, is the highly characteristic use of pen and wash, and the masterly assurance with which the figural elements have been drawn; analogies can be found in many of Rubens' drawings, especially in the second and third decades of the century, such as the sheet with Venus and Cupid in the Frick Collection.[4] A cherub's head, very similar to the one in the Avery drawing, is seen in the drawing for the title page of the *Gelresche Rechten* in the collection of J. Q. van Regteren Altena.[5] That drawing dates from about 1619; the book was published in 1620.

The discovery of this drawing makes it a tempting task to review critically what is known of Rubens' activity in the field of sepulchral architecture. It is actually the second discovery in this field, having been preceded by the identification, made by this author, of a drawing in Amsterdam as a project for a tomb of Jean Richardot, probably designed by Rubens in 1609 but apparently never executed (Fig. VII.2).[6] Whereas the Avery drawing was clearly made for an epitaph, most likely of modest dimensions, the Richardot tomb, if executed, would have been an impressive monument. Basing his design on a small classical cinerary altar, Rubens planned for it a large wall niche into which he placed a majestic altar-like structure, the main feature of which was a pair of doors held slightly ajar by two full-size angels. The text of the inscription was to appear on a relatively small tablet placed above the doors. Except for the presence in both designs of garlands of fruit and of two angels, there is virtually no connection between them. The only feature worth noting in this context is the similarity in feeling, rather than actual design, of the basis of the whole structure. In the Richardot tomb as well as the Avery drawing, the composition rises on top of a clearly defined and almost completely unadorned socle zone. In the former it is the sarcophagus, in the latter a bracket-like base. In each case the main element is a wide, lazily bulging form which, like its accompanying forms, extends from one side to the other without any interruption.

If we now turn to Rooses' monumental catalogue of Rubens oeuvre, we find listed three additional works dedicated to the commemoration of the dead and attributed, on various

authority, to Rubens.[7] One of these, mentioned but briefly by Rooses, is known only from an eighteenth-century description found in P.J.J. Mols' edition of Jacobus de Wit's *De Kerken van Antwerpen*.[8] There we read: "After this chapel [of Our Lady, west of the left transept of the church] one sees against the first pier of the church a nice black marble epitaph of the family De Moy, with three white marble figures: in the middle a seated figure of the Virgin, with St. Catherine and St. John at her sides, all done by Joannes van Mildert, from the design and under the supervision of Petrus Paulus Rubens" ("met inventie teeckeninge en onder de conduite van Petrus Paulus Rubens").[9] Giving no other reference than Mols' text, Rooses states that the tomb, destroyed during the French Revolution, was executed by Artus Quellinus.

This attribution, obviously an error on Rooses' part, was not taken over by later scholars. Both Devigne[10] and Leyssens[11] retain the old attribution to Van Mildert but differ in the date they assign to the lost piece. Devigne suggests tentatively a date of 1622, while Leyssens prefers a date of 1611-1612. Of the two dates, the latter alone was proposed on historical grounds; yet it can surely be shown to be incorrect. Leyssens based her date on the inscription of the only major funeral monument for the De Moy family to have existed in the Cathedral (there had also been a tombstone for Hendrik and a copper plaque for Dirk de Moy), the text of which has been preserved in the monumental collection of *Inscriptions funéraires de la province d'Anvers*, 1860, 1,132. The monument was erected for Hendrik de Moy (1534-1610) and his wife Clara van Gulick by their three daughters, Clara, Catherina, and Maria, and by Jan Brant, husband of Clara. Leyssens' date of 1611-1612 for the tomb was evidently chosen in cognisance of the year of Hendrik de Moy's death. Yet the inscription also makes reference to the death, four years after her husband's, of Clara van Gulick ("Illa Deo itidem obsecuto quadriennio[12] post secuta"), so that the work ought to be dated at least after 1614.

Rubens was closely related to the De Moy family, and it is quite likely that he was indeed asked to design and supervise a sepulchral monument for them. In March 1609 his brother Philip had married the youngest of the De Moy daughters, Maria; in October of that same year Rubens himself married Isabella Brant, the daughter of Clara, the oldest of the De Moy sisters. Philip Rubens died in 1611 and is consequently not included in the funeral inscription of the lost tomb; Jan Brant, the only surviving son-in-law, is mentioned. It is regrettable indeed that nothing except the text of the inscription remains of the work which Rubens designed at the request of relatives as close as the parents of his wife and the widow of his brother.

The two remaining funerary monuments listed by Rooses, although both have also been lost, have at least been preserved in early engravings. The first (Rooses, V, no. 1363) was dedicated to Jan Gevartius (Gevaerts), who died in 1613. It was placed in the shoemakers' chapel in the Cathedral at Antwerp; the engraving is by Adrian Lommelin (about 1616-after 1673).

Lommelin came to Antwerp only after Rubens' death. Hence none of his engravings after Rubens were done for the master or under his supervision and their documentary value has to be judged with certain reservations.

Lommelin's print of Jan Gevaerts' epitaph (Fig. VII.3) shows the bust of the deceased in a niche above his motto *Non Semper Imbres* ("It Does Not Always Rain") and a dove with a laurel branch in its beak. The inscription tablet with an endless text (Jan's son Caspar was famous for his Latin funeral inscriptions) is flanked by two allegorical figures. Peace with laurel, caduceus and serpent stands to the left, Justice with scroll and scale to the right. Under each figure is her name, inscribed in Greek, and lower still are appropriate phrases.[13] Cherubs' heads and scrolls form the base, while cornucopiae and a tightly bound wreath accompany the portrait niche. A burning lamp crowns the whole design.

The engraving gives Rubens' name as designer (*Pet. Paul Rubenius delin*). Yet according to Dutuit,[14] who in turn quotes the catalogue of the collection Del Marmol, there exists a first state of the print in which the design is attributed to Erasmus Quellinus.[15] Rubens' name appears only in the second state. Nevertheless, Rooses tentatively accepted Rubens as author of the design, following Basan[16] and Schneevoogt.[17] Some doubt about the attribution was expressed by Van den Wijngaert[18] but Oldenbourg[19] and Konrad[20] adopted Rubens' authorship without question.

The execution of the epitaph has been credited to Artus Quellinus the elder (1609-1668), but it is not correct, as Oldenbourg stated, that his name appears on Lommelin's print. As far as I can see, the attribution is first mentioned in De Wit's inventory. De Wit (or Mols?) mentions Rubens as author of the design but obviously takes this information from Lommelin's print, which is cited in the same passage. Rooses appears to have considered the possibility of the epitaph having been done soon after the death of Jan Gevaerts (which, as he immediately adds, would exclude connection with either Quellinus), but it is obvious from its style that the work could not have been done that early. Konrad, indeed, states that the epitaph was done around 1640.

There is internal evidence, hitherto overlooked, in the epitaph itself, that helps to arrive at least at a *terminus post quem*. The inscription states that the monument was dedicated to the memory of their father by Carolus Gevartius, dean of the college of Canons of Lier, and by Gasperius Gevartius, *I.C., Caesareus Regiusque Consilarius et Historiographus, Archigrammateus Antverpianus*. Now Caspar Gevaerts' appointment to the post of imperial historiographer dates from February 15, 1644. The instrument of appointment, preserved in MS 21.363 of the Bibliothèque Royale in Brussels,[21] is printed verbatim at the end of the 1645 edition of Hubert Goltzius' *Icones Imperatorum Romanorum*, with introduction and text written by Gevaerts. On the title page of an earlier work of Gevaerts, the *Pompa Introitus Ferdinandi*, published in Antwerp in 1642, Gevaerts is listed only as *Archigrammataeus Antverpianus*. It does not seem to be known just when Gevaerts was appointed counselor and historiographer of King Philip of Spain (the date is missing also from Hoc's study),

but it must have been after 1644.[22] That at any rate, would seem to be the earliest date to be considered for the execution of the tomb of Gevaerts' father—four years after Rubens' death!

There may of course have existed a Rubens sketch for the epitaph, but the evidence of Lommelin's print does not speak in favor of this assumption. The character of the work is determined by a cool classicism, as foreign to Rubens as it is familiar from the works of Erasmus Quellinus. There are awkward details, such as the inert mass of garlands sagging heavily downward along the entablature, or the weird idea of using a well-filled cornucopia to support a protruding bit of the architecture. The figures of Peace and Justice are likewise "prettier" and more decorous than similar personifications by Rubens. This becomes more obvious if one compares, for instance, the figure of Peace with the same personification from the title page of Haraeus' *Annales Ducum Brabantiae* of 1622,[23] which probably served as a model. No matter how much of the impression of uninspired correctness and propriety be blamed on the engraver, there remains a non-Rubensian residue which prompts me to accept the evidence of the reported first state of Lommelin's print and thus to give the design of the Gevartius epitaph to Quellinus.

The third sepulchral monument described by Rooses is known only from an engraving by P. Clouwet (Fig. VII.4).[24] Clouwet, born in 1629 in Antwerp and master there in 1645-1646, probably never knew Rubens alive. His print is not dated; like Lommelin's it is clearly the product of a period when the art of engraving had again retreated into the technical doldrums from which Rubens had saved it for a while by his high demands and constant supervision. As a work of the burinist's art, Clouwet's mechanically produced print stands even lower than Lommelin's, but it is revealing to see how in spite of the *Knechtsgestalt* (to quote a beautiful, if untranslatable, word of Dehio's) forced upon it, the design still conveys a good deal of the master's thought and imagination.

The monument preserved in Clouwet's print is not an epitaph but a wall tomb. Like the tomb for Richardot it is set into a shallow niche framed by pilasters carrying a semi-circular arch. Unlike the Richardot tomb, however, the niche is treated like an apse, its upper parts being slightly vaulted. In this niche stands the sepulchral structure itself, the base of which might enshrine the actual corpse. It is decorated with four piers created by combining cherubs' heads with lions' feet. Garlands of fruit hang between them, and in the center is a winged skull from which two scrolls emerge laterally. Above this base is a tablet for the inscription, flanked by two female personifications.

Rooses did not try to identify these figures, which are devoid of explanatory attributes. Indeed, the only object that can be identified is a seemingly flat disc in the hand of the figure at the right. While the engraver may not have understood its meaning, it is quite certain that the object is a *patera*, a shallow dish used by the ancients in libations. Rubens himself, in an inscription for a title-page drawing,[25] described it as a symbol of religion: *Ara, Patera et Simpulum Pietatem, Religionem et Sacra Indicant.*[26] On the front of the Arch of Ferdinand, erected in 1635 for the Triumphal Entry into Antwerp of Cardinal-Infante

Ferdinand and reproduced in the *Pompa Introitus Ferdinandi*,[27] is a veiled figure of a woman representing *Pietas*, a chalice in one hand, a *patera* in the other. Thus the meaning of the figure in Clouwet's print is fairly clear in its context no matter whether we call her *Pietas* or *Religio*; her glance toward heaven, appropriate enough in such an allegory, may also suggest the eschatological hopes of a pious Christian. More problematical is the meaning of the pendant figure, who is without any attribute whatsoever. Her nature is evidently to be read from her attitude and dress, clearly based on the famous classical figure type known as *Pudicitia*.[28] Rubens' extreme fondness for this type is attested by its frequent occurrence in his work.[29]

The center of the design, between the two blank fields, is occupied by a small but meaningful emblematic configuration. Two doves are associated with the stylized form of a yoke to which is also added a shell. The yoke is crossed on each side by a loosely hanging string or cord.

The yoke is a traditional symbol of wedlock (*con-jugium*!) and is used as such several times in Rubens' work. It appears—most pertinent in our context—on the vignette which Rubens designed for Balthasar Corderius' *Catena Patrum Graecorum in S. Joannem, nuptiis Ferdinandi III consecrata* of 1630.[30] Here a similar yoke joins together the princely couple, symbolized by an eagle and a peacock (the animals of Jupiter and Juno) whose necks are tied to the yoke by strings. In the print by Clouwet the strings are loose, as a sign that death has untied the bonds of marriage. The closest analogy, however, to our print is found on the reverse of the Arch of Philip, another arch of the Triumphal Entry of 1635 and also reproduced in an etching by Van Thulden in the *Pompa Introitus Ferdinandi* of 1642. Above the scene of the marriage of Philip the Handsome and Johanna of Aragon, which forms the main feature of the arch, there appears a yoke with two doves sitting on it. The text which Gevaerts provided for the publication is very specific (p. 34): "Supra Tabulam IVGUM AVREVM Conjugale expressum est IVGO Geminae insident COLVMBAE, Conjugis Symbolum."[31] Two burning torches are added to the yoke as "FACES NVPTIALES."

Contrary to their appearance on the Arch of Philip, where they are arranged in perfect symmetry, the two doves in Clouwet's print are represented in very different attitudes. One is looking downward and seems to suggest a state of sorrow;[32] the other by contrast flaps its wings and seems to be ready to take off while looking back to its companion as if beckoning it to follow. If the yoke and the two doves are a clear sign that the tomb was to commemorate a married couple, the differentiation of, and the meaningful interplay between, the birds indicates that at the time Rubens made the design only one partner had died and had left the other bereft and in sorrow.

It is not without interest to see that each of the animals is contrasted to the nearby personification while sharing features with the one to which it seems opposed. The dejected one sits near hopeful *Pietas*, while the active and outgoing one is placed next to veiled *Castitas*; the association of the volatile bird with the withdrawn figure and of the downcast animal with the upward looking one is an idea worthy of the master. In the context of

death and after-life, the shell beneath the yoke probably refers to the soul's transit to the other world.[33]

Above the doves and the yoke is an oval tablet, framed by cherubs' heads. Their wings curl upward, merging with a cornucopia-like structure that ends in what looks like dolphins' tails. Fruit garlands attached to the center between them are draped gracefully over the tubular "horns" before being suspended from rings fastened to the vault of the "apse." The "dolphins' tails" support a small pedestal on which stands the obligatory lamp. Two smoking torches, inverted and tied together crosswise, are placed in front of the pedestal. Cupids leaning on inverted torches are a well-known sign of death in ancient funeral decoration.[34] Rubens used the motif of two inverted torches in the print dedicated to the memory of his brother Philip (engraved by Cornelis Galle I, and inscribed "Piis Manibus Philippi Rubeni Sacr."),[35] on the sketch designed in commemoration of Charles de Longueval, Comte de Bucquoy (Fig. X.1), and on the Temple of Janus of the *Pompa Introitus Ferdinandi*.[36]

What makes the design rendered in Clouwet's print both aesthetically rewarding and characteristic of Rubens' approach to such themes is this, that despite the great variety of individual shapes and objects and a corresponding density of meaning, the overall design retains a graceful fluidity and easy transition from one form to another. It is precisely these qualities, conspicuously absent in the much more conventional design of the Gevartius epitaph, that make the tomb in Clouwet's engraving so eminently acceptable as the work of Rubens. Yet it is not easy to assign a date to it in the absence of any external evidence. It is obvious, at any rate, that it must be separated by a considerable interval of time from the only other known design for a wall tomb, the drawing in Amsterdam for Richardot's tomb. Rubens foregoes here all the literal classical reminiscences of the Richardot tomb, as well as the heavy architectural forms of the early Roman Baroque. Looking for analogies in such decorative projects as titles for books, one is led to the first half and the middle of the 1620s as the period most likely to have originated a design of that kind. Rubens still stresses clear divisions between the various components; there is none of the fusion of all the elements and the free use of spatial depth that characterizes his later designs; nor have the figures any of the volume and pure physical size in relation to the decorative elements that is a striking feature of the decorative works of the thirties. The chronological limits within which the work ought to be placed are best fixed by the title of the *Gelresche Rechten* of 1620[37] and Herman Hugo's *Obsidio Bredana* of 1626 (Fig. XV.15), where the oval inscription tablet appears for the last time.

Fixing the date of the tomb of Clouwet's print, if only approximately, helps us in dating the drawing in the Avery Library collection. It should be obvious that if anything, it is less fluently composed and more restrained in its ornamental detail. A somewhat earlier date than that of the tomb is also suggested by an examination of the formal analogies that exist between the Avery drawing and dated works of the master. The volutes at the bottom of the sheet, each one ending in a rosette, may be observed in practically identical forms

in the London drawings with the portrait of *Lipsius*,[38] except that they appear there vertically on either side of the base. With slight modifications this ornamental motif is seen also in the drawing of the *Holy Family* in London.[39] The *Lipsius* drawing dates from 1615, the *Holy Family* from about 1615-1617. There are also unmistakable analogies between the Avery drawing and the title page of the Bible published in Douai in 1617,[40] in the proportion and shape of the inscription tablet, the use of elongated lateral scrolls, and the frontal cherubs' heads in a central position (although it crowns the cartouche with the printer's address on the title page, rather than the main inscription as in the drawing). The egg-and-dart ornament, too, a motif which occurs frequently with Rubens, appears in the Avery drawing in a pattern more closely related to the print of 1617 than, for instance, to the drawing for the Haraeus title of 1622.[41] The idea of placing the two sorrowing angels on a molding from which their legs hang down freely is comparable to the placing of the allegories of Faith and Divine Love in the title for Bosius' *Crux Triumphans* of 1617 (Fig. XV. 16). There, in addition, the shape and make-up of the luxurious garland of fruits is particularly close to the hanging fruit of the Avery drawing. Thus, without trying to squeeze from the stylistic evidence more than can safely be inferred, it seems permissible to place the date of the Avery drawing into the five-year span between 1615 and 1620.

Summing up the results of this examination of the available evidence on Rubens' concern with sepulchral monuments, we have now before us the visual evidence of three of them: the Richardot tomb of about 1609, known from the preparatory drawing in Amsterdam; an epitaph of about 1615-1620 for an unknown person, preserved in a first sketch in the Avery Library; and a tomb of about 1620-1625 for a married couple, known from the engraving by Clouwet. There was, in addition, the epitaph for the De Moy family, known only from an eighteenth-century description. The epitaph of Gevartius, on the other hand, preserved in a print by Lommelin, is either not at all, or at most in a very limited sense, a work of Rubens. While none of these monuments has been preserved (assuming they were ever executed, which is doubtful, at least in the case of the Richardot tomb), it would now seem to be worthwhile to study the relationship of Rubens' ideas for sepulchral monuments with the established patterns in this field and the influence, if any, they had on the subsequent development in Belgium. Such a study, however, exceeds the limits of this paper, the more so since the pertinent material is widely scattered and has never been systematically collected.

There is, however, one aspect of Rubens' designs for sepulchral monuments that deserves more attention here. In an effort to date the tomb engraved by Clouwet we made reference to Rubens' designs for book titles as a type of work that consists of similar decorative ensembles and has the advantage of being dated precisely. Yet the connection of a funeral monument with title pages of books has a significance that goes beyond chronology. With its two large standing personifications and its division into definite zones, the tomb preserved in Clouwet's prints is clearly related to Rubens' earlier book titles, compositionally

as well as iconographically. The formal analogy with the design of title pages was already noticeable in the Avery Library drawing. With the later tomb, these analogies extend to the distinction of a lower zone which, in the tomb, is dominated by Death, while in the books it is often occupied by subjugated or sorrowing figures;[42] the central zone where the inscription tablet (in books, the title) is flanked on either side by a full-length figure, often of allegorical character (a feature so common in Rubens' frontispieces that quotation of special examples is superfluous); and a crowning zone, which in the book titles may contain a glorified allegorical personification such as *Ecclesia, Roma, Historia*, the figure of a deity or the image of the author himself. In the tomb rendered in Clouwet's print this zone contains the oval frame, which may have been designed to contain an image of the deceased surrounded by allusions to the bliss of after-life.

To make an association between figurated book titles and sepulchral monuments may not have been a far-fetched notion to Rubens. Both tasks involved, first of all, the combination in one design of word and image. For Rubens, this meant not only a juxtaposition, or a purely decorative combination, but an integrated plan in which both basic components, word and image, supported each other in form as well as in thought. In his design of frontispieces the printed title represents in a condensed form the content of the book, for which the surrounding figurative apparatus provides a highly charged allegorical commentary.[43] In the same way in sepulchral monuments the commemorative tablet contains, as it were, the "title" that gives meaning to the surrounding imagery and is in turn illuminated by it.

Yet Rubens may have been aware of a still closer connection between books and tombs. Both, in their way, are monuments that keep alive the memory of men long after they have passed on. In one of the title pages designed by Rubens this idea is indeed made perfectly explicit. The central form in his title for Ludovicus Nonnius' commentary on Hubert Goltzius' *Graeciae Universae Asiaeque Minoris et Insularum Numismata* (1618) is a classical sarcophagus; the title of the book, with the names of both authors prominently displayed, is inscribed on a tablet that on an actual sarcophagus would announce the name of its occupant.[44] Rubens used the same idea a second time when he inscribed the author's name and the title of Augustin Mascardi's *Silvarum libri IV* (1622) on a form resembling a tomb stele, although the portrait on top is not the author's, but Virgil's.[45] Other title pages evoke sepulchral monuments in a more general way, and it is easy to discover single decorative motifs common to, and probably derived from, the tradition of funerary sculpture. Finally, in the very distinction of zones which we have discussed, with its implied ideas of the triumph of Christianity over paganism, of Roman civilization over barbarian brutishness, and of the church over its enemies, there are analogies only too obvious to the underlying thought of practically all sepulchral art, the triumph of life over death. This very idea is formulated in one of Rubens' book titles, which could almost be called another design for a funerary monument: the title page to F. Tristan's *La peinture de la Serenissime Princesse Isabelle-Claire-Eugénie, Infante d'Espagne,* designed in December 1633

immediately after the death of the princess (Fig. VII.5). While in the lower sphere a globe and a rudder, on which a dove is seated, express the bereavement of the lands over which the princess had ruled, and the cylindrical block in the center is, in the words of Balthasar Moretus, the "ara salutis cum anguibus,"[46] the upper half of the composition is a kind of apotheosis in which the image of the deceased appears below the halo-like evening star (of Spain), framed by the circle of the Zodiac and surrounded by symbols of her high origin and her lasting deeds.

In view of this interrelation between title plates and sepulchral monuments, it is perhaps not too presumptuous to inquire what, if any, influence the modestly diminished art of the frontispiece, as developed by Rubens, may have had on the most impressive and monumental creations of the seventeenth century in the field of sepulchral architecture, the tombs of Gian Lorenzo Bernini, especially the tomb of Urban VIII (Fig. VII.6), his first great work in this category. By the time Bernini began making his plans[47] a great many of Rubens' title pages had appeared, and it is certain that most of them were available in Rome. Many of the authors published by the Plantin Press, and whose books Rubens had provided with title pages, were members of the Jesuit order, men such as Leonardus Lessius, Heribertus Rosweydus, and Carolus Scribanius. Their books were automatically distributed in Rome. It is practically certain that publications such as the *Breviarum Romanum* of 1614, Bosius' *Crux Triumphans* of 1617, Longus a Coriolano's *Summa Conciliorum* of 1623, and Haraeus' *Annales* of 1623 were well known in Rome at the time Bernini began his work on the tomb.[48]

It is precisely in these title pages that certain definite analogies are found with Bernini's tomb. As Wittkower points out, Bernini went back to such earlier Roman works as Guglielmo della Porta's tomb of Paul III, and even to Michelangelo's Florentine Medici tombs for the idea of placing the sarcophagus and the allegorical figures in a different plane from that of the statue of the deceased; but instead of the reclining allegories of these older works, Bernini's are upright and move "in a seemingly casual way"; and the pedestal with the image of the Pope has been given a pronouncedly vertical tendency. If we compare Bernini's allegories with the personifications of *Christian Politics* and *Abundance* on the title page of Scribanius' *Politico-Christianus* of 1624 (Fig. VII.7), we cannot fail to see the same relaxed freedom of movement; Rubens' *Abundance* in particular seems to anticipate Bernini's *Justice* in the way in which she leans softly against a curved surface. The fact that a nude infant appears in the same place, between their legs and the central object against which they lean, is almost too good to be the result of mere coincidence. The spatially involved figure of Death writing Pope Urban's name on Bernini's tomb fulfills a compositional function similar to that of the complex emblematic configuration above the central cartouche in Rubens' title page. This does not mean that we wish to "explain" Bernini's work by assuming for it the conventional sort of influence from one work of art to another. The genesis of any of Bernini's works, and above all of one that has always been rightly considered one of his abiding masterpieces, was surely more complex; Bernini hardly ever

abdicated for one moment the visionary intensity of the creative genius. There is, in fact, a workshop drawing[49] that preserves an early phase in the development of the tomb, datable to the fall of 1627, which shows less analogy with Rubens' design than does the finished work. The figure at the right moves differently and is not accompanied by a child; indeed, she is a different personification (according to Brauer and Wittkower *Fides* [?]) and death is a gnomish creature whose wings have been fused with the volutes of the sarcophagus. Thus, Rubens' title page designs in general, and the Scribanius title in particular, can only be said to have served as mental "background material." But taking them as no more than memory images, hidden away and possibly fused with one another in the artist's store of visual impressions and recollections, these titles may well have helped Bernini toward a crystallization of his own thoughts. And while the Scribanius title admittedly lacks a crowning form to correspond to the figure of the pope on the tomb, it should be remembered that there were many other examples among the titles mentioned before, in which the lower allegorical figures lead up to and are surmounted by a majestically enthroned figure, as in, for instance, Lessius' *De justitia et jure*, 1617 (Fig. XV.24); Bosius' *Crux Triumphans* of the same year (Fig. XV.16); Mudzaert's *Kerckelycke Historie* of 1622;[50] and Haraeus' *Annales* of 1623 (Fig. XV.8). Twice, indeed, the crowning figure, though not the image of an actual pope, wears the papal crown: in the *Breviarum Romanum* of 1614 (Fig. XV.5) and the *Summa Conciliorum* by Longus a Coriolano of 1623 (Fig. XV.6). And if Wittkower particularly stresses in Bernini's allegorical figures their "human qualities that create the impressions of real and pulsating life,"[51] it is obvious that this had always been the special quality, indeed the very glory, of Rubens' personifications, and strikingly so in his title page designs.

A systematic study of the question of Rubens' influence on Bernini may yet yield additional observations along these lines. I should like to finish here with one instance in which one more of Rubens' title page designs appears to have played a role. Between 1626 and 1628 there was erected in S. Agostino in Rome an altar designed by Santi Ghetti, which Bernini decorated with two angels kneeling behind the slanting tops of a broken entablature (Fig. VII.8).[52] These angels are strikingly reminiscent of two similarly placed angels which Rubens had designed about six years before for the high altar of the Jesuit church at Antwerp.[53] A most convenient historical coincidence seems to offer the best explanation possible for the transmission of the idea: precisely when the Roman altar was undertaken (1626-1627) P. Huyssens, the chief architect of the Antwerp church and a close collaborator of Rubens, was present in Rome.[54] The idea is all the more persuasive as the structure of the Roman altar seems to follow fairly closely the Antwerp one, which, incidentally, had also been designed by Rubens.[55] Yet there are still a number of differences. The Antwerp pediment has segmental tops rather than straight ones, and while the angels in either case are kneeling, their attitudes are sensibly different. Happily, there are Rubensian prototypes even for the features in which Bernini's angels differ from the Antwerp ones. Several years ago Michael Jaffé published a drawing by Rubens for a little-known

title page of a book by a Flemish Jesuit, Cornelissen van den Steen (Cornelio a Lapide) with a Commentary on the Pentateuch (Fig. VII.9).[56] This book first appeared in 1616, and in that same year its author followed an invitation of the General of the Company to visit Rome; Jaffé surmises, surely correctly, that "the professor left his university . . . probably with the first copies of the Commentary in his baggage."

On this title page a broken architrave and entablature frame a seated figure of Moses, and on the *straight* slants of the pediment are two kneeling angels. They are nude except for multiple pairs of wings, but their gestures correspond surprisingly well with those Bernini gave to his angels ten years later: one of them folds his hands in prayer while the other presses them against his breast (with Bernini the hands are actually crossed) in an expression of humble devotion.

Here then, is a case where a tangible contact between Rubens and Bernini can be established; it is not without a kind of inner, if not rational, logic, that the architect and the sculptor of the S. Agostino altar should have combined features from the altar of the Antwerp Jesuit church with others taken from the title page of Van den Steen's book, which, as Jaffé has also pointed out, had been almost a sort of "dry run" for the design of the altar itself.

NOTES

1. The drawing was brought to my attention by a graduate student, Jack Spector. I am also grateful to Mr. Van Derpool for having facilitated my study of the drawing and for helpful suggestions in writing this paper.

2. Pen and wash with some lines in chalk; 286 × 122 mm.

3. Julius S. Held, *Rubens, Selected Drawings*, London, 1959, pl. 160, cat. no. 148.

4. Held, *Drawings*, pl. 47, cat. no. 46.

5. J. G. van Gelder, *Nederlandsch Kunsthistorisch Jaarboek*, 1950-1951, p. 137.

6. Held, *Drawings*, fig. 36, cat. additional 171. [J. Müller Hofstede identified the scenes sketched on the doors of the tomb as depicting incidents from the life of St. John the Baptist, Richardot's patron saint (*Wallraf-Richartz Jahrbuch*. XXVII, 1965, p. 261. no. 171).]

7. Max Rooses, *L'Oeuvre de P.-P. Rubens*, Antwerp, 1892, V, pp. 187-188.

8. Published 1910 as vol. 25 of the *Antwerpsche Bibliophilen*, with notes by J. de Bosschère.

9. De Wit, *Kerken*, p. 30.

10. Thieme-Becker, *Allgemeines Lexikon der bildenden Künstler*, 1930, p. 556.

11. *Gentsche Bijdragen*, 1941, VII, 110.

12. Leyssens read an impossible "quadriesinio."

13. *Servanti Benedictio* (Blessing to him who preserves, i.e., peace) and *Violanti Anathema* (Curse upon him who violates, i.e., justice).

14. *Manuel de l'amateur d'estampes*, Paris, 1885, VI, 90, no. 20.

15. See *Catalogue de la plus précieuse collection d'estampes, de P. P. Rubens et d'A. van Dyck . . . Le Tout recueilli . . . par Messire Del Marmol (Theodore-Jean-Laurent) . . .* (Brussels?), 1794, no. 427, p. 25: "L'epitaphe de J. Gevartius, avant les inscriptions, & avec le E. Quellinus del Lommelin sculp." It is followed by no. 28: "La même avec les inscriptions & P. P. Rubens delin. Lommelin sculp." (Information kindly provided by Mme. M. Mauquoy of the Bibliothèque Royale de Belgique, Brussels, where there is a copy of this catalogue [VB 5432/112].)

16. *Catalogue des estampes gravées d'après P. P. Rubens*, Paris, 1767, p. 48, no. 20.

17. *Catalogue des estampes gravées d'après Rubens*, Haarlem, 1873, p. 71, no. 54.

18. *Inventaris der rubeniaansche prentkunst*, Antwerp, 1940, p. 71, no. 412.

19. *Jahrbuch der preussischen Kunstsammlungen*, XL, 1919, p. 25.

20. *Belgische Kunstdenkmäler*, ed. Paul Clemen, Munich, 1923, II, pp. 191-192.

21. See Marcel Hoc, *Etude sur Jean-Gaspard Gevaerts, Philologue et Poète (1593-1666)*, Brussels, 1922, p. 54.

22. Gevaerts' career is clearly reflected in the inscriptions on prints of him, or dedicated to him. The earliest must be the portrait by Van Dyck, made for the so-called *Iconography* (see M. Mauquoy-Hendrickx, *L'Iconographie d'Antoine*

van Dyck, Brussels, 1956, no. 49). In the third state (the first with an address) Gevaerts is only called I.C. [iurisconsultus] ANTVERPIAE GRAPHIARIVS ETC. In the seventh state a new title was added in which he is called ARCHIGRAMMATEVS ANTVERPIANVS, HISTORIOGRAPHVS CAESAREVS. Since his appointment dates from February 15, 1644, this state of the etching must be at least later than that date. 1644 is also a *terminus post quem* for the dedication to Gevaerts on Schelte a Bolswert's engraving of the so-called *Shipwreck of Aeneas* by Rubens, where he is also called ARCHIGRAMMATAEVS of Antwerp and imperial historiographer. The print is dedicated to Gevaerts by Gillis Hendricx, the publisher, who entered the Antwerp guild in 1643-1644; Rubens, apparently, had nothing to do with this dedication. The last inscription, because it contains the most complete listing of all Gevaerts' titles, is found on Pontius' engraving of Rubens' portrait of Gevaerts (in Antwerp) where Gevaerts is credited with the ranks of counselor and historiographer of both Emperor Ferdinand III and King Philip IV, in addition to being chief grammarian of Antwerp. (Hoc, *Gevaerts*, reproduced this print, p. 48, but gave it by mistake to C. Galle.)

23. Rooses, *L'Oeuvre de P.-P. Rubens*, V, pl. 367.

24. V. Schneevoogt, *Catalogue*, p. 71, no. 53; Dutuit, *Catalogue*, VI, 90, no. 19; Van den Wijngaert, *Inventaris*, p. 39, no. 131.

25. Gustav Glück and F. M. Haberditzl, *Die Handzeichnungen von Peter Paul Rubens*, Berlin, 1928, no. 216.

26. "The altar, the libation-saucer, and the small pitcher represent Piety, Religion, and Holy Things." I assume that in Rubens' mind each object of the first triad of words was the symbol of the corresponding concept in the second.

27. See Van Thulden's etching in the publication of 1641-1642.

28. See M. Bieber, *The Sculpture of the Hellenistic Age*, New York, 1955, fig. 524.

29. In keeping with this prototype the figure on the tomb may represent *Castitas*; another possibility is *Mourning*. Wherever the *Pudicitia* type appears in Rubens' work the figure touches the veil near her face with her *right* hand, exactly as in all classical examples. We may confidently assume that this was the case also on the tomb; in other words, Clouwet's print renders the composition in reverse. It does seem more logical, too, that *Pietas* should hold the patera with her right rather than her left hand.

30. See H. G. Evers, *Rubens und sein Werk, Neue Forschungen*, Brussels, 1943, fig. 101.

31. "Above the picture is rendered a conjugal yoke. . . . a pair of doves sit on the yoke as symbols of wedlock."

32. The turtle dove itself is a symbol of bereavement. See the letter by Rubens' friend Balthasar Moretus of January 29, 1634 (Rooses, *L'Oeuvre de P.-P. Rubens*, V, 125), in explanation of a design by Rubens: "Turtur viduitatis symbolum." Rubens was probably also familiar with the

traditional symbolism of doves as images of the human soul (see F. Cabrol and H. Leclercq, *Dictionnaire d'archéologie chrétienne et de liturgie*, III², Paris, 1914: *Colombe*, col. 2203 ff., especially 2206-2207). On early Christian tombs, doves appear singly or in pairs as figures of the souls of the faithful entered into Paradise.

33. See W. S. Heckscher, *Rembrandt's Anatomy of Dr. Nicolaas Tulp*, New York, 1959, p. 176, note 228.

34. See F. Cumont, *Recherches sur le symbolisme funéraire des Romains*, Paris, 1942, pp. 341, 391, 409; see also W. H. Roscher, *Ausführliches Lexikon der griechischen and römischen Mythologie*, Leipzig, 1884-1927. For a Flemish sixteenth-century example, see *Gentsche Bijdragen*, VIII, 1942, 103 (C. Floris). The genius with lowered torch was also known to the Middle Ages; see H. Ladendorf, "Antikenstudium und Antikenkopie," 2nd ed., Berlin, 1958, pl. 2, nos. 6, 7.

35. Rooses, *L'Oeuvre de P.-P. Rubens*, V, pl. 375.

36. Ibid., III, pl. 247 and p. 315.

37. Evers, *Rubens*, fig. 87.

38. Held, *Drawings*, pl. 152, cat. no. 141.

39. Ibid., pl. 153, cat. no. 142.

40. Rooses, *L'Oeuvre de P.-P. Rubens*, V, pl. 357.

41. Held, *Drawings*, pl. 156, cat. no. 146. [For the engraved title page, see Fig. XV.8.]

42. See Lessius, *De Justitia et Jure*, 1617 (Fig. XV.24); Biaeus, *Numismata Imperatorum Romanorum*, 1617; Rosweydus, *'t Vaders Boeck*, 1617; Mudzaert, *De Kerckelycke Historie*, 1622; Longus a Coriolano, *Summa Conciliorum Omnium*, 1623 (Fig. XV.6); Hugo, *Obsidio Bredana*, 1626 (Fig. XV.15).

43. See "Rubens and the Book," in this volume, and Evers, *Rubens*, pp. 167 ff.

44. Ibid., fig. 85.

45. Ibid., fig. 90 (reproduced from a later edition in which the same design was used for the publication of the poetic works of Don Francisco de Borja, 1663).

46. For the idea of the "altar of health with the serpents," see for instance Guillaume du Choul's *Discours de la réligion des anciens Romains*, Lyon, 1581. It contains woodcuts of ancient coins showing altars dedicated to Aesculapius with a snake wound around them (pp. 117-118). In the text Du Choul speaks of health, which is represented by a serpent ("la santé, qui est signifiée par le serpent"). He also reproduces and describes an altar on which Aesculapius himself is represented "sous la figure du serpent" (pp. 118-119). On page 119, finally, there is the picture of a coin of Commodus with a column alongside which a serpent rises not unlike those seen in Rubens' print.

47. About 1627-1628; see Rudolf Wittkower, *Gian Lorenzo Bernini*, London, 1955, p. 194, and H. Brauer and R. Wittkower, *Die Zeichnungen des Gian Lorenzo Bernini*, Berlin, 1931, pp. 22 ff.

48. As an example of the close connection between the

Rome of Urban VIII and the house of Plantin we may also cite the edition of the pope's poems of 1634, for which Rubens designed the title page; see Held, *Drawings*, pl. 161, cat. no. 154, and "Rubens and the Book," in this volume, Fig. XV.26.

49. Brauer-Wittkower, *Zeichnungen*, pl. 151, text pp. 22-25.

50. Rooses, *L'Oeuvre de P.-P. Rubens*, V, pl. 374.

51. Wittkower, *Bernini*, p. 25.

52. Ibid., p. 188, no. 23, fig. 26.

53. See M. Konrad in *Belgische Kunstdenkmäler*, II, fig. 157; also J. H. Plantenga, *L'Architecture religieuse du Brabant*, The Hague, 1926, fig. 117.

54. See Plantenga, *L'Architecture*, p. 119.

55. For a reproduction of the whole of the altar see *Zeitschrift für Kunstwissenschaft*, XI, 1957, p. 196, fig. 7.

56. *The Art Quarterly*, XVI, 1953, pp. 131 ff.

PADRE RESTA'S RUBENS DRAWINGS
AFTER ANCIENT SCULPTURE

PADRE Sebastiano Resta is known as one of the most colorful collectors of drawings in the seventeenth century.[1] What he lacked in knowledge and critical discernment he made up in enthusiasm and an evangelist's zeal. In that enviable age when drawings were plentiful and collectors few, he cast his nets widely and could not help coming up with some spectacular catches. Various scholars, including Meder[2] and Popham,[3] have shed light on the activities of the garrulous padre. One of the albums of drawings he collected, preserved in the Biblioteca Ambrosiana in Milan, has recently become widely accessible in the splendid facsimile edited by Giorgio Fubini.

Among the other treasures of that library is yet another album of drawings, likewise assembled by Padre Resta but hitherto unnoticed by scholars. In numbers this collection cannot stand comparison with the large album, containing as it does only nine drawings. Yet of these nine drawings seven are certainly originals by Rubens and an eighth very likely so. The ninth (in the book actually the first) Padre Resta also believed to be by the master. Unfortunately, that drawing is but a copy after Rubens.

The slim volume, bearing the classmark *F. 249 inf.*, measures 748 × 542 mm. Bound in reddish brown morocco, both covers gilt-tooled with floral ornaments and stamped with the initials P.R., it consists of twelve folios, counting the flyleaves. The drawings themselves are fastened to the recto of seven of these, one to a page except for folios 5 and 6 which hold two drawings placed side by side. All of the drawings are surrounded by ruled borders consisting generally of six black lines of varying thickness.

I shall begin by briefly describing the contents in the order of appearance.

Reprinted by permission of *Master Drawings*, II, no. 2, 1964, pp. 123-141.

Folio 2 (recto and verso). An introduction by Padre Resta in the form of a letter, addressed "Alli Signori Pittori e Virtuosi di Milano."

Folio 3. *The Brazen Serpent*. After Rubens' drawing of the same subject in the British Museum (Hind No. 4) which in turn used motifs from Michelangelo's fresco on the Sistine Ceiling. Black, yellow, and white chalk, bistre wash, 423 × 630 mm. A strip about 100 mm. in width is pasted on at the right.

Folio 4. *Laocoön and His Sons*. After the marble group in the Vatican. Black and possibly some white chalk, 475 × 457 mm. The figure of the older son at the right was drawn on a separate sheet and, after having been silhouetted along the left side, was combined with the other two figures in such a way that the smaller sheet to some extent overlaps the larger one (Fig. VIII.1).

Folio 5. *The Younger Son of Laocoön, Seen from the Back*. Black and some white chalk, 443 × 265 mm. (Fig. VIII.2).

Laocoön, Seen from the Back. Black chalk, 440 × 283 mm. A small piece of paper cut out at the right just below the center (Fig. VIII.3).

Folio 6. *The Younger Son of Laocoön, Seen from the Front*. Black chalk, 411 × 260 mm. (Fig. VIII.4).

The Hercules Farnese. After the famous marble now in Naples. Black chalk, 316 × 220 mm. (Fig. VIII.5).

Folio 7. A *Fisherman in Profile, towards the Left ("Seneca")*. After the black marble statue in the Louvre. Black chalk, paper irregularly cut, 460 × 320 mm. (Fig. VIII.6).

Folio 8. *The She-Wolf with Romulus and Remus*. After a marble group forming part of the personification of the Tiber River in the Louvre. Black chalk, 355 × 484 mm. For the inscription see below, p. 100 (Fig. VIII.7).

Folio 9. *Reclining Figure (Hercules?), Drawn twice from Slightly Different Angles*. In the sketch at the right a second, headless figure appears behind the main figure and the grinning face of a faun emerges from behind his back. In the center near the upper edge is the bust of a river god. Black chalk, 360 × 513 mm. (Fig. VIII.8).

Resta's "letter" attached to this collection as a kind of foreword was written in Rome "questo di della Festa del Padre S. Filippo Neri [May 26] 1684." An Oratorian himself, and residing in the Chiesa Nuova, Resta was of course particularly devoted to the memory of the founder of the order and may have deliberately chosen the day of this saint for an act of devotion and high educational purpose. Though forced to spend his life in Rome, he had remained deeply attached to his native Milan—"mia Patria." He begins by telling the painters and "virtuosi" of Milan that as a sign of his affection for his home town, he is donating to the "Academia del Disegno" an original drawing by Michelangelo for the fresco of the Brazen Serpent in the Sistine Chapel.[4] This drawing, slightly damaged, but still well preserved considering its age, he had framed and reproduced in an engraving. He claims to have received it from "il fiamingo"—undoubtedly Francesco Duquesnoy, who

had it from the mysterious "Monsù Habé," "diletto alievo" of both Rubens and Van Dyck, whom we know from other writings of Padre Resta.[5] In the British Museum's Lansdowne manuscript 802 (p. 235 verso), he says of him: "Questo Habé fu un Fiamingo discepolo di Vandyck che venne anco per la Lombardia a nostri giorni, fu d'Enthusiasmo feroso."[6] "Habé" claimed that the Michelangelo drawings had been in the possession of Peter Paul Rubens and had been obtained by him after this artist's death.

After expressing the hope that the Michelangelo treasure which he is donating to the Academy will be held in deserved veneration by its members and mentioning briefly the respect paid by Del Sarto to the Michelangelo and Leonardo cartoons in Florence, Resta goes on to a lengthy discussion of the album's first drawing, which he admired as an original by Rubens. He recognized that Rubens had made rather free use of Michelangelo's drawing[7] and had stamped his work with the character of his own personality. Resta expresses in advance his agreement to having this drawing framed and exhibited next to Michelangelo's original—a suggestion which the members of the Academy evidently did not follow.

Resta is much briefer in his comments on the remaining drawings. Recognizing them as copies from ancient statuary, he compliments Rubens for turning "scholar" before the works of the ancient "masters." He admits to a certain dislike for the drawing of the "Seneca" (Fig. VIII.6), but mentions two other drawings of the same subject which he hopes to acquire from their present owner and add to the volume—a plan which also did not materialize. He praises the other drawings in the album, especially those of Laocoön, as proof of Rubens' growing mastery of a more controlled Italian manner. In that connection he lists other copies by Rubens after Correggio, Polidoro, Titian, and Veronese, which, he says, he may enclose with another gift. He concludes with the hope that the drawings may encourage the young Milanese painters to make the trip to Rome, presumably, one supposes, to study the antique.

In contrast to his careful discussion of the provenance of the Michelangelo drawing, Resta remains silent about the sources from which he had obtained the drawings by Rubens. In view of the close connection Rubens in his last Italian years had with the Oratorian fathers, it might be tempting to think that Resta had found them right there on the premises of the Chiesa Nuova. This, unfortunately, is impossible, as we shall see. Several of the drawings must have been in Antwerp around 1630, and it is hence likely that they were part of Rubens' estate and were sold only in the great dispersal sale of 1657.[8] If so, they too may have been brought to Italy by "Habé"—perhaps supporting his claim (unjustified, if he was indeed Hallet of Liège: see note 6) that he had been a pupil of Rubens and Van Dyck.

Whatever the history of the drawings may have been, Rubens' authorship cannot be questioned for the majority of them. They are not only of a quality worthy of one of the greatest draughtsmen of the past, but they also have strong stylistic ties with similar

drawings for which Rubens' authorship has been generally recognized. Moreover, Rubens' authorship can be supported by circumstantial evidence.

The drawing on folio 8 (Fig. VIII.7) contains in the upper left corner an inscription demonstrably from Rubens' own hand. It agrees perfectly with similar inscriptions on several early Rubens drawings, such as the drawing with St. Liberalis, after Pordenone,[9] the *Descent from the Cross*, the *Entombment of Christ*, and *Sketches for a Last Supper*.[10]

Additional evidence of Rubens' authorship is found in the remarkable collection of copies preserved in the Copenhagen Print Room.[11] Many of these drawings were identified by their maker (Willem Panneels) as copies after Rubens' drawings. A high proportion of the Copenhagen copies was taken from studies Rubens had made after classical sculptures. It is a happy accident that among the drawings in the Milan album there are four that served as models for the corresponding sheets in Copenhagen. Thus, the two groups supplement each other nicely. The Copenhagen copies support the originality of the Milan drawings, while the latter furnish proof of the reliability of the former.

The Ambrosiana drawings, however, facilitate also the observation of the difference in quality between Rubens' originals and the products of the Copenhagen copyist. The style of the copies (Figs. VIII.9-VIII.13) is consistently more schematic, the shading less subtle, the understanding of anatomy less sure. The copyist, working from a two-dimensional model, tends to be rather final in the outlines. In the copy of Laocoön seen from the back (Fig. VIII.9) he neglects, for instance, to render the first tentative lines with which Rubens sketched the coils of the serpent. When he copied the reclining Hercules(?) (Fig. VIII.10) from the corresponding figure on the lower left of Rubens' drawing, he relaxed the pose and increased the proportions, making the figure more lumpish and soft. In his copy of *Laocoön with His Younger Son* (Fig. VIII.11), he manages to transform the noble pathos of Rubens' Laocoön into the clumsy posturing of a near-simian figure.

Yet it is precisely this drawing which exemplifies the value of the Copenhagen copies. It has long been recognized that they permit us to round out our knowledge of Rubens as draughtsman with works lost today in their original versions. In the present case, the copy contributes in another way to our knowledge. It permits us to state that Rubens was not responsible for the combination of the silhouetted figure of the older son with the sheet on which he had drawn Laocoön and his younger son. When the Copenhagen draughtsman made his copy (probably around 1628-1630), he evidently found only the father and younger son on the sheet from which he worked. His copy depicts parts of Laocoön's left arm and of the entwining serpent which in the Milan original are now hidden by the arm of the superimposed figure of the older son. Since it is unlikely that Rubens should have busied himself in the last years of his life with the pasting together of some of his early sketches, the integration of the whole Laocoön group by grafting the study of the older son onto the sheet containing the other two figures is probably the work of a later collector. I rather suspect that the crude silhouetting of the figure of the older

son and the ultimate combination of the two sheets was the work of none other than Padre Resta himself who, according to Popham, "seems to have had a predilection for small drawings and must, I am afraid, have been in the habit of cutting out single figures from larger sheets."

The survival in Milan of no fewer than five drawings after the Laocoön (counting the drawing of the elder son as a separate item) is a welcome stroke of good luck. Hitherto, only one original drawing by Rubens after the Laocoön has been known. That drawing, now preserved in the Dresden Print Room (Fig. VIII.14),[12] renders Laocoön's torso seen from the left and below. However, as there are twelve drawings after the Laocoön among the Copenhagen copies, including one of the Dresden sheet, it was easy to postulate that at least twelve original drawings must once have existed.[13]

The Milan discovery permits us to enlarge that number to fifteen, and the three pieces now added are doubly valuable, as they portray the sons of Laocoön, one of whom had appeared only in outline in one of the Copenhagen copies and the other not at all. The album in the Ambrosiana contains a frontal view of the older son and two beautiful sketches of the younger, showing him both from the front (Fig. VIII.4) and from the back (Fig. VIII.2). The latter is one of the finest pieces in the album, distinguished by a masterly grasp of the motion and a vibrant effect of *contre-jour*.[14]

When Rubens drew the Laocoön group, it had been restored by sixteenth-century artists, especially Sansovino and Montorsoli, in a manner that is no longer accepted as correct.[15] All scholars are now agreed that Laocoön's right arm was not extended upward, but bent at the elbow, the hand touching the back of the head. Nor is it believed that the right arm of the younger son was raised, although the gentle inward curve of the arm as drawn by Rubens admittedly captivates us with a melodious beauty all its own.

For the history of the various transformations of the Laocoön group, Rubens' drawings are of considerable interest, and archaeologists occupying themselves with the post-classical history of the Hellenistic group will probably study them closely. They will notice that on the right hand of the older son all the fingers were missing except for the thumb and the index finger. Moreover, on the evidence of Rubens' drawings all the fingers on the right hand of the younger son were missing, too, except for some stumps—a puzzling fact, since that hand was supposedly a relatively modern restoration.[16] It is known that the toes of the same figure's right foot are lost, but is it also known that in Rubens' time the big toe appears still to have been in place?

These and similar problems (for instance, the position of the older son in relationship to his father) need not concern us here. The drawings, however, also teach us something about Rubens' attitude toward ancient sculpture in general. Undoubtedly, Rubens' drawings of the Laocoön group are more spectacular than any similar work preserved from his hand. Executed with the utmost care and displaying an astounding variety of light and shade, they also convey forcefully the excitement and the pathos of the subject. Choosing unexpected and unconventional angles of vision, Rubens lent stirring truth to the father's

frantic convulsions and the younger son's hopeless lassitude as he hangs suspended in the monstrous coils.

It is precisely this search for unconventional views which helps us to understand the fascination that the famous Hellenistic sculpture held for the Flemish painter. Seen in the context of ancient art, the work of the sculptors from Rhodes is strikingly baroque. Yet the same piece, compared with Rubens' drawings, is almost classical with its smooth flow of lines and its obvious stress on frontality. In Rubens' drawing, the serpents' coils twist and rotate more excitedly, the bodies heave in greater agitation, the surface undulates in multiplied bulges, and the impression of the fluidity of a violent action is increased. Moreover, Rubens' figures are differently proportioned. His Laocoön has a distinctly Flemish quality, with a heavy rump and short arms and legs, and even the sons are built more compactly than their ancient models.

The result is that Rubens' figures are less heroic in the grand manner but more human than their models. Their plight is more touching because they are less idealized, and the intimate angles of vision, so foreign to the traditional manner of drawing from the antique, bring them still closer to our sympathetic attention.

Compared with the graphic furor of the Laocoön drawings, the sketch of Hercules Farnese (Fig. VIII.5) is somewhat disappointing. Certain schematic devices, like the emphasis frequently given to the outlines by an increase of pressure, are rather reminiscent of some of the Copenhagen copies. Yet the Milan sketch is done more softly than the drawings attributed to Panneels; the concept of the whole is more coherent and unified; for the time being, an attribution of the sheet to Rubens himself seems to me still justifiable.

The majestic marble of Hercules Farnese, long a favorite object of study for Northern Mannerists, had fascinated Rubens from the very beginning. He rendered it in a very early drawing, formerly in the collection of Pierre Dubaut in Paris.[17] Count Seilern, who questioned—I believe incorrectly—the attribution of the Dubaut drawing to Rubens, was the owner of two studies after the head of the colossal statue.[18] The Copenhagen collection of copies contains two views of Hercules (III, 33 and 34). With appropriate modifications, the figure of Hercules appears in various contexts and combinations in Rubens' work, both in its original meaning and changed into St. Christopher.[19]

The drawing of a fisherman (Fig. VIII.6) also offers no surprise. The model was the famous piece in black marble believed to be an image of Seneca. Now in the Louvre, it was in Rubens' time part of the collection of Scipione Borghese. There are no fewer than five drawings after this figure in Copenhagen, including a copy of the Milan piece (Fig. VIII.12).[20] Moreover, several original drawings by Rubens of this figure are known, three of which are in Leningrad[21] and one in the Morgan Library in New York.[22]

In drawing this figure Rubens may have tried to ennoble the features of a very ordinary and slightly negroid face in accord with the notion that the marble portrayed Seneca dictating his verses to a scribe up to the moment of his self-chosen death. This may explain the tense and serious expression on the face of the figure in the Ambrosiana drawing, an

expression which the Copenhagen copyist miserably failed to emulate. When Rubens finally painted the Death of Seneca (KdK 44), he used the Louvre statue for the body only. The head he modeled after a beautiful bust of which he owned a version and which was likewise believed—alas, also mistakenly—to be of Seneca.

Rubens' drawing of the Roman *Lupa* (Fig. VIII.7) is, again, of highest interest, for several reasons. It is the only one of the Ambrosiana drawings which bears inscriptions. One of these, running along the lower edge, is in Padre Resta's hand[23] and gives the kind of information he was fond of supplying: "il Bellori nella vita di Rubens parla della sua eruditione, e come arnava i suoi studij di pittura con Poesie, e con versi di Virgilio et altri Poeti; in segno di che si osservina li sud[ti] versi di Virgilio da lui qui trascritti, de la lupa romana."

The other inscription is from Rubens' own hand as Padre Resta correctly recognized. Rubens quotes here the lines from Virgil's *Aeneid* (VIII, 630-634) in which the poet describes precisely the subject of the drawing as part of the prophetic decorations Vulcan had applied to Aeneas' shield:

> fecerat et viridi fetam Mavortis in antro
> Procubuisse lupam geminos huic ubera circum
> Ludere pendentis pueros Et lambere matrem
> Impavidos, illam tereti Cervice reflexa
> Mulcere alternos et Corpora fingere lingua.[24]

Rubens' model was not the celebrated bronze of the standing she-wolf, or any of its derivatives, but the rendering of the theme that forms part of the large marble group of the *Tiber* (Louvre, Fig. VIII.15). In Rubens' time the *Tiber* was one of the famous antiquities in the Vatican Belvedere. That Rubens had known this work had been evident from the painting in the Capitoline Gallery (Fig. VIII.16), although to the best of my knowledge this has never been specifically stated.[25] The drawing in Milan clearly formed the basis for the painting; a comparison permits us to observe Rubens' attitude toward his sources in a particularly instructive example.

As the drawing shows, and any examination of the ancient sculpture in Paris confirms, the group of the *Lupa* was sadly mutilated. The she-wolf had lost its snout and ears; both children were without heads; each had lost one arm and one of them large portions of his legs as well. (All these parts have now been restored, but the lines of the old breaks are clearly visible.) Rubens drew the group in great detail, in what we may call a frontal view (which shows the Lupa from her left side); he also sketched the head of the animal a second time, rendering it more *de face*. Instead of indicating, however, the form of the river god behind this group, Rubens set it against a background of tall reed grasses, a theme he developed more fully in the setting of the Capitoline painting.[26]

The position of the she-wolf in the painting follows fairly closely that of the ancient

marble. The differences lie mainly in the left paw, which is less sharply bent backward, and the hind legs, which are more comfortably stretched out. Yet precisely as Rubens had specified in his famous fragment *De Imitatione Statuarum*[27] that the painter adopting classical figures ought to translate marble into human flesh with all its coloristic subtleties, so here he changed the rather short-cropped animal of the Roman sculpture into one covered with ample and soft fur. Enriching, as he did also in other instances,[28] the plastic prototype with observations from nature, Rubens endowed his model with the immediacy of life and in doing so absorbed his borrowings completely into the *élan vital* of his art.

Nor did he follow the ancient marble in the arrangement of the children. He used both of them in almost identical poses, but in reverse, and they have traded places, as it were. Thus the one sitting up is farther from the watchful head of the animal, while the one reclining and suckling is nearer to it. The reason for this change is obvious. Since Rubens made the center of interest what in the Tiber group had been only a marginal element, he felt the need of creating a composition in which the elements were neatly balanced. Indeed, the group of the *Lupa* with Romulus and Remus in the Capitoline painting forms part of a grand compositional curve from the river god at the left to the astonished farmer approaching from the right.

However, there is probably still another reason for this change. Virgil's text, which Rubens had inscribed on his drawing, specifically describes the animal as "licking the children into shape." In the Louvre marble and in Rubens' drawing based on it, the children are placed too far from the animal's head to serve as a literal illustration of these words. By the ingeniously simple device of reversing the order of the children, Rubens eliminated this interval. Nor did he omit the licking tongue of the wolf, a detail not considered by the later, and less erudite, restorer of the Louvre group.[29]

Analogy with the previous drawings and internal evidence both suggest that the last drawing, too, was done from a classical sculpture (Fig. VIII.8). The main figure, an elderly but athletic man, in a reclining position, was drawn twice from slightly different angles. He probably held a drinking vessel in his right hand. A younger companion lying behind him supports the older man's right wrist, while placing his left hand familiarly on his partner's shoulder. Both figures are draped with or rest on animal skins, in one case surely a lion's.

Despite the generous assistance of several archaeologists,[30] I have been unable to identify Rubens' models. Not even a search in early engraved books of ancient sculpture and in the various drawn records of classical remains yielded any tangible results. The river god in the upper center resembles one of the two famous river gods on the Capitol, although there are a few discrepancies.

It is fairly certain, however, that the main group depicted the drunken Hercules. Both the vigorous build of the man and the large lion's paw of the skin on which he reclines argue in favor of this theory. The theme is one frequently treated in ancient art.[31] The

companion draped with the skin of a much smaller animal (leopard?) was probably a satyr. The Bacchic associations of the scene are reinforced by the faun's head peeping out from behind "Hercules."

Whatever the model, it was probably a piece of some prominence. Rubens normally did not go out of his way to study obscure objects. Moreover, although damaged, it was obviously a work of considerable artistic merit. One wonders whether it might not also have influenced some of Michelangelo's reclining figures such as those of the Medici tombs, especially Evening and Night, or even Raphael's river god in the *Judgment of Paris*, engraved by Marcantonio Raimondi.

An echo of this figure is found in Rubens' paintings of Lot and His Daughters (KdK 40) and the Birth of Maria de' Medici (KdK 244). The grinning faun's mask resembles, among others, the satyr in the upper right of the painting *Nature Attired by the Three Graces* (KdK 61) and the similar figure in the *Drunken Silenus*.[32] In his foreword Padre Resta spoke of this sheet rather vaguely as "li fiumi," although only one figure was actually taken from a river god. The fact that even Resta was vague about Rubens' prototype could mean that by 1684 the model was no longer commonly known. We may perhaps discover it one day in an out-of-the-way place, unless it has actually been destroyed. For the professional archaeologist this sheet should therefore be of the highest interest.

Stylistically, Rubens' drawings at the Ambrosiana represent a rather close-knit group. This is of importance for the problem of dating them. In their discussion of the Laocoön drawing in Dresden, Burchard and D'Hulst avoided the issue of a date. Victor H. Miesel[33] alone has assigned an approximate and, I feel, correct date to that work.

It cannot be doubted that Rubens made these copies of ancient sculpture in Rome in front of the originals. He was there in 1602-1603 and again, with interruptions, from at least November 1605 until his departure in October 1608. It is likely that he studied ancient monuments whenever he had the time and opportunity. Thus, theoretically, such drawings as those in the Ambrosiana could have been done during his first as well as his second Roman period. If I follow Miesel in dating the Dresden *Laocoön* and by implication all the Ambrosiana drawings in the later Roman years, I do it for several reasons. First, we notice among Rubens' drawings of classical sculptures a group that is less self-assured and less plastic than the Milan-Dresden group. Among them are the Chicago sheet jokingly identifying two figures from a sarcophagus as "Socrates" and "Xantippe,"[34] the copy of the Belvedere torso,[35] the Dubaut Hercules mentioned before, and possibly the drawing of Mars and Venus in Leningrad.[36] If these drawings are dated in the early Roman period, we are practically forced to place the Milan-Dresden group in the second. Considering that toward the end of his Italian period Rubens' art moved toward a dramatic and passionate style, culminating in his paintings of about 1608-1612, a date of 1606-1608 for these drawings would seem to be the most appropriate.

Such a date can perhaps be supported by an observation made by one of my students, Gary Goldberg. Assigned the problem of determining precisely which version of the

classical reclining Hermaphrodite Rubens copied in the drawing in the Walter C. Baker collection, Goldberg established that it must have been the piece which in the seventeenth century was in the collection of Scipione Borghese and is now in the Louvre.[37] It was found in 1608 when the excavations were made for the Church of Santa Maria della Vittoria.[38] Rubens' drawing hence cannot have been done before 1608 and probably dates precisely from that year. As the only drawing of this kind for which a *terminus post quem* can be established, the Baker sheet assumes a key position in the chronology of Rubens' drawings after the antique. It lends additional support to the dating of the Milan-Dresden group proposed here.[39]

NOTES

1. The drawings published here were discovered and identified in 1955 by Dr. Giorgio Fubini, consultant for drawings at the Ambrosiana. [In recognition of this discovery as well as his having provided the photographs of the album, this article was originally printed under both Dr. Fubini's and my name. Dr. Fubini, however, left me complete liberty to deal with the scholarly aspects of the problem and took no part in the writing of the article.] I should like to thank Dr. Karel G. Boon for having first drawn my attention to this group of works, and Dr. Paul Oskar Kristeller and Dr. Sheila Edmunds for having provided me with some pertinent information before I had the opportunity to examine the originals myself.

2. Joseph Meder, *Die Handzeichnung*, 2nd ed., Vienna, 1923, pp. 647, 654.

3. A. E. Popham, "Sebastiano Resta and His Collections," *Old Master Drawings*, XI, 1936, pp. 1-19.

4. Dr. Fubini informs me that no such drawing is known in the Biblioteca Ambrosiana, nor does he know an engraving like the one mentioned by Padre Resta.

5. See Popham, "Sebastiano Resta," p. 14.

6. The Landsdowne manuscripts are copies made by the Richardsons of Padre Resta's original writings. In Lansdowne 803, page 36 and again page 85 verso, Resta gives the date of Habé's birth as 1599—transferring, I suspect, with his usual carelessness, the date of Van Dyck's birth to his pupil. No "Habé" is known from conventional sources. Popham hazarded the guess that he was Hendrick Abbé, a painter inscribed in 1676 in the guild in Brussels. This identification is most unlikely, since Abbé was born in 1639 and hence could not have been a pupil of either Rubens or Van Dyck. Nor is he known to have visited Italy. A more likely candidate, I believe, is Gilles Hallet, born in Liège in 1620, who executed a number of frescoes in Rome (especially in S. Maria dell'Anima) and died there in 1694. See Thieme-Becker, *Allgemeines Lexikon der bildenden Künstler*, XV, p. 522, and Leo van Puyvelde, *La peinture flamande à Rome*, Brussels, 1950, pp. 124-126. In

Rome he was known as Monsù Alé Liegese. [In their book on *Rubens Drawings* (Brussels, 1963, p. 183), L. Burchard and R.-A. d'Hulst identified "Habé" with Gelande Habert, a Brussels dealer in paintings who was visited in 1687 by Nicodemus Tessin. Tessin spelled the name "Abber." This identification was accepted by Michael Jaffé, "Rubens as a Draughtsman," *Burlington Magazine*, CVII, 1965, p. 381.]

7. The London drawing, indeed, is ingeniously made up of different Michelangelesque figures in new combinations. [See Figs. 2 and 3 of the original version of this article for the Milan and London drawings.]

8. See Julius S. Held, *Rubens, Selected Drawings*, London, 1959, p. 16.

9. Gustav Glück and Franz Martin Haberditzl, *Die Handzeichnungen von Peter Paul Rubens*, Berlin, 1928, no. 1.

10. Held, *Selected Drawings*, nos. 3, 4, and 7. I owe to Dr. Müller Hofstede the information that the inscription on the *Entombment* in Rotterdam (Held, no. 4), examined in ultraviolet light, has been found to read: "focus hic ad miscendum et mirram et aloen."

11. See G. Falck, "En Rubenselevs Tegninger," *Kunstmuseets Aarsskrift*, 1918, p. 64, and Held, *Selected Drawings*, pp. 13 and 48-51.

12. See Burchard and D'Hulst, *Rubens Drawings*, no. 15, p. 32: "The only original study by Rubens after the Laocoön group so far known." In Heemskerck's famous sketchbook in Berlin there is a view of Laocoön from the same angle (Christian Hülsen and Hermann Egger, *Die römischen Skizzenbücher von Marten van Heemskerck*, Berlin, 1913, I, folio 39 recto), but this is probably sheer coincidence.

13. See Held, *Selected Drawings*, p. 51.

14. In light of these drawings, the theory expressed by Burchard and D'Hulst (*Rubens Drawings*, p. 33) that Rubens may have made his drawings of the Laocoön group from a plaster cast should probably be rejected.

15. See A. Brandi, "La fortuna del Laocoonte dalla sua scoperta nelle terme di Tito," *Rivista dell'Istituto Nazionale*

d'Archeologia e Storia dell'Arte, n.s. III, 1954, p. 78, and Filippo Magi, "Il ripristino del Laocoonte," *Atti della Pontificia Accademia Romana di Archeologia*, III, 1960.

16. With minor changes this is also the condition shown in Jan de Bisschop's (Episcopius) prints; see *Signorum veterum icones*, The Hague, 1669, pls. 16-17.

17. See *Rubens-Tentoonstelling*, Amsterdam, 1933, no. 94.

18. See *Flemish Paintings & Drawings at 56 Princes Gate*, London, 1955, p. 85, no. 53.

19. See Ludwig Burchard in *Catalogue of the Rubens Exhibition at Wildenstein's*, London, 1950, nos. 8 and 9, and Held, *Selected Drawings*, pp. 113-114, no. 48.

20. Two of them have interesting inscriptions: "het princepael van dese figuer hebbe ick gehaelt vant cantoor ende dit is Ceneca" (III, 28); "Dit is oock ceneca di ick het princepael vant cantoor hebbe gehaelt desen is heel goet" (III, 30).

21. See Glück and Haberditzl, *Die Handzeichnungen*, no. 26, and M. Dobroklonski, *Risunki Rubensa*, Moscow, 1940. One of the Leningrad drawings was offered for sale in Leipzig, April 29, 1931 (see H. F. Bouchery and F. van den Wijngaert, *P. P. Rubens en het Plantijnsche Huis*, Antwerp, 1941, p. 78, note 2), but was apparently not sold. Padre Resta may have been thinking of two of these drawings when he said in his introduction that he knew of two other drawings by Rubens after this figure which had fallen into other hands but which he hoped to be able to acquire later. Given his general enthusiasm for drawings, it is interesting to note that he did not particularly care for this piece.

22. See Jan-Albert Goris and Julius S. Held, *Rubens in America*, New York, 1947, no. A100. Contrary to the view expressed there, I now believe that the drawing is entirely by Rubens' hand. It was made for the engravings by Cornelis Galle, published in *L. Annaei Senecae Philosophi Opera quae exstant omnia*, ed. I. Lipsius, Antwerp, 1615 (2nd ed., 1632). The Milan drawing, curiously enough, must have been known to Franz Martin Haberditzl. In the collection of photographs which this author acquired from his widow, there was one of the Ambrosiana *Seneca*, taken by Cesare Sartoretti of Milan. No further information, however, was found on it. Haberditzl apparently never pursued this lead.

23. His manner of "hugging" the margin is also seen in an album recently acquired by the Morgan Library.

24. "He had fashioned, too, the she-wolf outstretched in the green cave of Mars; around her teats the twin boys hung playing, and mouthed their foster-mother without fear; she with sleek neck bent back, licked them by turns and shaped their bodies with her tongue."

25. See F. Freiherr Goeler von Ravensburg, *Rubens und die Antike*, Jena, 1882, p. 171.

26. The landscape in the Capitoline picture, as Oldenbourg suggested, may have been painted by Jan Wildens.

27. See Goeler von Ravensburg, *Rubens und die Antike*, p. 195.

28. See, for instance, the case of the Amsterdam and London drawings of a lioness (Michael Jaffé, "Rubens en de leeuwenkuil," *Bulletin van het Rijksmuseum*, Amsterdam, 1955, no. 3) where Rubens derived the movement from a Paduan bronze but successfully camouflaged his borrowing with naturalistic detail based on his observation of live animals.

29. Another variant of the group is rendered on the title page, designed by Rubens, of Jacob Biaeus [de Bie], *Numismata Imperatorum Romanorum*, Antwerp, 1617, and used again for Ludovicus Nonnius, *Commentarius in Nomismata, Imp. Iulii, Augusti et Tiberii*, Antwerp, 1644.

30. I am indebted to Professors Bieber, Brendel, Harrison, and von Blanckenhagen, as well as to Dr. Phyllis Pray Bober and Dr. Andrew Oliver for assisting me in this search. Dr. Oliver pointed out to me that the large figure of Hercules in repose in the Museo Chiaramonti (no. 733) may originally—before the later restoration—have looked more like the presumed model of Rubens, but there remain too many discrepancies between the two works for the Roman figure to have actually served as that model.

31. See, among others, E. Löwy, "Scopa Minore ed il simulacro di Ercole Olivario," *Römische Mittheilungen*, 1897, pp. 56-70 and 144-147.

32. See Hans Gerhard Evers, *Rubens und sein Werk, Neue Forschungen*, Brussels, 1943, fig. 256.

33. Victor H. Miesel, "Rubens' Study Drawings after Ancient Sculpture," *Gazette des Beaux-Arts*, LV, 1963, p. 311.

34. See Held, *Selected Drawings*, no. 160, pl. 169.

35. See *Rubens-Tentoonstelling*, no. 93.

36. See Burchard and D'Hulst, *Rubens Drawings*, fig. 13. I cannot share the doubts about the authenticity of this piece expressed by Miesel ("Rubens' Study Drawings," p. 319).

37. Hitherto it had been assumed that the Hermaphrodite now preserved in the Uffizi had been Rubens' model; see *Drawings & Oil Sketches by P. P. Rubens from American Collections*, exhibition catalogue, Fogg Art Museum and Pierpont Morgan Library, 1956, no. 1, pl. II, and Claus Virch, *Master Drawings in the Collection of Walter C. Baker*, New York, 1962, no. 43.

38. See M. Armellini, *Le chiese di Roma dal secolo IV al XIX*, Rome, 1942, pp. 333 and 383, and U. Donati, *Carlo Maderno*, Lugano, 1957, p. 48.

39. Clearly connected with the group of drawings published here is another one, familiar to specialists but curiously enough never before reproduced despite its prominent place of preservation. This is a sheet in the British

Museum (Hind, II, 1923, no. 51; black chalk, 413 × 262 mm.), reproducing Silenus leaning against a tree (Fig. VIII. 17). Two ancient marbles have been preserved representing this type, one in the Munich Glyptothek, the other—already mentioned in this context, although only tentatively, by Hind—in the Staatliche Kunstsammlungen, Dresden. I am grateful to Dr. M. Raumschüssel, the Director of the Dresden Skulpturensammlung, for a photograph of that piece, taken from about the same angle as the Rubens drawing; there seems to be little reason to doubt that this was indeed Rubens' model (Fig. VIII. 18). The figure came to Dresden in 1728 with the collection of antiquities of Prince Agostino Chigi of Rome; from the evidence of Rubens' drawing we can now state that it must have been in Rome as early as the beginning of the seventeenth century. Today all old restorations have been re-moved; they include the legs from below the knees, and the tree trunk, still visible in our photo. When Rubens drew it, the left hand evidently had also been restored. As he did in other cases, Rubens rendered the figure somewhat more broadly and with more swelling contours but essentially faithfully, even to details of hair and beard.

The London Silenus, too, was copied by one of the artists of the Copenhagen copies. It is a piece of exceptional quality (Fig. VIII. 13). An attentive comparison undoubtedly confirms the superiority of the London sheet, but the similarity of the two drawings is uncomfortably close. The case is instructive and ought to serve as a warning. I, for one, am not sure that I might not have been willing to defend the originality of the Copenhagen drawing if it had been the only one preserved.

RUBENS' *HET PELSKEN*

WHILE in art history the writings of scholars may not always make a contribution toward the understanding of works of art, they always throw light on the personal interests and idiosyncrasies of the art historians themselves. The two problems, indeed, are obviously connected with each other. The more we perceive how art history is affected by the specific attitudes and prejudices of the writers and the thought patterns current at the time, the greater will be our reluctance to accept their verdict without qualification. Today it is easy to recognize typical nineteenth-century attitudes in much of the art historical writing produced at that time. But it is equally certain that those who follow us will know to what extent our own studies are colored and our own image of history distorted by the tastes, pet theories, and popular scientific notions to which we have fallen heir.

In the meantime, we may derive a bit of innocent merriment from the examination of our ancestors' pitfalls in art scholarship.[1] In the beginning of the present paper, I should like to examine the views expressed in art historical literature on an illustrious example of Flemish seventeenth-century painting: the portrait by Rubens of Hélène Fourment, preserved in Vienna and commonly known as *Het Pelsken*, or *La Petite Pelisse* (Fig. IX.1).

The title of the picture goes back to Rubens himself. In his will[2] he stated that the painting known as *Het Pelsken* should go to his wife "sonder iet daervore te geven oft intebrengen."[3] Although the pedigree of the Vienna painting does not go back further than a painted inventory (a gallery picture) of 1730,[4] no one has ever questioned that it is indeed the painting referred to in Rubens' will, and I, too, consider the identity established as beyond any reasonable doubt.

Ever since its appearance in the Vienna Collections, the painting has occupied an honored place in Rubens' work. No serious biographer has ever failed at least to mention it, and it also figures frequently in popular writings. To the best of my knowledge, it has never

Reprinted from *Essays in the History of Art Presented to Rudolf Wittkower*, London, Phaidon, 1967, pp. 188-192.

been taken for anything but a somewhat unusual, possibly daring, portrait of Hélène Fourment. Most writers have praised the beauty of colors and the sympathetic portrayal of young womanhood, but they have disagreed in a number of points. In the older literature (Smith, Van Hasselt, Voorhelm Schneevoogt, Engerth, Burckhardt, and Hourticq[5]) she is generally described as going to the bath. Others (Michel, followed by Rea, Bode, and Van Puyvelde[6]) maintain that she is coming from the bath. Although they differ on whether it was before or after the bath, both Hourticq and Van Puyvelde agree that Rubens surprised Hélène on her way and painted her while the impression was still fresh. Gustav Glück[7] is sure that she is neither going to, nor coming from, the bath, "as is occasionally assumed"—for what woman would wrap herself in a fur coat on such an occasion? Yet he, too, believes that we owe this masterwork to a lucky accident: "during a pause between modeling, Hélène may have wrapped herself into a fur coat in order to get warm. This may have aroused in Rubens a recollection of . . . Titian's girl in a fur coat, now also in the Vienna gallery. . . . The accidental view of the magnificent youthful body brilliantly standing out from the soft background of the dark fur and the red carpet combined with that recollection of Titian's half-length picture, may have given Rubens the idea of painting his Hélène once entirely for his own pleasure." Who would not recognize in the theory that credits the genesis of *Het Pelsken* to a lucky visual accident a characteristic late nineteenth-century concept about the purely sensory character of artistic inspiration common to artists and art historians alike?[8]

Writers have disagreed on other points. Rooses, who thought that this may have been the very first portrait painted by the master of his bride, describes her breasts as "young and firm."[9] This may have been an implied retort to Michel's statement that Hélène's flesh "lacks its former firmness." Since he dated the painting rather late (about 1638), Glück, too, sees the flesh as "ein wenig schlaff," and suggests that the breasts need the support of the arm. (He also thinks that Hélène here appears slenderer than in earlier portraits, and attributes her loss of weight to her many pregnancies.) Several authors (Michel, Verhaeren[10]) dwelled on the marks left above the knees by the garters as signs of Rubens' unsparing realism. Rooses thought her feet deformed, from wearing shoes that were too tight.[11] Madame Bouchot-Saupique[12] recognizes Rubens' "objectivity," which prompts him to render "des détails anatomiques peu esthétiques." Leo van Puyvelde sees in the picture Rubens' "swan song," although this image is slightly blurred when he calls the work "un cri vigoureux d'amour," and, yielding to no one for colorful writing, describes "ces plis de chair lymphatiques, ces fossettes grassouillettes, ces genoux gonflés." Occasionally Rubens is even accused of a "positive depravity in taste," for seeking beauty in ugliness.[13]

Critics were sometimes troubled by the artist's willingness to paint his wife in a rather intimate view. Rooses could not help reproaching Rubens for a certain indelicacy, but justifies the portrayal by the husband's pride (did he think of the story of ill-fated Candaules?) in letting others see and appreciate the treasure he himself possessed.[14] By contrast, he recognizes in Hélène's face a somewhat bashful expression ("l'expression un peu

gênée"). This again is almost like an answer to Michel's statement that Hélène shows no sign of embarrassment or shame;[15] Verhaeren tries to have it both ways, for he sees in her expression a mixture of modesty and immodesty. Cammaerts,[16] aware of the gulf between Rubens' painting and official English taste, believes that the beholder needs "racial sympathy," in other words, some Flemish gusto, to appreciate fully the Vienna canvas. At any rate, most scholars are relieved to know that the picture was never meant to be sold, but was willed by the master to Hélène as her personal property.

While most writers of the late nineteenth and early twentieth centuries are concerned with the outward appearance of Hélène, frequently giving descriptions that are literally no more than skin deep, and, as did Vanzype,[17] justify this approach on the basis of the supposed shallowness of Hélène Fourment, a somewhat different attitude is taken by Evers.[18] He finds in the picture something comparable to the feminine "Zauber" and "Unergründlichkeit" of Leonardo's Mona Lisa. His is a poetic description of Hélène's appearance: she cradles her breasts in her arms like a child; her legs are covered with the artist's tenderness, a necessary attitude of the painter in view of the fact that Evers, too, believes that Hélène was basically a homely woman. At any rate, Evers was the first specifically to reject the "surprise" theory when he states: "Surely such a picture is not due to improvisation, but matured slowly." Even he, however, fails to ask whether the painting is really no more than an intimate portrayal of Hélène Fourment.

Such a question involves a simple iconographic problem: whether or not the Vienna panel is unique in the choice of its subject. Before we examine this problem, it is useful to stress one observation that, as far as I can see, is mentioned nowhere in the literature. All descriptions and especially those based on the "surprise" theory tacitly assume that Rubens painted Hélène indoors, either in a room near the bath (although we may wonder if Rubens' house had a special "bath" room), or in the studio. This assumption is contradicted by the evidence of the picture itself. On the right we see, if only vaguely, the forms of a fountain with water gushing from a lion's mouth. At the left are horizontal streaks of light which seem to indicate a sky. Hence, despite the pillow and the carpet, the setting is out-of-doors.[19] (All old photos as well as the graphic renderings such as the one by Paul Gleditch[20] show a uniformly black background, which makes understandable the failure of all interpreters to see this important detail.)

With the setting plainly characterized as out-of-doors, all the romantic notions about the genesis of the picture (including Van Puyvelde's sentimental "il peint une dernière fois sa chère Hélène") fall to the ground. A portrait of a nude Hélène standing near a fountain out of doors makes no sense unless the true meaning of the picture can be shown to be structured in a more complex fashion. We must ask whether, besides being a portrait of Hélène, it may also render another type of subject.

Three themes, all of them frequently rendered in art, qualify for the basic iconographic elements of the picture: Bathsheba, Susanna, and Venus. An unknown artist of Rubens' school (possibly Justus van Egmont) indeed used the theme of a nude figure draping herself

in a fur coat for a Bathsheba. She is identified beyond any doubt by a young Negro messenger who is handing a letter to her. Rubens' painting has no such detail, nor does the setting suggest the vicinity of a palace, from which the woman could have been seen. The Bathsheba story, hence, is a rather unlikely literary base for *Het Pelsken* and can safely be eliminated.

It is a different case with Susanna. Contrary to Bathsheba, Susanna is a proverbially chaste figure, so that Hélène's pose of modesty would not be inappropriate. The choice of Susanna as a disguise for Hélène would even make a certain psychological sense, considering the age difference between Hélène and her illustrious husband, comparable to the one between Susanna and the Elders. Moreover, there exists a print by Jan Collaert after Marten de Vos (Fig. IX.2),[21] probably known to Rubens, which renders Susanna in terms surprisingly similar to those of *Het Pelsken*. Like Hélène, Susanna stands before us in full length, and largely nude, only flimsily covered by a bit of a shirt and an elegantly trimmed fur-lined coat draped over her shoulders. (It is perhaps worth noting that the fur coat in *Het Pelsken* is not made like a modern coat with the fur worn outside. The coat is clearly a dark velvet coat *lined* with fur.) The sleeves of this coat hang down on either side of the figure as they do in *Het Pelsken*, and Susanna's head, like Hélène's, is turned toward the right shoulder. Thus it is quite possible that De Vos' print played a role in the formal genesis of the Vienna painting. Iconographically, however, there remain considerable differences. De Vos' figure is the image of chastity and with her hands folded in prayer, and her heavenward glance, a symbol of confidence in God. Hélène, by contrast, is worldly and seductive, and there is no hint of any impending danger.

There remains the classical theme of Venus, and all the evidence indeed points to it as the correct identification. While it is not always easy to establish Rubens' familiarity with specific ancient works of art, there is no doubt that he knew thoroughly all that ancient writers, above all Pliny, had to say about the creations of the great masters. Like other artists of the Renaissance and the Baroque, he was influenced not only by what he had seen of ancient art, but also by what he read about it. It is fortunate that we have his own words for this aspect of his study of the ancients. On August 1, 1637, he wrote to Franciscus Junius (1589-1677), who had sent him a copy of his book *De Pictura Veterum*, that a similar book ought to be written about the Italian painters.[22] He maintains that things which can be seen physically make a deeper impression than those "which can be perceived only in the imagination, like dreams, and imperfectly outlined by words; apprehended in vain, they elude us often (like Eurydice's image Orpheus) and thwart our hopes."[23] He then continues, "I speak from experience. For how few of us, trying to reconstruct for the sake of its dignity, a famous work, by Apelles or Timanthes, graphically described by Pliny or other authors, will not produce something tasteless or foreign to the majesty of the ancients? Each one following his own talent will offer a new wine for that bittersweet *Opimianum* [a celebrated wine of the vintage of A.U.C. 633 when Opimius was consul] and will do an injustice to those great souls whom I follow with the highest

veneration; and while I adore their vestiges, I am not ingenuous enough to claim that I could equal them, not even in thought."

No wonder that a good many subjects treated by Rubens can be linked to themes listed by Pliny as the works of ancient artists. The theme, often painted by Rubens, of nymphs surprised by satyrs evokes Pliny's reference to a picture by Nicomachus, showing Maenads with Satyrs stealing upon them (XXXV, 109: Nobiles Bacchas obreptantibus Satyris). In a lost painting, for which we have, however, a magnificent drawing, Rubens painted the Death of Hippolytus—the same subject Antiphilos is said to have painted (XXXV, 114: Hippolytum tauro emisso expavescentem). Another classical subject, treated by Rubens, is mentioned by Pliny as the theme of a work of Athenion of Maroneia (XXXV, 134: Achilles in the guise of a maiden at the moment of detection by Ulysses).

When he painted Count Lerma on horseback, showing both rider and horse *en face*, he may have remembered paintings by Pordenone and possibly El Greco. Yet without Pliny's mention of a painting by Apelles showing Antigonus in armor, advancing with his horse (XXXV, 96), Rubens might not have thought of applying to a portrait a compositional scheme that had hitherto been used only in narrative context.

According to Pliny, Parrhasius had painted a picture of two boys "whose features express the confidence and the simplicity of their age" (XXXV, 170: pueros duos in quibus spectatur securitas et aetatis simplicitas). This indeed seems to be the theme of the portrait of Rubens' two sons in the Liechtenstein collection. One might even go so far as to say that Rubens depicted more *securitas* in the older boy, more *simplicitas* in the younger.[24]

In the light of this evidence, it is certain that Rubens knew well Pliny's reference to that work which "excelled all works of art in the whole world" (XXXVI, 20), the Cnidian Aphrodite of Praxiteles. Its powerful attraction had been described tellingly in the *Erotes* (formerly attributed to Lucian), and witty poems in its honor were still written at a later date.[25] Though he may not have had a very correct idea of her appearance, Rubens surely knew that she was standing and undressing to take a bath.[26]

If *Het Pelsken* was indeed stimulated by what Rubens knew about the Cnidian Aphrodite, it is also obvious that at least in regard to the position of her arms, his notion of the figure was influenced by other, more familiar classical Aphrodite types, such as the Venus Medici (Uffizi, formerly in the Villa Medici), or the Capitoline Venus.[27]

The theory that the painting renders Hélène Fourment in the role of Aphrodite finds support in a composition known to me in two nearly identical versions. One of them, apparently the better of the two, is in the Gallery at Potsdam-Sanssouci (Fig. IX.3). The other belonged, in 1949, to the Conde de Adanero in Madrid. The paintings, reminiscent of the style of Sustermans, portray a lady very much as Rubens had portrayed Hélène Fourment in *Het Pelsken*. Here, too, the model is naked and only lightly draped in a fur-lined coat, and she also looks at the beholder, though we see her from the left instead of the right. The picture is obviously a portrait of a definite individual, and there is a slight possibility that she is Vittoria della Rovere of Tuscany (1622-1694), the wife of Grand

Duke Ferdinand II.[28] Whoever she was, one thing is obvious: she is unmistakably cast in the role of Venus, since she is accompanied by Cupid, complete with wings and arrow-filled quiver, playfully tempting a fuzzy lapdog with some titbit. Moreover, the mirror standing on a table at the right is often, as we shall see, an object associated with Venus.[29]

That the "Sustermans" painting is derived from *Het Pelsken* no one can possibly doubt, though Rooses clearly went too far when he called it a copy.[30] The picture, at any rate, proves that the meaning of Rubens' painting, Hélène Fourment in the guise of Venus, was perfectly understood by contemporaries. If it is reasonable, on the basis of the foregoing discussion, to give both De Vos' engraving of Susanna and Praxiteles' Cnidian Aphrodite (and some of her derivatives) a place in the genesis of *Het Pelsken*, we must consider yet another source. It has always been realized that Rubens' painting was decisively influenced by Titian. Titian, more than once, had increased the glamour of a lovely female body by using a fur-lined garment as a coloristic relief. The picture closest to *Het Pelsken* is Titian's *Woman in a Fur Cloak* in Vienna, a painting which was in the collection of Charles I and in Rubens' time hung in his Privy Lodging Rooms.[31] Undoubtedly, Rubens had seen it during his extended visit to London in 1629-1630. The motif of the nude body enshrined, as it were, by a fur coat, also occurs, however, in the painting by Titian now in Washington (formerly in the Hermitage), showing Venus as she admires herself in the mirror, held by Cupid. Rubens painted a version of this theme that is clearly derived from such a Titianesque prototype, though not necessarily from the picture in Washington. That canvas is now in the Thyssen Collection in Lugano and is probably identical with a painting listed as no. 48 in the inventory of Rubens' estate, as the last of eleven pieces which Rubens had copied after Titian: "Venus qui se mire avec Cupidon"[32] (Fig. IX.4).

The painting at Castle Rohoncz was dated by Ludwig Burchard about 1610-1615, which seems to me much too early. It could hardly have been done before the 1620s. Rubens, however, had indeed dealt with the theme of Venus looking into the mirror at an early period in a painting in the Liechtenstein Collection at Vaduz (KdK 101).[33] That painting, of which Velasquez may have had some knowledge when he painted the Rokeby Venus in London, brings us back once more to *Het Pelsken*.

In the Liechtenstein picture Venus, sitting at the right, is seen from the back, and the mirror is held in such a way that we see her face reflected in it slightly turned to the left. If Venus were actually looking at her own face, it would have to appear in the mirror turned to the right rather than the left. Actually, Venus is not looking at her own reflection. Rather, she uses the mirror to glance at and communicate with somebody outside, whoever he may be.

In a brilliant discussion of English eighteenth-century portraiture,[34] Edgar Wind commented on the difference between English eighteenth-century portraits "in disguise" and Rubens' use of Hélène Fourment as a model for a Saint Cecilia or an Andromeda. He claims that our knowledge of the true identity of his model is hardly indispensable for a proper understanding of such works by the master. Yet it is dangerous to generalize. In the case

of *Het Pelsken* the knowledge that Hélène Fourment was painted in the role of Venus certainly gives a richer meaning to the painting than straight portrayal would have. Hélène Fourment was, after all, not only "the perfect, if mortal, representative of a certain type of beauty" (Wind) but the artist's young wife. He could hardly express his affection for her more aptly than by painting her in the role of the goddess of love and of beauty. It was obviously a "natural" disguise, and Hélène appears more than once in this role, especially in the great painting of the Judgment of Paris in Madrid (KdK 432), a fact duly appreciated by the Cardinal Infante Ferdinand when he wrote to the king: "Venus in the center is a very good likeness of his [Rubens'] own wife, who without doubt is the most beautiful woman in this city" (*que sin duda es lo mejor de lo que ahora hay aqui*).[35]

As Venus had done in the early Liechtenstein panel, Venus-Hélène looks out of the canvas called *Het Pelsken* but without recourse to the subterfuge of a mirror. Frankly facing the beholder, she may well have found herself mirrored in the loving and admiring eyes of her devoted artist-husband.

NOTES

1. For the romantic interpretation of Van Dyck's portrait of Charles I in the Louvre (*Le Roi à la Ciasse*), see my article of 1958 [reprinted above, Chapter VI].

2. See J. Denucé, *De antwerpsche konstkamers*, Antwerp, 1932, p. 80, CVI.

3. The legal terms mean that she receives the painting free of any obligation toward the estate.

4. Storffer, *Gemaltes Inventarium*, II, 1730, no. 101, now preserved in the Direktion of the Vienna Gemäldegalerie.

5. John Smith, *A Catalogue Raisonné of the Works of the Most Eminent Dutch, Flemish, and French Painters*, II, London, 1830, p. 94, no. 300; A. van Hasselt, *Histoire de P.-P. Rubens*, Brussels, 1840, p. 331, no. 1035; C. G. Voorhelm Schneevoogt, *Catalogue des estampes gravées d'après P.-P. Rubens*, Haarlem, 1873, p. 165; Eduard R. v. Engerth, *Kunsthistorische Sammlungen des Allerhöchsten Kaiserhauses, Gemälde, Beschreibendes Verzeichnis*, II, 1884, p. 402, no. 1181; Jacob Burckhardt, *Recollections of Rubens*, trans. Mary Hottinger, ed. Horst Gerson, New York, 1950, p. 40; Louis Hourticq, *Rubens*, New York, 1918, p. 132.

6. Emile Michel, *Rubens, His Life, His Work, and His Time*, New York, 1899, II, pp. 175-176; Hope Rea, *Peter Paul Rubens*, London, 1905, p. 107; Wilhelm von Bode, *Die Meister der holländischen und flämischen Malerschulen*, 4th ed., Leipzig, 1923, p. 332; Leo van Puyvelde, "Les portraits des femmes de Rubens," *Revue de l'art ancien et moderne*, LXXI, 1937, pp. 1-24.

7. Gustav Glück, *Rubens, Van Dyck, und ihr Kreis*, Vienna, 1933, p. 128.

8. See, for instance, Emile Zola, *L'Oeuvre*, Le Livre de Poche, pp. 16-17.

9. Max Rooses, *L'Oeuvre de P.-P. Rubens*, IV, Antwerp, 1890, no. 944, pp. 166-168.

10. Emile Verhaeren, *Rubens*, trans. Stefan Zweig, Leipzig, 1913, p. 51.

11. Max Rooses, *Rubens, sa vie et ses oeuvres*, Amsterdam, 1903, p. 502.

12. Madame Jacqueline Bouchot-Saupique, *Hélène Fourment*, Paris, 1947.

13. Rea, *Rubens*, p. 108.

14. Rooses, *Rubens*, p. 502.

15. Michel, *Rubens*, p. 175.

16. Emile Cammaerts, *Rubens, Painter and Diplomat*, London, 1932, p. 257.

17. G. Vanzype, *Pierre-Paul Rubens*, Paris, 1926, p. 74.

18. Hans Gerhard Evers, *Peter Paul Rubens*, Munich, 1942, pp. 451 ff.

19. Our photograph renders the painting without the later lateral additions, which are still seen in Oldenbourg's edition of the Klassiker der Kunst of 1921, pl. 424.

20. See Rooses, *L'Oeuvre de P.-P. Rubens*, IV, pl. 289. It is possible that in the nineteenth century the background details were hidden under a layer of old varnish. Rooses actually described the background as a "fond de noir opaque" (ibid., p. 166).

21. *Icones Illustrium Feminarum Veteris Testamenti A Philippo Gallaeo Collectae atque Expressae*, no. 19.

22. See Max Rooses and Charles Ruelens, *Correspondance de Rubens et documents epistolaires*, V, Antwerp, 1909, p. 179, and Ruth Magurn, *The Letters of Peter Paul Rubens*, Cambridge, Mass., 1955, p. 407. The letter was first printed, contrary to the statement by Rooses, in the Dutch

edition of Junius' book published in 1641 in Middelburgh. The following quotations deviate in minor ways from the translation given by Magurn.

23. Rubens characteristically uses here a quotation from Virgil's *Aeneid* (2.794): ter frustra comprensa manus effugit imago.

24. In a short report submitted at one of the sessions of the XX International Congress of the History of Art held in New York in 1961, I listed a number of paintings which may have been inspired less by actual works of ancient art than by Pliny's report about them. Thus, in Giotto's Ognissanti Madonna both the Virgin and the Christ Child show their teeth, a detail mentioned by Pliny as having been introduced into art by Polygnotus of Thasos (XXXV, 58); a whole series of paintings by Bassano, El Greco, Rubens, Jordaens, and Honthorst, among others, can be traced to Pliny's statement (XXXV, 138) that Antiphilos "was praised for his picture of a boy blowing on fire, and for the reflection cast by the fire . . . on the boy's face"; the so-called *fruttaiuolo* by Caravaggio brings to mind Zeuxis' famous boy carrying grapes (XXXV, 66); the gorgon-pictures of Leonardo (mentioned as unfinished by Vasari), Caravaggio, and Rubens dealt with a subject for which Timomachus of Byzantium had been praised (XXXV, 136); even in works of Frans Hals, who hardly was an avid reader of Pliny, we find themes made famous by ancient artists, such as "a [Thracian] nurse with an infant in her arms" and "two boys whose features express the confidence and the simplicity of their age," both by Parrhasius (XXXV, 170); Jordaens' young satyr in Amsterdam recalls a picture by Protogenes (XXXV, 106); Aetion's picture of Tragedy and Comedy, known only from Pliny (XXXV, 78), may have been in Reynolds' mind when he painted his canvas of Garrick between these personifications; and, finally, the striking manner in which Pluto's hand is impressed on Proserpina's flesh in Bernini's famous sculpture has its classical analogy—and probably literary "model"—in a Pergamene sculpture by Cephisodotus described by Pliny (XXXV, 197). For all quotations from Pliny, see K. Jex-Blake, *The Elder Pliny's Chapters on the History of Art*, London, 1896. A corollary of the interest artists took in works which they knew only from description by ancient authors is the frequent comparison of "modern" artists with Greek masters.

For this complex of problems, see especially Charles Sterling, *Still Life Painting*, Paris, 1959, pp. 11-12, and E. H. Gombrich, *Norm and Form*, London, 1966, pp. 6-7 and 112-114; see also Erwin Panofsky, *Renaissance and Renascences*, Stockholm, 1960, p. 115.

25. See Antologia Graeca, I, 97, 1, and I, 104, 6, as cited by Heinrich Bulle, *Der schöne Mensch im Altertum*, Munich, 1922, p. 108.

26. See Christian Blinkenberg, *Knidia*, Copenhagen, 1933, passim, but especially pp. 21, 37, and 56.

27. Bulle, *Der schöne Mensch*, pls. 156 and 158.

28. This identification rests primarily on a comparison of the model with a painting by Sustermans of St. Margaret in the Uffizi, which Pierre Bautier reproduced and discussed as a portrait of Vittoria della Rovere (*Juste Suttermans, peintre des Médicis*, Brussels, 1912, pl. XVI). The connection between the St. Margaret and the authentic portraits of Vittoria (ibid., pls. VI and VII) is, however, not sufficiently close to make this identification completely convincing.

29. For the use of Cupid in conventional portraits of ladies, see Van Dyck's portrait of Mary, Duchess of Lennox, in the North Carolina Museum of Art, Raleigh, North Carolina.

30. Rooses, *L'Oeuvre de P.-P. Rubens*, p. 167.

31. See Margaret Whinney and Oliver Millar, *English Art, 1625-1714*, Oxford, 1957, p. 5, n. 4. According to Hans Tietze, *Tizian, Leben und Werk*, Vienna, 1936, II, p. 317, Titian used the same model for the so-called Bella in the Pitti Palace and for the Venus of Urbino in the Uffizi.

32. See *Sammlung Schloss Rohoncz*, catalogue by Rudolf J. Heinemann, Lugano, 1958, no. 358a. Heinemann misunderstood the entry in Rubens' inventory and thought that Rubens had actually owned the original by Titian.

33. The mirror in that painting has the same octagonal shape as the mirror in the Sustermans picture(s) discussed earlier.

34. Edgar Wind, *Humanitätsidee und heroisiertes Porträt in der englischen Kultur des 18. Jahrhunderts*, Vorträge der Bibliothek Warburg, 1930-1931, p. 192.

35. Rooses and Ruelens, *Correspondance*, VI, p. 228: February 27, 1639.

RUBENS AND VORSTERMAN

THE lives of few artists of the past are documented more fully than that of Peter Paul Rubens. Yet despite the wealth of records preserved, Rubens' biography is singularly devoid of the material that so often with other masters lends color to the historical narrative. There are no hints of scandals such as beclouded the life of the artist's father; few witty sayings are reported by his biographers, and there are hardly any anecdotes worth quoting. The unpleasantness with the Duke of Aerschot reflected essentially political differences, sharpened, to be sure, by the resentment of a nobleman at seeing a commoner meddle in affairs of state. With one exception, Rubens' relationships with all the people he dealt with professionally and privately seem to have been smooth, cordial, and above all eminently correct. The one exception concerns his relationship with Lucas Vorsterman, the first, and probably best, engraver of all those trained by the master himself, or at least working primarily for him. Enough is known about this strange affair to arouse our curiosity, but far too little to satisfy it. Henri Hymans, the eminent Belgian scholar who provided us with the standard catalogue raisonné of Vorsterman's engravings and introduced it with a biographical sketch, twice speaks of the "mystery of the case,"[1] and a mystery it has remained. The present study presents a piece of evidence which had been in full view for centuries but might have been overlooked by this writer, too, had not the clear light of an autumnal Leningrad sun fallen on it just at the moment when he stood in front of it. And yet, even this new evidence, welcome though it is, raises more questions than it answers.

We do not know when Rubens began to employ Vorsterman, but it is certain that the engraver worked for him in 1618 since in a letter of January 23, 1619, Rubens speaks of a young engraver which can only be he: "And to tell the truth, the major part [of the engravings] is close to being finished and can soon be published. I have wanted above all

Reprinted from *The Art Quarterly*, XXXII, 1969, pp. 111-129.

that my engraver was capable of imitating well the model given to him, and it seems to me better to have them made in my presence by the hand of a youth of good intentions than by some great virtuosi according to their own caprice."[2]

Vorsterman had surely been hired by Rubens for the specific purpose of making engraved reproductions of Rubens' designs. In a letter of June 19, 1622 (to which I shall return), Rubens states that the print of *Lot's Flight from Sodom* was made by Vorsterman soon after he had begun staying with him (*da principio ch'egli venne a star meco*).[3] Rubens had recognized early the value of engravings as a source of steady income. His trip to Holland in 1613 is generally assumed to have been prompted by his desire to obtain the services of an engraver trained by Hendrik Goltzius of Haarlem, undoubtedly the foremost engraver of the age. Yet it was only when Vorsterman began to work for the master that the production of prints after Rubens' paintings went into high gear. It was at that time, too, that Rubens made great efforts to obtain the protection of copyrights, and he succeeded in these efforts when special privileges to that effect were issued for France (July 3, 1619), for Brabant (July 29, 1619), subsequently extended for all of the Spanish Netherlands (January 16, 1620) and for Holland (February 24, 1620). The French privilege was to run for ten years, the Flemish for twelve, and the Dutch for seven. A Spanish privilege was extended to Rubens in 1630 and was prolonged in 1644 for another twelve years for the benefit of the master's heirs.[4]

In the beginning of 1620 Rubens was obviously ready to issue the engravings Vorsterman had been working on but which he had held back until he had the protection of the copyright. He now published nine prints, among them some of the finest ever done of his works. While most of them are dated 1620, it is certain that many, if not all, had been done before that date. At any rate, Hymans called the publishing of these prints "a memorable event in the history of engraving."[5]

Vorsterman was probably in his early twenties when he began to work for Rubens. Born about 1595, he had produced his first engraving (after Barocci) in 1607, as a mere boy of twelve. On April 9, 1619, he married Anne Franckx, aged twenty-three, a sister of Antoine Franckx who himself was an engraver. Their first child, Emile-Paul, was baptized on January 17, 1620, with Rubens acting as godfather. In the same year, Vorsterman acquired Antwerp citizenship and was accepted as master in the guild of St. Luke. He had two more children, Anne-Marie (July 1621) and Lucas Vorsterman, Junior (May 1624).

What in 1620 appears to have been still a close and seemingly friendly relationship soon thereafter turned into the very opposite. Hymans called attention to the peculiar circumstance that whereas all of Vorsterman's prints after Rubens done before and during 1620 bear dedications by Rubens to various patrons and friends, there are three prints of 1621 the dedications of which are signed by Vorsterman. Moreover, on July 11, 1622, Vorsterman himself obtained a privilege protecting his engravings.[6] If these facts suggest a definite cooling off between the painter and his engraver, the first clear-cut statement indicating that all was not well between Rubens and Vorsterman is found in a letter Rubens

wrote on April 30, 1622, to Pieter van Veen, "Raetsheer ende Pensionaris," at The Hague. Van Veen, the brother of the artist's last master, Otto van Veen, had assisted Rubens in obtaining the Dutch copyright and evidently had expressed (although his letter is lost) the wish to get some additional engravings from the master. Rubens regrets to inform him that for two years almost nothing has been done owing to the capriciousness of his engraver who, as he says, has given himself entirely to self-conceit (*albasia*) in such a manner that one can no longer deal or treat with him.[7] He maintains, Rubens continues, that it is his art and his illustrious name alone that determine the value of the prints. Rubens affirms, however, that the drawings (furnished to the engraver, many of which, if we can trust Bellori, were done by Van Dyck) are more finished and executed with more care than the plates, and since he has these drawings in his hands he can show them to all the world. He finally asks Van Veen to send him a list of all the prints he already owns, so that he (Rubens) can determine what is still missing. This list Van Veen sent on the twelfth of May. Rubens, who had been away for a few days, replied on June 19, apologizing for his inability to provide all the missing prints owing to the fact that for several years almost no progress has been made because of the disturbed condition of his engraver (*per il disviamento del mio intagliatore*).[8] The word *disviamento*, literally "aberration" was translated as "departure" by one author (Ruelens) but was correctly understood as referring to a mental condition by Hymans and Rooses.

After listing, with short comments on their quality, six engravings which are finished, Rubens mentions the large print, done from six plates, of the *Battle of the Amazons* which needs only a few more days' work but which he has been unable to obtain from the engraver despite the fact that he had paid for the work three years before. Although the date on this print reads 1623, Rubens' statement is borne out by the fact that it was listed in his letter of January 23, 1619, as the very first print for which, at that time, Rubens wished to obtain the Dutch copyright.[9]

Rubens' difficulties with Vorsterman were more worrisome, however, than would appear from these brief remarks. Some time in April 1622, friends of Rubens addressed a petition to the Privy Council of His Majesty (of which Isabella Clara Eugenia, Governess of the Spanish Netherlands, was chairman) in which they stated that in the last few days Rubens had been in danger of his life "owing to the attacks of an insolent and, in the opinion of several people, disturbed individual"; that they had asked the Antwerp magistrate for protection for Rubens but that this request had been turned down; and that they now were turning to the Governess herself urging her to instruct the Antwerp magistrate to protect Rubens as a person especially dear to her Highness.[10]

This petition was successful, and on April 29, 1622, the Infanta issued an ordinance to the Antwerp magistrate asking for the protection of Rubens "who is endangered by the attacks of an evil-intentioned one of his men, said to have sworn his death."

Nothing in these documents specifically refers to Vorsterman although the Archduchess speaks of one of Rubens' own men (*d'un sien malveillant*). Yet there is one document leaving

hardly any doubt to whom these notes refer. In the summer of 1622 rumors spread through Paris that Rubens had died. The first mention occurs in a letter of July 21, addressed to Rubens by his learned friend Peiresc.[11] Peiresc had heard the rumor the previous day but was greatly relieved when late that night he received a letter from Rubens written the fourteenth of that month; since the rumor apparently had been spread by an Antwerp Jesuit who had arrived four or five days before, Peiresc concluded wisely that Rubens' letter was of more recent date. Peiresc had indeed been so shocked by the bad news that he had been unable to eat or sleep; and he wasted no time the next morning in sending word to Claude Maugis, Abbé de St. Ambroise—deeply involved at that time in the plans for the cycle of the life of Maria de' Medici, to be painted by Rubens—informing him of the falseness of the rumor. The queen mother indeed had been *grandement faschée* when she learned of Rubens' supposed death, as the Abbé wrote to Peiresc on July 25.[12]

Yet four weeks later another rumor spread through Paris; and it is again Peiresc, the faithful correspondent, who tells us about it. According to this rumor, one of Rubens' engravers had tried, but failed, to assassinate the master (. . . *che un intagliatore de suoi rami et dissegni haveva mancato di amazzare V. S.* [Vostra Signoria]). Contrary to his reaction to the news of Rubens' death a month before, Peiresc mentions the rumor of the presumed attack by the engraver in a most casual manner and immediately proceeds to other problems.[13]

This letter, nevertheless, is of fundamental importance because despite Peiresc's incredulousness it permits us to connect the dangers to Rubens' life, variously referred to before in the same year, with the hostility of one of Rubens' engravers. It is likely that the rumor running through Paris in August had been fed by the events alluded to in the petition, and ordinance of protection, of April; we cannot of course exclude the possibility that there had been indeed a more recent attack. At any rate, it is safe to assume that *un sien malveillant* of the Archduchess' ordinance of April 29 is the same as *un intagliatore de suoi rami* of the assassination rumor of August, and, in view of the difficulties Rubens had had with Vorsterman, that all references refer indeed to this artist.[14]

Although some of these assumptions remain conjectural, they seem to fit together sufficiently to reconstruct a plausible sequence of events. Rubens' difficulties with Vorsterman, according to his own statement, began early in 1620. Vorsterman failed to turn over some of his work; Rubens attributes his recalcitrance to his excessive artistic vanity. In the very same month of April 1622 Vorsterman's animosity against Rubens had grown to such proportions that Rubens' friends feared for the master's safety. We do not know if Vorsterman only threatened the painter or attacked him physically. The latter theory may be supported by the fact that rumors of Rubens' death, and of an assassination attempt, were heard in Paris in July and August, respectively, of the same year. Vorsterman emerges from these records as a greatly gifted engraver but possessed by inordinate arrogance, willfulness, and a dangerous temper, due, in the opinion of some—Rubens among them—to a basically unstable mental condition.

A late reflection of the view that Vorsterman was somewhat unbalanced mentally is found in P.-J. Mariette's *Abecedario*.[15] In a note to one of Vorsterman's prints after Rubens he states: "Rubens prit un soin extreme a conduire le travail de son graveur et celuy ci le fit avec tant d'application que l'on asseure que son esprit s'en affoiblit tres considerablement." It should be noted that Mariette associated the mental disorder not with Vorsterman's vanity and overbearing but blamed it on the artist's excessive application to his work, in order to satisfy the exacting standards Rubens expected from his engraver. This explanation may be no more than a rationalization, on the part of the eighteenth-century expert, of a vague oral tradition. It is not impossible, however, in view of the following remarks, that Mariette's account reflects a more reliable tradition than has hitherto been assumed.

There is, finally, one more document that in a remote way may have some bearing on the case. Thanks to Egidius Joseph Smeyers (1694-1774), who jotted them into his copy of De Bie's *Gulden Cabinet*, we know of statements by Jan Erasmus Quellinus (1634-1715) based on his personal acquaintance with some seventeenth-century Flemish artists.[16] One of the longest and most intimate of these notes deals with Vorsterman. Quellinus states that he knew him well at the end of his life ("d'was mijnen vrint, en dit wete ik alles van hem") when Vorsterman was destitute and deprived of his eyesight and was taken care of by his daughter, a member of the Black Sisters, who lived across the street from Vorsterman's room. After reporting that Van Dyck had offered to portray Vorsterman in full-length in exchange for a pen-drawing he had made after a half-length figure of Christ by Rubens, Quellinus continues "hy schoen van de groote melancolie opt lest te suffen" (he seemed to be drowsy at the end with great melancholy). That an engraver who for a period of fifteen or sixteen years (as Quellinus reports) had to give up his trade because of failing eyesight should be affected by melancholy is surely not difficult to understand. Still, given the earlier record of Vorsterman's behavior, it is not entirely unthinkable that his "groote melancolie" had roots in earlier events. I also wonder whether he tried to compensate for the miserable condition in which he found himself when he told Quellinus of the flattering offer Van Dyck is supposed to have made. Knowing Vorsterman's drawings, we are justified in putting a very big question mark behind that story.

Quellinus does not refer to the events of the year 1622. Vorsterman may have passed them over—or if he did not, Quellinus may have preferred not to mention them. At any rate, up to now, the central figure in one of the most dramatic situations in Rubens' life has remained mute; what we know of it we owe to men looking at it from the other side— friends of Rubens, and Rubens himself. It is easy to understand that a statement by Vorsterman, undoubtedly referring to the troubled times of the early 1620s, must arouse the greatest interest and expectations. Such a statement does indeed exist. It is inscribed on one of Rubens' own sketches in oil (Fig. X.1), the well-known one painted in memory of Charles de Longueval, Count of Bucquoy, since 1768 in the Hermitage in Leningrad.[17]

There has been some confusion about the date of this sketch. Leo van Puyvelde, the

only author up to now to devote a special study to Rubens' oil sketches, listed it as no. 27 with the remark: "The sketch may possibly have been made about 1620."[18] Evers even assumed that Longueval had ordered the portrait himself.[19] Both authors may have relied on Rooses, who in his basic study of the work of Rubens had dated it between 1615 and 1620. They had overlooked the fact that in his publication on Rubens' correspondence Rooses had revised his earlier judgment, since he realized that it must be the very sketch Chanoine Robert Schilders referred to when he wrote to Peiresc on August 19, 1621, that Rubens was preparing an emblematic design to be engraved, "avec le pourtraict et éloge du défunct."[20] Longueval indeed had been killed on July 3, 1621, and it is difficult to understand how the authors who assumed that Rubens painted the sketch while he was still alive could have overlooked the obvious references to his death in the allegorical framework of the design. The portrait bust of Count Bucquoy is flanked by a very grim-looking Hercules at the right and a clearly sorrowing female personification (Securitas, according to Rooses; Victory, according to Hymans) at the left. More telling yet is the funerary altar with the two inverted torches below. More recently Burchard and D'Hulst have drawn the logical conclusion that Rubens worked on the Leningrad picture during July and August of 1621.[21] What even they had not seen is a very simple fact: in the background of the section containing Longueval's portrait, above the count's left shoulder, is an inscription that reads *P. Rubens / fecit Et / Pinxit / A° 1621.*[22]

Nor is this the only inscription. It is balanced on the other side, in the same technique and clearly the same hand, by a Flemish inscription (Fig. X.2) in 10 lines, meant to be read as a two-line poem:

<div align="center">

Dit cost

mij door't

quaet vonnis

sor(gh?) en noot

Veel

nachten

Waken en

ongerust

heyt

groot

</div>

Below the last word of this text appears the well-known monogram of Vorsterman.[23]

The total height of this inscription is about 9 cm. (about 3½ inches). It appears to have been written with a sharp pen that spread somewhat when pressure was applied and even dug lightly into the ground. It is nevertheless difficult to see, let alone make out, with the naked eye, and was indeed read by me only when the sunlight fell on it (perhaps furnishing an argument against the growing practice of excluding direct lighting from our museums).

One word only of this inscription has been effaced to such an extent that some of the letters have to be interpolated. In translation the inscription reads as follows: "This cost me, because of the bad verdict, worry and vexation, Many nights of waking and great aggravation." The signature added so conspicuously leaves no doubt that the writer was Lucas Vorsterman. What he wanted to pass on to posterity (since it is hardly likely that he did it for his own "records") is a lament, written on the very object that had caused him anxiety and possibly even legal difficulties. The word *vonnis*, in fact, is normally used for a legal judgment. It is also found in such formulations as "The Judgment of Paris" (*het vonnis van Paris*), but the context of the inscription suggests more than a mere error in judgment; *quaet* has many shadings, from bad to actually evil, and in connection with *vonnis* may indeed refer to an unjust decision by a court of law. (I have not been able to ascertain whether or not in the years 1621-1622 Vorsterman was actually tried in a regular law suit.) The first word, "This," at any rate, can only refer to the sketch on which he wrote the rhymed expression of his unhappiness and resentment, Rubens' *modello* in memory of Charles de Longueval.

The sketch by Rubens was made to be engraved, and Vorsterman indeed made the engraving (Fig. X.3). It is not dated, and Hymans, followed by Rooses, had assumed that it was executed only in 1627, since on September 2 of that year Rubens wrote to Dupuy that he hoped to be able to send him soon the engraving of Longueval.[24] On the basis of the letter by Schilders, mentioned before, Rooses later changed his view and claimed that it was undoubtedly done in 1621 "avant la maladie de Vorsterman."[25] The inscription on the Leningrad sketch, if nothing else, proves that the engraving does not belong to a period before Vorsterman's "illness," or as Rooses elsewhere calls it "sa brouille avec le maître," but actually plays a central role in it.

The print, according to Hymans,[26] exists in a first state—apparently very rare—that has no inscription of any kind. The second state, reproduced here, has a seven line inscription on the funerary altar, commemorating Longueval; at the bottom it is inscribed *P. P. Rubens inuent. Cum privilegijs. Lucas Vorsterman sculp. et excud.* In some examples the print is accompanied by a dedication, addressed to Longueval's son Albert, and signed by Vorsterman.[27] There can be little doubt that Vorsterman remained in possession of the plate and that he felt free to dedicate it on his own accord.

Moreover, he surely retained also Rubens' oil sketch. No matter how strongly he may have felt about the torts supposedly inflicted upon him, or how small the lettering of his inscription on the sketch, it is most unlikely that he would have written it if he knew that the sketch would be returned to Rubens; nor is it likely that Rubens would have failed to see it, since it certainly was more legible then than now. Besides, the content makes sense only if we assume that some time had elapsed between the events to which the inscription refers and Vorsterman's decision to "commemorate" them with a short poem. The tenor of the text is clearly a final summing up of his feelings, and the very fact that he used a poetic form implies a certain distance in time as well as emotion. We know from

Rubens' letter of June 19, 1622, that he had difficulties obtaining a nearly finished print from Vorsterman. It may not have been the only such case.

How can we explain the fact, clearly attested to by Vorsterman's outcry, that the sketch in memory of Longueval, made to be engraved by him, was the cause of some grievous suffering? We can take it for granted that some resentment, partly caused by Rubens' exacting demands, partly by Vorsterman's pride and possibly a feeling of not being sufficiently appreciated, had been building up over a period of time. Why did it come to an explosion over the commemorative print for Longueval?

Longueval had been a military hero who had first served as commander-in-chief of the artillery in the Spanish Netherlands. In 1618 he joined the army of the Austrian emperor, and distinguished himself in many actions of the then still young Thirty Years War. When he fell near Neuhäusel in 1621, the news of his death was greatly regretted in all the countries supporting the Catholic camp.

Six weeks after his death, Rubens was charged with making an allegorical portrait in Longueval's honor, to be distributed in print. In matters that had any degree of urgency, Rubens responded quickly, and knowing his almost legendary facility to work, we may be sure that the Leningrad sketch was probably already finished when Schilders made his reference to it. The next step was to have Vorsterman engrave the plate. Normally Vorsterman was presented with fairly exact drawings. The oil sketch may have presented some difficulties. At any rate, we have a drawing made by Vorsterman himself, in which he transcribed Longueval's portrait from the bold coloristic treatment of Rubens' sketch into the precise, methodical, although rather dull medium of a drawing in pen (Fig. X.4).[28] Whether he made still other drawings, of the allegorical framework, we do not know.

From here on, everything is conjecture. It is likely, however, that Rubens pressed for a speedy completion of the work. While reputations of military men in the seventeenth century may have been less shortlived than in ours, the market for the distribution of the engraved portrait of a fallen leader was surely best during the first years after his death. More than in the case of devotional or mythological subjects, the quick execution of a print of such topical interest was essential, and it is quite possible that Rubens expressed his eagerness, if not actual impatience, in forceful terms. To him his engraver (we remember the "un sien malveillant") was a subordinate, from whom he could expect prompt and unquestioning service; had he not hired Vorsterman because he preferred a "well-intentioned youth" to the "caprices of the virtuosi"? Vorsterman, for his part, however, may well have been chafing under the lack of recognition of the artistic value and the technical difficulty of his work. In the Longueval sketch, he was confronted with an exceedingly complex design. This "urgent" and surely difficult job may have come his way at a time when he was either physically exhausted or mentally smarting, or both. The pressure of the Longueval print may well have been the "last straw," releasing the pent-up emotions.

Assuming that the overt causes of the conflict lay in the area of professional "misunderstandings" and the frictions that may develop between "boss" and "hired hand," the

vehemence of Vorsterman's reaction remains astonishing and out of proportion. That it was so viewed by his contemporaries appears from the statements referring to Vorsterman as mentally disturbed. Yet there is little in his biography that would lend support to an assumption that he was really mentally ill. Soon after his break with Rubens he worked for other artists, and he worked normally (although without the previous distinction) after his migration to England in 1624. The melancholy of his late years was surely largely due to his poverty and blindness.

To understand Vorsterman's violent behavior toward Rubens we may have to consider the relationship of the two men in psychological terms. In this undertaking a clue may be found in the portraits of Vorsterman that have come down to us. Two of them were painted by Van Dyck: one in the Museu Nacional de Arte Antiga in Lisbon (Fig. X.5),[29] later engraved by Vorsterman's son; the other, a grisaille in the Devonshire collection, etched by Van Dyck himself for the *Iconography* (Fig. X.6).[30] The Lisbon portrait, probably the earlier of the two, presents the engraver in a view slightly from below, thus creating the impression of a proud, almost condescending attitude. It is clearly the image of an ambitious, if not actually vain, man.

What is most striking, however, is the physiognomic similarity to Rubens. If we compare this picture with Rubens' famous self-portrait at Windsor, we cannot fail to notice a surprising number of analogies (high forehead, straight short nose, strongly marked upper eyelids, to mention a few) greatly helped by a virtual identity of tonsorial fashion: hair, moustache, and beard are worn exactly alike. The similarity still holds true for Van Dyck's etching, which makes Vorsterman look not unlike Rubens as he appears in his self-portrait drawing in the Louvre.[31]

It is perhaps less important that there may have been indeed a certain physical similarity of features; what is inescapable is the conclusion that Vorsterman used various devices to look like Rubens. It seems not unreasonable to suppose that such an aim reflects less a desire to rival the great master than a disciple's eagerness to emulate him, to come close to him, to be like him. No one can live close to a genius without being affected deeply; and Vorsterman's case may well have been similar to that of the much greater Van Dyck. Like Van Dyck, he may have had a period of hero worship, when nothing seemed to be more desirable than to imitate and be accepted by, perhaps even be indispensable to, the great artist.[32] As with Van Dyck, the amount of Vorsterman's artistic output during the years of close association with Rubens is astonishing, and Mariette's statement that Vorsterman had worked so hard that his mind suffered may well contain an element of truth and reflect a reliable tradition. In Van Dyck's case, as far as we know, circumstances permitted the inevitable cooling off to proceed without an open break, although much of Van Dyck's later behavior, and particularly his frantic activity after Rubens' death, can only be explained by the lingering attachment to, and subconscious identification with, Rubens. With Vorsterman, the impressionable and gifted small-town youth whom Rubens had picked as his assistant, the hate may have been all the greater, because he came to feel that his fervor was not appreciated and possibly rejected.

Some of the commentators on the Rubens-Vorsterman conflict have tried to explain it solely on the grounds of a disagreement over copyrights and general financial or business matters.[33] In the light of the Leningrad inscription, with its overtones of mental anguish and hurt feelings, the true reasons may have to be sought in the peculiar human relationship between the two men—a relationship which Rubens probably never quite understood— and to the violent end to which he may well have contributed unwittingly. In his short biographical sketch of Vorsterman, preceding his list of the artist's engravings, Frank van den Wijngaert included the following sentence: "He made an attempt on the life of the master because of a dark and basically unknown affair in which the painter, despite his complaint about the 'megalomania' of his engraver, must not have been without guilt."[34] There was nothing in the actual records accessible to Van den Wijngaert that would have supported such an assumption. As a partisan of Rubens' engravers, and biographer of Van Dyck, Van den Wijngaert may have been somewhat prejudiced. Yet it is also possible that he sensed the psychological tensions which separated the two artists and that there can be "guilt" where neither moral nor legal principles have been infringed. Whatever it was, it left no mark on Rubens; a master in life as well as art, he took such events in stride and in the years immediately following the "affair Vorsterman" he produced some of his grandest and most serene creations. Vorsterman's art, however, deprived of the guiding and goading of Rubens, declined. If we look at the last portrait we have of the engraver (Fig. X.7), an etching by Frans van den Wijngaerde after Jan Lievens, we cannot help being shocked at the ravages the passing of time has wrought in the handsome, proud face of Lucas Vorsterman. Admittedly, everyone's features change with time, and the normal processes of aging leave their mark on all. Yet as he appears in Lievens' portrayal, Vorsterman is not only an older man; his is a face that tells of deep suffering, suggesting a man broken in spirit more than in body.

If our reading of the case is correct, the "affair Vorsterman" had all the elements of a classical tragedy where there is no "guilt," only the blind workings of uncontrollable fate. The inscription on the Leningrad sketch, however, will have to take its place in the history of art among those touching documents—the most famous of which is Lucas Moser's equally rhymed two-line poem from the Tiefenbronn altar—in which an artist compulsively unburdened himself of his personal unhappiness. Moser inscribed it on one of his own works; Vorsterman, in a highly significant "revenge," placed it on the very work which he blamed for all his troubles, and which he thus made the carrier of his message. It may even have given him a degree of satisfaction to place his own monogram, in the shape used by him to sign his own works, on the sketch painted by the great master. His physical attack on Rubens, whatever form it had taken, had failed. He now forced one of Rubens' paintings—appropriating it by virtue of his own signature—to be the messenger of his unhappiness.

It took more than three centuries for his complaint to be heard.

NOTES

1. Henri Hymans, *Lucas Vorsterman: Catalogue raisonné de son oeuvre, précédé d'une notice sur la vie et les ouvrages du maître*, Brussels, 1893, pp. 10 and 30. See also Hymans, *Histoire de la gravure dans l'école de Rubens*, Brussels, 1897.

2. Max Rooses and Charles Ruelens, *Correspondance de Rubens et documents épistolaires*, II, Antwerp, 1898, p. 199: ". . . mi pare minor male di vederli fare in mia presenza per mano di un giovane ben intentionato che di gran valenthuomini secondo il lor capriccio."

3. Ibid., p. 444.

4. Ibid., pp. 196 and 208 ff. (On p. 208, Rooses inadvertently wrote January 24 for February 24 as the date of the Dutch privilege.)

5. Hymans, *Lucas Vorsterman*, p. 22.

6. The undated petition for this privilege, addressed to the Infanta, was reprinted by Hymans (ibid., p. 29). In it Vorsterman speaks of the "très grandes paines et despends" he has extended in making and publishing prints after works of several excellent painters. He continues, saying that unless he received from Her Royal Highness a privilege for ten years, he would be prevented from reaping through the sale and distribution of these prints the deserved fruits of his labor. The privilege was granted to him for six years only.

7. Rooses and Ruelens, *Correspondance*, II, pp. 399-400: ". . . mi dispiacce che duoi anni in ça non habbiamo quasi fatto niente per il capriccio del mio intagliatore, il quale si e dato totalmente alla albasia [modern: albagia] di tal maniera che non si po piu trattar ne pratticar seco."

8. Ibid., p. 44.

9. The print was finally published on January 1, 1623, with a dedication by Rubens to Alathea Talbot (actually spelled Taboth on the print), the wife of the Earl of Arundel.

10. First published by Alexandre Pinchart, *Archives des arts, sciences, et lettres*, II, 1861, p. 173. See also Hymans, *Lucas Vorsterman*, pp. 30-31, and Max Rooses, *L'Oeuvre de P.-P. Rubens*, IV, Antwerp, 1890, p. 204.

11. Rooses and Ruelens, *Correspondance*, II, pp. 466-467.

12. Ibid., p. 475.

13. Rooses and Ruelens, *Correspondance*, III, 1900, p. 24.

14. Two years later another rumor of Rubens' death reached Peiresc from Rome, in a letter of June 21, 1624, sent to him by Girolamo Aleandro, Jr. (ibid., p. 300). Peiresc immediately expressed doubts "since the envy of painters has many times caused such rumors to be circulated" (letter of July 12, 1624: ibid., p. 301). He admits, however, in a follow-up letter of August 8, 1624, that all such reports fill him with anxiety because, if true, the death of such a man would mean an incomparable loss. In this case, at any rate, he had the proof of the untruth of the rumor in a "very learned letter" Rubens had written to him on July 12—long after his supposed death. In that letter Peiresc refers again to earlier instances when "imposteri et pittori invidiosi" had spread such false reports (ibid., pp. 301-302).

15. P.-J. Mariette, *Abecedario*, V, Paris, 1858-1859, pp. 70-71.

16. See Theodor Levin, "Handschriftliche Bemerkungen von Erasmus Quellinus," *Zeitschrift für bildende Kunst*, XXIII, 1888, pp. 133-138 and 171-176.

17. Hermitage, Inv. no. 574. The sketch, on panel, measures 62 × 49.5 cm. See also Rooses, *L'Oeuvre de P.-P. Rubens*, no. 979, p. 206.

18. Leo van Puyvelde, *The Sketches of Rubens*, New York, 1954, p. 75.

19. Hans Gerhard Evers, *Peter Paul Rubens*, Munich, 1942, p. 254: ". . . für den Grafen Bucquoy, Charles de Longueval, musste er 1621 ein Ehren-Stichporträt herstellen lassen."

20. Rooses and Ruelens, *Correspondance*, II, p. 280.

21. L. Burchard and R.-A. d'Hulst, *Rubens Drawings*, Brussels, 1963, p. 293.

22. This inscription was already recorded in the 1958 catalogue of the Hermitage, published under the guidance of V. Levinson-Lessing (p. 82, no. 508).

23. I am greatly indebted to Mme. M. Varshavskaya of the Hermitage Museum for having facilitated the reading of the inscription by making the painting accessible to me in the conservation office, and for supplying enlarged photographs. Dr. A. L. den Blaauwen of Amsterdam was present and made a helpful suggestion. [The correct reading of the second-to-last line is due to Dr. C. A. Burgers of the Rijksmuseum.]

24. Rooses and Ruelens, *Correspondance*, IV, p. 299.

25. Ibid., II, pp. 205 and 281.

26. Hymans, *Lucas Vorsterman*, pp. 178-179, no. 184.

27. Ibid.

28. See Arthur M. Hind, *Catalogue of Drawings by Dutch and Flemish Artists . . . in the British Museum*, II, London, 1923, p. 146, no. 6. Some authors have averred that Vorsterman's drawing had been made from life and had served Rubens for his sketch. Hind, I believe correctly, declared it to have been done by Vorsterman after Rubens' sketch and as a study for the engraving.

29. Gustav Glück, *Van Dyck, Des Meisters Gemälde*, Klassiker der Kunst, London, 1931, p. 302.

30. See Marie Mauquoy-Hendrickx, *L'Iconographie d'Antoine van Dyck*, Brussels, 1956, no. 14, p. 168.

31. See Julius S. Held, *Rubens, Selected Drawings*, London, 1959, II, fig. 126.

32. For Van Dyck's relationship to Rubens, see the author's review of Horst Vey's book on Van Dyck's drawings, in *The Art Bulletin*, XLVI, 1964, p. 568.

33. Hind, *Catalogue of Drawings*, II, p. 145.

34. Frank van den Wijngaert, *Inventaris der rubeniaansche prentkunst*, Antwerp, 1940, p. 100. After this article had appeared both Dr. Leon Voet of the Musée Plantin-Moretus and Frans Baudouin of the Municipal Museums of Antwerp called my attention to an article on the Rubens-Vorsterman crisis published by the late Van den Wijngaert in *De Gulden Passer*, XXIII, 1945, pp. 159 ff. Van den Wijngaert recapitulated the then known facts of the case, drawing from them the conclusion that Vorsterman's resentment was caused by his—according to Van den Wijngaert probably justified—feeling of being commercially exploited by Rubens. Whether the author might have changed his view had he known the Leningrad inscription is impossible to say.

RUBENS' GLYNDE SKETCH
AND THE INSTALLATION OF THE
WHITEHALL CEILING

THE discovery of the preparatory sketches for the Whitehall ceiling on a panel in the collection of Mrs. Humphrey Brand at Glynde Place was undoubtedly one of the major surprises of modern Rubens scholarship (Fig. XI.1). On two occasions Oliver Millar dealt thoroughly with the significance, aesthetic as well as historical, of this work, and every student of the complex of questions connected with it will forever be in debt to his studies.[1] The following note, which addresses itself only to one particular problem, grew out of a new examination of all the evidence in connection with the preparation of a catalogue raisonné of Rubens' sketches in oil. In the course of this work, I came to certain conclusions which in some ways are at variance with Millar's discussions and, in others, supplement and expand them. In presenting these conclusions I feel encouraged by Mr. Millar's own modest statement at the end of his most illuminating article: "There can be no doubt that this wonderful panel has still many secrets to give up and that [this] preliminary article . . . may stimulate further and deeper analysis and interpretation."[2] In the context of this paper, another quotation is equally pertinent. Speaking of Rubens' Whitehall ceiling, Ellis Waterhouse said this about it: "It has remained the least fruitful and the least studied of the surviving great works inspired by the patronage of Charles I."[3] About its "fruitfulness" there will be a word below. That it has been studied insufficiently is one of the burdens of this paper.

In their simplest form, the questions to be discussed here are to what extent the Glynde sketch provides us with clues to Rubens' thoughts about the placing of the individual

Reprinted from *The Burlington Magazine*, CXII, 1970, pp. 274-281. In 1974, Rubens' paintings were installed in accordance with the plan presented in this paper.

panels in relationship to one another, and whether the current installation of the ceiling [1970] agrees with, or differs from, Rubens' plan insofar as it can be deduced from that sketch. The present arrangement of the panels on the ceiling was established after the successful cleaning and restoration conducted in the years before 1951 (Fig. XI.2). Although the new installation followed the older one fairly closely, certain changes were made in the placing of some of the secondary panels. The two long pictures with gambolling putti and animals accompanying the *Apotheosis of James I* were exchanged, so that the "base-line" of their activity is now toward the middle of the ceiling while their heads face outward. Before, it had been the other way around.[4] In today's arrangement, the allegorical triumphs in the four corners, too, have changed place with each other, so that those that were formerly on the east side of the hall are now on the west side, and vice versa.

This arrangement agrees in every detail with the well-known engraving of 1720 by Simon Gribelin (d. 1733) (Fig. XI.3). It may well have been this very engraving, the earliest and most "authoritative" rendering of the ceiling, which prompted the men responsible for the new installation to adopt the pattern now seen in the Hall. The questions whether an installation similar to Gribelin's order, and possibly based upon his print, was compatible with the nature of the paintings themselves, and whether Gribelin's print itself is really a reliable source for the placing of the pictures has, to my knowledge, not been asked, or, at least, not been aired publicly. Nor were these problems raised a few years later when the Glynde sketch was discovered. This is all the more surprising, as few visitors to the great Hall could have overlooked the fact that viewing Rubens' ceiling is no undivided pleasure. Several scenes, particularly the *Peaceful Reign of James I* at the south end of the Hall and the long putto friezes, force the visitor to look straight up—which is not only physically uncomfortable but also does a grave injustice to the works themselves, as the degree of foreshortening (contrary to such examples as Mantegna's circular opening in the Camera degli Sposi or, to quote a late example, Pozzo's ceiling in Sant'Ignazio) is not such as to demand a perpendicular point of view.[5] This angle of vision is particularly unsatisfactory in the *Peaceful Reign*[6] itself where the grand columnar architecture of the king's throne is disturbingly top-heavy, threatening to come tumbling down upon the beholder. And yet the area directly below it is the only place from which this painting can be seen right side up. The modern visitor, indeed, is informed by a booklet he buys for sixpence at the entrance that he must walk to the end of the Hall "since the paintings were meant to be seen from the Westminster or south end, where the throne with its canopy stood"; it is further suggested that he then move "northward towards the entrance doorway."

It is surely somewhat curious to assume that the paintings glorifying the rule of James I, and the Stuart monarchy in general, were meant to be seen primarily, if not exclusively, by the king's successor and his closest entourage, but not by the official visitors from abroad and the large number of people attending the various ceremonies staged in the Banqueting House. It is one thing to tell a modern visitor to stroll to the end of the Hall and only then to turn around to scan the ceiling, but an entirely different one to assume

that this was considered desirable, not to mention actually possible, for a seventeenth-century audience. And even if we assume for a moment (what I consider to be no more than a modern rationalization of the chosen installation) that Rubens' paintings were indeed designed to be seen from the throne, it has apparently not been noticed that the presence of a canopy of the size customary in the seventeenth century would have largely blocked the view of the last three paintings, particularly the one directly above the throne!

One further point should be considered in regard to this very painting. If we translate the painted architecture into its three-dimensional equivalent, as we are obviously expected to do in this kind of illusionistic painting, we must be struck by the fact that the vast throne structure (resembling a baroque altar-frame) faces south. Hence, it "turns its back" on the scene of the *Apotheosis*, and confronts an audience outside the actual room. If the scene were physically acted out, it would be practically invisible to those inside the Hall—the court included. It hardly needs stressing that Rubens was not the man to have overlooked such a problem.

While the Gribelin engraving seems to sanction this rather strange arrangement, it is easy to see that a still more authentic document, the sketch at Glynde Place, does not. The Glynde sketch combines, on one panel, sketches for seven different compositions, all of which, with minor or larger revisions, eventually found their place on the ceiling of the large Hall of the Banqueting House. In the center is a sketch for the *Apotheosis of James I*. Below and above the large oval into which this action has been inscribed appear studies for the putto friezes, which on the Whitehall ceiling accompany the *Apotheosis* on either side. In addition, Rubens sketched the four allegorical triumphs which, on the large ceiling, occupy the four corners of the composition, flanking the actions in the large rectangles in the center. In the Glynde sketch, these allegories are already inscribed in the long narrow ovals they were to occupy later, but Rubens was clearly "running out of space" on the panel: the *Triumph of Minerva* in the lower left seriously encroaches on the oval field reserved for the *Apotheosis*, creating a certain confusion where figures from the two scenes overlap. Moreover, the *Triumph of Royal Bounty*, appearing on the same side immediately above, was painted appreciably lower on the panel than its companion scene on the other side, most likely because Rubens respected the sketches for two putti which he had painted above in connection with the putto friezes at either end.

There are other multiple sketches in Rubens' oeuvre, such as the Chicago sketch for the *Triumph of the Eucharist*,[7] and several of the sketches for the *Triumphal Entry of Cardinal Infante Ferdinand* in Antwerp. Yet, the Glynde sketch is unique in that—except for the lightly drawn lines marking off the one large and the four small ovals—it makes no reference to the actual structural divisions of the ceiling and, indeed, seems to disregard the relationship in space to one another which the finished pictures were to have. In fact, most scholars seem to have assumed that Rubens was only interested in sketching the individual actions and gave little thought to their interrelationship.

This assumption, however, is hardly tenable seeing that the layout of the sketch is not

only rather peculiar but in its peculiarity also surprisingly consistent. Of the six scenes surrounding the central oval, three are painted from the same point of view as the *Apotheosis of James I* itself: the triumphs of *Royal Bounty* and of *Temperance*[8] above and the putto frieze below. The three remaining ones, however—the putto frieze at the top and the Triumphs of *Hercules* (Fortitude) and *Minerva* (Prudence) below—are painted upside down. There was no special need for Rubens to reverse the panel in order to paint these three scenes; the fields available to him would not have been different had he painted them, like the others, right side up. As they appear now on the ceiling, the allegorical triumphs are indeed "lined up" with one another. Why did Rubens, in the Glynde sketch, depict them inverted in relationship to each other when it would have been much simpler to keep the panel upright and to paint them all from the same point of view? If we assume, as I think we must, that Rubens knew what he was doing and that the inversion of one frieze and of two of the allegorical triumphs was not due to an unexplainable and quite irrational whim, we must study the arrangement of the Glynde Place sketch in the light of the entire program of the ceiling. Before we proceed to this task, it is necessary, however, to determine whether or not we can assume that Rubens knew the major divisions of Inigo Jones' ceiling when he painted the sketch. Oliver Millar called attention to remnants of an earlier sketch still visible on the panel; he suggested that these studies belong to the first thoughts for one of the compositions of the Henry IV cycle, the *Capture of Paris*. This being so, Millar thought that Rubens might have also begun the main oval "on the eve of his departure for England," using a discarded panel with a few preliminary sketches still on it, and that he took this doubly unfinished panel with him to London.[9]

This theory is not very plausible, for more than one reason. Some time in March 1629 King Philip IV of Spain, probably at the suggestion of Count Olivares, decided to send Rubens to London to sound out Charles I in regard to a cessation of hostilities between the two countries. Rubens was then still in Madrid where he had resided since September 1628. Once this decision was made, Rubens was quickly dispatched to Brussels to obtain further instructions from the Infanta. Whether or not he may have had hopes of using the opportunity of a visit to London to discuss the old Whitehall project, it is virtually certain that no word about the possible resumption of the Whitehall project could have reached him from London before his departure. We have, furthermore, his own words[10] that he had less than four days in Antwerp before departing again for England. After an absence of eight months, and with a difficult political assignment before him, he surely had other things on his mind than a project which had not been discussed with him for a long time. Yet, even if one grants, for the sake of argument, that he might have thought of the possibility of obtaining a definite commitment for the decoration of Whitehall, it is most unlikely that he would have begun a sketch on the very eve of a trip that would permit him to discuss the project personally with the king and his advisers, and to see with his own eyes the character of the setting he was to adorn with his pictures. (For the same reason, if not for more practical ones, he surely did not begin the sketch during the two

and a half weeks he spent in Dunkirk waiting for the English man-of-war that was to take him across the Channel.)[11]

The Glynde Place sketch itself, however, furnishes the clearest proof that before it was painted the basic iconographic program as well as the general shape of some of the major units of the ceiling had been agreed upon; as we know from the negotiations for the Medici cycle, such an agreement presupposes close personal negotiations among all parties involved. Among others, Inigo Jones most certainly must have conferred with Rubens about the shape and the themes of his paintings, and the Glynde sketch can only be the result (perhaps, indeed, the first) of these discussions. Taken individually, the compositions depicted on the Glynde sketch are as close to the final formulations as Rubens' sketches ever are; the elongated ovals of the allegorical triumphs are actually, as Millar pointed out, closer to the final pictures than some of the subsequent studies which Rubens painted in less awkward spatial units. This being so, we can discard the thought that Rubens might have intended these ovals to accompany the central oval with the King's Apotheosis, as they do on the sketch. Economical, as he was always with space, Rubens included them on the Glynde panel, but he must have known perfectly well where they would appear on the ceiling. In other words, he knew that each pair of ovals was to appear on either side of, and in close iconographic relationship to, a large rectangular field, and he probably knew also exactly what the subjects of these fields would be: the *Peaceful Reign of James I* and the *Union of the Kingdoms*.

The first conclusion we can draw as we follow this line of thought concerns the placing of the rectangular paintings. Since Rubens painted the ovals accompanying one of these fields "upside down" in relationship to the ovals flanking the other, we are forced to assume that he intended the rectangular fields themselves to face in opposite directions. Given the fact that the *Apotheosis* has a definite direction of its own, we must also decide which of the rectangles followed this direction and which ran in the opposite one. Here the Glynde sketch provides a clear answer: as the ovals containing the triumphs of *Royal Bounty* and of *Temperance* are painted in the same direction (i.e., right-side up on the sketch) as the *Apotheosis*, the painting meant to appear between them, i.e., the *Peaceful Reign of James I*, must have been designed to be seen like them; the *Union of the Kingdoms*, by contrast, was to be seen "upside down," like the triumphs of *Hercules* and *Minerva*.[12]

At this stage it is essential to remind ourselves that terms like "right side up" and "upside down" have no meaning and indeed are misleading when applied to paintings on a ceiling. What is meant, especially in the case of illusionistic decorations like those Rubens planned for Whitehall, is that the artist expected his pictures to be seen from two different points of view.

Following the lead of the Glynde sketch, and keeping in mind the unsatisfactory appearance of the paintings if they are inspected directly from below, we arrive at a very different arrangement. (For the following, see Fig. XI.4.) We know from the sketch that Rubens intended the *Apotheosis* and the *Peaceful Reign of James I* (with its two allegorical

satellites) to point in the same direction. If the *Peaceful Reign* is correctly placed where it is, at the south end of the Hall (and we shall see that not only tradition but iconographic arguments, as well, strongly support this placing), we are forced to conclude that it and its two flanking allegories must be turned to 180° and that this is also true for the *Apotheosis of James I* in the center. These four pictures, hence, would best be seen from the entrance at the north end of the Hall. The painting of the *Union of the Kingdoms* and its two allegorical companions could remain as they are and hence would best be seen from the south end, i.e., the Chair of State.

The Glynde sketch gives us also a very specific instruction in regard to the putto friezes. That Rubens painted them at the "narrow" ends of the central oval rather than its sides does not mean that he thought this to be also their eventual place on the ceiling: he painted them where he found sufficient space on his panel. (We have seen above that they were painted before Rubens jammed the oval compositions into what was left free of the panel.) Since even in modern times there has been a certain vacillation as to how these long canvases should be placed, it is reassuring to know that Rubens clearly designed them in such a manner that the "base lines" of the actions are on the *outside*, just as they were on the ceiling until the rearrangement of 1951. This, indeed, makes perfectly good sense. Mounted in this manner, the friezes can be viewed much more comfortably and much more in keeping with the chosen degree of foreshortening, in a chiastic pattern of the lines of vision. The frieze on the left side would be clearly seen by the people assembled at the right, and the right one by those on the left. One problem, however, remains. Both friezes are designed as processions; there is a definite movement from one side of the canvas to the other. If the two panels were only exchanged, restoring the situation that prevailed until 1951, this movement would go from south to north, in other words, in the direction of the painting depicting the *Union of the Kingdoms*. We shall have to come back to this problem later on.

The arrangement postulated here on the basis of a strict interpretation of the Glynde sketch permits the viewer to see all panels from a certain distance, with the result that all foreshortenings give a convincing optical illusion. Equally important is the fact that this arrangement has interesting iconographic implications.

The great Hall of the Banqueting House served a number of functions, none more important than the ceremonial reception of foreign ambassadors. For such occasions, railings were placed on either side of the central "nave"; behind them, and facing the center, were the invited guests, the ladies of the court along the left wall, lords and gentlemen along the right wall. Coming through the north door, the ambassador stopped almost immediately after entering the room: "two steps within the Hall, [he] made his first reverence."[13] Given the arrangement of the paintings as proposed here, he saw not only the king at the other end of the Hall, enthroned on the Chair of State, but also above him, on the farthest panel of the painted ceiling, equally enthroned and surmounted by magnificent architecture, the king's father as a Prince of Peace. (It should be remembered that the very purpose of

Rubens' mission to the court of King Charles was to prepare the ground for an official Spanish ambassador to be sent to conclude a treaty of peace between the two countries.) The obvious formal analogy between the reigning king on his throne below and his predecessor enthroned in a second order of architecture above him surely gave a special meaning to the personifications and their actions with which the artist surrounded the king's father. James' *Wisdom (Minerva)* repelling *War* and *Rebellion*; *Peace* embracing *Plenty*; *Royal Bounty* overcoming *Avarice*; and *Temperance* conquering *Intemperance*—all this would inevitably be associated with the qualities and actions of the reigning king below. Nor was this all. For the person entering the room, the painting of the *Peaceful Reign of James I* was the "lowest" to be seen (Fig. XI.5). As his glance rose up higher on the ceiling, he would become aware of the *Apotheosis* of the first Stuart king, illustrating the well-deserved rewards awaiting the just ruler. This painting, hence, would proleptically promise a similar honor to the prince who, below these pictures, occupied the throne of his deified father.

The *Union of the Kingdoms* (and its flanking ovals), appearing directly above the heads of those entering the room, would not be seen by them; these pictures would be read properly only from the other end of the Hall, that is, the Chair of State. It is surely not accidental that this is the only picture of the series in which Charles I himself appears, receiving, while still a child, the united crowns of England and Scotland. Looking at this painting across the hall, the king would be reminded that he wore the dual crown, thanks to his father's wise decision to unite these kingdoms. Per Palme's fascinating study of the deeper significance of this act and its implied analogy to the most celebrated example of royal wisdom, the *Judgment of Solomon*, enables us to see the meaning these paintings must have had for Charles personally, providing legitimacy but also entailing obligation. On either side, *Prudence* and *Fortitude*, as the essential qualities of the ruler, were adding their voices to the message he would read in the large painting between them.

To decide the question touched upon before—which way the putto friezes ought to move—we now must briefly consider their iconographic meaning. Their general significance was well expressed by Rubens himself when he wrote in 1638, in explanation of a similar scene included on the title page of De Marselaer's *Legatus*: "Idem fere significat lusus ille puerulorum lascivientum et exultantium quo omnis antiquitus in Marmoribus et numis temporum felicitatem designabat." (About the same idea is expressed by that game of exuberant and exultant children which through all antiquity indicated, in marble and on coins, the happiness of the times.[14]) The general theme of the happiness of the times was developed more specifically on the Whitehall ceiling by references to *Peace* (the hitching of wolf and ram to a chariot on one side, of a lion and bear on the other side, and the mounting of some of the wild beasts by cupids, a theme occurring also in Rubens' Medici cycle and his *Triumph of the Eucharist*) and to *Plenty* (garlands of fruits carried by cupids and cornucopiae filling the chariots themselves[15]). Now it is precisely the combination of *Peace and Plenty* which Rubens inserted in the *Peaceful Reign of James I* in terms of a warm embrace between two women personifying these concepts. The picture as a whole in fact,

in the language of courtly allegory, glorifies the monarch as the source of all happiness, keeping war and rebellion at bay, securing peace, and sharing—as indicated in the flanking ovals—the fruits of his efforts with his people through royal bounty and wise moderation. As mentioned before, the subject of the main panel at this end has also been described as the *Benefits of the Government of James I* (as, for instance, in the pamphlet printed by the Ministry of Public Building and Works)—a title which certainly characterizes the general tenor of the work. Thus, the putto friezes are closely related to this theme while they have little in common with the opposite canvas of the *Union of the Kingdoms*. We obviously must conclude that the joyful procession of the happy children was meant to converge upon the painting where their great benefactor was shown sitting on his throne. Carrying swags of fruit, driving chariots laden with the goods of the earth, they bring these symbols of prosperity and happiness to lay them at the feet of the prince to whom they owe them.

If this interpretation is accepted, it follows that it will not do simply to make the two friezes change place with each other. Just like the other panels at the south end of the Hall (the central *Apotheosis* included), these two friezes must be turned 180°, *in addition to being exchanged*. (I owe this observation to Miss Fiona Morgan.) Only in this way can they be seen easily by themselves, as well as in formal harmony with the paintings to which they belong thematically. Moreover, arranged in this manner, they will be meaningful even for the people entering the hall, for the putti's procession, proceeding from north to south, parallels the procession of those entering to do honor to the reigning prince. Taking all these changes into account we believe Rubens intended the ceiling to be assembled as may be seen in Fig. XI.6.

Up to this point, our deductions have been derived exclusively from the inner logic of the Glynde Place sketch. It is fortunately possible to adduce strong evidence in favor of this arrangement from the very sources that guided and influenced both Inigo Jones and Rubens in their plans for the Whitehall ceiling. It has always been recognized and repeated by many authors that both the general layout of the soffit and the paintings on it are greatly indebted to ceilings designed and painted by Venetian artists of the sixteenth century. This material has become more accessible than ever before, thanks to the exemplary study devoted to it by Juergen Schulz.[16] Unfortunately, a number of important ceilings have been destroyed or, at least, dispersed. The ceiling all scholars have cited, however, as the most important single influence on Rubens is happily still in place: the one of the Church of San Sebastiano, painted by Veronese in 1555-1556[17] (Fig. XI.7). It has three large canvases in the central aisle. The first and third are ovals; the one in the center is rectangular. (Inigo Jones put rectangles at the end, the oval in the middle.) Each of the large paintings is flanked by two long and narrow ones, making a total of nine paintings, precisely as is the case of the ceiling of the Banqueting House. In view of what has been said before, it is of the highest importance that the perspective design of the large paintings (illustrating scenes from the Book of Esther) is such that on entering the church, one sees fields 2 and 3 correctly, while field 1, nearest the entrance, is properly seen only from the region of

the altar. Moreover, the scenes of garland-bearing putti on either side are placed so that their feet point outward, meaning that those on the right are best seen from the left, those on the left best seen from the right—precisely as Rubens painted them, if our reconstruction is correct. Nor is the ceiling of San Sebastiano the only one that has this kind of arrangement. In his reconstruction of Titian's dispersed ceiling of Santo Spirito in Isola, Schulz arranged the three large canvases in such a way that *Cain and Abel*, placed near the entrance, face in the opposite direction from the two scenes that follow, *Abraham and Isaac* and *David and Goliath*.[18] The latter are best seen from the entrance, the former from the altar.[19] Schulz assumed, for good reasons, the same pattern in another one of his "reconstructions," the ceiling of Santa Maria dell'Umiltà, finished in 1566: two of the large paintings were meant to be seen as one entered, the third, as one turned around looking back from the east.[20]

Changes of direction, along the lines discussed here, are found in still other examples. A very important one in this context is the ceiling of San Francesco di Paola,[21] dating from the very end of the sixteenth century; it was surely one of the most recent decorations in Venice when Rubens was there. Of the four subordinate scenes that accompany the central *Resurrection*, two are aligned with it, while two others are reversed—precisely like the allegorical triumphs in the Glynde sketch. Moreover, all the lateral scenes point outward, as it were; that is, the assumed base line for all figures is farthest removed from the center. This is true also for the lateral scenes in the Sala del Collegio of the Palazzo Ducale.[22] The three relatively small canvases in the center zone, however, are in an identical alignment, I believe, for a very simple reason: in a hall of this length, the farthest canvas could not possibly have been seen from the entrance.

Without commenting on the assembly of the individual panels, Schulz quite correctly described Rubens' Whitehall ceiling as another example of the pervasive influence exercised by the brilliant tradition of Venetian *soffitti* of the Renaissance. This influence will be recognized as still greater if we visualize the ceiling as Rubens had intended it when he painted the Glynde Place sketch.

What, we must finally ask, has happened to this arrangement? Did Rubens himself change his mind? There is no later sketch known which would tell us how Rubens envisioned the ceiling at the time he finally painted the large canvases. It is, however, most unlikely that he would have abandoned a scheme which was extremely logical as well as hallowed by tradition, and substituted for it one visually awkward and iconographically inferior to his original plan. It is very unlikely that any pressure was applied by the English court forcing him to make such a change. Besides, Rubens was not easily swayed when he had formulated what to him seemed to be the best solution to a problem.

This brings us again to Gribelin's engraving of 1720, made about eighty-five years after the paintings were installed. *Prima facie* there is little reason to assume that it was not an authentic record of the way the ceiling presented itself at that time. If Gribelin saw the ceiling indeed as he engraved it, we would have to assume one of two things, neither completely impossible, but both rather unlikely. We know that the paintings were shipped

from Antwerp, but that Rubens never again set foot on English soil; he never saw the pictures *in situ*. Were his instructions disregarded when the pictures arrived in 1635? Or, might one assume that it was Parry Walton (known to have restored the paintings extensively in 1686-1688) who rearranged them in the way they appear in Gribelin's print?

Before considering any such far-fetched theories we should, I believe, approach the problem in a different manner. Let us assume the paintings were installed precisely as Rubens had planned, and that this order still obtained when Gribelin decided to engrave them. Gribelin's work is printed from three different plates; each of the three transversal triads of pictures was engraved on a plate of its own. They were meant to be combined into one large unified composition rendering the ceiling as a whole and provided with a brief explanation (in English and Latin), printed in the customary fashion as the bottom.[23] It would have been the height of folly for Gribelin to print one section of the composition— and the one at the bottom at that!—upside down. What made excellent sense for the paintings *placed on the ceiling* would have been meaningless and truly bizarre if copied literally on a print. Gribelin, indeed, was confronted with the same difficulty (only in reverse) we have in presenting our own thesis because of the basic difference between what we see when we look "down" at a photo or a print, or "up" to a ceiling. Gribelin surely did the correct thing when he lined up all longitudinal pictures along the same axis. He even was justified in reversing the putto friezes, for to make his children and animals turn outward would have been aesthetically disturbing in his print. Gribelin, perfectly sensibly, used his artistic license to make a pleasing whole; there was no need for him to be archaeologically correct and still less to provide a blueprint for future installations.

And yet, that is exactly what happened. We do not know when Gribelin's print was first used as a model for the installation. It may have been as early as 1729-1730 when William Kent took the paintings down. The pictures were also restored in 1776-1777 by G. B. Cipriani; and they were again taken down in 1906-1907, although the order chosen at that time (as we saw before) did not agree entirely with Gribelin's print.[24] But when they were put back again in 1951 after the last and most thorough restoration, Gribelin's print was apparently accepted as the absolute authority.

Fortunately, what we have here sketched as the most likely explanation for the difference between such a seemingly "trustworthy" document as Gribelin's engraving and what we firmly believe was the actual state of affairs on the Whitehall ceiling can be corroborated by one more piece of evidence. There is, in fact, a witness to support strongly our contention that down to the early eighteenth century, at the least, Rubens' paintings were installed in accordance with the master's wishes. Despite Waterhouse's statement that Rubens' Whitehall ceiling "remained the least fruitful . . . of the surviving great works inspired by the patronage of Charles I," an echo of it is surely found in Sir James Thornhill's vast ceiling of the Painted Hall at Greenwich. There, too, as in Rubens' Whitehall soffit, three distinct actions follow one another. The central one, in an oval, is an apotheosis which, despite its multiplication of all motifs, is still reminiscent of Rubens' *Apotheosis of James*

I. It is preceded and followed by scenes with strongly marked architectural elements, comparable to the first and third fields on Rubens' ceiling. In view of these similarities it is of particular interest that, of the three large divisions of Thornhill's ceiling, two point in the same direction, while the third is reversed, precisely as Rubens' paintings had been arranged. Thornhill started his work on the Painted Hall in 1708. If we are justified in assuming that his work was indebted to Rubens for the layout as much as for its general theme, the conclusion is inescapable that Rubens' panels were at that time still visible as they appear in our reconstruction.[25]

The clutter that for so long demeaned Inigo Jones' proud Hall and which was deplored in an eloquent editorial of *The Burlington Magazine* (October 1951) is now happily gone. Rubens' paintings have been restored to much of their original splendor, although no work of art will go unscathed through five major "restorations." Common sense and historical justice would now suggest that the installation of these paintings be modified to accord with Rubens' original intentions. Such an installation would go far to giving back to them the effect they were meant to make, and which, I fear, they have failed to make for a long time.

NOTES

1. Oliver Millar, "The Whitehall Ceiling," *Burlington Magazine*, XCVIII, 1956, pp. 258-267; and *Rubens: The Whitehall Ceiling*, Charlton Lectures on Art, London, 1958.

2. Millar, "The Whitehall Ceiling," p. 267.

3. Ellis Waterhouse, *Painting in Britain, 1530-1790*, Baltimore, 1953, p. 46.

4. See the photograph of the ceiling reproduced in Hans Gerhard Evers, *Peter Paul Rubens*, Munich, 1942, p. 259.

5. Wolfgang Schöne, "Zur Bedeutung der Schrägansicht für die Deckenmalerei des Barock," *Festschrift Kurt Badt*, Berlin, 1961, pp. 144-172, has argued with some justification that even some of these ceilings require an oblique angle of vision. (Dr. Susanne Heiland kindly called my attention to this article.)

6. Iconographical problems are at best marginal to the questions discussed here. Suffice it to say that I prefer this title for the southernmost picture rather than the more common one, *The Benefits of the Government of James I*.

7. See Julius S. Held, "Rubens's Triumph of the Eucharist and the Modello in Louisville," *Bulletin, J.B. Speed Art Museum*, XXVI, 1968, pp. 2-22.

8. The meaning of the four allegorical triumphs is a matter of disagreement among modern scholars. The titles chosen here are the easiest for quick identification. [The problem of interpretation—not germane to the purpose of this study—is discussed in my *Oil Sketches of Peter Paul Rubens*, Princeton, 1980, pp. 211-216.]

9. Millar expressed this idea in both studies cited above (note 1), although in the second even more hesitatingly than in the first. At any rate, we have no evidence whatever for Millar's statement that Rubens may have begun the study abroad "knowing that he was now to be given the Whitehall commission and knowing to some extent what was expected of him" ("The Whitehall Ceiling," p. 264). Nor can I agree with his view that certain differences between the Glynde sketch and the actual ceiling indicate that "the sketch was painted before he had actually seen the interior of the Banqueting House" (ibid., p. 267). The differences in the proportions of the central ovals certainly do not prove Rubens' lack of acquaintance with the actual layout of the ceiling. It is perfectly possible that the area to be filled with a painting was originally planned to have a shape like the Glynde *Apotheosis*. This may have been the reason Rubens had to send another sketch (now in Leningrad) for the king's approval when the plans for the size of the central oval had been changed. We must, besides, keep always in mind that Rubens' sketches often vary in their proportions from the work for which they were made; this, in fact, is true for most of the sketches painted for the decoration of the Banqueting House.

10. Max Rooses and Charles Ruelens, *Correspondance de Rubens et documents épistolaires*, V, Antwerp, 1907, pp. 148 and 153.

11. Ibid., p. 54. It is immaterial in this context whether or not the actual panel had been taken along from Antwerp. Rubens was accompanied by his brother-in-law, Hendrik Brandt, and at least two men servants. He surely took along things he needed for the practice of his *métier*. Small

panels may have been part of such luggage; the transport of a panel of the size of the Glynde sketch would seem to be somewhat cumbersome but evidently not impossible.

12. Although the large rectangular paintings are the two compositions *not* sketched on the Glynde panel, I see no reason to question the correctness of the connection of each of them with the pair of allegorical triumphs that still flank them.

13. See Per Palme, *Triumph of Peace*, Uppsala, 1957, p. 161.

14. Rooses and Ruelens, *Correspondance*, VI, 1909, p. 200. To express the hope for "temporum felicitas," Rubens included playing children also on the *Stage of Welcome for Cardinal Infante Ferdinand* in 1635; see Caspar Gevartius, *Pompa Triumphalis Introitus Ferdinandi Austriaci . . .* , Antwerp, 1642, p. 13.

15. For the meaning of these sections, see also Millar, "The Whitehall Ceiling," p. 18, where an analogy with William Davenant's masque *Salmacida Spolia* (1640) is adduced.

16. Juergen Schulz, *Venetian Painted Ceilings of the Renaissance*, Berkeley, 1968.

17. Ibid., pl. 47.

18. Ibid., pl. 11.

19. While accepting Schulz's reconstruction, I fear his formulation that "*Cain and Abel* was probably hung upside down" is somewhat misleading; as we said before, there is no upside down in such a situation.

20. Schulz, *Painted Ceilings*, pl. 68.

21. Ibid., pl. 151.

22. Ibid., pl. 73.

23. This text, which is not without interest for the interpretation of the paintings, has never, to my knowledge, been published in connection with Rubens' paintings. It reads:

This cieling [*sic*] represents in proper and curious Emblems, the prosperous State of Great Britain in the Reign of King James the 1st. His Concern for Religion, his Love of Arts and Sciences, the Birth of a Prince, the Union of the two Kingdoms, and his Majesty's most Eminent Virtues Crown'd with Glory and Immortality. *In hisce Tabulis Pax et Copia se mutuo amplexae, Res Britannicas, regnante Jacobo I°, Filio Regi recens nato, conjunctisque sub unius Imperio Angliae Scotiaeque Regnis, maxime floruisse testantur. His, plurimisque aliis beneficiis, Rex de Religione, de bonis Artibus, et de Patriâ bene meritus Coelo, et Immortalitate donatur.*

(The Latin version obviously follows the subject of the ceiling more carefully than the English.)

24. For these details in the history of the Whitehall ceiling, see *L. C. C. Survey of London, XIII, The Parish of St. Margaret, Westminster*, Pt. II, London, 1930, pp. 116 ff., especially p. 128.

25. [A still later exmple, painted about 1690-1695, is Vincenzo (Vincent) Waldré's ceiling in Dublin Castle; see John Gilmartin, "Vincent Waldré's Ceiling Paintings in Dublin Castle," *Apollo*, XCV, January 1972, pp. 42-47. Waldré even painted a modello with the inverted third field.]

A PROTESTANT SOURCE FOR
A RUBENS SUBJECT

ON April 30, 1933, ten paintings were stolen from the Brooklyn Museum, among them a sketch by Rubens.[1] None of them have been recovered. After forty years, we must regretfully conclude that they are permanently lost. The Rubens sketch, although at present known only from an old but good photograph (Fig. XII. 1) was unquestionably an authentic work of the master.[2] Depicting the theme of Christ's Victory over Sin and Death, it shows the risen Christ frontally sitting on a sarcophagus and looking straight at the beholder. He rests his left hand on the cover of the tomb and holds the standard of victory in his raised right. His feet, widely separated, are placed on the heads of two forces conquered through his resurrection: the right foot on the skull of a sprawling skeleton, symbol of death; the left on the head of a twisting but powerless serpent, emblem of sin. At the left an angel, seen but indistinctly (perhaps in damaged condition?), blows a trumpet. At the right a gracefully moving cherub holds a wreath above Christ's head, while another angel beside him propels himself upward, perhaps carrying a palm branch in his hand.

The lost sketch was obviously intended for a composition at present known from two painted versions, several prints, and some drawn copies. When Rooses compiled his great catalogue, he knew from sight only one painted version of this composition, then (1887) owned by the Paris dealer Charles Sedelmeyer;[3] however, he quotes Smith (II, 515) as mentioning another example of "the same composition" in the Palazzo Pitti. That painting, as we shall see, is actually quite different. The example Rooses knew may be identical with a picture last known to have been in the collection of Dr. O. Declercq in Antwerp (Fig. XII.2), but there is another version in the Museu Nacional de Arte Antiga in Lisbon which, although apparently slightly inferior to the Antwerp canvas, may render the com-

Reprinted from *Liber Amicorum Karel G. Boon*, Amsterdam: Swets & Zeitlinger, 1974, pp. 79-95.

position more completely, depicting, for instance, more of the skeleton along the lower edge.[4]

From eighteenth-century sources we know that such a composition adorned the epitaph of a "family Cock" or "Cockx" in the old St. Walburgis church in Antwerp. Mariette described it briefly and stated that it was in poor condition, because of neglect.[5] There is also a brief description in De Roveroy's *Chronyke van Antwerpen*.[6] Descamps lists the epitaph and comments on its poor state of preservation but does not even mention the name of the family for which it had been painted.[7] More precise information about the possible donor is found in the *Inscriptions funéraires et monumentales de la Province d'Anvers*, according to which in the year 1627 "JEREMIAS COCX gave 40 florins for the sepulchre and tomb in which he and his wife were later buried."[8] It was probably on the basis of this information that Rooses stated that the picture had originally been placed "sur le monument funèbre de Jeremie Cock et de sa femme," although he also had to admit that nothing is known about this person; nor can we add anything to making Jeremiah Cocx a more tangible historical figure. Assuming that at least one of the preserved versions is the one which originally adorned the Cocx epitaph, we may indeed question whether Rubens had had any hand in its execution. Compared to the brilliant work of the sketch (still strikingly evident in the photo luckily taken before it disappeared) the larger versions look rather feeble, even if we make allowance for the poor condition, already deplored by eighteenth-century observers.

Besides an etching by Remoldus Eynhoudts,[9] which seems to be a rather faithful rendering of the painting in Dr. Declercq's collection, there are three drawings in the well-known collection of drawings from Rubens' studio in the printroom of Copenhagen. One of them is a richly modulated study in chalk of the upper part of Christ's torso. It might be a copy of an original drawing by the master, but I consider it more likely, in view of its close similarity to the painted version, that it was copied from the finished picture itself. The other two, actually done on one sheet (Fig. XII.3) are more interesting. Both render the same subject, although seen from a different angle. The one at the left was clearly based on the design of the stolen sketch, with which it agrees in all essentials. The one on the right depicts Christ raising his left arm as if addressing an audience; the flying angel blows the *tibiae* rather than a trumpet. Both drawings undoubtedly reflect originals by Rubens. Theoretically, their models could have been either drawings or oil sketches. However, since the study on the left of the Copenhagen sheet was apparently based on the stolen sketch, the other drawing may be a record of another such sketch, no longer known.

The theme of the seated Christ trampling underfoot the symbols of Sin and Death occurs twice more in Rubens' oeuvre. His earliest formulation may be the painting now in the municipal museum of Strasbourg (Fig. XII.4).[10] It is probably identical with a picture described by Smith as an "excellent picture"[11] and listed again by Rooses, who did not know its whereabouts when he wrote.[12] Purchased by Bode from a London sale, it was deposited in Strasbourg where it remained even when Alsace was ceded to France. Christ,

facing front, sits on clouds, his right hand resting on a slender staff ending in a decorative cross; his left arm and hand are placed on a globe which is supported by a cherub. Another small angel carries a palm branch, and a third seems to look at the wound in Christ's side. As in the St. Walburgis epitaph, Christ's legs are covered with a mantle, but here this garment is fastened across the shoulders in the manner of a Roman military cape. Death is now represented by a skull rather than a skeleton, and both the skull and the snake curled around it are placed below Christ's left foot. As he appears in this composition, Christ evokes strikingly the image of a Roman emperor and, by obvious association, of Jupiter himself—a phenomenon not unusual with Rubens.[13]

In the third example of this theme in Rubens' works (Columbus Gallery of Fine Arts, Fig. XII.5)[14] the artist chose a more active pose for Christ; the references to the process of Christ's resurrection are made much stronger, both in Christ's own pose and in the activity of the angels, two of whom are engaged in freeing him from the enveloping shroud. The symbols of the serpent and the skull were now placed under the left foot of the Savior, almost as if he were ready to use them as a pad for launching himself upward into space. The artist had painted Christ in the same pose in a little-noticed picture in the Palazzo Pitti, mentioned above.[15] Yet the picture in Florence represents only the Resurrection, without any reference to the conquest of Sin and Death, stressing instead the dynamic pose of Christ's body ready to rise from the tomb. Whereas in the Strasbourg panel Rubens had treated Christ's victory over Sin and Death as a *fait accompli*, Christ being depicted on clouds, without the banner of his victory, and with the symbols of the conquered forces of Sin and Death playing a rather subordinate role, in the Columbus picture he gave greater emphasis to Christ's conquest of mankind's enemies. He raises the banner of victory, as he forcefully subdues his two adversaries; and the burning fires of hell visible at the lower right lend additional weight to the urgency of the combat.

While in the picture in Columbus Rubens tried to combine the ideas of Resurrection and Triumph over Sin and Death, when planning the sketch stolen from the Brooklyn Museum and the epitaph based on it he concentrated, as we saw, on the symbolic victory. It was only here that Death was identified with a complete skeleton rather than a skull, and Christ's triumph was proclaimed by the sound of a trumpet.[16]

The problem of assigning specific dates to Rubens' renderings of the subject of Christ's Victory over Sin and Death need not concern us here too much. As stated before, the Strasbourg panel probably came first; its idealized type of Christ, with long hair flowing down to the shoulders, and the somewhat conventional pose and drapery patterns, fits best into the years between 1613-1616. The more dramatic interpretation of the Columbus panel points toward the end of the second decade (it has been dated c. 1615-1618 by Jaffé, about 1620 by Burchard), but the fact that it was executed with the aid of the studio may have to be taken into consideration. The design preserved in the stolen sketch undoubtedly is the grandest and most spirited interpretation of them all. Purely on the basis of style, I would be inclined to date it in the period of the last of the Medici sketches. The dryly

firm application of lead-white found in these works disappears toward the end of the decade. The date of 1627 for Cocx's purchase of a "sepulchre and tomb" of course is not necessarily also applicable to the epitaph. Yet it is perhaps wise not to remove the sketch of the epitaph too far from the period in which Jeremiah Cocx is known to have made arrangements for his and his wife's burial site and actual grave.

A press release distributed by the Columbus Museum after its acquisition of the painting of the risen Christ stated that it "represents the Resurrection in its purest sense, as defined by the Catholic theologians after the Council of Trent." That Rubens approached religious imagery in harmony with the demands of the church of the Counter-Reformation is a truism, but the iconographic origin of the picture in Columbus and of the other versions of the theme under discussion is hardly explained by a blanket reference to tridentine "definitions." As Hubert Schrade demonstrated long ago, the origins of this iconographic formula are actually linked with Protestant and specifically Lutheran theological doctrines.[17] It was Luther who spoke of the "passage of Christ" (including his descent into limbo) by virtue of which he slew Sin, Death, and the Devil. Although the concept of Christ as victor was an old one, it was given new emphasis and was specifically associated with Christ's resurrection in Protestant imagery.[18] The earliest known formulation of this iconographic type is found, not surprisingly, in a woodcut by Lucas Cranach, contrasting man's perdition under the laws of the Old Testament with his salvation through the grace of the New. In the right half of that print (Fig. XII.6)[19] Christ is depicted in several roles: as the infant of the Incarnation; as the crucified Christ; as the lamb with the flag of victory; and finally, in the right foreground, as the Christ of the Resurrection. As he raises one hand in blessing and holds the banner of his victory in the other, his feet rest on a monstrous creature with a serpent's tail and on a prostrate skeleton. Although Christ is shown standing in paintings related to the theme of this print (e.g., the altar of 1553-1555 in the Herderkirche in Weimar), I suspect that in the woodcut Cranach intended to render Christ sitting on the rim of the sarcophagus; the point, however, is not entirely clear. At any rate, on the title-page of Luther's New Testament of 1533, Christ clearly sits on the sarcophagus, pinning Death's skeleton to the ground with the standard of the Cross.[20] It is self-evident that Rubens' renderings of Christ's Triumph over Sin and Death cannot be derived directly from the Reformatory works of Cranach and his German followers. They are obviously characteristic examples of the process of adaptation by the Church of the Counter-Reformation of Protestant formulae, a process discussed at some length by Schrade and also commented upon by Schiller. Yet no specific antecedents of Rubens' paintings have hitherto been pointed out.

It is for this reason that some attention should be paid, I believe, to a little-known picture, the significance of which has apparently escaped writers on this subject. In fact, I have not found any reference to it anywhere. This picture, unquestionably of Netherlandish origin, was formerly in the collection of Georges Hulin de Loo of Ghent. After the dispersal of the collections of this great scholar, it was owned, in 1928, by the Antwerp dealer

S. Hartveld (Fig. XII.7).[21] I have never seen the panel itself and do not know its present whereabouts. Although we do not know the authorship of the work, a question to which I shall return, it is evident that we have here a painting belonging to the first half of the century; a date of about 1540 cannot be far from the truth. Nor do I know of any iconographic models; this appears to be a highly original formulation. It was undoubtedly indebted to the type—about to disappear—of the solitary Man of Sorrows, which was given, just around the same time, an eloquent formulation in a painting by Marten van Heemskerck in Herentals.[22] Here also Christ is shown seated in a landscape to which he is only slightly related. Yet whereas Heemskerck, in keeping with iconographic tradition, stressed the suffering of Christ in his Passion, and in fact added small scenes of the Bearing of the Cross and of its Raising, the painting from the Hulin de Loo collection renders Christ in the role of a gentle Redeemer who has conquered man's adversaries; under his feet are a terrestrial globe, a sign of his power over the visible world,[23] and a skull; an obviously powerless serpent encircles his ankle.

Nor is the true theme of the picture confined to these details alone. Attached to the stem of the Cross Christ holds with his left hand is a paper inscribed PECCATV[M]; and his right hand, in a pose suggestive of both compassion and generosity, points toward a decoratively designed tablet to which another inscription has been fastened. Although partly effaced (and apparently poorly restored), this inscription is clearly taken from Paul's letters to the Colossians (II:14): CHRISTUS DELENS QVOD ADVERSVS NOS ERAT CHYRO-GRAPHVM DECRETI, QVOD ERAT CONTRARIVM NOBIS. COL.[24] It states in legal phraseology that Christ through his death on the Cross blotted out the "written bond" (chyrographum, translated in the King James version as "the handwriting of ordinances") that was against man, having forgiven all "trespasses" to those "dead in sins and the uncircumcision of the flesh," and having nailed the debenture to the Cross. This passage assumed a central place in Protestant theology. In his Institutes of the Christian Religion, Calvin devoted to it a special section, concluding that it is the ritual cleansing and sacrifices that constitute the "written bond" against those who observe them.[25] While ostensibly attacking Jewish ceremonial law, Calvin clearly attacked also the profuse ceremonial of the Roman church. The demonstrative inclusion of this tablet in the painting of the collection of Hulin de Loo (painted most likely as an epitaph) strongly suggests a Protestant, possibly Calvinist, patron.

The same iconographic type is encountered at a later date in a picture now in the Memling Museum in Bruges (Fig. XII.8);[26] it is known also from another version in the Accademia in Venice.[27] Here a nearly nude and "manneristically" agitated Christ sits in front of a landscape reminiscent of the style of Hans Bol, while far away, in the open skies, appears God the Father amid the symbols of the Four Evangelists. The text from Paul's letter to the Colossians is also included, carved on the face of a solid block of stone; the paper inscribed PECCATV[M] is affixed to the Cross. Both of Christ's feet are now

entangled by a huge serpent; one of his feet treads on a skull, the other on the globe. In a paper that appeared after the present study was completed, Giorgio T. Faggin published this painting and attributed it to Marcus Gheeraerts.[28] This attribution is of considerable interest in the context of the present study. Gheeraerts was a member of the Protestant community in Bruges, and in 1568, after Alba's arrival, he fled to London with his infant son.[29] In 1577, when William the Silent of Orange was in command of Antwerp, Gheeraerts, like other Flemish refugees, settled in that city; he probably returned to London in 1585, when Antwerp fell to the Spaniards. Although Faggin did not identify the inscription (which he quotes) and misread the 2 at the end for a Z, he seems to have sensed a possible connection of the subject of the Bruges panel with Protestant doctrine when he said "Sarebbe interessante studiare se la rappresentazione, in verità piuttosto insolita non sia da collegare con la spiritualità calvinista."[30]

In any effort to trace the antecedents of Rubens' paintings of Christ Victorious over Sin and Death, the former Hulin de Loo picture, and the later version derived from it, must be taken into account, above all because they represent the appearance of a "Protestant" theme on Flemish soil. Yet by the time Rubens occupied himself with the subject, variations and transformations of this theme were available, of both Protestant and Catholic origin. We must, most likely, turn to prints to find the agents operative in transmitting the theme. In a circular engraving of 1577 by Jan Sadeler, after Adriaan de Weerdt,[31] Christ, holding the Cross, is shown sitting on clouds with a halo of light behind his head and seraphs' faces emerging from clouds. A skeleton, a serpent, and the figure of a devil are beneath his feet, and the chained figures of Adam and Eve are below him. The conquest of Death is given a special emphasis by the inclusion of a piece of paper held by the skeleton against the stem of the Cross; it is inscribed with Gen. 2:17 containing the warning that if man should eat from the tree of knowledge of good and evil, he would "surely die"; yet this paper is torn in two—made worthless through the Cross of Christ. The caption is Isaiah 25:9 *Ecce Deus noster iste, expectavimus etim et saluabit nos* (following verse 8, which begins "He will swallow up death in victory"!).

De Weerdt was a Flemish refugee in Cologne, and his design may well have Protestant roots. The triad of "Sin, Death, and Devil" reflects Luther's formula, cited above. Three years later Sadeler engraved a design after Marten de Vos which presumably was a work of Catholic origin, revealing how the Protestant formula was adopted by the Church; it is this version which is the clearest prototype for Rubens' designs (Fig. XII.9). Although De Vos included the Cross, all reference to scriptures is removed from the picture itself; only the caption quotes the second part of I Cor. 15 (*Et sicut in Adam omnes moriuntur, ita et in Cristo omnes vivificabuntur*). Instead of sitting on a mound of earth, Christ sits on the open sarcophagus, the lid of which has been moved to the side. His feet rest on skull and serpent, as in the earlier Flemish picture, but the globe has been omitted or rather moved to rest on Christ's knee as a sign of his divine rule—a feature that reappears similarly in

Rubens' earliest treatment of the theme. De Vos, too, surrounded Christ's head with a glory and heads of seraphs, but he now raises his hand in a gesture of blessing which strongly evokes associations with the greeting of his subjects by a victorious emperor.[32]

What was still embryonic here was given its full development in Rubens' work, in which the idea of Triumph is given ascendency over that of Redemption. The Cross, which in De Vos' print had not only lost the paper of debenture but also was not even held by Christ, only leaned against his body, was replaced in Rubens' last two versions of the theme by the banner of Victory and other references to triumph such as trumpet, wreath, and palm branch. There is almost certainly an irony in the fact that by stressing Christ's triumph—conveyed now with all the grandeur of baroque pageantry—Rubens gave to his works a greater spiritual affinity with Cranach's works than with the more introspective version of the master of the Hulin de Loo panel, even though, on purely formal grounds, that work must be counted among the forerunners of those seventeenth-century formulations.

Yet who was the painter of this curious work, who appears to have created a type of devotional image (possibly already at that time destined for an epitaph) to which even the greatest Flemish painter of the next century was still indebted? And where was he active? The best clue for an answer to these questions is furnished, I believe, by the landscape. Aiming at a picturesque variety of scenery, the artist introduced constantly changing outcroppings of hills and cliffs. Dilapidated remnants of fortress-like buildings rise from them, as well as arched passageways and towers, among them a soaring structure not unlike the concrete television towers of modern times. Scattered among these forms are trees defying botanical classification, but characterized by nearly impenetrable foliage; they are occasionally contrasted with the twisting ramifications of completely bare trees or bushes. Small, agile figures can be seen walking along the roads.

The same kind of landscape is found in a painting depicting several incidents from the parable of the Good Samaritan, also in the Museum of the St. John's Hospital in Bruges (Fig. XII.10).[33] Though less "broken up" in terms of its terrain, the landscape has the same combination of densely foliated and bare-branched trees; some branches of the large tree at the left have the same snake-like motion as the corresponding forms in the former Hartveld picture. A slender obelisk in the mid-distance is reminiscent of the "tower" in the other work, and there are additional towers and ruins in the distance. The light-footed figures near the inn in the upper right are clearly related to the small figures peopling the scenery in the picture of the Redeemer with the Cross.

We can, I believe, establish another connection between the two paintings. The theme of the Good Samaritan with its strong thrust against the sanctimoniousness of priests was a favorite subject of Protestant art. As it is told in the Gospel of St. Luke (10:30-37) a man had fallen among thieves who wounded him and left him half dead. A priest ("sacerdos quidam") who saw him as he walked by "passed by on the other side"; a Levite passing

by did likewise. It was only the Samaritan who took pity on him, transported him to an inn, and paid enough money to cover his expenses, even for the time after his benefactor's departure. In the painting in Bruges the Levite walking away is dressed somewhat fancifully and may be meant to represent Judaism. There can be no doubt, however, that the "certain priest" seen at the upper left is a representative of the Catholic church, dressed as he is in standard liturgical garments. (The Samaritan's horse seems to follow him with what we may imagine to be disapproving eyes.) The Protestant message of the first picture hence appears to be sustained by the anticlerical bias of the second.[34]

Neither the painting formerly in the collection of Hulin de Loo nor the one with the Good Samaritan carry acceptable attributions; in the files of the Institut Royal du Patrimoine Artistique in Brussels (ACL) they are listed, respectively, as by Heemskerck and Lambert Lombard. There is no need to labor the point that both names are far off the mark. A much closer stylistic connection can be established with works by Lancelot Blondeel of Bruges (1498-1561). The Bruges Good Samaritan was, in fact, attributed to Blondeel by Paul Wescher,[35] an attribution subsequently accepted, and supported with additional arguments, by Giorgio Faggin.[36] Faggin considerably enlarged Blondeel's oeuvre depending largely on the artist's characteristic "romantic" manner of depicting landscape. Using as his point of departure the unsigned, but certainly authentic, *Virgin Enthroned* surrounded by seven scenes of her Joys (Visitation, Annunciation, Nativity, Adoration of the Magi, Christ appearing to her after his Resurrection, Pentecost, and Assumption) in the Cathedral at Tournai,[37] he added paintings as well as drawings to the oeuvre, thereby gaining stylistic links between Blondeel and Jan van Scorel in addition to their well-known historical association as cleaners and restorers of the Ghent Altarpiece in 1550. In all these landscapes we find the same interest in broken-up terrain, fanciful and partly ruined buildings, and an alternation between abundant foliage and bare branches and twigs in delicate, lacy patterns.[38] Even the gentle physiognomic type of Christ in the former Hulin de Loo picture and the smooth curvature of his drapery have analogies in the figures from Blondeel's paintings.

This does not necessarily mean that the Hulin de Loo painting must be attributed to Blondeel himself; as the original can no longer be examined, it seems to me preferable to leave this question open. That the picture belongs to Blondeel's circle and hence should be located in the Bruges school of the mid-century can hardly be questioned, in view of its connection with the painting of the Good Samaritan and the echo it found in the panel given to Marcus Gheeraerts.

This group of works points up a problem which may deserve further study. While art historians have shown some interest in the reflection, in Pieter Bruegel's work, of religious controversies of his time, not enough attention seems to have been given to possible manifestations of specific Protestant doctrines and attitudes in Flemish sixteenth-century painting in general. Some of the works discussed here appear to prove that such reflections

do, in fact, exist, and it is noteworthy that even in Bruges—a city not in the forefront of reform movements in the Netherlands—Protestant groups were established in sufficient force to leave a mark on paintings produced by local artists.[39]

NOTES

1. *The Studio*, CVI, 1933, p. 47.

2. Canvas, 30.5 x 28.5 cm. Canvas being an unusual support for Rubens sketches, it is likely that the picture had been transferred from wood. Said to have come from the collection of Prince Demidoff, Pratolino, the sketch was in the collection of Mrs. S. D. Warren, sold January 8-9, 1903 (lot 89), New York (American Art Association). In 1917 it was lent to the Brooklyn Museum by A. A. Healy and was bequeathed by him to the museum in 1921. Max Rooses, *L'Oeuvre de P.-P. Rubens*, II, Antwerp, 1888, p. 201, lists a sketch sold with the collection of the 12th Duke of Hamilton (June 17-July 20, 1882); it measured 30 × 38 cm. and was sold for the good price of 150 guineas. To identify the stolen sketch with the one from the Hamilton collection we would have to assume an error in transcribing one digit (38 for 28), surely not an impossible thing. For the possibility of a still earlier provenance see below, note 4. I am indebted to Sarah Faunce for providing the photo and giving additional information.

3. Ibid.; p. 200, no. 378.

4. Rooses (ibid., p. 201) suggested that the Sedelmeyer version had figured in the Vinck de Wesel sale, Antwerp, August 16, 1814; he thought that it might also be the same picture that John Smith had described (*A Catalogue Raisonné of the Works of the Most Eminent Dutch, Flemish, and French Painters*, IX, London, 1842, p. 244, no. 4) as in the collection of George Watson Taylor in 1832. This, however, is not correct, as Smith specifically states that Christ was "girt with a white mantle" while the drapery of the Sedelmeyer picture is red. Actually, the lost Brooklyn sketch showed Christ with a white mantle and hence may have been the picture from the Watson Taylor collection. (Smith did not mention any dimensions.)

5. P. J. Mariette, *Abecedario*, V, Paris, 1858-1859, p. 89.

6. Antwerp, 1775, p. 48.

7. Jean Baptiste Descamps, *La Vie des peintres flamands, allemands et hollandois*, I, Paris, 1753, p. 321.

8. Antwerp, 1856, II, p. CIII. The inscription reads "Eod' A° 1627 JEREMIAS COCX, gaff 40 guldens voor de sepulture ende kelder daer hy ende syne huysvrouwe daer naer in begraven zyn." On p. 315 of the same publication we read "Ostium Monumenti/JEREMIAE COCK et Familiae." I am grateful to Dr. Leon Voet for having checked these texts for me.

9. C. G. Voorhelm Schneevoogt, *Catalogue des estampes gravées d'après P.-P. Rubens*, Haarlem, 1873, p. 56, no. 408.

10. Panel, 175 × 135 cm.

11. Smith, *Catalogue Raisonné*, II, London, 1830, p. 211, no. 757.

12. Rooses, *L'Oeuvre*, II, p. 202, no. 379.

13. See Louis Réau, *Iconographie de l'art chrétien*, II, part 2, Paris, 1957, p. 588.

14. Panel, 211.4 × 170.8 cm.

15. Alinari 4765.

16. Christ as victor over Sin and Death appears also in a different form and context in the sketch in the Metropolitan Museum (panel, 71.1 × 48.2 cm., KdK 291). Painted probably around 1630 for the Carmelite church at Antwerp, it depicts Christ standing on the globe, placing one foot on the serpent that surrounds it, while the skeleton of death lies crushed beneath the sphere. At the left are Elijah and Melchizedek, on the right St. Paul and St. Cyril of Alexandria; above them appear God the Father and the Holy Ghost, together with a large group of cherubs. The emphasis has here clearly shifted from the Resurrection to the Eucharistic sacrifice as the main agent of man's delivery from sin and death. See also P. Jean de la Croix, O.C.D., "La Glorification de l'Eucharistie de Rubens et les Carmes," *Metropolitan Museum Journal*, II, 1969, pp. 179-195.

17. Hubert Schrade, *Ikonographie der christlichen Kunst*, I, *Die Auferstehung Christi*, Berlin, 1932, pp. 299-304.

18. The most comprehensive survey of the tradition of Christ as Victor is found in Gertrud Schiller, *Ikonographie der christlichen Kunst*, III, Gütersloh, 1971, pp. 32-39 and 85-86. Its origin is evidently rooted in several forceful passages of the Bible, above all Psalms 91:13 ("Thou shalt tread upon the lion and adder: the young lion and the dragon shalt thou trample under feet"), but also I Corinthians 15:25-26 (". . . The last enemy that shall be destroyed is death"), Hosea 13:14; I Corinthians 15:54-55; 2 Timothy 1:10; and Revelations 1:18. For the iconographic pattern in the Reformation, see Schiller, II, 1968, pp. 174-176, figs. 532-538.

19. Max Geisberg, *Der deutsche Einblatt-holzschnitt in der ersten Hälfte des 16. Jahrhunderts*, XVII, Munich, n.d., 22; [see also Max Geisberg, *The German Single-Leaf Woodcut: 1500-1550*, rev. and ed. Walter Strauss, New York, 1974, II, p. 582, G. 615]; F.W.H. Hollstein, *German Engravings*.

Etchings and Woodcuts ca. 1400-1700, VI, Amsterdam, n.d., p. 124, 14. The same confrontation of Old and New Testament can be seen in a painting from the studio of Cranach of 1529 (Schiller, *Ikonographie*, figs. 533-534) and a title of 1539 (Max Geisberg, *Buchillustration* Heft 5, no. 500, Pl. 226). I am indebted to Susanne Heiland for the photo of the Cranach woodcut and other useful references.

20. Schiller, *Ikonographie*, II, fig. 538. On Cranach's Wittenberg Altar of 1547, Christ is depicted with the banner of Victory, sitting *behind* an open tomb containing the defeated figures of Death and the Devil (see Oskar Thulin, *Cranach-Altäre der Reformation*, Berlin, 1955, figs. 4-11, and Donald L. Ehresmann, "The Brazen Serpent, a Reformation Motif in the Works of Lucas Cranach the Elder and His Workshop," *Marsyas*, XIII, 1966-1967, pp. 32-47.

21. S. Hartveld, exhibition catalogue, May 1928, no. 115; panel, 73.5 × 64 cm.

22. [Illustrated as Fig. 11 in the original version of the present article.]

23. In the context of this picture, the terrestrial globe can only be taken as a symbol of a power subdued; see Schrade, *Ikonographie*, I, pp. 299-300. Slightly different interpretations have been given by Schiller, *Ikonographie*, II, p. 210, and III, p. 248. In an etching by Wendel Dietterlin the Elder (Schrade, *Ikonographie*, fig. 151), Death and the Devil are seen *inside* a transparent globe.

24. The entire passage reads as follows: "Et vos cum mortui essetis in delictis, et praeputio carnis vestrae, convivicavit cum illo, donans vobis omnia delicta: delens quod adversus nos erat chirographum decreti, quod erat contrarium nobis, et ipsum tulit de medio, affigens illud cruci."

25. John Calvin, *Institutes of the Christian Religion*, Library of Christian Classics XX, Philadelphia, 1960, I (Book II, Chapter 17), p. 366.

26. As "Antwerp School, end of the 16th century"; panel, 108 × 74.5 cm. The painting, property of the Commissie van Openbaar Onderstand, has been on exhibition at the museum of the St. John's Hospital since 1958. I am greatly indebted to Jacqueline Folie for information about this picture as well as the one reproduced in Fig. XII.10.

27. The painting in Venice (panel, 164 x 136 cm.) creates a problem. Published by Sandra Moschini Marconi (*Gallerie dell'Accademia di Venezia, Opere d'arte del secolo XVI*, Rome, 1962, p. 289, no. 497, fig. 500), it is there attributed to an unknown master of the first half of the Cinquecento. It is said to have come from the church of S. Giovanni Evangelista in Torcello. The author of the catalogue sees in it connections with Tuscan mannerism, but also with an "allegorismo nordico." Its connection with the painting at present in Bruges is so close that one must be copied from the other unless both are derived from the

same model. If Marconi's date is correct, the picture in Venice would precede the Bruges painting. Yet the Bruges picture itself, as we have seen, depended on the earlier painting from the Hulin de Loo collection, which certainly is a Northern work. Moreover, judging from the available reproductions, I am confident that the Bruges panel is qualitatively superior to the one in Venice. From these circumstances I draw the conclusion that Marconi's date is too early, and that the painter of the picture in Venice followed a Northern model, presumably the very picture now in Bruges.

28. Giorgio T. Faggin, "Due dipinti di Marcus Gheeraerts il Vecchio," *Album Amicorum J. G. van Gelder*, The Hague, 1973, pp. 114-118.

29. See Edward Hodnett, *Marcus Gheeraerts the Elder of Bruges, London and Antwerp*, Utrecht, 1971, pp. 11 ff.

30. [The Bruges picture has twice been published by Reinhard Liess as an early painting by Rubens, in *Die Kunst des Rubens*, Braunschweig, 1977, pp. 67-72, and "Entdeckungen im Frühwerk des Rubens," *Mitteilungen der Technischen Universität Carolo-Wilhelmina zu Braunschweig*, XIII, 1978, pp. 57-81. I cannot follow the author in this attribution.]

31. Schrade, *Ikonographie*, fig. 154.

32. A painting apparently based on this print is in the museum of Aix-en-Provence (no. 402, as Ecole Flamande, on panel, 64 × 68 cm.). In it the seraphs' heads are omitted.

33. Panel, 99.5 × 71.1 cm. It, too, belongs to the Commissie van Openbaar Onderstand and has been deposited in the museum since 1958.

34. A clear anticlerical bias in the illustration of the parable of the Good Samaritan is found also in a drawing by Michael Kirchmaier (Kirmer) of 1552 in the Museum der bildenden Künste, Leipzig; see K.-H. Mehnert and S. Ihle, *Kataloge der graphischen Sammlungen*, I, *Altdeutsche Zeichnungen*, Leipzig, 1973, pp. 77-78, no. 26. [See also the original version of the present study, in which the Kirchmaier drawing is illustrated as Fig. 15.] While in the foreground the highwaymen strip the victim, two men, both apparently clerics and one dressed in a manner characteristic of canons of the church, turn their backs on the scene in the middle distance, where the turbaned (!) Samaritan attends the wounded. The contrast of the humanitarian "heathen" and the callous representative of the Roman church is underscored by the presence of a roadside votive cross (a "Wegkreuz"), clearly unheeded by both the "priest" and the Levite. Kirchmaier lived in Regensburg, a city that solemnly embraced the Reformation on October 13, 1542, and where, despite the strong Catholic reaction after 1648, a Protestant community continued to exist. It was precisely in 1552, the year of the drawing, that the negotiations began which led to the religious peace of Augsburg of 1555. See L. von Ranke, *Deutsche Geschichte im*

Zeitalter der Reformation, Vienna, n.d., pp. 900, 1038, and 1142 ff. I owe the photo and some additional information to Dr. Susanne Heiland.

35. Paul Wescher, "Zu zwei niederländischen Bildern der Berliner Museen," *Berliner Museen*, XII, n.s., heft 2, 1962, pp. 55-59.

36. Giorgio T. Faggin, "Nuove opere di Lanceloot Blondeel," *Critica d'Arte*, XV, n.s. fasc. 95, May 1968, pp. 37-54. Faggin follows Wescher also in attributing to Blondeel a *Baptism of Christ* in Berlin, an attribution which, if correct—of which I am not entirely convinced—would make Blondeel virtually a follower of Jan van Scorel.

37. Ibid., fig. 8. [See also the original version of the present study, where a detail of the Tournai painting is illustrated in Fig. 16.]

38. It hardly needs stressing that the landscape style of Blondeel is a Flemish variant of a widespread trend in European landscape art, the roots of which may be found in certain works of the *Donauschule*, but which by midcentury had found practitioners as different as Jan van Scorel, Jean Cousin, and the "Master of the Liechtenstein Adoration."

39. A curious and apparently Dutch variant of this landscape style is found in a little-noticed pair of paintings of 1546 in the museum of Castle Gaasbeek near Brussels. They represent Scelto van Liaukama, a nobleman from Friesland, aged twenty-five, and his fifteen-year-old wife, Sjouck van Martena. The portraits are on panels measuring 98 × 86 cm. (Scelto), and 97 × 83.5 cm. (Sjouck). [See Figs. 17 and 18 of the original version of the present article.] The identification of the two models, given in cartouches above the portraits, has been substantiated by

G. Renson, "Schilderijen en sculpturen uit het Staatsdomein van Gaasbeek . . . ," *L'Intermédiaire des généalogistes*, no. 141, 1969, p. 180. Sjouck was Scelto's second wife, his first having died in 1538, when, according to his age given in the picture, he was only about seventeen years old (!). Abraham Wassenbergh attributed these portraits to Adriaen van Cronenburg, chiefly, I presume, because he was the only major artist known to have been active in Friesland at this time. Stylistically they differ considerably from Van Cronenburg's other, mainly later, work. The figures are seen somewhat incongruously through a framework designed as an arcade in Renaissance style; behind them extends a landscape that also contains some of the picturesque elements we have seen before, including even the obelisk-like towers. Since in addition to this kind of landscape the Dutch painter was also interested in an elaborate decorative framework, it is reasonable to assume that he had been in contact with, or had seen works by, Blondeel. The style of the Dutch master is drier and more pedantic than Blondeel's; he clearly lacks the playful ornamental fantasy of the Bruges artist. Yet because of their early date, these portraits have a certain importance as a reflection of Blondeel's art. The use of open arcades or arches is a specifically "Blondeelian" expedient; it never occurs in other of Van Cronenburg's works. Thus the two paintings in Gaasbeek may give an idea of what Blondeel portraits may have looked like, assuming that he painted portraits. They contribute, if only marginally, to our knowledge of Blondeel, a master who only recently has begun to receive the attention to which he is clearly entitled. [See now Karel G. Boon, "Lancelot Blondeel as a Designer for Sculpture and Textiles," *Hafnia*, 1976, pp. 113-124.]

THE *FOUR HEADS OF A NEGRO*
IN BRUSSELS AND MALIBU

THE Brussels study of the head of a Negro seen from four different angles (Fig. XIII.1) has always been a favorite with the general public, surely long before it appeared on a 500 franc note. Naive beholders apparently had no difficulty recognizing immediately the truth—ethnically and artistically—of this study from life. There is something compelling about the psychological variety of expression depicted in what clearly was the same individual (one wonders what he may have been in life), ranging from a seemingly cheerful smile, to a state of serene calm, and, in the most striking of the views, a tense pathos reminding us movingly of the traditional roles assigned to the members of his race.

The popularity of the work has evidently not been affected by the critical and material problems attached to it. We know today that in 1870 the sketch, originally painted on panel, was transferred to canvas by A. Sidorov.[1] Even if done with professional skill, such an operation is apt to leave traces; some of the difficulties scholars have had with the work may have been caused, at least in part, by its physical condition. The chief problem, at any rate, has always been that of the attribution. In the earliest records available, the inventories of 1719 and 1746 of Castle Weissenstein in Pommersfelden, the work was listed as by Van Dyck. In the catalogue of 1857, however, it was attributed to Rubens. Beginning in 1900 an influential group of German art historians (Weizsäcker, Glück, Bode) revived the old attribution to Van Dyck. In 1931, Glück indeed reproduced it as Van Dyck's work in his edition of the master's paintings in the *Klassiker der Kunst*.[2] The most respected Rubens scholar of his time, Ludwig Burchard, spoke in 1933 of the attribution to Rubens as an "irrige Zuschreibung."[3] Twenty years later Christopher Norris still wrote: "Neither the quality nor the technique of this sketch resembles Rubens' own."[4]

Reprinted from *Miscellanea in Memoriam Paul Coremans (1908-1965), Bulletin de l'Institut Royal du Patrimoine Artistique*, XV, 1975, pp. 180-192.

In his publication of Rubens' oil sketches in public collections in Belgium and Holland, R.-A. d'Hulst pointedly ignored the picture.[5]

To be sure, the attribution to Rubens was never completely abandoned, least of all in the museum where the painting was on display. Rooses, and particularly Van Puyvelde, defended it as Rubens' work. It was exhibited as by Rubens in 1933, 1937, 1953-1954, and 1965; yet in 1936 it was shown as a work by Van Dyck.[6] And as if it had not been in trouble enough with professional art historians, it was stolen on February 16, 1964, by an enterprising nineteen-year-old who thought that it must have some value, having been used on a high denomination bill. Fortunately, no harm came to the picture by this bizarre incident.

More recently a new problem has arisen with the appearance of a rival with an equally distinguished provenance, having been at least since 1818 in the collection of the Earl of Derby (Fig. XIII.2). Smith listed it[7] with a flattering comment as a work of Rubens, and so did Rooses.[8] In modern times, however, this attribution was challenged and Van Dyck's name substituted, especially after the painting was exhibited in London in 1953-1954;[9] in 1969, however, a new name was proposed, when Jaffé attributed the picture firmly to Jordaens.[10] Yet it was sold in 1971 (Christie's, June 25) as a work of Van Dyck and was acquired, at nearly one million dollars, for J. Paul Getty's Museum in Malibu. There it has recently been included in a new catalogue of the collection and—coming full circle—has again been given to Rubens. In fact, it is said to have preceded the Brussels picture, which is called "a larger repetition by the same hand, done perhaps for studio use in yet larger compositions."[11]

The case of the two pictures should be of considerable concern to an art historian believing in the validity of the methods of his discipline. Wildly divergent views like those reported here would seem to give support to the not uncommon contention that judgments in our field are ultimately mere matters of opinion, and that results, unlike those based on strictly scientific examinations, defy all efforts of reliable verification. Yet no one knew better than Paul Coremans, the scholar to whom this essay is dedicated, that in many situations the scientific data of the laboratory alone are inconclusive and that the last word will have to be spoken by the historian of art. In fact, in the case of the Brussels canvas and the Getty panel, a conclusive decision as to their relationship can be made without reference to complex scientific tests; the application of conventional art historical methods combined with a dose of common sense is sufficient, I believe, to arrive at a result.

Leaving aside the question of attribution (to which I shall return) there are three theoretical solutions for the relationship of the two pictures to each other: a) the Brussels picture came first, b) the Getty picture came first, and (c) both were assembled *independently* from pre-existing individual studies. Of these possibilities the last one can be eliminated easily, not only because it is unlikely per se, but also because there is strong evidence against it: in both paintings the laughing head is considerably smaller than the three others; even the head in left profile, while larger than the "happy" one, is somewhat smaller

than the one in near profile, looking toward the right. The sameness of these scale relationships in both pictures virtually excludes an independent origin of each sketch.

The differences in scale of the heads provide in fact an important argument for the priority of the Brussels sketch since that sketch alone permits a rational explanation of these differences. Even a cursory examination of the Brussels version shows that of the four heads it is the two turned toward the right that were painted first; [12] for our purposes it is relatively unimportant in what sequence these two were painted though I am willing to argue that the painter began with the "pathos"-study at left. Since these two heads occupied a major part of the available surface, the two other heads had to be fitted into what space was left. If the strict profile view was—as I think it was—the third head to be done, the last one *had* to be reduced in scale to get into the picture at all. (The final shape of the cranium of the "second" figure was determined as an afterthought, this pentimento accounting for the brushstrokes which appear to overlap the collar of the smiling face.)

The differences of scale can be accounted for in a logical manner in the Brussels canvas but not in the Getty version. By using a long board and stringing them out in a more or less horizontal sequence, the painter had obviously ample space to depict the four heads equal in size. That he did not do so suggests that he worked from the other picture.

Yet it is not only the fact that the scale-differences can be logically accounted for in the Brussels sketch and not in the Getty version that helps to define the relationship of the two works. What is even more important is the obvious inability of the painter of the Getty panel to make any pictorial use of the space he had at his disposal. This is particularly obvious in the case of the two heads in the middle. In the Brussels sketch, the artist was prevented from painting more than a minimum of the head seen in profile because the head lower down, previously painted, was in the way. No such limitation existed for the painter of the Getty panel. The situation is even more obvious—and more damaging—when we come to the smiling head (Fig. XIII.3). In the Brussels version, there was barely enough space to include the white collar—and that, in fact, is all that was painted also by the painter of the Malibu panel, despite the large open area that was at his disposal. Whoever painted the Malibu panel was an artist of greatly limited imagination; where his model failed to give him any guidance, he was unable to improvise anything on his own. The conclusion is inevitable that the Getty panel is not only a copy of the Brussels sketch but a copy by a less than original painter.

This view can be supported by conventional art historical comparisons, which show clearly that contrary to some of the favorable opinions expressed in the literature the Getty panel is unquestionably inferior in quality to the one in Brussels.

To take the most obvious case: the "worried" head at the left, brilliantly constructed in the Brussels canvas, is clearly twisted out of shape in the Getty copy. The mouth is pushed up on the far side, losing its harmonious relationship to the central axis of the face. In the other head turned to the right, the forward extension of the mouth and chin section

is more exaggerated in the Malibu panel than in the canvas in Brussels, and the one visible eye stares more rigidly than the one in the original.

Beyond the observation of details, it is the compositional concept as such that is as unsatisfactory in the Getty version as it is of a high artistic order in the Brussels canvas. Without being anecdotally related to one another or following a calculated compositional plan, the four heads in the Brussels sketch are distributed in a manner that creates a high degree of cohesion among them. The body of the figure at the left is taken frontally but the head turns to the right; in the second "take," head and shoulders are both facing in that direction. As if responding to the barrier of the frame, the third head, placed higher as well as slightly behind the second, turns back to face left, followed by the smiling head which, being smaller, suggests a further recession into the depth of space. At the same time, however, we cannot help noticing that the upward glance of the first figure establishes a link—directional as well as expressive—with the smiling head; in the juxtaposition of two strongly contrasting mental attitudes, a circle in which each head fufills a meaningful part seems to be closing.

Not so in the Getty panel. Here the confrontation of the two "expressive" heads loses its significance not only because it is introduced without the compositional support of the other figures but also because the upward glance of the first head passes by the other, going into empty space. And whereas in the Brussels canvas heads two and three complement each other, the lower one being formally fitted into the receding lines of the other, their harsh *dos-à-dos* in the Getty panel creates an unpleasant break, completely isolating the last of the heads from the others.

It is not difficult to follow the procedure of the painter responsible for the Getty version. Having chosen (or possibly been given) a longitudinal panel on which to copy the Brussels picture, he chose to proceed from left to right, not unreasonably, if insensitively, beginning with the three heads which are about on the same level in his model. The one definitely below that level had to be added at the right, with the result that it is irrevocably isolated; at the same time, both "framing" figures look in the same direction, the last one right out of the picture—as awkward an arrangement as could be imagined.

If it is agreed that the Getty picture is a copy, and not even a good one, of the Brussels canvas, its attribution to Rubens can no longer seriously be debated. Could it then be a work of Van Dyck's or Jordaens', as some scholars have thought?[13] Aside from the fact that both these painters were imaginative enough to fill an empty area, at least with some quick indications of the model's clothing, we happen to have examples of Negroes' heads painted by both these artists; they are stylistically incompatible with the Getty picture. A good example in Van Dyck's work is the smiling Negro from the *Martyrdom of St. Sebastian* in Edinburgh (Fig. XIII.4). Van Dyck's approach is clearly more fluid and broad, lacking entirely the pedantic explicitness of the Getty picture. As regards Jordaens, there exists an authentic study of two views of a Negro's head (Fig. XIII.5),[14] clearly revealing Jordaens' softer and more superficial manner of seeing forms, greatly at variance with the efforts at

sculptural modulation (reflecting of course the style of the Brussels painting) found in the Malibu sketch. The Getty panel, in short, far from being the work of Rubens, Van Dyck, or Jordaens, is no more than an anonymous copy, although I readily grant that it may have been painted in the seventeenth century.

We are left, then, with the problem of the authorship of the Brussels picture. In the literature about that work, there are found three different opinions. In addition to the straight attributions to either Rubens or Van Dyck mentioned before, there is also a theory which appears to be a compromise. It was Norris (see note 4) who first suggested that the picture was copied from earlier studies made by Rubens. He also hinted, although with commendable caution, that the copy may be the work of Van Dyck. This view was embraced, and in the process considerably firmed up, by Jaffé,[15] who stated unequivocally that the Brussels canvas is in fact the work of Van Dyck, combining in one field four separate studies painted by Rubens. Although no individual study of any of the four heads is known, we do have indeed, as Jaffé pointed out, a single study of a Negro by Rubens, now in the Hyde collection in Glens Falls.[16] It is even likely that the model portrayed in the Glens Falls sketch was the same as the one posing for the four heads of the Brussels picture, although probably seen at a different period. (The attribution to Van Dyck of the Brussels picture—including its conception—is usually supported by a reference to a picture listed in 1689 in the inventory of A. Voet: "Een mooretroniken van Van Dyck.")[17]

The Norris-Jaffé thesis, at any rate, leaves the invention—that is, the painting of the original studies postulated by that theory—to Rubens. It is only the actual execution of the picture which is credited to another hand which—at least in Jaffé's opinion—was definitely Van Dyck.

Of the three opinions I find the one giving both the invention and the execution of the Brussels picture to Van Dyck the least acceptable. Considering the number of scholars of repute who have held this opinion, it is surprising to see how little there is in their writing to support the attribution. In his introduction to the Van Dyck volume of the *Klassiker der Kunst*, Glück talked poetically of Van Dyck's paintings during his closest association with Rubens, stressing particularly his "penetrating and lovingly executed studies"— among them the Brussels heads of a Negro. The only specific characteristic he mentioned was their color: "a fine shimmering shade of silver, with a tender, cool light-blue as a basic tone." Aside from the fact that this description hardly applies to the colors of the Brussels canvas, it should be obvious that the skin of a Negro requires a different coloristic *gamme* than either artist would have used for a white man. Nor should it be forgotten that several of the heads appear in works either painted by Rubens,[18] or at least based on his design, while they do not appear in any painting conceived and painted by Van Dyck himself— even where he did include Negroes.[19] In fact, the forceful plasticity of the forms and the use of a dull red of the color of bricks (noticeable particularly in the smiling face) are more characteristic of Rubens than Van Dyck. So is, above all, the very personal ethos that makes the four faces of this black man such a memorable experience. I cannot see that Van

Dyck ever saw such nobility in a member of a foreign race; nor is there any analogy anywhere in Van Dyck's oeuvre for the particular range of expression depicted here; obversely, there is nowhere in the four heads anything of the nervous intensity that marks Van Dyck's studies of heads from the very beginning of his career.

This argument carries of course less weight if we retain, with Norris and Jaffé, the invention for Rubens, giving only the execution to Van Dyck. The first argument against this thesis ought to be the uniqueness of the case. We know, of course, that Van Dyck assisted Rubens in the execution of some of the major commissions accomplished during the period in which he was in close personal contact with the master. He also is believed to have drawn the models for engravings on the basis of Rubens' designs, primarily on the strength of Bellori's statement to that effect. Yet to the best of my knowledge no case similar to that assumed to account for the Brussels canvas is either known, or documented.

The assumption that the Brussels picture is a copy, compiled from separate studies by Rubens, can also be questioned on internal evidence. The picture is painted with considerable freedom and reveals, on closer inspection, a number of pentimenti. The correction of the cranium of the head in the lower center has been mentioned before. There is also an adjustment of the outline of the neck as well as of the shoulder of this figure, and there are obvious modifications in the design of his white collar. Other changes can be observed in the X-ray photographs.[20] The collar of the head at the left had first been essayed about 2½ cm. lower; the upper lip of the smiling face has been broadened during the work, and the neck of this figure was extended downward, the dark skin now overlaying a strong accent of white, originally probably intended for the collar. These and other observable changes, made during the process of painting, speak against the thesis that it is a copy and favor the originality of the work. Yet I admit that they could have been made by an artist endowed with a temperament of his own, even if he was working from another picture rather than from nature.

The balance shifts still more strongly toward Rubens if we examine the X-ray photographs for what they reveal about the basic pictorial technique. We see in them Rubens' economic use of lead white, applied more boldly and more deliberately, with concentration on the areas of main highlights, than is found in the works of other Flemish artists, including Van Dyck. It is this method of painting which accounts for the effect, not unlike bronze sculpture, that is characteristic of X-ray photographs of all of Rubens' works.

I do not claim to have accumulated definite and incontrovertible proof that Rubens and no one else is the author of the Brussels canvas. There evidently must be aspects of the painting that have troubled experienced scholars and have prompted them to deny his authorship. The case, like so many in the history of art, boils down to the question of what degree of stylistic latitude we find compatible with the image we have formed in our minds of the oeuvre of a given artist. In the case of the Brussels *Morenkoppen* the unusual subject, and the desire to combine four versions of the head in one field, may have worked together to affect its appearance. Of course, even the transfer from wood to canvas, as I

said in the beginning, could have resulted in an appearance that some scholars found unacceptable in a painting by Rubens. All things considered, I find Rubens' authorship still the most likely and—given the quality of the work—the most satisfactory solution of the problem.

NOTES

1. See R.-A. d'Hulst, "De 'Morenkoppen': Enkele gegevens betreffende pedigree en physische toestand," *Bulletin*, Musées Royaux des Beaux-Arts, III, 1954, pp. 117-121.

2. Gustav Glück, *Van Dyck, Des Meisters Gemälde*, Klassiker der Kunst, Stuttgart, 1931, p. 14. For the earlier literature see Egbert Haverkamp-Begemann, *Olieverfschetsen van Rubens*, exhibition catalogue, Rotterdam, 1953-1954, pp. 48-49, no. 17.

3. Note added to Gustav Glück, *Rubens, Van Dyck und ihr Kreis, Gesammelte Aufsätze*, Vienna, 1933, p. 390.

4. Christopher Norris, "Rubens' Sketches at Rotterdam," *Connoisseur*, June 1954, p. 26. Denys Sutton, in "Flemish Painting at the Royal Academy, An Essay," *Les Arts Plastiques*, 1954, p. 53, also stated that the picture should not be given to Rubens.

5. R.-A. d'Hulst, *Olieverfschetsen van Rubens uit nederlands en belgisch openbaar bezit*, n.p., 1968.

6. The exhibitions were held in Amsterdam (Goudstikker), 1933; Paris, 1936; Brussels, 1937; Rotterdam, 1953-1954; and Brussels, 1965.

7. John Smith, *A Catalogue Raisonné of the Works of the Most Eminent Dutch, Flemish, and French Painters*, II, 1830, p. 272, no. 919; IX, 1842, p. 327, no. 305.

8. Max Rooses, *L'Oeuvre de P.-P. Rubens*, IV, 1890, p. 788.

9. *Flemish Art, 1300-1700*, exhibition catalogue, 1953-1954, Royal Academy of Arts, London, no. 326. The catalogue entry refers to the panel in Brussels "which is also certainly by Van Dyck."

10. Michael Jaffé, "Reflections on the Jordaens Exhibition," *Bulletin*, National Gallery of Canada, Ottawa, XIII, 1969, pp. 9-10.

11. Burton B. Fredericksen, *Catalogue of the Paintings in the J. Paul Getty Museum*, Malibu, 1972, pp. 68-69.

12. This observation is also confirmed by the examination of the X-ray photographs.

13. Jaffé—the only author to attribute the work to Jordaens—supported his view by referring to qualities in the picture that I find hard to see: "the externalization of form, the patterning of the inner structure of ears and the forms of cheeks and jowls, the incandescent lighting or emphatic shading of silhouettes—all speak for Jordaens." See note 10.

14. Julius S. Held, "Notes on Jacob Jordaens," *Oud Holland*, LXXX, 1965, pp. 112 ff.

15. Jaffé, "Reflections on the Jordaens Exhibition," p. 9, no. 12.

16. See Jan-Albert Goris and Julius S. Held, *Rubens in America*, New York, 1947, no. 30; see also *Rubens Drawings and Oil Sketches from American Collections*, exhibition catalogue, New York, 1956, no. 36.

17. J. Denucé, *De Antwerpsche Konstkamers*, Antwerp, 1932, p. 321.

18. An early example of the use of the Brussels sketch in Rubens' work is the *Allegory of Nature* in Glasgow (KdK 61), a painting surely no later than 1616. Still earlier is a sketch in Frankfurt, of *Diogenes* (KdK, 1st ed., 171). While the *Eigenhändigkeit* of the Frankfurt sketch is uncertain (and the picture in the Louvre, based on it, is surely no more than a school piece), I am convinced that it reflects a Rubens composition of about 1613-1615. The Frankfurt painting contains also the head of an old woman derived from a sketch in Besançon; see A.-P. de Mirimonde, "Un Rubens retrouvé," *Gazette des Beaux-Arts*, 6th ser., LII, 1958, p. 219. [The attribution of that sketch to Rubens, however, is not certain.] The composition is known also from Paul Pontius' *Livre à dessiner* (see Rooses, *L'Oeuvre*, V, pl. 353) and a drawing—by Pontius?—in the British Museum (see Arthur M. Hind, *Catalogue of Drawings by Dutch and Flemish Artists in the British Museum*, II, London, 1923, no. 98). Two of the heads appear in the *Bacchanal* formerly in Berlin and destroyed in 1945, which was based on Rubens' design, even if executed by assistants, or, as Bode, Glück, and others thought, by Van Dyck.

19. Negroes appear in Van Dyck's so-called *Fishmarket* (Vienna, KdK 16); the *Silenus* (Dresden, KdK 67); the *St. Sebastian* in Edinburgh, mentioned before, and the similar version in Munich (KdK 66); and the *Magnanimity of Scipio* (Oxford, KdK 140). None of these figures is based on or is in any way connected with the four views assembled in the Brussels canvas.

20. I am indebted to Mr. Philippe Roberts-Jones and Mr. René Sneyers for providing me with prints of the X-ray photographs as well as to Mrs. Nora De Poorter, Rubenianum, Antwerp, for lending the Cooper photograph of the Getty panel reproduced in Fig. XIII.2.

XIV

THE DAUGHTERS OF CECROPS

THE subject of the daughters of Cecrops, who—against the express command of Minerva—opened the basket entrusted to their care and so discovered the strange, serpent-tailed infant Erichthonius, was treated by Rubens in two major paintings; the earlier one is in the Liechtenstein collection in Vaduz, the later, unfortunately preserved only in fragmentary form, in Oberlin (Figs. XIV.1 and XIV.2).[1] A sketch for the earlier one of the two is known from two versions. One such sketch is in the collection of the late Count Seilern (Fig. XIV.3) and is of sufficiently high quality, although not in the best state of preservation, to be acceptable as the original one. It is necessary, however, to make this a qualified statement since the other version has disappeared and is known only from reproductions in sales catalogues.[2] We have insufficient evidence for a final decision but enough to suggest caution in approaching the problem. In addition there exist an engraving of the composition by Peter van Sompelen and drawn models for that engraving, which have been amply discussed by Konrad Renger; they have no bearing on the problem to be examined here.

There is also a preliminary sketch for the later formulation of the theme, now in the Nationalmuseum of Stockholm (Fig. XIV.4). According to Burchard, a more finished version (panel, 42×51 cm.) is in the collection of the Duke of Rutland, Belvoir Castle; not having seen that painting, I must leave open the question whether it is indeed, as Burchard thought, Rubens' *modello* that preceded the large but now dismembered canvas. It in any case can give us an idea about the appearance of the large picture now in Oberlin before its curtailment, although to some extent our mental reconstruction of the finished work is aided also by several copies. In Burchard's discussions the problem of changes in

This paper is the first half of a study published in the *Zeitschrift für Kunstgeschichte*, XXXIX, 1976, pp. 34-53, under the title "Zwei Rubensprobleme." Both studies had grown out of my researches on Rubens' sketches in oil but had assumed an extent that seemed to me out of proportion with the character of the book as I had planned it. In the end I retained the second part of the paper, on the Miracles of St. Francis of Paola, more or less in the way in which it had been printed in the German periodical. The first part, however, was considerably reduced in the book and hence seemed to qualify for this publication, in my own translation and with minor changes.

the position of one leg of the figure seen from the back has played a certain role; in the context of the present study, this problem, too, need not be aired any further.

The question that occupies us here is the identity of the three sisters and of the additional figures introduced into the large canvases, and of the function they play in the overall presentation of the theme. The names of the three sisters are known from the text of Ovid's *Metamorphoses*: Aglauros, Herse, and Pandrosos. Yet not one of the authors who have occupied themselves with the treatment of the theme in Rubens' oeuvre has made a serious effort to connect these names with specific participants in the action portrayed. Renger, the last one to deal with the subject, somewhat hesitantly referred to the figure standing at the left in the Liechtenstein canvas as "wohl Pandrosos," but he, too, avoided attaching names to the other characters. And despite the fact that there hardly can be any doubt that the figure who in all the versions lifts the cover of the basket must be Aglauros, the first to yield to curiosity and violate Minerva's injunction, Burchard—trusting the description of the later version given by Roger de Piles[3]—assumed that the figure seen from the back should be identified with Aglauros. The same figure was called Herse by Sterling.[4] There are also differences of opinion regarding the identity of the "winged genius" in the large canvas in Vaduz.

The principal difficulty in the interpretation of the scene is due to the fact that hitherto all the authors have approached the subject with a fixed idea about the nature of the action, based upon the standard version of the myth; it is a version which dominates the major present-day mythological handbooks. When Burchard spoke of the "tragic consequences for the young women," he undoubtedly had in mind this version, which had appeared first in Euripides' *Ion* (21 ff. and 270 ff.) and was repeated, with minor variations, by Apollodorus, Pausanias, and Hyginus. According to this version, the three sisters jumped to death from a rock (or from the Acropolis), either from fear and horror after seeing the serpent-legged child in the basket, or driven to madness by the goddess herself. Even Stechow, who occupied himself three times with the theme, referred to the "tragic end" and the "following tragedy" and—perceptive connoisseur of Rubens' narrative art that he was—expressed astonishment that so little of the unhappy events that followed had been indicated in Rubens' paintings.

Burchard had identified the winged youth in the canvas in Vaduz correctly, as I shall point out, with Cupid, but interpreted his role as that of a seducer, having "roughly the same function as the serpent in Eden." Stechow, in fact, followed Burchard's lead, putting even more emphasis on this function of the youth by suggesting that he tries to persuade the somewhat hesitant and frightened sister at the left "to join the fun." In doing so, he dropped the identification of the figure with Cupid and—like Kieser before him—simply called him a "putto,"[5] just as Renger again did more recently.

Alpers also mentioned only the official version of the myth: "the discovery drives the sisters mad and they commit suicide by jumping off a cliff." Yet since she realized that Rubens gave not the slightest hint of the unhappy end of the story, she denied what for

Burchard and Stechow had been self-evident, that the artist's intention had been to depict a mythological *action*. According to Alpers, the canvas in Vaduz is essentially an allegory of fertility and of the diversity of nature. In her opinion, Erichthonius, born of Gaea (Earth), who was accidentally impregnated by Vulcan's premature ejaculation when he had tried to rape Minerva, "far from being an unnatural monster . . . represents the diversity of natural things created by nature."[6] Stechow had already pointed out that the fountain sculpture with her multiple breasts is based on the Ephesian Artemis generally identified as a personification of Terra (Gaea). Alpers goes so far in her interpretation of the picture as an allegory that she describes the scene not in terms of an action but as a tableau vivant: "Aglauros and her sisters are in fact displaying him (Erichthonius) rather than discovering him. The lush nudes—Rubens' constant image for the fullness of nature—appear here most appropriately as handmaidens in an allegory of fertility."[7] In support of her thesis she points to the evident difference between the more dramatic action of Count Seilern's sketch and the becalmed composition in Vaduz. This development she asserts to be contrary to the normal change in Rubens' work from sketch to final formulation, hence proving the master's intention to have the large painting understood as an allegory. Yet as Aust demonstrated long ago, and as any study of the material makes abundantly clear, the development mentioned by Alpers is the normal one and can hardly be used in defense of the proposed interpretation.

The figure of a boy or youth inserted in the composition ("a winged putto" in Alpers' words) was called a "hilfreicher Genius" by Müller Hofstede in the remarks he devoted to the picture, although he made no attempt to establish more clearly the boy's relationship to the other figures. However, it should be marked a gain that contrary to the purely negative interpretations of Burchard and Stechow, that of Müller Hofstede regarding the role of this figure is more sympathetic.

It is astonishing and difficult to understand why Rubens' renderings of the myth were discussed by all these authors exclusively in terms of the "official" version rather than the one in Ovid's *Metamorphoses*, the book which for Rubens, as for many artists before him, was indeed a veritable mythological "bible." Ovid had devoted two passages to the daughters of Cecrops, both in the second book of the *Metamorphoses*, but separated by 147 lines. The first section contains the story of the discovery of Erichthonius, which is reported by the crow as a warning to the raven not to inform Phoebus of the faithlessness of Coronis. The story ends immediately after the discovery of the monstrous child; the reader's attention is then again turned to the crow who had left the scene to report the disobedience of Cecrops' daughters posthaste to Minerva—and with her garrulousness earned only the goddess' anger. The crow then tells of her own change from a beautiful princess to an unattractive bird. Not a word as to what happened after the opening of the fatal basket! (Ovid, by the way, described the monster as "infantem apporrectum draconem" [a child on the side of a snake] in a most unusual formulation; it is easy to understand why Rubens preferred the traditional image of a child ending in the form of a serpent.)

Beginning with line 708, Ovid returned to the daughters of Cecrops but in a completely different context. We are told how Mercury, idly cruising through the skies, and seeing from above the three sisters on the way to the temple of Pallas, suddenly fell passionately in love with Herse and tried immediately to visit her in her home. Although he identified himself to Aglauros, who sat on the threshold, she denied him entrance unless he paid her a handsome fee for her permission. This renewed manifestation of Aglauros' arrogance prompted Minerva—mindful of Aglauros' guilt in the discovery of Erichthonius—to punish the maiden severely. In a famous description of the cave of Envy, Ovid tells of Minerva's visit to this sinister deity, whom she orders to poison Aglauros' mind. Envy obeyed; and the more Aglauros now saw of the happiness of Herse, enjoying the love of the god, the stronger became her own feelings of jealousy and envy. When she finally tried again to stop the god from entering and swore not to leave the threshold until he stopped visiting Herse, Mercury took her at her word—and changed her into a stone.

Ovid nowhere mentions the triple suicide of the sisters; it is only Aglauros who meets a bad end, punished for her hubris, that human quality that gods never could forgive in mortals. There is no further mention of Herse or Pandrosos, but Rubens surely knew that Herse bore a son to Mercury, Cephalus; that in Athens there were temples dedicated to her as well as to Pandrosos; and that celebrations were held in their honor.

Returning now to Rubens' canvas in Vaduz and the sketch for it in London, we should clearly face the fact that there is nothing in these formulations that might force us to look beyond Ovid's text for any other or additional source to explain his rendering of the myth. Details that cannot be derived from Ovid's text—the old maid, the Gaea-fountain, the "putto," the peacock and the garden-herm of a satyr in Vaduz, and the curious shadowy figure that Stechow interpreted, not really convincingly, as *Curiositas* in Count Seilern's sketch—cannot be accounted for by any of the other ancient texts either. Moreover, the action in Rubens' formulations of the theme offers no difficulty to the interpretation if we assume, what can hardly be questioned, that as he painted these versions Rubens was also conscious of what the poet subsequently told about the later involvements of the young women with the gods.

The figure that must have attracted him above all was surely Herse, whose beauty Ovid had extolled eloquently: "Quanto splendidior quam cetera sidera fulget/Lucifer; et quanto, te, Lucifer, aurea Phoebe/Tanto virginibus praestantior omnibus Herse/Ibat." She was the fortunate one whom a god had chosen as his mate and whose love-token—Cephalus—was in turn abducted, as Apollodorus reported, by a goddess, Aurora. If we keep in mind Ovid's sequel to the story of the discovery of Erichthonius, the identity of the figure standing at the left in the Vaduz canvas can no longer be questioned; she must be Herse, and not only for the prosaic reason that—with Aglauros clearly identified as the one opening the basket—Rubens would hardly have shown the most beautiful of the sisters only from the back. Of the three it is only this standing figure who is entirely nude; and Rubens painted her, particularly in the large version, as the purest embodiment of his ideal of

beauty as it appears also in other paintings of the period, the middle of the second decade.

In the sketch from the Seilern collection Herse seems to look down at the open basket. In the canvas in Vaduz, however, her glance is directed elsewhere: she looks at the youthful "genius," who, far from "egging her on," as Stechow somewhat flippantly described his role, looks at her with an admiring glance that seems to come close to worship; and her traditional pose of chastity, echoing the old Venus Pudica type, is surely meaningful in this context: beauty and modesty combined make her a worthy companion of a god. In this perspective, the true identity of the "putto" or "genius" should no longer be in doubt. Burchard was surely right when he recognized in him the god of love himself. He is too large and too dignified for a mere putto and his place and action in the context of the whole too central for an anonymous genius. There is a special significance in the manner in which Cupid turns from the fruit of a loveless and purely accidental sexual union, which he seems to have helped to uncover with his left hand, to the ideally beautiful woman whom a god will choose as his love and who will be the mother of a hero. It was probably this interest in the figure of Herse that induced Rubens to suppress in the final version the figure of a flying genius about to trumpet the news of the girls' transgression; the emphasis should be less on the crime than on the future exaltation of one of the sisters.

This interpretation finds support in Jordaens' treatment of the same myth in a large canvas now in the museum at Antwerp (Fig. XIV.5); dated 1617, it evidently was painted soon after Rubens had finished his picture in Vaduz. In Jordaens' painting, too, Herse stands at the left, accompanied by Cupid, who has taken hold of her hand while raising a burning torch as an eloquent symbol of love. Within the limits of his coarser taste and his less subtle way of thinking, Jordaens also made an effort to distinguish the less corpulent and altogether more attractive Herse from her adipose sisters. He included also the old woman who smilingly bends forward to get a glimpse of the strange infant in the basket. The presence of this figure in Rubens' painting had been explained by Burchard and Stechow as a device by the master to emphasize the beauty of the young women by contrasting it to the wizened features of a maid or nurse. For Alpers, too, she was "just a nurse." Yet it should give pause if we see how closely, in Rubens' painting, she is associated with Herse and not with her sisters. With a gesture of warm familiarity the young woman puts her arm across the shoulders of the older one. More striking still is the pose of the latter: as she bends forward, she looks straight out of the picture, offering her face in full front view. Although something most unusual and exciting is visible in the foreground, she seems to pay no attention to it; it is almost as if she were seeing in her mind's eye something else. It is unlikely that Rubens should have inserted such a figure solely as a genre motif or for the sake of a pictorial contrast. (She had not yet been present in the London sketch, unless one considers the shadowy figure behind Herse as a first thought for her.)

Heads of such uncompromising frontality are rare in Rubens' work. They are encountered chronologically relatively close to the Vaduz canvas in the *Dying Seneca* and the *Two Satyrs*,

both in the Alte Pinakothek in Munich (KdK 44 and 135). Both express aspects of vaticination, in Seneca induced by his awareness of an imminent physical death that cannot, however, affect his survival in a spiritual sense; in the satyr by the stimulation of the mind under the effect of wine. All the more should it be noticed that in the painting in Vaduz two such heads appear, since the fountain figure of Gaea, too, is rendered completely *en face*. Nor may it be accidental that she belongs to the right half of the picture, in which all the figures are concentrating on Erichthonius, including even the small dog who barks at the monstrous child. Thus it might well be that the presence of Gaea in the immutable form of a figure of stone contains a reference to what lies in the past and can no longer be undone. With her unseeing eyes she forms an exact contrast to the old woman at the left whose alert glance seems to be directed into a different layer of time—the future. In a prosaic sense she may well be the girls' old nurse, but on a higher, poetic, level she also appears to assume the nature of a sibyl foreseeing the fascinating events that will change the life of the lovely girl standing at her side. That the figure of Cupid is placed midway along a compositional diagonal, linking the two parts of the canvas, gains new significance if seen from this point of view.

In such an analysis of the picture the other elements, too, gain a clear and simple relationship to the central theme. In Alpers' allegorical construction the presence of a peacock (seen in the London sketch as well as the Vaduz canvas) signifies, like his irregularly patterned plumage, that nothing in nature is ever completely beautiful. To arrive at this explanation, Alpers had to have recourse to an obscure passage in the mythological handbook of Natalis Comes (Conti) which refers, however, not to beauty but to happiness ("cum nihil omnino felix possit contingere"). Yet if we assume that Rubens intended poetically to enrich the scene of the discovery of Erichthonius by alluding also to the future exaltation of Herse as the spouse of a god, we can see in the peacock, the animal sacred to Juno, protectress of marriage, an allusion to that intimate union. The satyr-herm with its frowning countenance may indeed, as Alpers also thought, signify the purely physical nature of the sexual union, and in the context of the picture possibly the unsuccessful effort of Vulcan to force his passion on chaste Minerva.

In his publication of a drawing acquired for the Rijksmuseum in Amsterdam in 1966 (Fig. XIV.6), Karel Boon, too, discussed the painting in Vaduz. He suggested that two studies on the verso of the sheet are intended for the figure here interpreted as Herse (Fig. XIV.7). Count Seilern accepted Boon's thesis (1971) and in fact carried it still further. Noticing that a piece of drapery across the arm of one of the figures in the Amsterdam drawing agreed more with a figure in the large canvas than in his sketch, he declared this to be a further confirmation of Haberditzl's "well-known discovery that in Rubens' work the drawing comes between painted sketch and finished picture." Yet Haberditzl's observation holds only for exact studies, from the model, of individual parts of figures, generally done in chalks on large sheets of paper, and not for rapidly done pen sketches; these belong to the first stages of the development of almost any project.

The two figures in question are clearly first attempts at fixing a particular pose; yet this pose, as has also been pointed out by Müller Hofstede (1968), is only superficially related to the figure of Herse, despite the drapery folds indicated across her arm. The nude in the Amsterdam drawing leans to one side, with the right shoulder turned backward. Her head, however, turns sharply toward the left shoulder, and her glance is directed horizontally toward the right, indicating apprehension or even anger. This is not at all the position of a figure who, as in Count Seilern's sketch, inclines as she looks downward inquisitively, or in the Vaduz painting, who stands calmly before us in the consciousness of her own beauty. She rather appears to be trying to protect herself from an approaching unpleasantness. The meaning of such a pose becomes clear if one compares it with the figure of Syrinx in a painting of *Pan and Syrinx* that appears to be a work done jointly by Rubens and Jan Brueghel the Elder (sold in London at Christie's, March 23, 1973; see Fig. XIV.8). The Amsterdam drawing was of course not made as a study for the nymph, pursued by Pan, who moves in the opposite direction so that the arrangement of body and legs is the reverse of that in the drawing. Yet it is likely that the drawing pertains to an action thematically related to the Pan and Syrinx story. The logical choice is obviously the story of Diana and Actaeon; this had also occurred to Müller Hofstede when he wrote that the drawing might have been made in connection with a project such as *Diana and Actaeon* or *Nymphs Surprised by Satyrs*. Yet from a careful examination of the Amsterdam drawing we can tell that the subject could only have been *Diana and Actaeon*, and nothing else. On the recto side near the left edge, Rubens had made another study of the woman who, apprehensively looking across her shoulder, tries to shield her nude body from a danger she perceives coming from the right (Fig. XIV.7). An attendant woman standing behind her aids her in that predicament by hurriedly throwing a light gown over her shoulders. Now this is precisely a motif that Titian had introduced into one of his renderings of the Diana and Actaeon myth (formerly Bridgewater House, now on loan at the National Gallery of Scotland in Edinburgh), and which Rubens had adopted for his fragmentarily preserved version of the subject (Rotterdam), after having actually painted a faithful copy of Titian's painting (Coll. Earl of Derby). It may be not without interest for our perception of works of art and the interaction of thought and sight, or "knowing" and "seeing," that only after I had mentally established the connection of the figures with the Actaeon myth was I able to interpret correctly the hastily drawn lines around the head of the forward leaning figure, drawn twice, on the verso: in both cases, although perhaps more clearly in the second and slightly more finished figure, Rubens indicated a second figure whose function it is to protect the principal character—surely Diana—by covering her nakedness with a light piece of clothing thrown over head and shoulders. With this observation any connection of the main figure with Herse or with a nymph surprised by satyrs can safely be abandoned. What is more important, however, is the evidence provided by the drawing in Amsterdam of a painting of *Diana and Actaeon* planned, and possibly also executed, by Rubens relatively early in his career. In fact it might have formed a companion piece to a composition of

the *Rest of Diana after the Hunt*. Müller Hofstede recognized that the remaining studies on the Amsterdam sheet pertain to such a composition, still preserved in a picture in Munich.[8]

Some support for the assumption that a painting of Diana and Actaeon based on the studies on the Amsterdam sheet actually existed might be found in what seems to be an—admittedly weak—echo of it in a painting by Jordaens in Besançon (Fig. XIV.9); there, too, Diana stands upright (she is seen seated in Titian's painting and Rubens' later variation on the theme in Rotterdam), and there, too, she is accompanied by a nymph who tries to cover the nude goddess by draping a white shift over her head and shoulders.

After the foregoing commentary on the painting in Vaduz and the study for it in London, it should be obvious that in the Stockholm sketch for the later version of the theme of the Discovery of Erichthonius, the figure standing behind the basket with Erichthonius can only be Herse (Fig. XIV.4). As in the earlier paintings, the emphasis is given to her; and the loss of this key figure from the large version in Oberlin is particularly galling. Until recently her left arm and other only fragmentarily preserved parts of the picture had been toned down with a dark layer of paint. These modern repaints have now been removed. Thanks to the courtesy of the Allen Memorial Art Museum, the painting can here be reproduced—for the first time—without them.

Of the three sisters Aglauros alone is preserved. In keeping with her part in the story, she holds the cover of the basket, having lifted it up only seconds before; she now looks almost smilingly at the strange sight before her. The old woman who had not yet been added in the Stockholm sketch, also appears to look at the child, her gesture probably meant to express astonishment and surprise. The Stockholm-Oberlin treatment of the theme is clearly less complex than that of the earlier versions in London and Vaduz; this fact is in accord with Rubens' tendency, in his later years, to avoid intricate iconographic constructs while establishing more subtly the mood of the action and the basic human emotions of his characters.

Stechow tried to sum up the character of the later version of the theme when he said (1968): "This is an idyl, not a story; but it is a thoroughly antique idyl." Nevertheless Rubens alluded to the mythological "background" of this idyl. There are two herms forming part of the garden architecture that closes off the scene behind the figures. They were only lightly indicated in the Stockholm sketch, but we can tell from several copies (and the *modello* of Belvoir Castle) that in the large canvas they were identified as a bearded man with a rather sinister expression, and a woman with her breast exposed. In analogy with the deities in the form of herms with which Rubens framed his designs for the Achilles cycle, we may recognize here, too, the deities—Vulcan and Gaea—whose involuntary sexual union was responsible for the birth of the misshapen child.

The figure of a dolphin playfully mounted by a lively boy—a detail appearing only in the Stockholm sketch—was a favorite motif of Rubens for the decorative embellishment of fountains. He used it first in the painting of *Susanna and the Elders* in the Real Academia

de Bellas Artes de San Fernando in Madrid (KdK 32) and again for the pictures of *Cimon and Efigenia* in Vienna (KdK 133) and *Diana and Actaeon* (Rotterdam). Rubens appears to have had just such a fountain in his own garden as one can tell from the Munich panel of *Rubens and Hélène Fourment in the Garden* (KdK 321). The motif is of classical origin and was used emblematically to suggest the celerity and impatience of love; dolphins were known both for their speed and their capacity to feel love. In the context of the theme of the daughters of Cecrops it is meaningful only if it alludes to the sudden love felt by Mercury for Herse as he saw her from the skies; if so, its appearance in the Stockholm sketch furnishes an additional confirmation of Rubens' willingness to enrich his rendering of the discovery of Erichthonius by associating it proleptically with Herse's subsequent exaltation. In the finished version, admittedly, Rubens replaced the dolphin and putto motif with a triton pouring water from a large shell.

For this, Rubens' last version of the Erichthonius myth, there is also again an echo in Jordaens' oeuvre, in a canvas now in Vienna (Fig. XIV.10). Herse stands upright in the center of the composition and watches, disapproving gently (to judge by her gesture), as Aglauros opens the wicker basket in such a manner that the child tumbles backward to the ground; this, in turn appears to amuse Pandrosos who smilingly turns around to look at the little intruder. Jordaens may have seen only the Stockholm sketch when he painted the Vienna canvas. Not only does his version lack the old nurse (which Rubens added only in the final formulation) but he also gave to the fountain sculpture the shape that appeared only in the sketch: the putto on the dolphin.

NOTES

1. Rubens' renderings of the *Discovery of Erichthonius by the Daughters of Cecrops* have been treated in the following studies: Ludwig Burchard, "Rubens' 'Daughters of Cecrops,'" *Allen Memorial Art Museum Bulletin*, Oberlin College, XI, no. 1, 1953, pp. 4-26. (This study had been written in 1940 and was published thirteen years later without any changes, despite the fact that in the meantime Burchard had changed his opinion about the sketch in the collection of Count Seilern. He had considered it first only to be a copy, but as Count Seilern stated in his book of 1955—see the next item—had later accepted it as Rubens' original.) See also [Count Antoine Seilern] *Flemish Paintings & Drawings at 56 Princes Gate*, London, 1955, no. 22; Wolfgang Stechow, "The Finding of Erichthonius: An Ancient Theme in Baroque Art," *Studies in Western Art: Acts of the Twentieth International Congress of the History of Art*, Princeton, 1963, III, pp. 33 ff.; K. G. Boon, "Een blad met schetsen voor een Diana en haar Nimfen door Rubens," *Bulletin van het Rijksmuseum*, XIV, 1966, pp. 156 ff.; Wolfgang Stechow, "Erichthonius," *Reallexikon zur deutschen Kunstgeschichte*, V, 1967, col. 1243; Svetlana Al-

pers, "Manner and Meaning in Some Rubens Mythologies," *Journal of the Warburg and Courtauld Institutes*, XXX, 1967, pp. 280 ff.; Justus Müller Hofstede, "Rubens und Jan Brueghel: Diana und ihre Nymphen," *Jahrbuch der Berliner Museen*, X, 1968, pp. 212-213; Wolfgang Stechow, *Rubens and the Classical Tradition*, Cambridge, Mass., 1968, pp. 65-68; [Count Antoine Seilern] *Corrigenda & Addenda to the Paintings & Drawings at 56 Princes Gate*, London, 1971; Konrad Renger, "Planänderungen in Rubensstichen," *Zeitschrift für Kunstgeschichte*, XXXVII, 1974, pp. 18-24.

2. The sketch that has disappeared (panel, 37.5 × 49.5 cm.) came from the collection of Victor Bloch, Vienna, and was first offered for sale in Lucerne (Gilhofer and Ranschburg), November 30, 1934 (lot 40), then again, as from a "Collection B., Vienna," in Berlin (H. W. Lange), November 18-19, 1938 (lot 180). It was accompanied by certificates from Max J. Friedländer (December 8, 1930) and Gustav Glück, both very positive in attributing the picture to Rubens. Count Seilern states in his catalogue (see note 1) that he has never seen that picture, and it is also unknown to me, except for the reproductions in the

catalogues of the sales, of which the one of 1938 is the better. The sketch was clearly a work of considerable quality and in some details appears to have been more precise (the garden-gate and balustrade at the left) and more expressive (the face of Aglauros, for instance). Nevertheless, until the Bloch sketch reappears and can be studied, it would seem to be hazardous to place it above the Seilern sketch; thus I am willing, with reservations, to accept Count Seilern's opinion in favor of his own version.

3. Burchard, "Rubens' 'Daughters of Cecrops,' " pp. 12-13.

4. Charles Sterling, *Rubens et son temps*, exhibition catalogue, Paris, 1936, no. 80. The reference is to the Stockholm sketch (see above), in which there appears also one of the sisters seen from the back; and it is this one Sterling identified as "Herse."

5. Stechow, "The Finding of Erichthonius," p. 32.

6. Alpers, "Manner and Meaning," p. 283.

7. Ibid., p. 284.

8. Bayrische Staatsgemäldesammlungen, Schloss Schleissheim, inv. no. 346/3885, panel, 66 × 109 cm. According to Müller Hofstede, "Rubens und Jan Brueghel," pp. 208-211, the Munich picture was painted jointly by Rubens and Jan Brueghel the Elder. In my view, any participation by Rubens in that painting seems at best to have been limited to some of the figures at the left.

RUBENS AND THE BOOK

THE four-hundredth anniversary of Rubens' birth has been celebrated with an astonishing variety of exhibitions, large and small. Most of them have been accompanied by elaborate scholarly catalogues. Not surprisingly, special emphasis was given in these exhibitions to what generally had been considered relatively marginal manifestations of the master's genius and therefore had not received sufficient attention in the scholarly literature. Among them are the studies and copies he made of minor works of antiquity, such as coins, gems, medals, and cameos. Another group of works so studied are drawings by earlier and generally inferior artists which Rubens reworked and by judicious "editing" elevated into small masterpieces. Many exhibitions (especially those held in London, Florence, Göttingen, and Cologne) concentrated on the engravings made from Rubens' designs. Problems of availability and expense had evidently worked in favor of exhibition of prints which exist in large numbers and can be insured for modest amounts.

When I thought about an appropriate and topical project for a graduate seminar to be given by me at Williams College in the fall of 1976, it seemed to me a good idea to examine the title pages and other book illustrations designed by Rubens and to organize, with the help of the students, an exhibition of that material. The exhibition was indeed held in May 1977 at the Chapin Library of Williams and, thanks to generous loans by the libraries of Harvard, Yale, and Columbia Universities as well as private collectors, we were able to exhibit almost the entire production of the master in this area.[1]

In the summer of 1977 the Museum Plantin-Moretus in Antwerp held a similar exhibition but concentrated more narrowly on books published by the Plantin Press. The Antwerp show, however, was enriched by some of Rubens' original drawings and oil sketches for these title pages.[2]

A lecture delivered December 1, 1977, at Houghton Library, Harvard University (published in the *Harvard Library Bulletin*, XXVII, January 1979, pp. 114-153), enlarged by a section taken from the catalogue of the Williamstown exhibition (see note 1, below).

While the attention given to these often neglected parts of Rubens' activity was bound to provide new insights, it should also be said that all contemporary students of Rubens' activity as illustrator of books and designer of title pages owe a great debt of gratitude to the two scholars who—each in his own way—made this field arable: Max Rooses who in 1892 catalogued and described the title pages, and Hans Gerhard Evers who in 1943 studied the material as an art historian interested in its stylistic development. In modern times, a controversy has arisen in regard to the authorship of some of the preparatory drawings. One school, to which I belong, accepts these drawings as coming from the master's own hand. Another sees in them the works of various engravers, above all of Cornelis Galle, who engraved more Rubens titles than any other practitioner of the craft; the members of this school believe these drawings to be copies of Rubens' original designs which today are lost.

Although I shall concentrate on Rubens' contribution to the art of the book, I ought to make at least passing reference to the well-known fact that Rubens was as avid a reader of books as he was a student of the arts of the past. In fact, in a lecture (on Rubens' approach to classical themes) I have stated flatly that he was *the* most learned artist who ever lived. The exact size of his library is unknown, but we have evidence of about three hundred titles of books he owned or from which he quoted in his letters. And it is surely no accident that in the only self-portrait in which he referred to a specific aspect of his activity, he is in the company of three men (Justus Lipsius, Jan Woverius, and his own brother Philip), all learned humanist scholars, engaged, so it seems, in a conversation based on *books* lying before them on a table. Rubens never painted himself at an easel or with a brush in his hand. There is also the famous report by a young Danish physician who visited Rubens' studio in 1621. He found the artist at work while someone read to him from Tacitus. Rubens also dictated a letter and yet managed to answer questions from his visitors, all while continuing to paint. Readings from Roman authors are surely an accompaniment different from the background music many of our own contemporaries seem not to be able to do without.

Yet with all his interest in books, Rubens might not have engaged in the particular activity I shall discuss had it not been for his close friendship, since his days in school, with Balthasar Moretus, the grandson of the founder of the Plantin Press and from 1610 to 1641 its guiding spirit. A shy bachelor, paralyzed on the right side since birth, Balthasar Moretus was a highly respected member of the learned group of classical scholars responsible for the intellectual climate of Antwerp in Rubens' time.

The economic basis of the Antwerp presses (there were several others besides Plantin) was provided by the publication of liturgical and devotional books, many to be sold in Spain and its colonies, school texts, almanacs, and other utilitarian products. These presses also published critical editions of ancient authors and fathers of the church, and painstaking philological treatises for the instruction of scholars all over Europe.[3] Yet Moretus published also the first major work on optics as well as books of poetry, including poems by Maffeo

Barberini, better known as Pope Urban VIII, which the pope had written when still a cardinal. There were books on law and contemporary politics, including polemical writings, for instance a collection of papers in defense of Maria de' Medici, the French queen mother who had been forced into exile. It may well have been Balthasar Moretus' idea to adorn some of his publications with engraved title pages and to use engravings, albeit sparingly, as illustrative material instead of the cheaper woodcuts generally used before. And it was surely he who persuaded Rubens to give some of his precious time to these decorative works. In fact we learn from a letter of Balthasar that Rubens made such designs only on holidays, as he would have had to charge a forbiddingly high amount if he were to use his regular working hours for them. Actually Rubens was paid very little for these products of a busman's holiday. For the largest (folio) drawings he received 20 florins, 12 for quartos, and 8 for octavos; the smallest size was remunerated with 5 florins. (The engravers received three to four times as much because their work simply took longer.)

In the same letter Balthasar wrote that he normally gave Rubens six months to reflect upon the best possible design; we know, however, that occasionally Rubens worked much faster. The correspondence in this particular case concerned a publication that clearly interested neither Moretus nor Rubens, and I am inclined to read Moretus' words as an effort politely to reject the job—it was a doctoral dissertation, and some dissertations even in the seventeenth century may have been less than earthshaking. Moreover, at the time Moretus wrote that letter (September 13, 1630), Rubens was not only busy with work that had accumulated during his long absence on diplomatic travels (he had returned only the previous April), but he also had decided to marry again. Two and a half months later he married Hélène Fourment, and one can fully understand that he had other things on his mind than decorating the thesis of a young theologian from Bratislava.

The illustrations, as distinct from title pages, that Rubens provided for books are on the whole straightforward affairs. The first, published in 1608, were for collected philological miscellanea—hardly more than footnotes—by his brother Philip. The slim volume, *Electorum libri II*, contains five engravings of drawings Rubens had made of Roman sculpture. They were chosen by Philip because they helped to clarify some of the fine points he made in his text. Yet Philip also acknowledged in the book his indebtedness to his brother Peter Paul, for having helped him greatly not only with his skilled hand (*artifici manu*) but also with his sharp and sure judgment (*acri certoque iudicio*). This cooperation took place most likely during 1606 and the first half of 1607, when both brothers lived in Rome.

Around this time Rubens drew also a number of incidents from the life of Ignatius of Loyola, to be added to an illustrated biography of the founder of the Jesuit order, published in 1609, as part of the movement to have him canonized. (It succeeded in 1622.) I am inclined to attribute to Rubens also the title page of this small volume which appeared without name of author or place of publication, although it is likely that it was published in Rome.[4]

The largest commission for illustrations Rubens ever received was for a folio edition of

the Roman Missal, published by the Plantin Press in 1613, and a Roman Breviary, published the following year with additional illustrations. The first designs Rubens made for this project were a set of small marginal drawings of Infancy scenes, from the *Annunciation* to the *Circumcision* of Christ; since the engraver was paid in September 1612, Rubens must have started with this work no later than the summer of that year. The Morgan Library, which owns these small sketches, has also one of the drawings for a full-page illustration, the *Adoration of the Magi*. A few years ago another of Rubens' drawings for the Missal came to light—for the *Last Supper* (Fig. XV.1)—which shows, just as does the drawing in New York, how carefully Rubens prepared the work of the engraver; knowing that engraving reverses the design, he drew Christ blessing the bread with his left hand, so that it would come out right in the print. Another drawing, discovered still more recently, depicts the *Assumption of the Virgin*; thus, only a few prints remain for which there are no original drawings. He also designed the title page, which will be discussed below. Parallel with his work for the Roman Missal and Breviary, Rubens made drawings of six vignettes for the book on optics that has already been mentioned; the text of this learned tome was written by Franciscus Aguilonius, a prominent member of the Jesuit order, and it was undoubtedly he who suggested to Rubens the actions to be depicted as headings for the individual chapters. One such print is for the fifth chapter, entitled *De Luminoso et Opaco* (Fig. XV.2), and depicts an experiment (carried out with the aid of putti) in which the relationship of distance to the intensity of light is measured; one lamp has two flames, the other only one, and the question is how far should it be necessary to go with the stronger light until its reflection equals in intensity that of the single flame. (Aguilonius, by the way, came to an erroneous result. He calculated that the lamp with two flames would have to be put at twice the distance of the lamp with one flame to achieve identical luminosity; this is the way Rubens rendered the experiment. Neither was apparently aware that, nine years before, Kepler had found that the intensity of light decreases with the square of the distance from the light source, so that—in this experiment—the same luminosity is obtained when the stronger lamp is placed at one and one-half the distance of the weaker one.)[5] Another of these vignettes is for chapter six, entitled: *De Projectionibus* (on projections) (Fig. XV.3). We see the giant Atlas carrying the armillary sphere representing the positions of the major circles and meridians of the celestial sphere. By means of a strong light source held above it by a putto with a torch, the individual circles are projected on the ground as cast shadows which then are measured by two other putti, with the aid of a compass. Artificial light-effects appealed to Rubens in these years, as he painted several works involving artificial sources of light and the deep shadows resulting from such illuminations.[6]

The appearance of a compass in this last of the vignettes must have been of interest to Balthasar Moretus; the very house where he did his business was called the *Golden Compasses*, and this modest measuring tool was used as the central object in the Plantinian printer's mark (Fig. XV.4). It is the perfect embodiment (in the emblematic mode) of Plantin's motto *Labore et Constantia* (By Labor and Constancy), constancy being the arm that remains

firmly rooted while the other, which moves around it, symbolizes labor. Rubens, in fact, drew for Balthasar Moretus a model for a new form of this printer's mark, distinguishing clearly, by the use of a cast shadow, between the fixed leg (or arm), which casts a shadow, and the turning arm, which does not. In keeping with the traditional form of the mark, he added the figures of Hercules (for labor) and a woman resting her hand on a pedestal or stele (for constancy).

The Breviary of 1614 is the last book published during Rubens' lifetime containing illustrations he had designed. In 1622 he himself published a volume on the Palaces of Genoa, but the numerous architectural engravings of that volume were based on drawings by professionals, which Rubens had collected for that purpose. The only contribution he made to that publication—and an important one it was—consists of a preface in which he welcomed the classically inspired architecture (like that of the Antwerp Jesuit church) that had begun to replace the buildings done in *la maniera Barbara, o Gothica*; but he also explained that his reason for publishing the façades, plans, and elevations of these Genoese *palazzi* was his interest in their function as homes of an upper bourgeoisie in distinction to the large castles occupied by absolute princes. It is, in fact, just such a home which he had built for himself and which very soon had become one of the great tourist attractions of the city of Antwerp.

Rubens had had plans for two other publications, neither of which was realized. One was a theoretical book, on the movement, proportion, and physiognomic expression of the human figure. A manuscript of this study still existed in the eighteenth century but perished in a fire; traces have, however, been found in other forms, and in copies by Van Dyck, which give us at least an idea of how he had planned to approach these questions. Another project was a corpus of ancient cameos, for which several prints were made during his lifetime, from his own drawings; yet nothing came of this plan either, except that the prints were reproduced in a volume of essays on the clothing of the Romans, written by his son Albert. Even this volume was actually published only after Albert's death! Lastly, there are a few chiaroscuro woodcuts, of Habsburg emperors, done by Christoffel Jegher from Rubens' design, which were included in a publication that appeared five years after the artist's death. There remain, then, the title pages designed by Rubens, numbering close to fifty, if we include those drawn by one of his most talented pupils, Erasmus Quellinus, from ideas suggested by the master himself. It should first be said that no other artist of the first rank was ever engaged to such an extent in this kind of project. And while Rubens knew of course the tradition of adorning title pages with more or less elaborate allegorical inventions, he developed a variety of solutions which both in form and in content are of an ingeniousness and originality worthy of a great master. There is evidence that suggestions on how to handle a particular project were furnished by the publisher or by the authors themselves; yet in the end most of them probably felt as did the Jesuit poet Bernardus Bauhusius who in 1617 wrote to Moretus, "I know that Rubens, with his divine genius, will find something for that page, suitable to my poetry, the order

to which I belong, and to Piety." And as late as 1639, when Rubens acted only in an advisory capacity, an author (Philippe Chifflet) whose idea for a frontispiece had been rejected agreed that another should be made "such as the learned Rubens will suggest, as I prefer his invention and your (Moretus') judgment to my own thoughts."

Authors being authors, there surely were situations when they had reservations about some of the designs; we know of one case when one of the Antwerp theologians felt that the figure of Truth on the title page Rubens had designed displayed too much of her anatomy. Balthasar Moretus brushed the criticism aside by saying that in Rubens' opinion Truth had been covered sufficiently. And when the abbot of a Benedictine monastery thought he had spotted an error because Rubens had rendered the Virgin on the *right* side of Christ, Balthasar Moretus informed him that Rubens had known exactly what he was doing, in conformity with the forty-fourth Psalm (of the Vulgate): "astitit regina a dextris tuis" (the queen stood on thy right side).

To what extent Balthasar Moretus himself submitted ideas to Rubens we do not know, but we have at least one interesting piece of evidence (to be exact: three). In connection with the publication of the Roman Breviary, Moretus drafted three times the basic layout of the title page, and inscribed on the sheets the biblical texts he wanted to be used in the different sections. But even this was not meant to be a firm program. Where Moretus' plan had called for the actual figures of King David and of St. Cecilia (lower left and right), Rubens inserted only David's harp and Cecilia's organ (along with other instruments), appearing of course reversed in the print (Fig. XV.5). Peter and Paul, Rubens' own patron saints, are flanking the postament that contains the title.

Rubens' own scholarly involvement with books in addition to his friendship with Balthasar Moretus may account to a certain extent for his willingness to design title pages for Antwerp publishers. To these motivations must be added, however, the master's manifest interest in the figurative mode of expression that is allegory. An incredible amount of ingenuity had been expended in the sixteenth century on devising intricate and largely abstract conceits, and on modes of visualizing them in terms of concrete forms and figures. In several of his large pictorial cycles, above all the cycle for Maria de' Medici, Rubens found in allegory the ideal device to allude to contemporary situations without giving offense, while at the same time permitting the beholder a certain intellectual satisfaction deciphering a language that was accessible only to the erudite. I strongly suspect that what appealed to Rubens most in the activity of drawing title pages was the necessity, owing to an established tradition, of presenting in allegorical terms, and in a severely limited space, a condensation of the contents of a given book or at least a pictorial equivalent of its basic message.

As he faced the challenge of a worthy design for a title page, Rubens relied above all on his classical learning. And while it is true, as I have written elsewhere, that he "preferred the codified and easily understood personifications and symbols" and "favored the lucid expression over the obscure, the sanctioned image over the newly contrived," we are

nevertheless occasionally uncertain what a given image, or combination of symbols, really means, a fact Rooses stated when he said of these allegories "on ne les comprend pas aisément."[7] I suspect, however, that this failure is more a manifestation of our own ignorance and obtuseness than the result of an intentionally obscure and concealing manner of representation.

It is fortunate at any rate, and exceedingly helpful, that authentic explanations of the iconographic program have come down for several of the allegorical designs. Three books contain full and detailed explanations—addressed to the reader—of the meaning encapsulated in Rubens' compositions. Two of these descriptions were written by Rubens himself; one appeared with only minor modifications in De Marselaer's book *Legatus* (see below). The other has been preserved in a transcription of Rubens' text from the hands of the great eighteenth-century collector P.-J. Mariette. Two other explanations have come down in the words of Rubens' friend Gevartius, written, undoubtedly, with Rubens' knowledge if not his actual collaboration. In his *Frontispicii Explicatio* of the first volume of Hubert Goltzius' catalogue of ancient coins (*Fasti Magistratuum et Triumphorum Romanorum* . . .) Rubens' design is identified (with a bow to one of Cicero's favorite words, *revivisco*) as *Antiquitatis reviviscentis typus* (the image of the revival of antiquity). Rubens himself, in keeping with the theme of a revived antiquity, is referred to as "the Apelles of our Age," a form of flattery which was, however, by this time used routinely to add luster to an artist's name. The explanation of yet another title was given in a letter by Balthasar Moretus to Philippe Chifflet, one of his closest advisers and friends, in which he praised the ingenious symbolism of the design. Of particular interest are two drawings by Rubens for two tiny books of poetry; he evidently sent these drawings to Moretus, whom he informed about their meaning in brief accompanying words. In one of them he could not suppress an expression of personal satisfaction at having condensed a rich emblematic conceit into the apparently simple form of a *hermathene*. Short explicatory references to the title page are found in Aguilonius' *Optics* and Petrasancta's *Symbola Heroica*; some letters throw light on the title of Boyvin's *Siege of Dôle* (see the letters exchanged between Moretus and Chifflet on January 17, February 1, February 11, February 13, March 5, and March 9, 1638); and various inscriptions on the prints themselves elucidate, to some extent, the meaning of such titles as that of the *Breviarium Romanum* and De Morgues' collection of pieces defending Maria de' Medici, "la Royne Mère."

The sources from which Rubens drew his inspiration were both literary and artistic; to an overwhelming degree they belonged to the civilization of ancient Rome. An admirer of ancient sculpture in marble, which he drew assiduously during his eight years spent in Italy, and the owner of a sizable collection of ancient sculpture which he acquired in 1618 by trading against it paintings from his own hand, Rubens was also a keen student of Roman coins, medals, and cameos. During the sixteenth century scholars had become increasingly conscious of the importance of numismatic material for the knowledge of ancient history, religion, and allegorical imagery. As ever larger numbers of coins were

found, they were collected avidly; publications of this rich source of information were prepared by many students, none more ambitious than those of the engraver and archaeologist Hubert Goltzius, whose efforts were continued in the seventeenth century by Jacob de Bie. For a few years (in the late 1620s) Rubens was actually the owner of the very plates Goltzius had engraved for his books; he sold them in 1630 to Balthasar Moretus for over six thousand florins. A significant statement—hardly ever noticed—on the importance of coins (and other ancient relics) is found in the book of philological studies by Rubens' brother Philip, already mentioned. We can safely assume that it reflects (if it does not actually quote) Rubens' own views: "It is unbelievable how valuable is the study of coins, (carved) stones, and other monuments of the ancients for a fuller understanding of antiquity" ("Incredibile est, quantum ad pleniorem antiquitatis notitiam valeat observatio numorum, lapidum, aliorumque veterum monumentorum").

One very early title designed by Rubens was, in fact, for a book on coins; it was followed by three others. The reliance on classical formulae of allegory was natural where the content of the volume itself was the result of archaeological studies or—as in the edition of the collected works of Lipsius—the literary output of one of the foremost humanist scholars of his time. Yet Rubens drew also on his knowledge of the ancient world, its gods, its religious customs and implements, its symbolism and pictorial *topoi*, when he worked on titles for books on past and contemporary history, on political thought and theory, on science, on poetry or emblematics. In choosing this approach, Rubens was clearly aided by the fact, rarely mentioned but obviously of basic significance, that virtually all this literature was written in Latin—the learned language par excellence—and that the poetic exercises of even the most devout Jesuit poets were patterned after, and freely acknowledged their indebtedness to, Roman literary models.

It is well known that by Rubens' time symbols of classical origin (torches, laurel wreaths, the hoop of Eternity, the trumpets of fame, to mention a few) had become so much an integral part of the vocabulary of allegorical rhetoric that they were used unhesitatingly for the illustration of purely Christian themes. When Rubens designed the great tapestry cycle known as the *Triumph of the Eucharist*, he employed for several of its major compositions the pattern of Roman triumphal processions. Likewise, in several of his title pages for books on ecclesiastical history, he depicted the personification of the triumphant Roman church enthroned in majestic frontality comparable to the figure of victorious Roma herself; her enemies—Heresy, Blindness, Falsehood—are relegated to, and crouch in abject submission in a lower zone, in imitation of the bound captives that are standard features of Roman allegorical triumphs, particularly as they appear, in abbreviated form, on coins. To the ancient sources consulted by Rubens directly must be added the publications, chiefly of the sixteenth century, in which learned men, on the model of earlier transliterations of Egyptian hieroglyphs, patiently and with much acuity assembled either encyclopedic collections of the many possible symbolic meanings embodied in concrete "things" (including ancient deities, planets and other celestial bodies and constellations, plants,

animals, and man-made objects) or, on the basis of such meanings, developed new "emblematic" combinations of their own.

A basic problem for Rubens in designing title pages was evidently where to place the words of the title and how much space to allow for it and the wordy information that traditionally went along with it. The lettering generally varied only in regard to the size of the letters or in the shift (in subordinate places) from roman to italic. The Antwerp publishers in the seventeenth century did not go in for fancifully designed alphabets, although they may have preferred one type-cast to another. They did, however, like lengthy titles, subtitles, and summaries of the contents, and ample information about their own enterprise. The title of the Breviary represents the simplest type (Fig. XV.5), which in fact remained the most popular one, especially for books designed at a later date when Rubens himself had pretty much withdrawn from this activity. It consists of three zones, a base, or socle zone below, ending at a platform on which rises a rectangular, stele-like postament that carries the text of the title, leaving space on either side for figures comparable in function to jamb figures on medieval portals. The postament in turn supports a dominant figure—here for instance the Catholic Church herself—which may be accompanied by additional figures or objects. This is clearly the pattern followed also in the title of the *Summa Conciliorum omnium* (the record of all the Councils) which can be shown in an interesting example: it is a proofprint, on which Balthasar Moretus inscribed with the pen the title he wished to have used (Fig. XV.6); we learn from this case that the letters of the title were set only after the engraver had committed Rubens' design to the plate; in this way both type-size and spacing could be worked out to best advantage.

Rubens used this compositional pattern—always, to be sure, with variations—for the title page of Aguilonius' *Optics* (Fig. XV.7), where the lateral figures have become part of the actual architecture in the form of herms, Mercury at the left, Pallas at the right; the figure enthroned above is Optica herself, ennobled by a halo of radiating light. The Aguilonius title, in fact, coming very early in Rubens' preoccupation with the design of title pages, is a good example of his ability to provide, on the opening page of a book, an abbreviated and emblematically disguised table of contents. That optics is the science dealing with sight, and depending on light, is indicated not only by the halo but also by the lamps on either side; at the bottom a dog-headed ape greets the light of the moon emerging from an eclipse according to a somewhat ludicrous myth believed to be Egyptian, and asserting that the creature loses its sight and falls to the ground during an eclipse, but regains its sight when it is over. All the other details refer to sight: the eye on top of the scepter in the hand of Optica symbolizes the eye of God; the index-finger of her left hand rests on the apex of the "pyramid of sight"—meaning, of course, the human eye. At her feet is an eagle, reputed to have the keenest sight and to be able to see into the sun without suffering damage; he rests one talon on an armillary sphere which we have encountered before in one of the vignettes. The peacock on the other side received the "eyes" on its feathers when Mercury killed the hundred-eyed Argus, and Juno implanted

its eyes on the tail of her favored animal. The herm figure of Mercury, in fact, still holds the head of Argus, its forehead covered with eyes; and on the shield of Pallas on the other side is the head of Medusa, whose staring eyes turn enemies into stone. A still-life of measuring instruments used in optical research completes the design below.

The stele-type of organization of the title page appears also on the title of the first volume of Haraeus' *Annales* (Fig. XV.8). Here it is History which is enthroned above, looking at an open book and accompanied by a globe illuminated by a torch in her hand. The trumpet of fame is combined with the symbol of Eternity, a hoop made of a serpent biting its tail, but it is characteristic of Rubens that such emblems are often activated, as they are here, by the ever-ready putti who are as delightful as they are essential. War—personified by Mars—looks across at Pax, whose attribute is Mercury's caduceus and who directs the fire of a torch at a military helmet—a motif taken from Roman coins comparable to the biblical injunction of beating swords into plowshares. The bottom zone is given to geographic personifications: the Scheldt river at the left and Belgica (Belgium) with her lion at the right.

A title no more than five and one-half inches high is still, despite its simplification, recognizable as belonging to this type, but the central shape is not a neatly outlined post-ament but an irregular stone, possibly meant to evoke the shape of tombstones (Fig. XV.9). The royal path of the cross (*Regia via crucis*) here taken by three men, leads—as I think we must read the message—beyond death to eternal life.

With the next two titles I shall not go into the symbolism (in one of them a rather esoteric one) but I wish to comment on the structure, which resembles only superficially the type examined so far. Actually, in these titles of 1617 and 1620 the plaques that hold the inscriptions are part of a unified architectural ensemble, the nearest relatives of which are large epitaphs or wall-tombs (Fig. XV.10). Rubens is known to have designed several epitaphs, none of which, unfortunately, has survived (they are known from a drawing and some prints).[8] The epitaph, with its memorial function, is certainly related to the purposes of book titles, one of which—and not the least—is to keep alive the memory of the authors themselves. In view of this, it is not surprising that we frequently encounter funeral associations, including the form of Roman cinerary altars, on title pages.

In a number of title pages Rubens introduced a curtain or a hanging on which to print the title of the book. This is the case in the earliest title page designed by him (if my attribution of it to the master is indeed correct): the title of the *Vita Ignatii* of 1609 (Fig. XV.11). In this early and rather small example (the book measures only seven and one-quarter inches in height) the design is dominated by a single architectural motif, resembling a baroque altar. But when Rubens dealt again with a larger volume, as in the third volume of Haraeus' *Annales Ducum Brabantiae*, where the hanging covers the interior of the temple of Janus (the doors of which have been opened by nefarious characters in order to release the fury of war), we are back again to the tripartite organization of socle zone, main field with "jamb-figures," and crowning field, here with the double-headed bust of Janus himself.

Two more examples (Thomas à Jesu's *Six Books on Divine Contemplation*, and Heribertus Rosweydus' ten books on the *Lives of the Fathers*) may indicate that hangings suspended in various ways were indeed favorite devices to receive the printed titles. The title page of Corderius' *Catena* (Chain) of sixty-five Greek commentaries on the Gospel of St. Luke (the title with the insufficiently covered allegory of Truth, Fig. XV.12) uses the idea of a hanging in a particularly original manner: it is not a curtain but the very skin of Luke's attribute, the ox, that is here suspended; and two of the most prominent commentators on the Gospel, St. Augustine at the left (to indicate harmony with the Latin Fathers) and St. Gregory Nazianzen at the right, fulfill the standard function seen many times before. In choosing the skin of the ox to carry the title, Rubens may well have remembered that, in the form of parchment, animal skins had been used for centuries as particularly durable substrata for writings intended to last.

Occasionally Rubens inscribed the title on an oval shield. It occurs first on a design he made in 1611, although the book, illustrating the Roman imperial gold coins from the collection of Prince Charles de Croÿ, was published first in 1615 (Fig. XV.13). The statuesque figure is the goddess Moneta holding the balance determining the proper coinage in perfect equilibrium. The cornucopia in her other hand is a transparent symbol of prosperity resulting from good monetary practices, and at her feet lie the tools used for minting coins. The figure is clearly derived from Roman coins, where she also holds the balanced scales and the cornucopia. But why the oval shield? I believe Rubens wished to allude to a Roman representation of Victory in which the goddess of Victory inscribes the record of successful campaigns on the oval shield of Ares; Rubens knew the type from coins (Fig. XV.14), from the reliefs of the columns of Trajan and Marcus Aurelius, and possibly also from full-round figures, such as the so-called Nike of Brescia.

That there is in fact a connection between the use of the oval shield in title pages and the recording of military successes can be substantiated by the title Rubens designed for a book describing Spinola's successful siege of the strongly fortified town of Breda (Fig. XV.15), a much heralded victory commemorated also in one of Velázquez's most celebrated paintings. The triumph, referred to in the title and inscribed, as it were, on the shield of Ares, was achieved, as the flanking figures indicate, by hard labor, signified by Hercules holding a spade, and by military prudence and vigilance, embodied by Minerva with a serpent coiled around her arm and a cock at her feet. That Breda was forced by famine to surrender to the Spanish arms is emblematically indicated by an emaciated figure (Famine) who with her bony hands strangles the dejected seated woman personifying the doomed city.

To these carriers of inscriptions we must add one more, a low semi-cylindrical body which often serves as the base for a dominant figure, for instance the personification of Roma on the title of Jacob de Bie's book on imperial Roman coins, first published in 1617. The inspiration for this form came, I believe, from a type of Roman altar that was frequently depicted on coins as well as other objects. Altars of this kind often had carved garlands

hanging from them such as we see on the title page, designed by Rubens, for the book
by Bosius entitled *Crux triumphans*, the triumphant Cross (Fig. XV. 16). While Faith and
Divine Love (Fides and Caritas) are seated on the lateral extensions of the central form,
the resurrected Christ—echoing a sculpture of Michelangelo—stands above in the center.
Rubens chose the motif of an ancient altar in full knowledge of its meaning. Not only
would it indicate the triumph of the Cross over the pagan rites, but with the altar also
capable of being interpreted in a Christian sense, Christ's bodily appearance on it is
suggestive of the Eucharistic truth of the real presence in the sacrifice of the mass. In one
of its correct classical forms, the cylindrical altar appears in yet another of Rubens' title
pages, Tristan's glorification of Isabella Clara Eugenia, the governess of the Netherlands,
of 1634 (Fig. VII.5). The book, although begun while she was still alive, appeared only
after her death, but no change was considered necessary in Rubens' design. It is one of
the seven title pages for which we have authentic contemporary explanations, in this case
from the pen of Balthasar Moretus himself:

> Rubens' composition is quite ingenious. The evening star above the head of the most
> pious princess designates Spain, her native country; the chain of coins, the series of
> her ancestors. On the right the imperial crown, the laurel leaves, the scepter and
> palm branch indicate that she is the daughter of Philip II and the granddaughter of
> Charles V and the descendant of many illustrious emperors of the house of Austria.
> On the other side the lilies attest that the royal blood of the Valois runs also through
> her veins. The genii on each side symbolize, by the thunderbolt and the caduceus,
> the wars she fought and the peace she procured. In the center stands the altar of public
> safety with two serpents as represented on Roman coins. The turtledove, symbol of
> widowhood, is sitting on the rudder and the globe. It signifies that the safety of
> Belgium depended on her government.

The motif of Roman altars appears in yet other shapes, closely modeled—for instance
in Ludovicus Nonnius' Commentary on Hubert Goltzius' volume on coins of Greece and
Asia Minor—on funerary altars. The design is of 1618 and was used again for the final
edition of 1644, when Rubens had been dead for four years. The decorative elements all
refer to Greek deities, here represented by animals, or objects known to be their attributes.
Finally, a still more graceful form of a Roman altar was used for small volumes of poetry,
in 1634 for the spiritual poems by a German Jesuit, Jacob Biderman (Bidermanus, Fig.
XV. 17), as well as two years earlier (1632) on the title page of poems honoring Urban
VIII written by a Polish Jesuit, Mathias Casimir Sarbiewski (Sarbievius, Fig. XV. 18). In
the Sarbiewski title, Apollo puts his own lyre on the altar, which straddles the waters
from the fountain Hippocrene on Helicon, sacred to the Muses. The figure at right is in
fact one of the Muses, perhaps Calliope, the muse of heroic poetry. The child in the cradle
can be identified as the most famous lyric poet of antiquity, Pindar, the sweetness of whose
poetry was attributed to the honey which bees had left on his tongue when he was a child—

a legend which was also told of Plato and of St. Ambrose, Bishop of Milan, among others. There is also a connection between Pindar's bees and those of the Barberini pope (see the coat of arms), but I will discuss them in another context. The significance of the Bidermanus title has been explained by Rubens himself. On the drawing he gave to Moretus (Fig. XV.19) he wrote, "The altar patera (dish) and jug symbolize piety, religion, and sacredness; the lyre, and crown of ivy, poetry." To this we should perhaps add that the lion-footed altar was "christianized" by the corner ornaments of cherubs' heads with two pairs of wings. With Roman altars playing such a large role in Rubens' title pages, it is amusing to see that one of his drawings for a title page was later used as the cover for a collection of drawings possibly made by Sir Peter Lely, who inscribed it "A Collection of Altars & Altar Pieces, Churches, &c by ye famous Boroméne &c Severall of them in their propper colours. with severall drawings of Albert Dürer, Correggio, Pordenone &c" (Fig. VII.9).

While the examples shown so far provided a rationally conceived surface for the inscription of the title, there are a few title-page designs which do not fall into any such category. The title page for the collected works of Lipsius, for instance (Fig. XV.20), which Rubens designed in 1634 (the book appeared three years later), introduces as the central device an open arch, around which the various personages are assembled (in a rather characteristic inversion of the concept of reality, since the figures that are alive and acting are either mythical deities or allegorical personifications—Philosophy, Politics, Military Virtue, and Pacific Prudence—while the actual historical personages, Tacitus, Seneca, and Lipsius himself, are present only as sculpted or painted images). The words of the title, at any rate, are most unusually inscribed inside the arch, almost as if they were written into the empty air. Could it be that by freeing the title from any perishable surface, Rubens stressed the timeless validity of Lipsius' writings? Had not a Roman poet (Horace) spoken of his own works as a monument *aere perennius* (more durable than brass)? (Rubens chose the same idea for the title of Aedo y Gallart's *El memorable y glorioso Viaje del Infante Cardenal D. Fernando de Austria*, 1635.)

Another exceptional title page is the one Rubens provided for the volume recording the splendid festivities at the triumphal Entry of Cardinal Infante Ferdinand into Antwerp in 1635. The book came out only in 1642, and since even the Cardinal Infante was by then dead (as was Rubens) some copies were dated 1641 so as to make it appear that they had been printed when he was still alive. For the reception of the Spanish prince, and new governor, triumphal arches and stages had been erected, almost all of them from Rubens' designs. They were reproduced in the volume for which he now had to design a title page. What he decided, in keeping with the structures actually built, was to add another, resembling them in many ways and yet summing them all up with many subtle allusions to the glory of Spain, the auspicious mission of the Prince, and the hoped-for end of the war. It is worth noting that the engraver must have worked from a reversed copy of Rubens' oil-sketch, since with one exception the print corresponds to the sketch; it is only the

portrait of King Philip IV that was reversed, perhaps to make sure that he faced toward Aurora and the rising day at the left, rather than toward Luna and the night, however starry, on the other side. For this design, too, we have a very detailed explanation, from the hand of Caspar Gevartius, a friend of Rubens and the author of the book.

It is apparent that some of the freer and less conventional solutions (like the one for the Lipsius title) belong to a later period in the artist's career. In fact it is quite obvious that there is a stylistic development, and we find a more imaginative treatment of allegory in those title pages that belong to the later period of the artist's activity. The elements of the design are now more often connected with one another in a continuous action, and entirely new possibilities were introduced into this genre. Thus, in Corderius' edition of the writings of St. Dionysius, the saint is shown enthroned in the middle of the page, accompanied by other saints and the three theological virtues; he holds a large foreshortened tablet before him, and it is this tablet which now becomes the carrier of the title. From here it was only one step to think of the seemingly simple, and yet actually complex, solution of inscribing the title of the book *on a book*, depicted as part of a more comprehensive arrangement. This Rubens did twice. The example reproduced here is from Blosius' works, edited by members of the Benedictine monastery where Blosius had worked the century before (Fig. XV.21). In this title of 1632 Blosius is shown kneeling before Christ and the Virgin, offering to them, with the help of four monastic virtues (which are mentioned in the dedication), his collected writings—the title of which is inscribed on two open pages of a large folio. Thus the very book the reader has in his hands has become part of its own title page, involving us in an intriguing interplay between reality and image. (The other example is the title page of O. Bonartius' Commentary to Ecclesiasticus, 1634.)

Earlier I referred to the drawing Rubens made for the Plantinian printer's mark (*Labore et Constantia*, Fig. XV.4). In the early 1630s he designed another for the publisher Jan Meursius, who had been associated with Moretus for a while but had split with him after an angry disagreement. The vignette Rubens designed for him is one of the nicest examples of Rubens' ability to condense a variety of meanings into a harmonious and smoothly integrated decorative scheme (Fig. XV.22). The brooding hen in the center refers to the name of the house in which the press was located: "in the fat hen." This zoological emblem was developed into a meaningful reference to the unceasing activity of the publisher which goes on, just like the brooding of the mother hen, by day and by night: *noctu incubando diuque*—Meursius' motto—is inscribed on a scroll above. Yet the reference to day and night suggested to Rubens two other animals, the cock that announces the coming of the day, and the owl, the proverbial bird of darkness. And there is still more: industry alone is not enough for a publisher to succeed: he must have wisdom and commercial sense, which accounts for the addition of the busts of Minerva and Mercury, the latter with a purse hanging from his neck. The owl, of course, which on one level refers to night, is also the bird associated with Minerva, a fact which determined where the head of the goddess had

to go. The design is completed above by a lamp that can be read in more than one sense (*e.g.*, as the device for nocturnal illumination) and below by Mercury's caduceus joined to the trumpet of fame (or should we say propaganda?).

That Rubens took delight in developing such richly symbolical images conjoined in an attractive design we know from another sketch for a tiny volume of verse, written by several poetically inclined Jesuits. Rubens sent his drawing (Fig. XV.23) to Moretus with a note added on the same paper: "You have here the Muse, or Poetry with Minerva or Virtue joined in the shape of a Hermathene." (A Hermathene is a statue or bust combining Mercury and Minerva. Such statues were placed in schools where eloquence and philosophy were taught, because these deities presided over the arts and sciences.) Rubens continues, "I have placed there the muse instead of Mercury, which is permissible on the basis of several examples. I do not know if you will like my idea; I myself am rather pleased with it, not to say that I compliment myself on it." And he added to the left: "Notice that the Muse has a feather on her head by which she is distinguished from Apollo." In addition— and this quite clearly for the benefit of the engraver, Karel de Mallery—he drew the profile of Minerva a second time, with greater clarity of details. The title itself, of course, is on the central field, actually the lateral surface of the Hermathene.

I should like now to examine the question I have touched upon before but which deserves a still closer look—the question of whether, and to what extent, there is a development in Rubens' approach to the problem of title pages. In the background of such a study lurks naturally a still broader question, how such a development accords, if at all, with the development of Rubens' art in general. It should be understood that we do not get very far if we base this study purely on formal criteria; in a category of art to which these title pages belong, with their particular cerebral juggling of traditional symbolism, literary allusion, and antiquarian erudition, all formal elements are linked up with one another and serve to give emphasis to the intended message of the page.

A good pair to begin with is two title pages we have seen before. They are nine years apart: the title for the Roman Breviary was probably done in 1613, that for Haraeus' *Annales* in 1623 (Figs. XV.5 and XV.8). Basically they represent the same type, but in comparison the earlier one appears heavy, with the figures rather isolated from one another, not to mention the curious disproportion between the huge block in the center and the small figure of Ecclesia sitting above it. It may be that in this case Rubens was hampered by the wishes of Moretus, who, it should be remembered, had suggested the general layout. Not only is the design of the title page of the *Annales* of 1623 vastly more harmonious visually, with a beautiful formal balance achieved between the slender postament and the figures above it and at its side, but harmony also ensues from an iconographic interdependence of all parts. What Rubens designed is not a summary of the contents, since he made no reference to the main part even of the title—the annals of the Dukes and Princes of Brabant; there is no hint at a glorification of the ruling class. It is more like a philosophical statement about history, as it is written, and as it is lived. History personified—the figure

at the top—keeps the records of the vicissitudes that the land of Brabant, represented by the passively reclining figures below, had to endure. And these historical events have been shaped essentially by the alternating periods of war and peace, here present in their established classical personifications. That the historian may have a bias in favor of peace is perhaps expressed by History's turn toward the side of Pax. Nor should we overlook the fact that even Mars cannot avoid looking to the beautiful figure of Peace, who quietly sets fire to the implements of war, holding at the same time Mercury's caduceus, symbol of peace as well as of commerce, which needs political tranquillity to flourish.

In 1617, Rubens designed a title for Leonard Lessius' book *De iustitia et iure* (on Justice and Law), a compendious dissertation by the learned Jesuit dealing with many questions pertaining to law, particularly as it applies to commercial activities (Fig. XV.24). The book is still regarded as an important text in the history of economic jurisprudence. In his title design, Rubens assembled five figures around an oval plaque (not a shield!), on which the title itself is printed. Formally speaking, the result is not entirely successful, possibly because he tried to do too much. In fact, this is one of the most complex titles, which for that very reason apparently pleased the author greatly. The fettered figures below seem to refer to some relatively minor chapters of the book, on the desirable control of Anger, Cruelty, Gluttony, Drunkenness, and Lust—vices for which Rubens found ready personifications in the tradition of Western iconography. The women steadying the plaque are Cybele at the left, symbolizing civic virtue, and Ceres, fused—by the addition of many breasts—with Nature herself, at the right. (In the Columbia copy the bare breasts of both figures were inked out by a puritanical but vandalic soul.) Sitting on clouds above is Astraea, the mythical personification of justice, who because of man's iniquity left the earth to take abode, as the constellation Virgo, in the circle of the Zodiac. She will return to earth when good laws and obedience to them are again established—as she is actually doing here, having come forward from her place between Leo and Libra seen in the distance. The idea behind it all is subtle and beautiful, adding a dimension to the concept of law *not* found in Lessius' book. Yet the complete formal unification, achieved six years later in the Haraeus title, has still eluded the master; the composition is top-heavy, and the intention to establish symmetry has prevented a more lively interaction of the figures.

The title page of Scribanius' *Politico-Christianus* of 1624 achieved this kind of harmony despite its emblematic complexity, which is also too rich to be analyzed here in detail (Fig. VII.7). The basic message is simple enough: happiness and prosperity will be achieved if the ruling princes combine statecraft with god-fearing moderation. For this message Rubens found a particularly happy compositional arrangement. The title, in the form of a dedication, appears on a cartouche of relatively modest size in the center; the emblems of government are placed above, while the appropriate personifications gracefully conform to the shape of the cartouche, without relinquishing the impression of perfect freedom of motion. Even the sky, and the divine emanations above, help to insure the overall fluidity of design.

I am glad to say that an idea which I expressed almost timidly some years ago has been widely accepted—namely, that a few years later, when Bernini undertook the design of his monumental tomb of Urban VIII, he may well have remembered Rubens' title page of Scribanius' book, particularly in the way the allegorical maidens, Justice and Charity, conform to the shape of the sarcophagus between them.[9] (Scribanius was a leading member of the Jesuit order, and his book, dedicated to King Philip IV of Spain, was surely widely distributed.)

The Scribanius title, however, was not the last word even for designs where a similar grouping was required. A further step was taken with the title page of a curious collection of *imprese* by Silvester Petrasancta (Pietra Sancta), a rather vociferous propagandist for the Jesuit order (Fig. XV.25). The composition is a graceful compliment to the clever thoughts invested in these personal *imprese* and to the artists' skill that gave them pleasing visual shape. Nature and Art are the figures standing on either side of the altar, while a heavenly genius assists in the creative union that gives birth to the desired image. What is new here, and skillfully expresses the thought behind it all, is the interlocking of all the figures and their attributes. Instead of being aligned, as they are in most previous designs, facing the beholder, the standing personifications are involved in an action entirely within the pictorial space provided by the artist.

The Petrasancta title dates from 1634, and I believe it is easy to see that it is roughly contemporary with one of Rubens' most famous paintings, the *Three Graces* in the Prado. The same principle of a loose and harmonious interlacing of three figures, concerned only with themselves, holds true for both works.

The new freedom of action reappears, although in an entirely different manner, in the title of the poems of Pope Urban VIII, designed in 1634 (Fig. XV.26). This may well be the most famous of Rubens' title pages, possibly because it is the most startling. If we had only the magnificent drawing we should hardly guess that it was meant to adorn the opening page of a book. It has more the appearance of a sketch for a wall decoration, possibly an overdoor. Yet the rough-hewn arch frames only a small commemorative plaque, evoking a tombstone or the lid of a small burial chamber. Above this simple architectural motif and supported by it, there unfolds a furious action, as a herculean Samson rends the young lion (in the words of Judges 14:6) "as he would have rent a kid, and he had nothing in his hand." Rubens followed the tradition according to which Samson tears open the mouth of the lion with his bare hands. There was a good reason for him to choose the biblical hero for this place, for he combined the actual killing of the lion with a slightly later incident, when Samson returned to the carcass of the lion and found a swarm of bees and honey in it. In the title page the bees swarm from the open mouth of the lion, but they are not only the bees mentioned in the Bible: they are also Barberini-bees, the heraldic animals of the family of Urban VIII. And yet Rubens surely thought of them as more than mere armorial devices. We can assume safely that the bees actually represent the poems of Urban VIII gathered in the slim volume and that Rubens wanted to allude to yet another line in the biblical story—the riddle Samson put before the Philistines: "out of the eater

came meat, and *out of the strong came forth sweetness*." And again we recognize the basic unity of Rubens' style no matter what the nature of the work, for the Samson title, in the utter freedom of its design, represents the same stylistic phase to which belong his larger works for the Whitehall ceiling and the sketches for the Torre de la Parada, all done about the same time.

I should like to finish with two title pages, the first designed in 1631-1632, the second in 1638. Both are of the highest interest for their iconographic program, their supreme artistry, and because their meaning has been explained to the last detail by men who knew them best: one most likely by Gevartius, the other by Rubens himself. The larger one (Fig. XV.27) is the chief title page for the new edition of Hubert Goltzius' record of ancient coins. (It was published only in 1645.) The image of the revival of antiquity, it depicts a virtually continuous quasi-circular action. At the right we witness the downfall of the great empires of Antiquity, overturned by Time and Death. With a nice historical sense, Rubens arranged them in the sequence of their doom, the earliest to fall (the kingdom of the Medes) at the bottom, followed by the Persian and Macedonian empires, with the last one, Rome, tumbling upside down at the top. From the cavern of the ages below (a concept taken from Lucretius), Mercury at the left lifts up the torso of a Roman imperial statue, having also uncovered two busts; higher up, Hercules—always the representative of labor or industry—hands a bowl full of coins to another excavator, while Minerva, the goddess of learning, literally and of course also metaphorically illuminates them with the help of a torch. The action circulates around a rectangular block that carries the title and above which stands the sculpted bust of Antiquity, surmounted by a phoenix, the symbol of Rebirth and Eternity. What Gevartius did not say in his explanatory text is that Rubens conceived the destruction of the pagan world and the recovery of its cultural treasures by learned archaeologists of the Christian era in terms of one of the greatest of Christian religious themes, that of the Last Judgment, where traditionally the damned fall down into Hell at the right, and the blessed rise to Heaven at the left. To a man as passionately interested in the study of ancient literature and art as was Rubens, it must have given special satisfaction that he could justify salvaging what was still left of antiquity by analogy with another, and even more hallowed, theme of salvation.

The title page of De Marselaer's *Legatus* (Fig. XV.28) brings us to the end. It had a rather curious history. Frederic de Marselaer, a member of the landed gentry, held several municipal posts in Brussels and as a young man had written a book—his only one, as far as we know—on the training, function, and legal status of ambassadors. It had appeared first in 1618, but he apparently hoped for a new edition in the middle of the 1630s, to be adorned with a title page designed by Rubens. Rubens, however, was in no hurry; it was only after three years, in 1638, that he delivered the drawing. Despite the delay, De Marselaer was overjoyed; he wrote to Balthasar Moretus that it was difficult to say what one should admire more, Rubens' ingenuity and knowledge, his courtesy and affection, or his artistic talent. And speaking of the long delay, he was reminded, so he said, of a French author, Pierre Mathieu, who after being reproached by King Henry IV for taking

so long to produce something, answered, "Yes, but it will also last long!" But that was not the end of it; even though Rubens had made the design, the book was not put into production. In fact, the engraving of the title page was only made in 1656, eighteen years after the date of the drawing, and long after the death of both Rubens and Balthasar Moretus. And still the book did not come out; it was finally published, after another delay of ten years, in 1666. By that time De Marselaer was eighty-two years old, but I am sure he was pleased to see his book out, and with Rubens' title page in place. In fact, in the preface he gave an explanation of the meaning, but I prefer Rubens' own, which also has been preserved. Nor is it necessary to identify every detail as described in that text. While the art of good government is represented as a sculpted bust in the center, accompanied by two genii with appropriate attributes, and while the eye of Divine Providence watches from above, Prudence (in the form of Minerva) extends her hand to place it in a traditional marriage gesture into the hand of Mercury—"the interpreter and messenger of the Gods." This is clearly a direct reference to the function of the Ambassador, who must also have the gift of eloquence, one of Mercury's chief qualities. The frolicking children below indicate the happy times assured by successful diplomatic negotiations.

The theme had of course a special significance for Rubens, who himself had been involved in many delicate diplomatic missions. Maybe it was the memory of his own efforts for the sake of peace that induced him here to fall back once more on an ancient theme, the joining of hands as a token of good faith—and to give to it a special degree of warmth and urgency.

We could assess this spirited joining of the hands of two figures right across the central sculptural bust in a purely *formal* sense as the final but complete breakdown of the more rigid patterns Rubens had adopted originally for the organization of his title pages. But surely a deeper significance underlies such a joining of hands. Historic handshakes then, as now, might be harbingers of peaceful times, such times as men of good will have always prayed, hoped, and worked for, but have only too rarely been permitted to see established during their own lives.

NOTES

1. *Rubens and the Book: Title Pages by Peter Paul Rubens*, prepared by students in the Williams College Graduate Program in the History of Art, edited and introduced by Julius S. Held, Williamstown, Mass., 1977. The catalogue of this exhibition, containing not only detailed discussions of the title pages but also papers on special problems connected with them, was marred unfortunately by a number of errors and misprints, largely corrected in an errata sheet that now accompanies each copy.

2. *P. P. Rubens als boekillustrator*, Antwerp, Plantin-Moretus Museum, foreword by Leon Voet, introduction and catalogue by J. Richard Judson, Antwerp, 1977.

3. Leon Voet, *The Golden Compasses*, 2 vols., Antwerp, 1969-1972.

4. See Julius S. Held, "Rubens and the *Vita Beati P.*

Ignatii Loiolae of 1609," *Rubens before 1620*, Princeton, 1972, pp. 93-134.

5. Wolfgang Jaeger, *Die Illustrationen von Peter Paul Rubens zum Lehrbuch der Optik des Franciscus Aguilonius, 1613*, Heidelberg, 1976. Jaeger believes that Rubens' vignette (Fig. XV.2) is at variance with Aguilonius' demonstration and comes close to Kepler's theorem.

6. See Julius S. Held, "Rubens and Aguilonius: New Points of Contact," *Art Bulletin*, LXI, 1979, pp. 257-264.

7. Max Rooses, *L'Oeuvre de P.-P. Rubens*, III, Antwerp, 1890, p. 311.

8. See "Rubens' Designs for Sepulchral Monuments," chap. VII in this volume.

9. Ibid.

PUBLICATIONS
BY JULIUS S. HELD
Compiled by Edith Howard

BOOKS AND PORTFOLIOS

Dürers Wirkung auf die niederländische Kunst seiner Zeit. The Hague: Nijhoff, 1931.

Rubens in America, Catalogue of Paintings and Drawings by Rubens in American Collections, with an Introduction by Jan-Albert Goris. New York: Pantheon, 1947.

Flemish Painting. The Library of Great Painters, Portfolio Edition. New York: Abrams, 1953. Enlarged edition, 1956.

Peter Paul Rubens. The Library of Great Painters, Portfolio Edition. New York: Abrams, 1953.

Paintings by Rembrandt. The Metropolitan Museum of Art Miniatures. New York, 1956.

Rubens: Selected Drawings. 2 vols. London: Phaidon, 1959. German edition, Cologne: Phaidon [1960].

Rembrandt and the Book of Tobit. Gehenna Essays in Art, No. 2. Northampton, Mass.: Gehenna Press, 1964.

Rembrandt's Aristotle, *and Other Rembrandt Studies.* Princeton: Princeton University Press, 1969.

P. P. Rubens, *The Leopards: "Originale de mia mano."* [New York:] privately printed, 1970. Reprinted in *The Burlington Magazine*, CXV, May 1973, ad. suppl.

17th and 18th Century Art, Baroque Painting, Sculpture, and Architecture, written with Donald Posner. Englewood Cliffs, N.J.: Prentice Hall [1971].

Rubens and the Book: Title Pages by Rubens. Prepared by students in the Williams College Graduate Program in the History of Art; edited and introduced by Julius S. Held. Williamstown: Williams College, 1977.

Der blinde Tobias und seine Heilung in Darstellungen Rembrandts, mit einem Vorwort von Wolfgang Jaeger (Die medizinhistorische Bedeutung der Tobiasheilungen Rembrandts), Heidelberg: Brausdruck, 1980.

The Oil Sketches of Peter Paul Rubens. 2 vols. Princeton: Princeton University Press, 1980.

Rubens and His Circle: Studies by Julius S. Held. Ed. Anne W. Lowenthal, David Rosand, and John Walsh, Jr. Princeton: Princeton University Press, 1982.

ARTICLES

"Burgkmair and Lucas van Leyden," *The Burlington Magazine*, LX, 1932, pp. 308-313.

"Heinrich Aldegrever (1502-after 1555)," *Old Master Drawings*, VI, 1932, p. 70.

"Zwei Ansichten von Paris beim Meister des Heiligen Aegidius," *Jahrbuch der Preussischen Kunstsammlungen*, LIII, 1932, pp. 3-15.

"Notizen zu einem niederländischen Skizzenbuch in Berlin," *Oud-Holland*, L, 1933, pp. 273-288.

"Nachträglich veränderte Kompositionen bei Jacob Jordaens," *Revue belge d'archéologie et d'histoire de l'art*, III, 1933, pp. 214-223.

"Porcellis," Thieme-Becker, eds., *Allgemeines Lexikon der bildenden Künstler*, XXVII, Leipzig: Seemann, 1933, p. 269.

"Post, Frans Jansz.," Thieme-Becker, eds., *Allgemeines Lexikon der bildenden Künstler*, XXVII, Leipzig: Seemann, 1933, pp. 296-297.

"Dutch and Flemish Primitives in the Historical Society of New York," *Art in America*, XXIII, 1934, pp. 2-17.

"Zum Meister der Darmstädter Passion," *Zeitschrift für Kunstgeschichte*, III, 1934, pp. 53-54.

"Ein Johannes aus Claus Sluters Kreis," *Pantheon*, XV, 1935, p. 141.

"Exhibitions of Dutch and Flemish Art in Europe in 1935," *Germanic Museum Bulletin*, I/1, 1935 [5-6].

"Frans-Hals-Ausstellung in Detroit," *Pantheon*, XV, 1935, pp. 163-166.

"Pieter Coecke and Pieter Breugel," *Bulletin of the Detroit Institute of Arts*, XIV, 1935, pp. 107-109.

"Seventeenth-Century Dutch Paintings Recently Added to American Collections," *Art in America*, XXIII, 1935, pp. 112-119.

"Bildnisse Jan Mostaerts," *Pantheon*, XVI, 1936, pp. 93-96.

"A Diptych by Memling," *The Burlington Magazine*, LXVIII, 1936, pp. 176-179.

"The Illustrations of the Fliegende Blätter," *Germanic Museum Bulletin*, I/3, 1936, pp. 19-22.

"Allegorie," *Reallexikon zur deutschen Kunstgeschichte*, I, Stuttgart: Metzlersche Verlagsbuchhandlung, 1937, cols. 346-366.

"Architekturbild," *Reallexikon zur deutschen Kunstgeschichte*, I, Stuttgart: Metzlersche Verlagsbuchhandlung, 1937, cols. 905-918.

"Ett bidrag till Kännedomen om Everdingens skandinaviska resa," *Konsthistorisk Tidskrift*, VI, 1937, pp. 41-43.

"Two Rembrandts," *Parnassus*, IX/4, 1937, pp. 36-38.

"Jacobus de Punder," *Journal of the Walters Art Gallery*, I, 1938, pp. 44-50.

"Malerier og tegninger af Jacob Jordaens i Kunstmuseet," *Kunstmuseets Aarsskrift*, Copenhagen, XXVI, 1939, pp. 1-43.

"Reflections on 17th Century Dutch Painting," *Parnassus*, XI/2, 1939, pp. 17-18.

"Jordaens' Portraits of His Family," *The Art Bulletin*, XXII, 1940, pp. 70-82.

"Rubens' King of Tunis and Vermeyen's Portrait of Mūlāy-Aḥmad," *The Art Quarterly*, III, 1940, pp. 173-181.

"Unknown Paintings by Jordaens in America," *Parnassus*, XII/3, 1940, pp. 26-29.

"Achelous' Banquet," *The Art Quarterly*, IV, 1941, pp. 122-133.

"Masters of Northern Europe, 1430-1660, in the National Gallery," *Art News*, XL/8, 1941, pp. 11-15, 39.

"The Animal Kingdom," *Art in America*, XXIX, 1941, pp. 100-104.

"Rembrandt, The Self-Education of an Artist," *Art News*, XL/20, 1942, pp. 10-14, 28.

"Corot in Castel Sant' Elia," *Gazette des beaux-arts*, XXIII, 1943, pp. 183-186.

"A Forgotten Prud'hon in New York," *Gazette des beaux-arts*, XXIII, 1943, pp. 283-294.

"The Museum and the Private Collector," *The Magazine of Art*, XXXVI, 1943, pp. 270, 276.

"A Rubens Problem: Authorship of the Holy Family in the Walker Art Center," *Gazette des beaux-arts*, XXIII, 1943, pp. 119-122.

"Rembrandt's 'Polish' Rider," *The Art Bulletin*, XXVI, 1944, pp. 246-265.

"Rubens and Virgil," *The Art Bulletin*, XXIX, 1947, pp. 125-126.

"The Stylistic Detection of Fraud," *The Magazine of Art*, XLI, 1948, pp. 179-182.

"Ambroise Benson et le Maître de Flémalle," *Les arts plastiques*, III, 1949, pp. 196-202.

"Jordaens and the Equestrian Astrology," *Miscellanea Leo van Puyvelde*. Brussels: La Connaissance, 1949, pp. 153-156.

"Debunking Rembrandt's Legends," *Art News*, XLVIII/10, 1950, pp. 20-24, 60-62.

"A Rubens Discovery in Chicago," written with David Rosen, *Journal of the Walters Art Gallery*, XIII, 1950-1951, pp. 76-91.

"Edward Hicks and the Tradition," *The Art Quarterly*, XIV, 1951, pp. 121-136.

"Notes on David Vinckeboons," *Oud-Holland*, LXVI, 1951, pp. 241-244.

"Rubens' Pen Drawings," *The Magazine of Art*, XLIV, 1951, pp. 286-291.

"A Rubens Portrait for Sarasota," *Ringling Museums Annual*, Sarasota, Florida, 1951, pp. 4-7.

"Sketches by Lucas Franchoys the Younger," *The Art Quarterly*, XIV, 1951, pp. 45-55.

"A Supplement to Het Caravaggisme te Gent," *Gentse bijdragen tot de kunstgeschiedenis*, XIII, 1951, pp. 7-12.

" 'The Burden of Time,' A Footnote on Abraham Janssens," *Bulletin, Musées Royaux des Beaux-Arts*, I, 1952, pp. 11-17.

"Little-known French Paintings of the 15th Century," *The Burlington Magazine*, XCIV, 1952, pp. 99-108.

"A Tondo by Cornelis Engebrechtsz," *Oud-Holland*, LXVII, 1952, pp. 233-237.

"A propos de l'Exposition Rubens à Bruxelles," *Les arts plastiques*, VI, 1953, pp. 107-116.

"The Authorship of Three Flemish Paintings in Mons," *Bulletin, Musées Royaux des Beaux-Arts*, II, 1953, pp. 99-114.

"A Drawing by Michiel Coxie after the Ghent Altarpiece," *The Art Quarterly*, XVII, 1954, pp. 58-61.

"A Postscript: Rubens in America," *Art Digest*, XXVIII/16, 1954, pp. 13, 34-35.

"Rubens' 'Feast of Herod,' " *The Burlington Magazine*, XCVI, 1954, p. 122.

"Chanukkaleuchter," *Reallexikon zur deutschen Kunstgeschichte*, III, Stuttgart: Alfred Druckenmüller Verlag, 1954, cols. 414-415.

"Notes on Flemish Seventeenth-Century Painting: Jacob van Oost and Theodor van Loon," *The Art Quarterly*, XVIII, 1955, pp. 147-156.

"Drawings and Oil Sketches by Rubens from American Collections," *The Burlington Magazine*, XCVIII, 1956, pp. 123-124.

"On Preservation," *College Art Journal*, XVI, 1956, pp. 67-69. Reprinted from "The Contributing Editor," *Barnard Alumnae Magazine*, XLV/4, 1956, pp. 17-18.

"Artis Pictoriae Amator, An Antwerp Art Patron and His Collection," *Gazette des beaux-arts*, L, 1957, pp. 53-84. Included in *Essays in Honor of Hans Tietze*. New York: *Gazette des beaux-arts*, 1958, pp. 317-348.

"Comments on Rubens' Beginnings," *Miscellanea Prof. Dr. D. Roggen*. Antwerp: De Sikkel, 1957, pp. 125-134.

"Le Roi à la Ciasse," *The Art Bulletin*, XL, 1958, pp. 139-149.

"Rubens' Designs for Sepulchral Monuments," *The Art Quarterly*, XXIII, 1960, pp. 247-270.

"Flora, Goddess and Courtesan," *De Artibus Opuscula XL, Essays in Honor of Erwin Panofsky*. New York: New York University Press, 1961, pp. 201-218.

"A New Museum in Ponce," *The Burlington Magazine*, CIII, 1961, pp. 316-318.

"Jordaens' 'Night Vision'—a Rejoinder," *Journal of the Warburg and Courtauld Institutes*, XXV, 1962, pp. 131-134.

"Van Dyck," *Encyclopaedia Britannica*, XXII, Chicago, 1962, pp. 974-977, and later editions.

"What—and Who—Sets the Price of Art," *The New York Times Magazine*, July 29, 1962, pp. 18-19, 28-29.

"Alteration and Mutilation of Works of Art," *South Atlantic Quarterly*, LXII, 1963, pp. 1-28. Translated into Polish: "Przeróbki i zniekształcenia dzieł sztuki," *Pojęcia, problemy, metody współczesnej nauki o sztuce*, ed. Jan Białostocki. Warsaw: Państwowe Wydawnictwo Naukowe, 1976, pp. 79-94.

"The Early Appreciation of Drawings," *Studies in Western Art*, III. Acts of the 20th International Congress of the History of Art. Princeton: Princeton University Press, 1963, pp. 72-95.

"Prometheus Bound," *Bulletin, Philadelphia Museum of Art*, LIX, 1963, pp. 17-32.

"Two Drawings by Philip Fruytiers," *The Art Quarterly*, XXVII, 1964, pp. 264-273.

"Padre Resta's Rubens Drawings after Ancient Sculpture," with Giorgio Fubini, *Master Drawings*, II, 1964, pp. 123-141.

"Rubens' St. Ives," *Bulletin of the Detroit Institute of Arts*, XLIII, 1964, pp. 47-52.

"The Bearing of the Cross, Hitherto Attributed to Juan de Flandres," *The Art Quarterly*, XXVIII, 1965, pp. 31-39.

"Notes on Jacob Jordaens," *Oud Holland*, LXXX, 1965, pp. 112-122.

"Jan van Boeckhorst as Draughtsman," *Bulletin, Musées Royaux des Beaux-Arts*, XVI, 1967, pp. 137-154.

"Tekeningen van Jacob Jordaens (1593-1678)," *Kunstchronik*, XX, 1967, pp. 94-110.

"Rubens' *Het Pelsken*," *Essays in the History of Art Presented to Rudolf Wittkower*. London: Phaidon, 1967, pp. 188-192.

"The Exhibition from Switzerland," *Master Drawings*, VI, 1968, pp. 47-50.

"Rubens' Triumph of the Eucharist and the Modello in Louisville," *Bulletin, J. B. Speed Art Museum*, XXVI/3, 1968, pp. 2-22.

"Die Ausstellung 'Rembrandt and His Pupils' in Montreal und Toronto," *Pantheon*, XXVII, 1969, pp. 384-389.

"Jordaens at Ottawa," *The Burlington Magazine*, CXI, 1969, pp. 265-272.

"Rubens and Vorsterman," *The Art Quarterly*, XXXII, 1969, pp. 111-129.

"Einige Bemerkungen zum Problem der Kopfstudie in der flämischen Malerei," *Wallraf-Richartz-Jahrbuch*, XXXII, 1970, pp. 285-290.

"Rubens' Glynde Sketch and the Installation of the Whitehall Ceiling," *The Burlington Magazine*, CXII, 1970, pp. 274-281.

"The Last of the 'Attic Nights': A Drawing by Jan Goeree," *Master Drawings*, IX, 1971, pp. 51-54.

"Caravaggio and His Followers," *Art in America*, LX/3, 1972, pp. 40-47.

"Das gesprochene Wort bei Rembrandt," *Neue Beiträge zur Rembrandt-Forschung*. Berlin: Mann, 1973, pp. 111-125.

"Rubens and the *Vita Beati P. Ignatii Loiolae* of 1609," *Rubens before 1620*. Princeton: Princeton University Press, 1972, pp. 93-134.

"Observations on the Boston Triptych of Saint Hippolytus," *Album Amicorum J. G. van Gelder*. The Hague: Nijhoff, 1973, pp. 177-185.

"Rembrandt en de klassieke wereld," *De Kroniek van het Rembrandthuis*, XXVI, 1972, part 1, pp. 3-17; part 2, pp. 32-41. Printed in English: *Rembrandt after Three Hundred Years: A Symposium—Rembrandt and His Followers*, October 22-24, 1969. Chicago. The Art Institute, 1973, pp. 49-66.

"The Emergence of Georges de La Tour," *Art in America*, LXI/4, 1973, pp. 82-87.

"A Protestant Source for a Rubens Subject," *Liber Amicorum Karel G. Boon*. Amsterdam: Swets and Zeitlinger, 1974, pp. 79-95.

"Some Rubens Drawings—Unknown or Neglected," *Master Drawings*, XII, 1974, pp. 249-260.

"Rubens's *Leopards*—a Milestone in the Portrayal of Wild Animals: La première oeuvre d'envergure de Rubens au Canada," *M., a Quarterly Review of the Montreal Museum of Fine Arts*, VII/3, 1975, pp. 5-14.

"The Four Heads of a Negro in Brussels and Malibu," *Miscellanea in Memoriam Paul Coremans (1908-1965), Bulletin, Institut Royal du Patrimoine Artistique*, XV, 1975, pp. 180-192.

"Gravity and Art," *Art Studies for an Editor, 25 Essays in Memory of Milton S. Fox*. New York: Abrams, 1975, pp. 117-128.

"On the Date and Function of Some Allegorical Sketches by Rubens," *Journal of the Warburg and Courtauld Institutes*, XXXVIII, 1975, pp. 218-233.

"Rubens's Sketch of Buckingham Rediscovered," *The Burlington Magazine*, CXVIII, 1976, pp. 546-551.

"Zwei Rubensprobleme," *Zeitschrift für Kunstgeschichte*, XXXIX, 1976, pp. 34-53.

"Rembrandt's Juno," *Apollo*, CV, 1977, pp. 478-485.

"Evocation de Max J. Friedländer," *Revue de l'art*, no. 42, 1978, pp. 37-40.

"Rubens and the Book," *Harvard Library Bulletin*, XXVII/1, January 1979, pp. 114-153. A lecture delivered at the Houghton Library, December 1, 1977.

"Rubens and Aguilonius: New Points of Contact," *The Art Bulletin*, LXI, 1979, pp. 257-264.

"Was Abraham Left-handed?," *The Print Collector's Newsletter*, XI, 1980, pp. 161-164.

BOOK REVIEWS

Nederlandsche Houtsneden 1500-1550. Die Graphischen Künste, Mitteilungen der Gesellschaft für vervielfältigende Kunst, LVI, 1933, pp. 17-18.

"Overzicht der litteratuur betreffende nederlandsche kunst," *Oud-Holland*, L, 1933, pp. 133-144, 179-192.

Charles L. Kuhn, *A Catalogue of German Paintings of the Middle Ages and Renaissance in American Collections. Art in America*, XXIV, 1936, pp. 165-166.

Horst Gerson, *Philips Koninck, Ein Beitrag zu Erforschung der holländischen Malerei des 17. Jahrhunderts. Art News*, XXXVI, 1937, pp. 20-21.

"Dr. Friedländer's Scholarly Study of Early Flemish and Dutch Painting," *Art in America*, XXVII, 1939, pp. 79-89.

G. Knuttel Wzn., *De nederlandsche schilderkunst van Van Eyck tot Van Gogh. Art in America*, XXVIII, 1940, p. 135.

Christian Wolters, *Die Bedeutung der Gemäldedurchleuchtung mit Roentgenstrahlen für die Kunstgeschichte*; and Alan Burroughs, *Art Criticism from a Laboratory. The Art Bulletin*, XXII, 1940, pp. 37-43.

Christian Wolters, *Die Bedeutung der Gemäldedurchleuchtung mit Roentgenstrahlen für die Kunstgeschichte. Art in America*, XXVIII, 1940, p. 89.

Thomas Bodkin, intro., *The Paintings of Jan Vermeer. College Art Journal*, I, 1941, pp. 16-17.

Charles Sterling, *La peinture française: Les primitifs. Art in America*, XXIX, 1941, p. 171.

Charles de Tolnay, *Le Maître de Flémalle et les Frères van Eyck. Art in America*, XXIX, 1941, pp. 241-242.

N. S. Trivas, *The Paintings of Frans Hals. Art in America*, XXX, 1942, pp. 255-256.

"Periodical Literature on Flemish and Dutch Painting of the Fifteenth and Sixteenth Centuries, 1939-1941," *The Art Bulletin*, XXIV, 1942, pp. 388-399.

Tancred Borenius, *Rembrandt, Selected Paintings. College Art Journal*, III, 1943, pp. 31-32.

Baron van der Elst, *The Last Flowering of the Middle Ages. Antiques*, XLVII, 1945, p. 170.

Franz Landsberger, *Rembrandt, The Jews and the Bible*; and [unsigned] *Rembrandt. Drawings for the Bible. College Art Journal*, VII, 1947-1948, pp. 143-145.

Otto Benesch, *Rembrandt: Selected Drawings. College Art Journal*, VIII, 1949, pp. 234-236.

Harry B. Wehle and Margaretta M. Salinger, *A Catalogue of Early Flemish, Dutch, and German Paintings in the Metropolitan Museum of Art. The Art Bulletin*, XXXI, 1949, pp. 141-143.

Ruth Massey Tovell, *Flemish Artists of the Valois Courts. Canadian Art*, VIII, 1950, p. 37.

H. P. Baard, *Frans Hals: The Civic Guard Portrait Groups*; Ten Koot, *Rembrandt's Night Watch: Its History and Adventures*; and Frithjof van Thienen, *Jan Vermeer of Delft. The Magazine of Art*, XLIV, 1951, p. 201.

P. B. Coremans, *Van Meegeren's Faked Vermeers and de Hooghs: A Scientific Examination*; Jean Decoen, *Back to the Truth: Vermeer-Van Meegeren, Two Genuine Vermeers. College Art Journal*, X, 1951, pp. 432-436.

Emil Maurer, *Jacob Burckhardt und Rubens*, Basler Studien zur Kunstgeschichte, 7. *Erasmus*, V, 1952, cols. 771-774.

H. Gerson, *Van Geertgen tot Frans Hals: De nederlandsche schilderkunst, deel I. College Art Journal*, XI, 1952, pp. 297-298.

A. Janssens de Bisthoven and R. A. Parmentier, *Les primitifs flamands, I. Corpus de la peinture des anciens Pays-Bas meridionaux au quinzième siècle, fascicules 1-4, Le Musée Communal de Bruges. College Art Journal*, XII, 1952, pp. 87-91.

Paul Coremans and Associates, *L'Agneau Mystique au laboratoire: Contributions à l'étude des primitifs flamands, II. The Art Quarterly*, XVI, 1953, pp. 379-380.

P. T. A. Swillens, *Johannes Vermeer: Painter of Delft: 1632-1675. The Magazine of Art*, XLVI, 1953, pp. 41-42.

Jean Seznec, *The Survival of the Pagan Gods. Review of Religion*, XIX, 1954, pp. 181-184.

Erwin Panofsky, *Early Netherlandish Painting. The Art Bulletin*, XXXVII, 1955, pp. 205-234.

Ruth Massey Tovell, *Roger van der Weyden and the Flémalle Enigma. Canadian Art*, XIII, 1955, pp. 215-216.

Martin Davies, *Les primitifs flamands, I. Corpus de la peinture des anciens Pays-Bas meridionaux au quinzième siècle. 3. Fascicules 6-13, The National Gallery, London. College Art Journal,* XV, 1956, pp. 281-283.

R. H. Hubbard, *European Paintings in Canadian Collections: Earlier Schools. Canadian Art,* XIV, 1957, p. 80.

The National Gallery of Canada: Catalogue of Paintings and Sculpture, I, Older Schools. Canadian Art, XV, 1958, p. 232.

Leo van Puyvelde, *Jordaens. The Art Bulletin,* XL, 1958, pp. 81-83.

H. Gerson and E. H. ter Kuile, *Art and Architecture in Belgium, 1600 to 1800. Art Journal,* XX, 1960, pp. 186, 188.

Marie Mauquoy-Hendrickx, *L'Iconographie d'Antoine van Dyck, Catalogue Raisonné. The Art Bulletin,* XLII, 1960, pp. 73-74.

Katherine Fremantle, *The Baroque Town Hall of Amsterdam. Journal of the Society of Architectural Historians,* XX, 1961, pp. 41-42.

Colin Tobias Eisler, *Les primitifs flamands, I. Corpus de la peinture des anciens Pays-Bas méridionaux au quinzième siècle. 4. New England Museums. The Art Bulletin,* XLIV, 1962, pp. 344-347.

H. Gerson, *Seven Letters by Rembrandt. Art Journal,* XXII, 1962, pp. 202, 204.

E. K. J. Reznicek, *Die Zeichnungen von Hendrick Goltzius. The Art Quarterly,* XXV, 1962, pp. 283, 285.

Horst Vey, *Die Zeichnungen Anton van Dycks. The Art Bulletin,* XLVI, 1964, pp. 565-568.

Max J. Friedländer, *Lucas Van Leyden. The Art Bulletin,* XLVIII, 1966, pp. 446-447.

Ernst Scheyer, *Schlesische Malerei der Biedermeierzeit. The Germanic Review,* XLIV, 1969, pp. 76-79.

John Rupert Martin, *The Ceiling Paintings for the Jesuit Church in Antwerp,* Corpus Rubenianum Ludwig Burchard, I. *Zeitschrift für Kunstgeschichte,* XXXII, 1969, pp. 84-89.

Jacques Thuillier and Jacques Foucart, *Rubens' Life of Marie de' Medici. The Art Quarterly,* XXXIII, 1970, pp. 304-306.

E. Haverkamp-Begemann and Anne-Marie S. Logan, *European Drawings and Watercolors in the Yale University Art Gallery, 1500-1900. Master Drawings,* X, 1972, pp. 41-45.

Hans Vlieghe, *Gaspar de Crayer, sa vie et ses oeuvres. The Art Bulletin,* LVI, 1974, pp. 452-454.

H. Vlieghe, *Saints,* Corpus Rubenianum Ludwig Burchard, VIII. *The Burlington Magazine,* CXVIII, 1976, pp. 775-777.

Michael Jaffé, *Rubens and Italy. Apollo,* CVIII, August 1978, pp. 134-137.

R.-A. D'Hulst, *Jordaens Drawings. The Art Bulletin,* LX, 1978, pp. 717-732.

J. Richard Judson and Carl van de Velde, *Book Illustrations and Title Pages,* 2 vols., Corpus Rubenianum Ludwig Burchard, XXI. "Rubens as a Book Illustrator," *Apollo,* CX, 1979, pp. 234-237.

INTRODUCTIONS TO EXHIBITIONS

Jacob Jordaens. New York, Mortimer Brandt Gallery, 1940.

Peter Paul Rubens. New York, Schaeffer and Brandt, Inc., 1942.

Paintings by Evelyn M. Mudgett. New York, The American British Art Center, 1947.

Holbein and His Contemporaries. Indianapolis: John Herron Art Institute, 1950.

Lovis Corinth, 1858-1925. Retrospective exhibition held in Boston, Colorado Springs, Columbus, Detroit, Kansas City, Milwaukee, Montreal, Ottawa, Portland, and Toronto, 1950-1951.

Introductions to exhibitions at Barnard College, New York (Dr. Fritz Littauer, 1958; Kaethe Kollwitz, 1961; Josef Scharl, 1962; The collection of Milton and Edith Lowenthal, 1962).

Saul Baizerman. Exhibition held in Minneapolis, Des Moines, San Francisco, and Ottawa [Minneapolis, 1953]. Reprint, The Heckscher Museum, Huntington, New York, 1961.

Leonard Baskin. Brunswick, Bowdoin College Museum of Art, 1962.

Joyce Reopel, Drawings in Silverpoint and Goldpoint. New York, Cober Gallery, 1965.

Frances Shannahan, Sculpture. Brattleboro Museum and Art Center, 1967.

Dürer Through Other Eyes: His Graphic Work Mirrored in Copies and Forgeries of Three Centuries. Williamstown: Clark Art Institute, 1975.

MISCELLANEOUS

"Albrecht Dürer," *Onze Kunst*, XLV, 1928, pp. 138-142.

"Kunstberichten: Tentoonstellingen, Weenen," *Onze Kunst*, XLVI, 1929, pp. 67-69.

"Veilingen, Weenen," *Onze Kunst*, XLVI, 1929, p. 75.

"Rembrandt and Nicholas Lanier," letter, *The Burlington Magazine*, LXIX, 1936, p. 286.

Syllabus of Lectures. Ottawa: National Gallery of Canada, 1936-1937.

"Family Group—Beckmann," *Barnard Bulletin*, XLII/46, 1938, p. 2.

"Baroque Painting—a Preview," *Art in America*, XXX, 1942, p. 71.

"Aeneas Appearing to Ascanius by Peter Paul Rubens (1577-1640)," *Schaeffer Galleries Bulletin*, no. 2, 1947, n. p.

"Van Meegeren's Faked Vermeers," film review, *The Magazine of Art*, XLV, 1952, pp. 234-235.

"Hans Tietze—1880-1954," obituary, *College Art Journal*, XIV, 1954, pp. 67-69.

"The Contributing Editor," *Barnard College Alumnae Magazine*, XLV/4, 1956, pp. 17-18.

The Samuel H. Kress Collection of Italian and Spanish Paintings. Ponce: Museo de Arte, 1962.

"Paintings," in *The Joys of Collecting*, by J. Paul Getty. New York: Hawthorne Books [1965], pp. 85-137.

"Exchange on Corinth," letter, *Arts Magazine*, XXXIX/6, 1965, p. 6.

Catalogue I: Paintings of the European and American Schools. Ponce: Museo de Arte, 1965.

A Preliminary List of Basic Reference Works in the Fine Arts. The American Group, International Institute for Conservation of Historic and Artistic Works [1966].

On the reconstruction of the Altarpiece of the Santissima Trinità in Mantua, letter, *The Art Bulletin*, XLVIII, 1966, pp. 468-469.

"Good Wish, With All My Heart: A Tourist behind the Iron Curtain," *Barnard Alumnae*, XVII/1, 1967, pp. 18-19, 22-24.

Joseph Floch, introductory essay. New York: Thomas Yoseloff, 1968.

"Faculty Impressions," pen sketches. *Barnard Alumnae*, XVIII/1, 1968, pp. 9-13.

Selections from the Drawing Collection of Mr. and Mrs. Julius S. Held, preface. Exhibition held in Binghamton, Williamstown, Houston, Chapel Hill, Notre Dame, Oberlin, and Poughkeepsie, 1970.

Oscar Klein's Drawings, foreword. Meriden: privately printed, 1976.

PHOTOGRAPH SOURCES

Hanna Elkan, Amsterdam, II.11; Rijksmuseum, Amsterdam, V.8, VII.2, IX.2, XIV.6, XIV.7; Photo Felt, Antwerp, VII.3, XII.2; Jörg P. Anders, Berlin, XIV.1; Museum of Fine Arts, Boston, I.1; Brooklyn Museum, Brooklyn, XII.1; A.C.L., Brussels, V.2, V.12, XII.7, XII.8, XII.10, XIII.3, XV.4, XV.22; Paul Becker, Brussels, II.10; Fogg Art Museum, Cambridge, V.13; The Houghton Library, Harvard University, Cambridge, III.2, III.3; Hans Petersen, Copenhagen, VIII.9, VIII.10, VIII.12; Statens Museum for Kunst, Copenhagen, VIII.11, VIII.13; Staatliche Kunstsammlungen, Dresden, VIII.14, VIII.18; Tom Scott, Edinburgh, XIII.4; Alinari, Florence, VII.9, VIII.15, VIII.16; Musées Nationaux, France, VI.1, VI.6; Annan, Glasgow, VI.7; A. Dingjan, The Hague, VI.5; Museu Nacional de Arte Antiga, Lisbon, X.5; British Museum, London, VIII.17, X.4, XI.3; Department of the Environment, London, XI.2; National Gallery, London, V.1; Galerie Thyssen, Lugano, IX.4; Ambrosiana, Milan, VIII.2, VIII.3; Scansani Walter, Milan, VIII.1, VIII.4, VIII.6, VIII.7, VIII.8; Oliver Baker, New York, V.9; H. Brammer, New York, XIV.2; Bullaty Lomeo, New York, II.9; Metropolitan Museum of Art, New York, II.8, III.1, VI.2; John D. Schiff, New York, V.4; National Gallery of Canada, Ottawa, IV.3; Bibliothèque Nationale, Paris, XV.6; Staatliche Schlösser und Gärten, Potsdam-Sanssouci, IX.3; Anderson, Rome, II.3, VII.6, Musées de la Ville, Strasbourg, XII.4; Osvaldo Böhm, Venice, XI.7; Albertina, Vienna, III.4; Kunsthistorisches Museum, Vienna, IX.1; Osterreichische Lichtbildstelle, Vienna, IV.2.

INDEX

Library of Congress Cataloging·in Publication Data

Held, Julius Samuel, 1905-
 Rubens and his circle.

 Bibliography: p.
 Includes index.
 CONTENTS: Rubens' King of Tunis and Vermeyen's Por-
trait of Mūlāy Ahmad.—Jordaens' portraits of his family.—
Achelous' Banquet.—[etc.]

 1. Rubens, Peter Paul, Sir, 1577-1640—Addresses, es-
says, lectures. 2. Rubens, Peter Paul, Sir, 1577-1640—
Influence—Addresses, essays, lectures.
I. Lowenthal, Anne W. II. Rosand, David.
III. Walsh, John, 1937- . IV. Title.
N6973.R9H44 759.9493 80-27441
 ISBN 0-691-03968-2
 ISBN 0-691-00332-7 (pbk.)

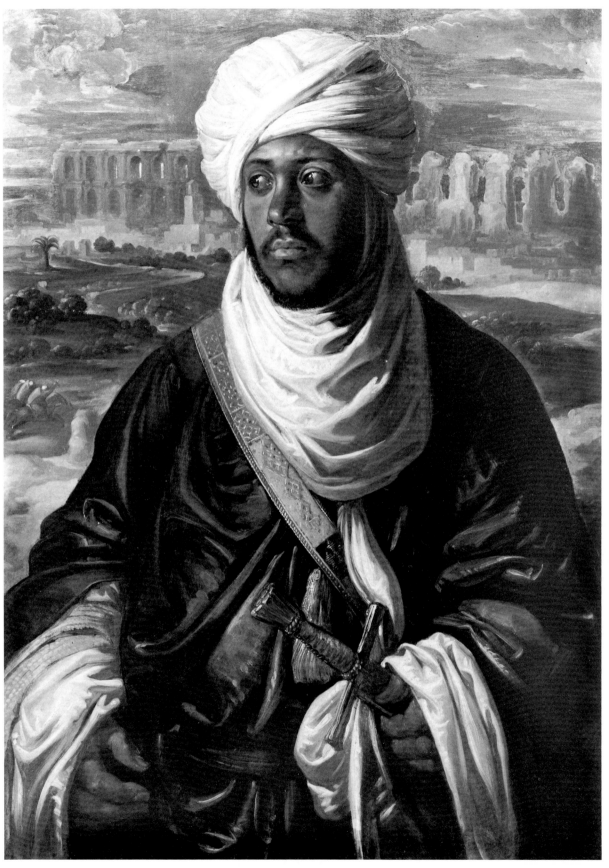

I.1 Peter Paul Rubens, *King of Tunis*, Boston, Museum of Fine Arts, Maria Theresa Burnham Hopkins Fund,
Courtesy, Museum of Fine Arts, Boston

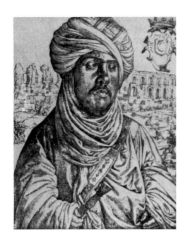

← I.2 Jan Vermeyen, *Portrait of Mūlāy Aḥmad*, etching

II.2 Jordaens, *Self-Portrait*, Amsterdam, P. de Boer (1949)

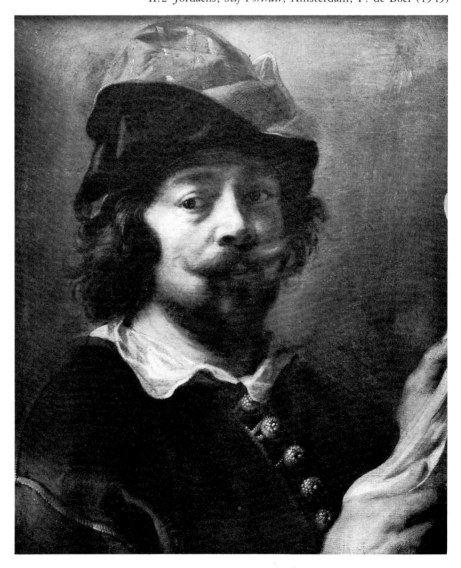

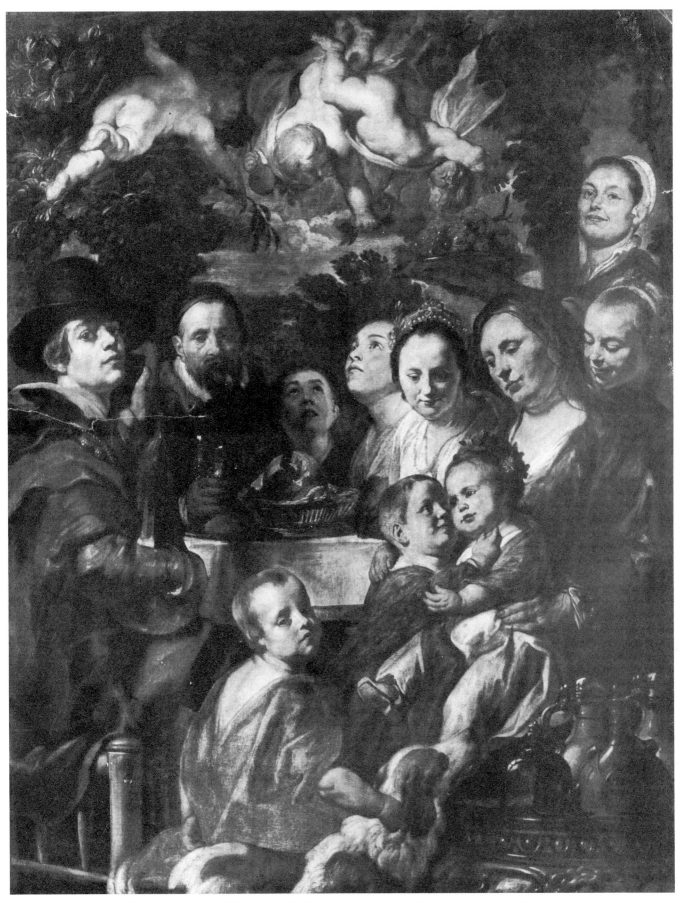

II.1 Jacob Jordaens, *Self-Portrait with His Parents, Sisters, and Brothers*, Leningrad, Hermitage

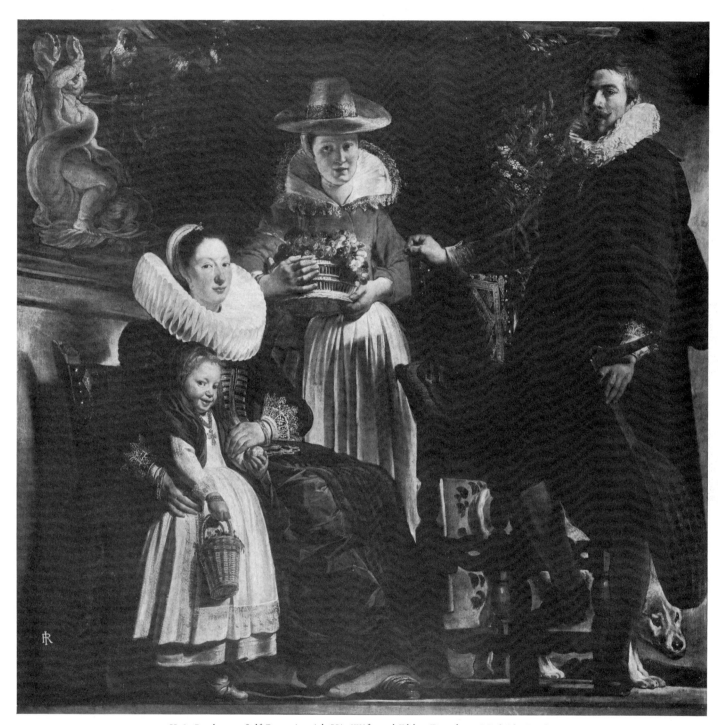

II.3 Jordaens, *Self-Portrait with His Wife and Eldest Daughter*, Madrid, Prado

II.5 Jordaens, *Portrait of His Mother* (?), Antwerp, Musée Royal des Beaux-Arts

II.4 Jordaens, *The Holy Family*, Brussels, Musées Royaux des Beaux-Arts

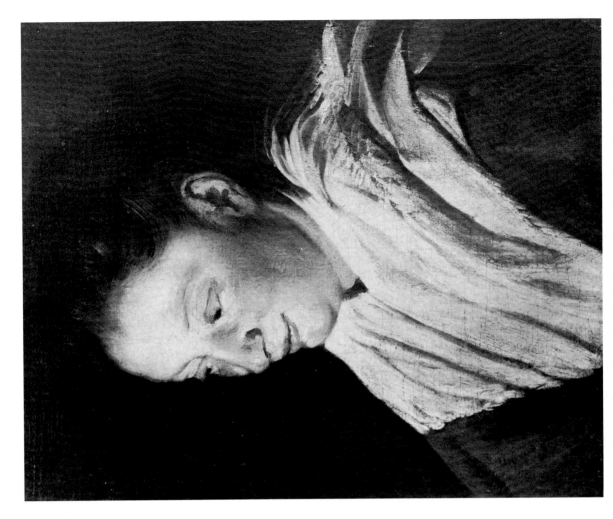

II.7 Jordaens, *Portrait of Catherine van Noort*, Brussels, private collection

II.6 Jordaens, *The Holy Family*, present location unknown

IV.1 Jacob Jordaens, *The Eye of the Master Makes the Horse Fat*, Cassel, Staatliche Kunstsammlungen

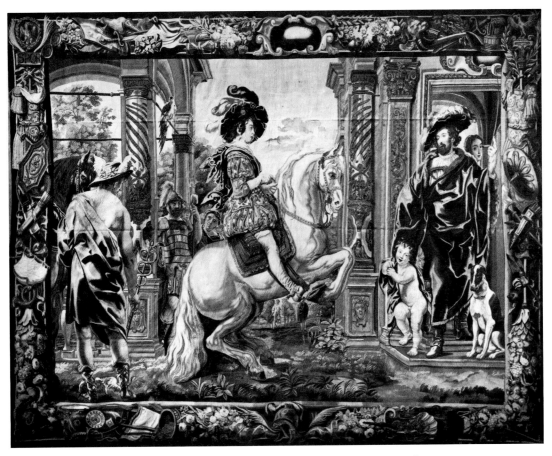

IV.2 After a design by Jordaens, *A Riding Academy with Mercury and Mars*, tapestry,
Vienna, Kunsthistorisches Museum

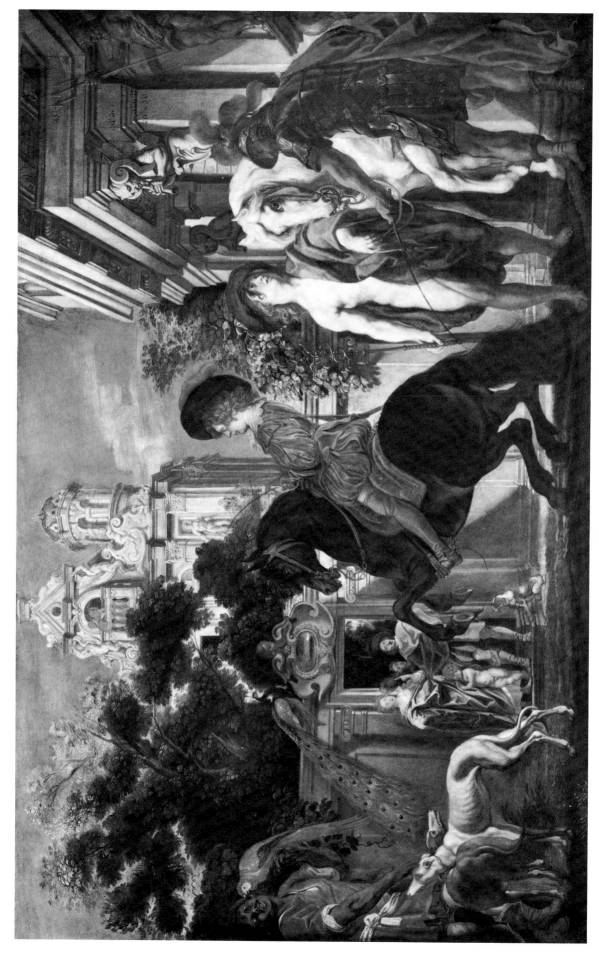

IV.3 Jordaens, *A Riding Academy with Mercury and Mars*, Ottawa, National Gallery of Canada

V.2 Frans Francken the Younger, *The Miracle of St. Gommarus,*
Lier, St. Gommarus, copyright A.C.L., Brussels

V.1 Anthony van Dyck, *Portrait of Cornelis van der Geest,*
Reproduced by courtesy of the Trustees, London, National Gallery

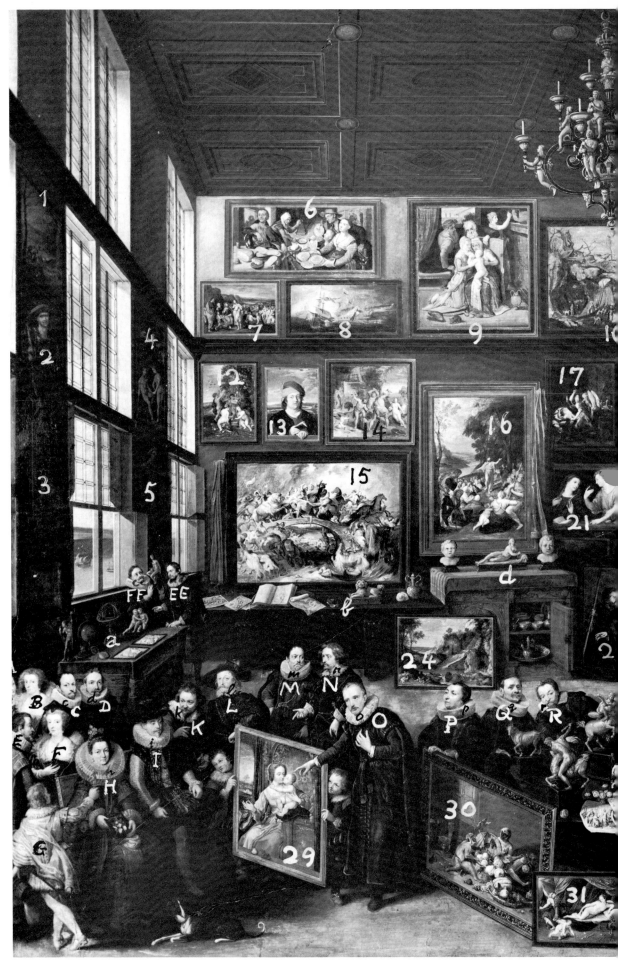

V.3 Willem van Haecht, *The Gallery of Cor*

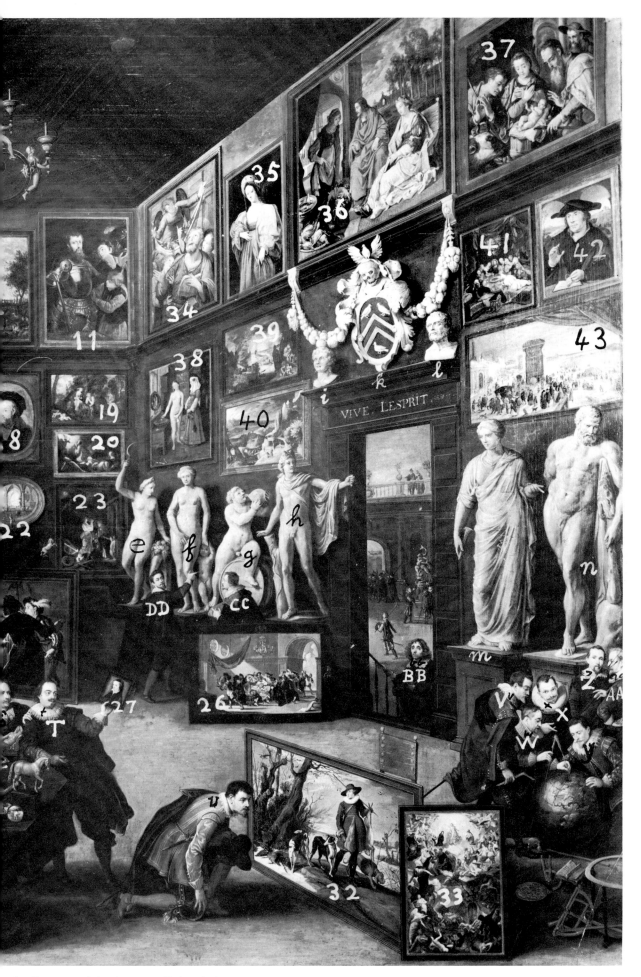

V.4 Detail of Fig. V.3, lower left corner

V.6 Detail of Fig. V.3, lower right corner

V.5 Detail of Fig. V.3, center

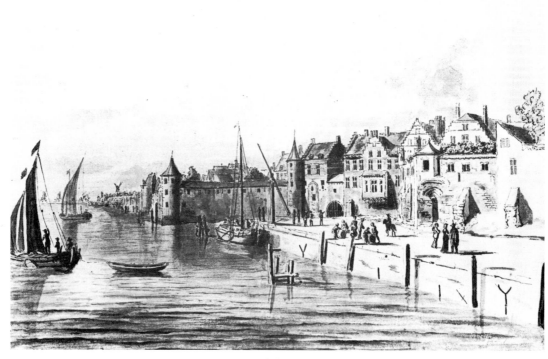

V.7 Unknown Master, 18th–19th century, *View of the Antwerp quais with the house of Cornelis van der Geest*, present location unknown

V.8 Sebastiaen Vrancx, *View of the Scheldt at Antwerp*, Amsterdam, Rijksmuseum

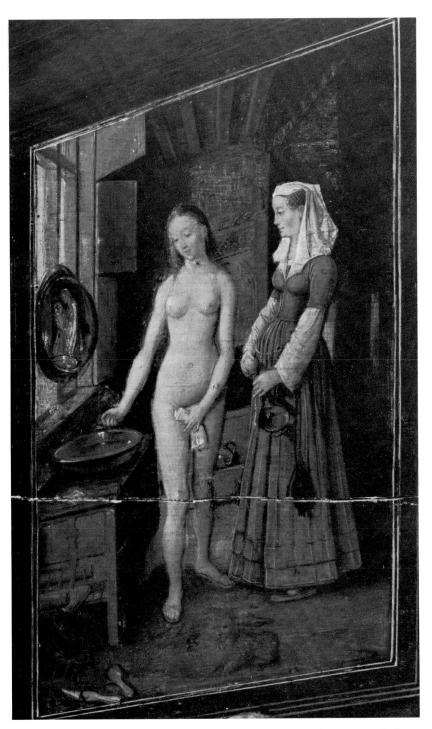

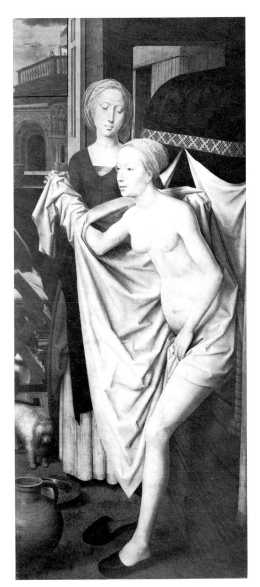

V.10 Hans Memling, *Bathsheba*,
Stuttgart, Staatsgalerie

V.9 Detail of Fig. V.3, showing copy of a lost painting by Jan van Eyck

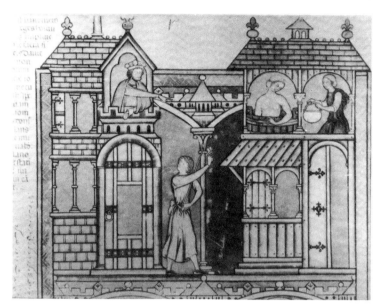

V.11 *Bathsheba Observed by King David*, Imagines Biblicae, about 1250, New York, Pierpont Morgan Library, Ms. 638, fol. 41 verso

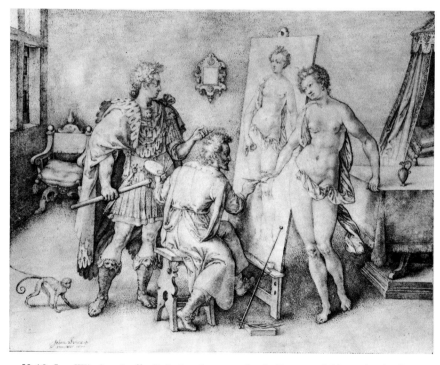

V.12 Jan Wierix, *Apelles Painting Campaspe in the Presence of Alexander the Great*, Antwerp, Museum Mayer van den Bergh, copyright A.C.L., Brussels

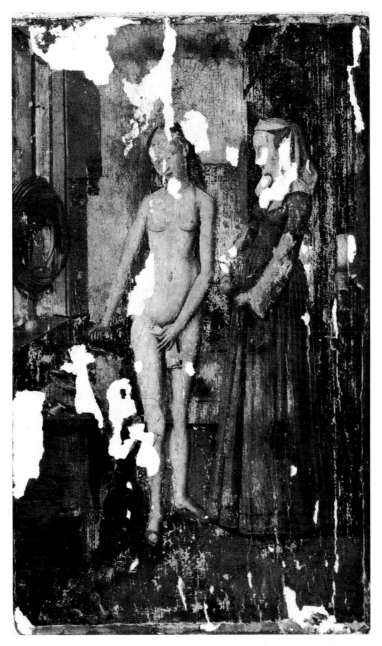

V.13 Copy after Jan van Eyck, *Marriage Bath*, courtesy of the
Fogg Art Museum, Harvard University, Purchase, Francis H. Burr,
Louise Haskell Daly, Alpheus Hyatt, and William M. Prichard Funds

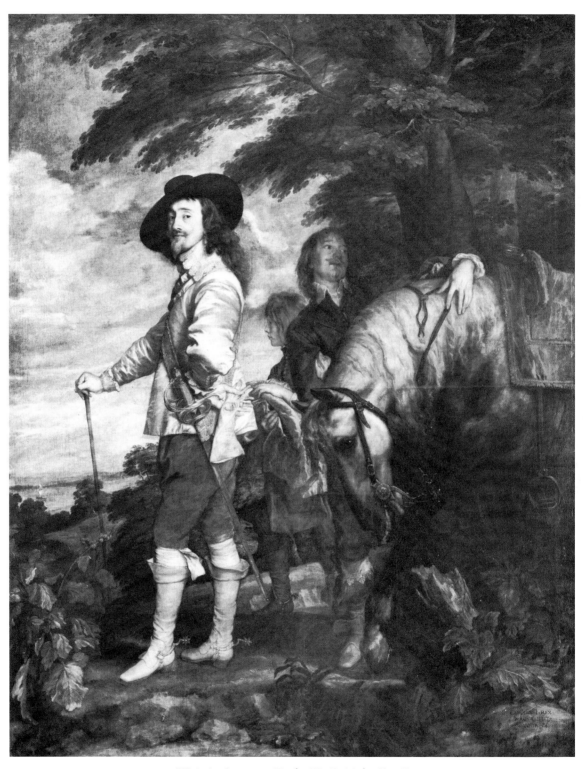

VI.1 Anthony van Dyck, *"Le Roi à la Ciasse"*
(*Portrait of Charles I*), Paris, Louvre, negative Musées Nationaux

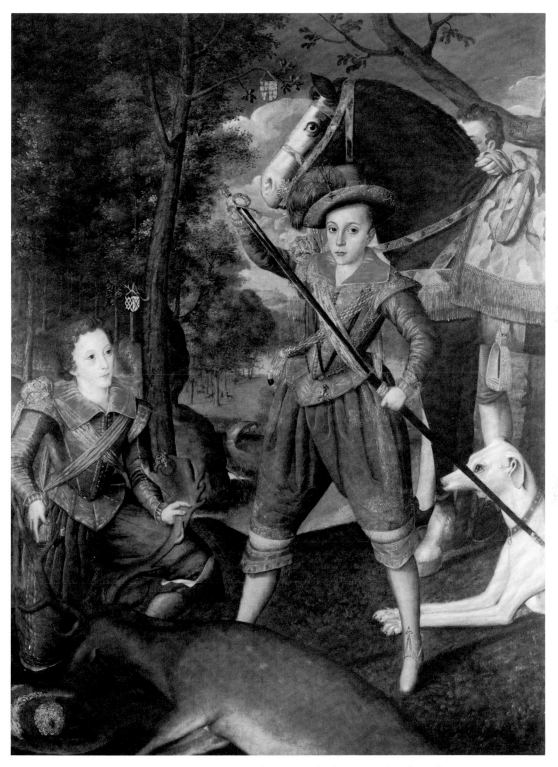

VI.2 British School, *Portrait of Henry Frederick, Prince of Wales*, 1603,
New York, Metropolitan Museum of Art, Purchase, 1944, Joseph Pulitzer Bequest

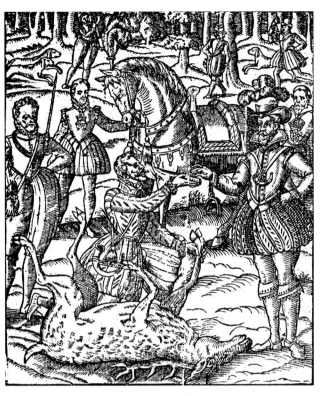

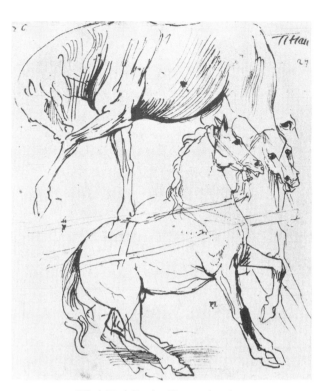

VI.3 *The Breaking Up of the Deer*, woodcut,
1611 edition of Turbervile's *Booke of Hunting*

VI.4 Van Dyck, *Horses*, drawing,
Devonshire Collection, Chatsworth. Reproduced by
Permission of the Trustees of the Chatsworth Settlement

VI.5 Peter Paul Rubens, *Roma Triumphans* (detail),
oil sketch, The Hague, Mauritshuis

VI.7 Edward Bower, *Charles I at His Trial*,
Edinburgh, National Portrait Gallery of Scotland

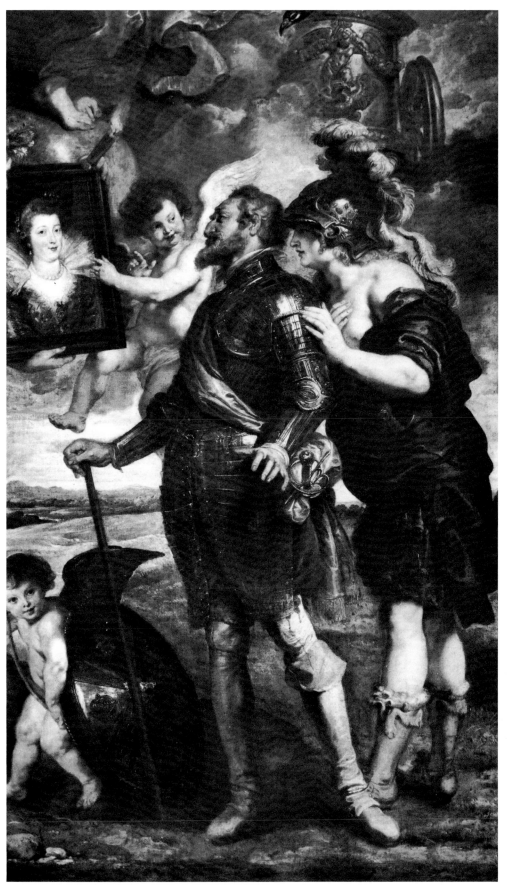

VI.6 Rubens, *King Henry IV Receives the Portrait of Maria de' Medici* (detail), Paris, Louvre, negative Musées Nationaux

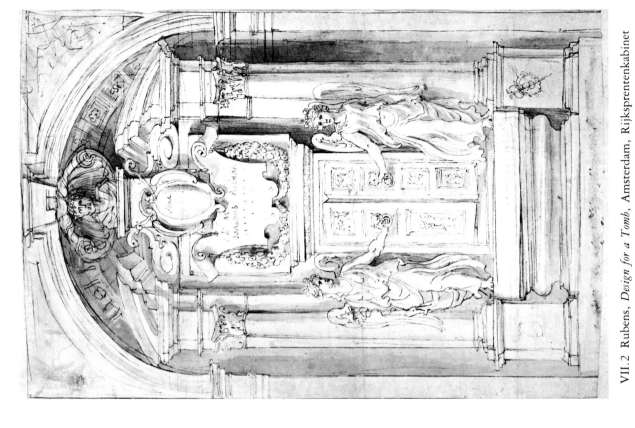

VII.2 Rubens, *Design for a Tomb*, Amsterdam, Rijksprentenkabinet

VII.1 Peter Paul Rubens, *Sketch for an Epitaph*,
New York, Avery Architectural and Fine Arts Library, Columbia University

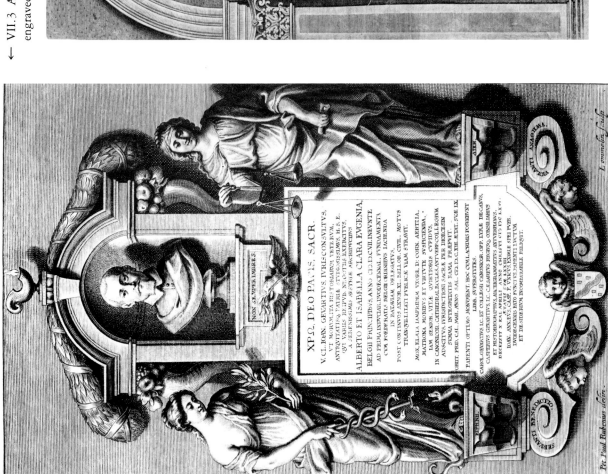

← VII.3 Attributed to Erasmus Quellinus, *Epitaph for Jan Gevaerts*, engraved by A. Lommelin

VII.4 Attributed to Rubens, *Tomb for a Married Couple*, engraved by P. Clouwet

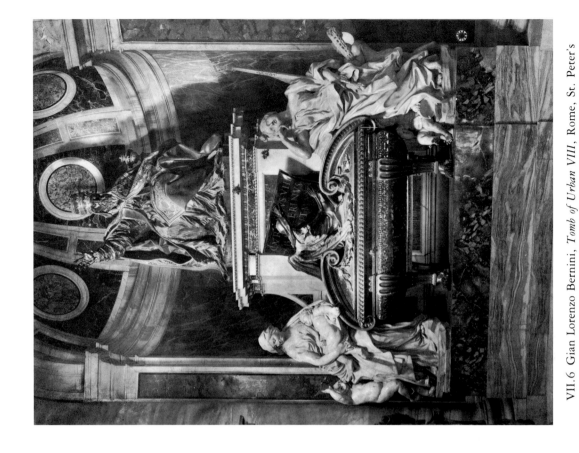

VII.6 Gian Lorenzo Bernini, *Tomb of Urban VIII*, Rome, St. Peter's

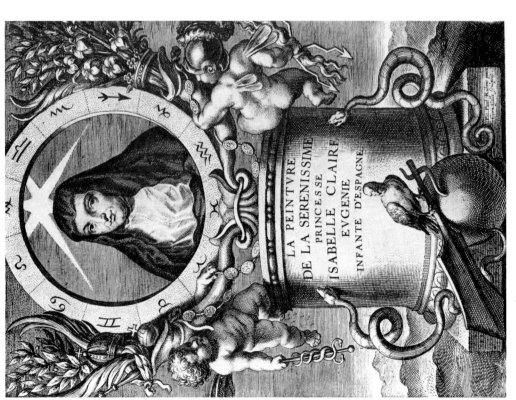

VII.5 Rubens, Title page of Tristan's *La Peinture
de la Sérénissime Princesse Isabelle Claire Eugenie, Infante d'Espagne*,
Antwerp, 1634, engraved by Cornelis Galle

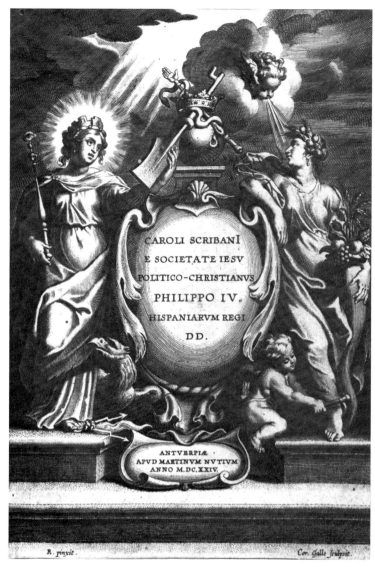

VII.7 Rubens, Title page of Carolus Scribanius' *Politico-Christianus*,
Antwerp, 1624, engraved by Cornelis Galle

VII.8 Santi Ghetti and Bernini, Altar, Rome, S. Agostino

VII.9 Rubens, Design for a title page,
Houghton Library, Harvard University, bequest of Frances L. Hofer

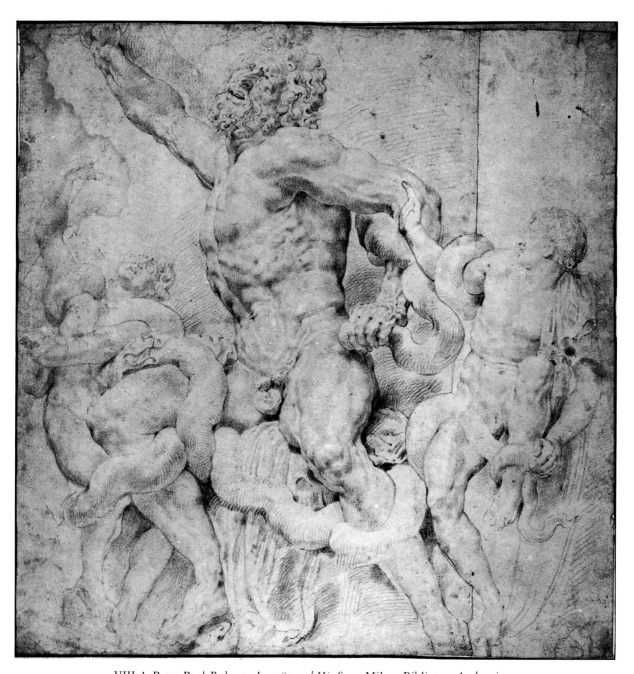

VIII.1 Peter Paul Rubens, *Laocoön and His Sons*, Milan, Biblioteca Ambrosiana

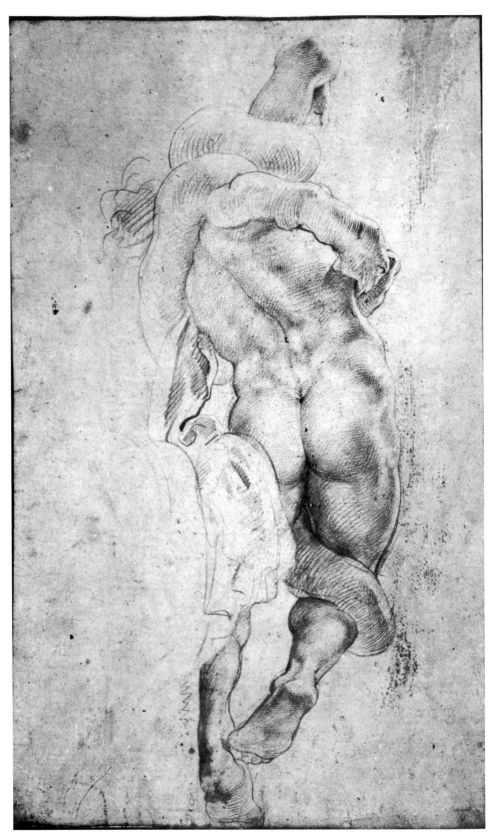

VIII.2 Rubens, *The Younger Son of Laocoön, from the Back*, Milan, Biblioteca Ambrosiana

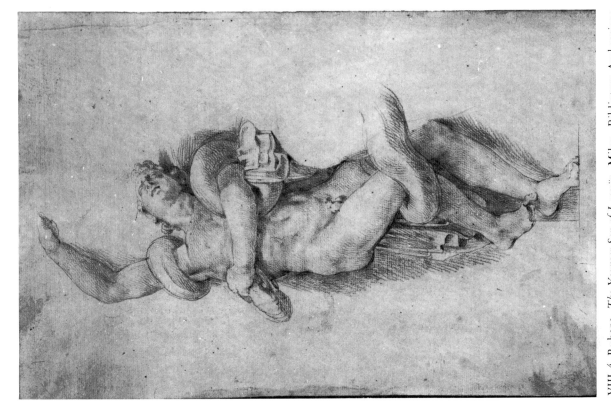

VIII.4 Rubens, *The Younger Son of Laocoön*, Milan, Biblioteca Ambrosiana

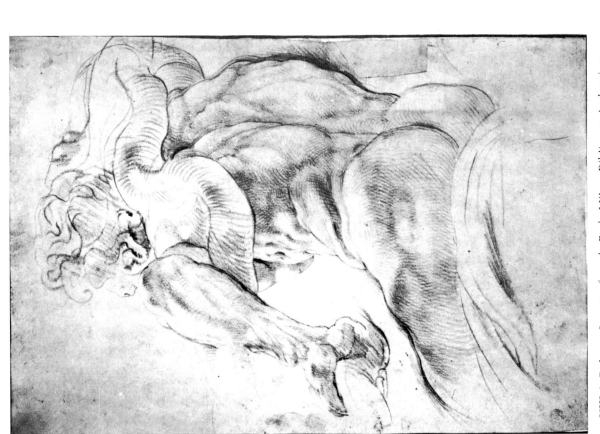

VIII.3 Rubens, *Laocoön, from the Back*, Milan, Biblioteca Ambrosiana

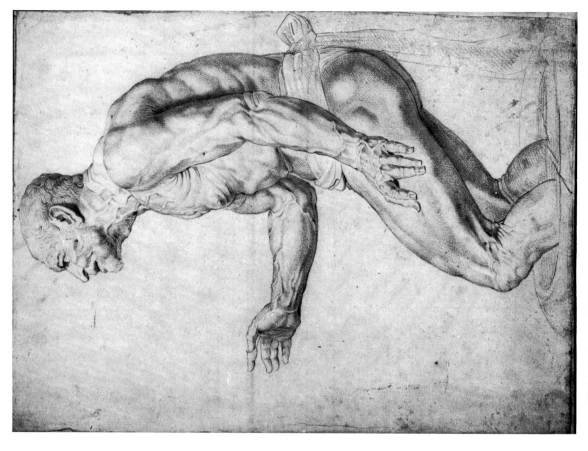

VIII.6 Rubens, *A Fisherman* ("Seneca"), Milan, Biblioteca Ambrosiana

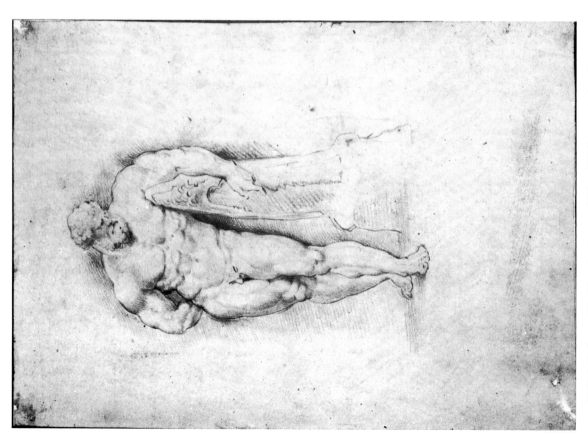

VIII.5 Rubens, *The Hercules Farnese*, Milan, Biblioteca Ambrosiana

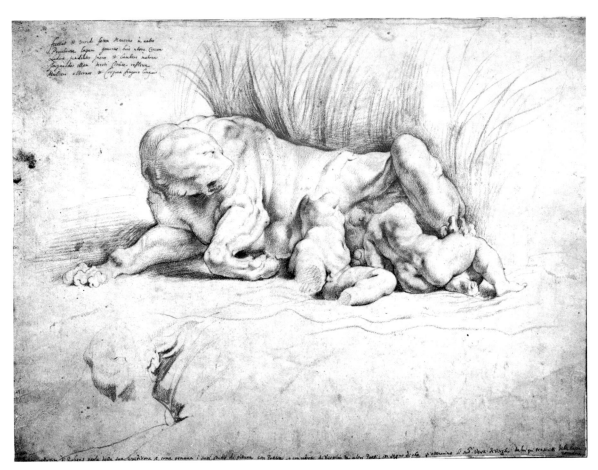

VIII.7 Rubens, *The She-Wolf with Romulus and Remus*, Milan, Biblioteca Ambrosiana

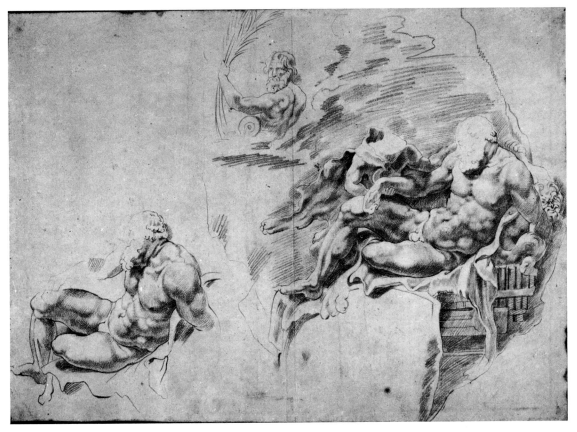

VIII.8 Rubens, *Studies of a Reclining Hercules and a River God*, Milan, Biblioteca Ambrosiana

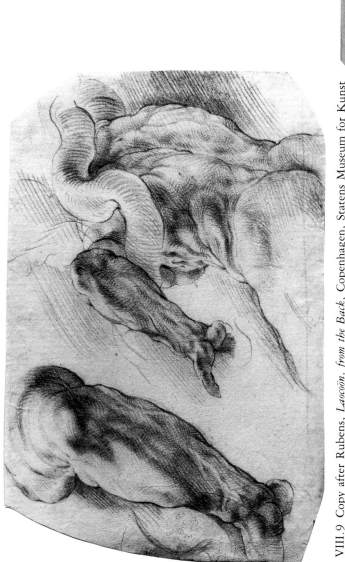

VIII.9 Copy after Rubens, *Laocoön, from the Back*, Copenhagen, Statens Museum for Kunst

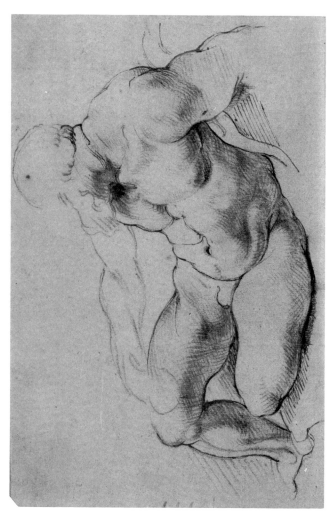

VIII.10 Copy after Rubens, *Reclining Hercules*, Copenhagen, Statens Museum for Kunst

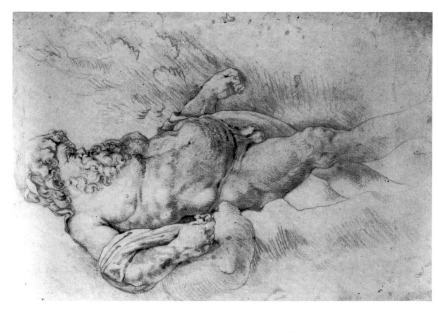

VIII.13 Copy after Rubens, *Silenus*,
Copenhagen, Statens Museum for Kunst

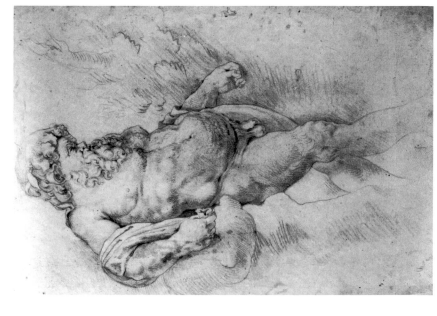

VIII.12 Copy after Rubens, *A Fisherman*,
Copenhagen, Statens Museum for Kunst

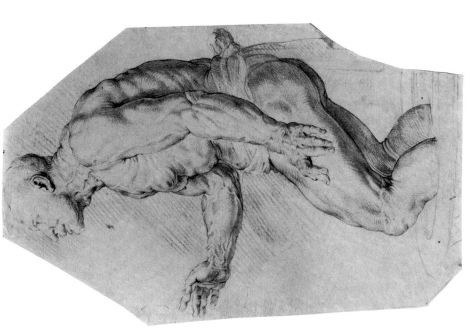

VIII.11 Copy after Rubens, *Laocoön*,
Copenhagen, Statens Museum for Kunst

VIII.15 *The She-Wolf with Romulus and Remus*
(detail of "The Tiber"), Paris, Louvre

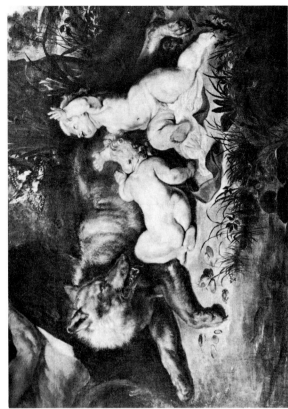

VIII.16 Rubens, *The She-Wolf with Romulus and Remus* (detail),
Rome, Capitoline Museum

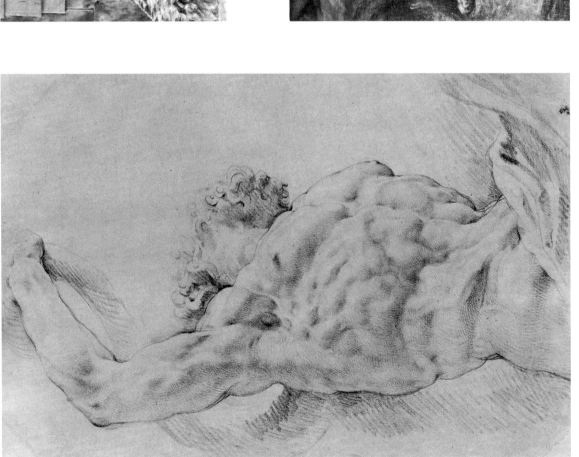

VIII.14 Rubens, *Laocoön*, Dresden, Staatliche Kunstsammlungen

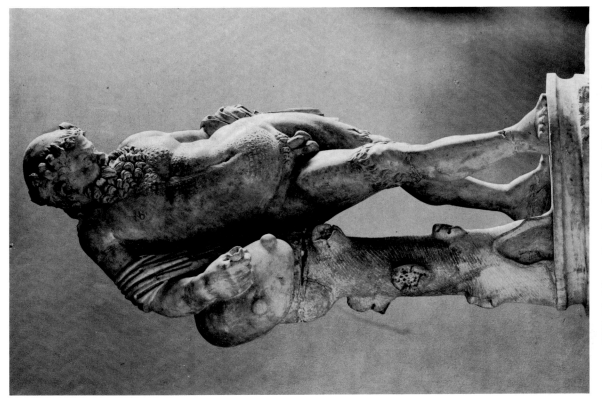

VIII.18 *Silenus*, Dresden, Staatliche Kunstsammlungen

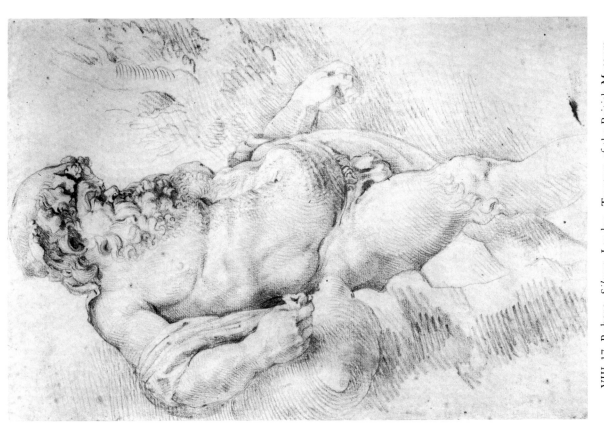

VIII.17 Rubens, *Silenus*, London, Trustees of the British Museum

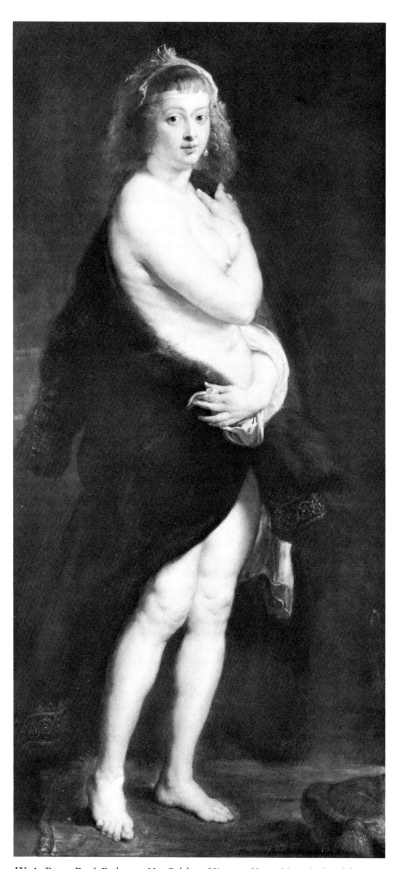

IX.1 Peter Paul Rubens, *Het Pelsken*, Vienna, Kunsthistorisches Museum

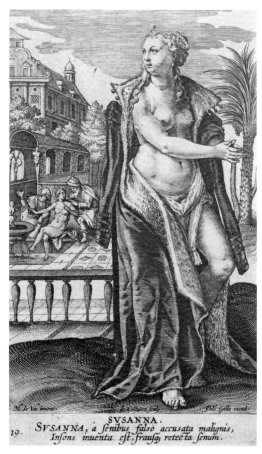

SVSANNA.
19. SVSANNA, à senibus falsò accusata malignis,
Insons inuenta est, frausq, retecta senum.

IX.2 Jan Collaert after Marten de Vos, *Susanna*,
engraving, Amsterdam, Rijksprentenkabinet

IX.3 Rubens School, *Venus*, Potsdam-Sanssouci

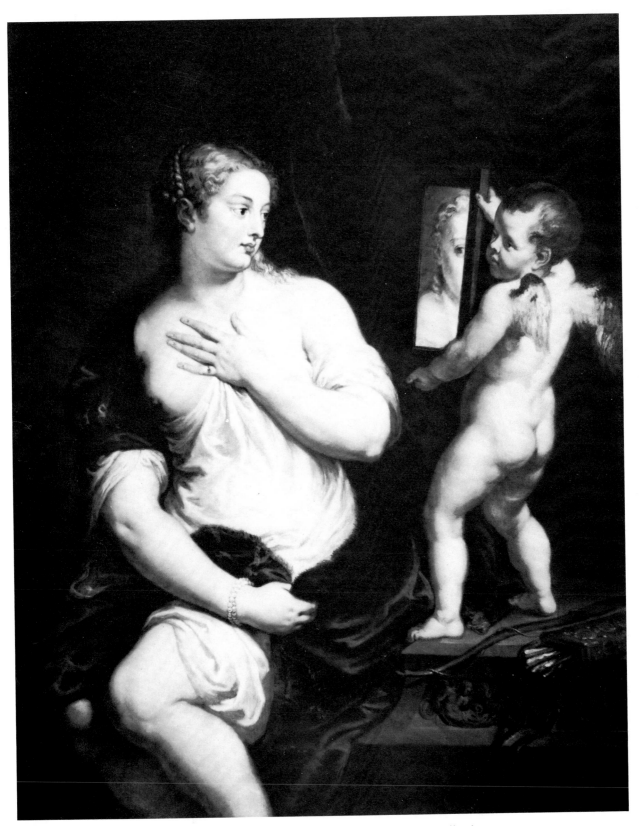

IX.4 Rubens, *Venus with a Mirror*, Lugano, Thyssen collection

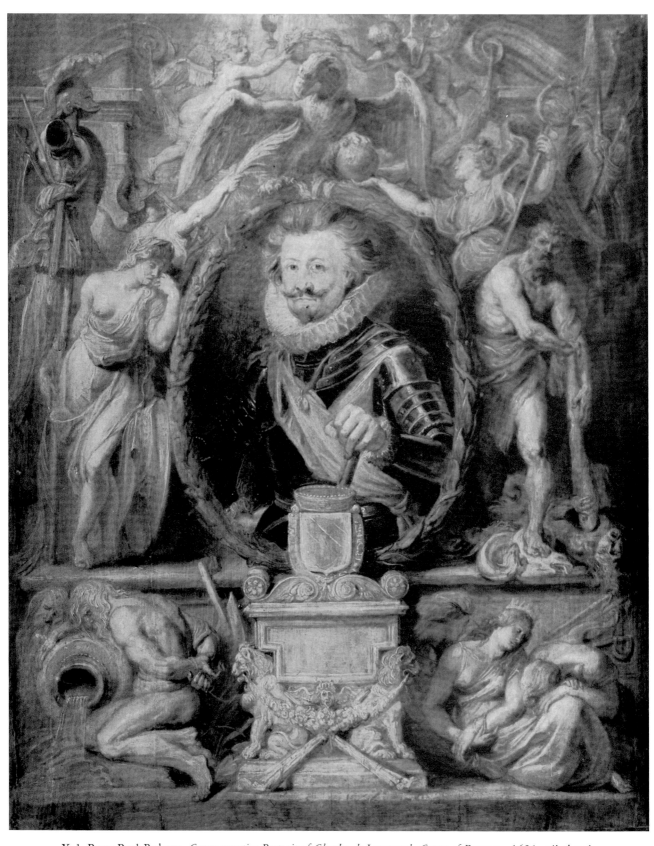

X.1 Peter Paul Rubens, *Commemorative Portrait of Charles de Longueval, Count of Bucquoy*, 1621, oil sketch, Leningrad, Hermitage

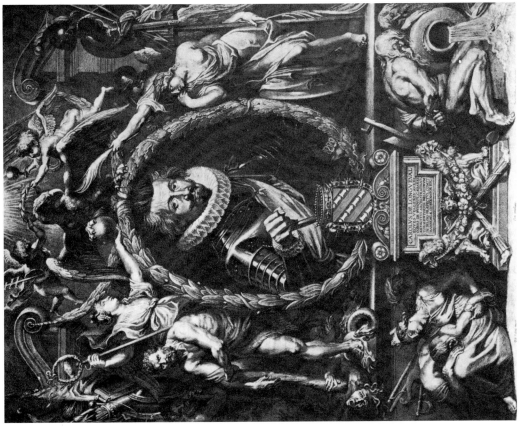

X.3 Lucas Vorsterman, engraving after Rubens' sketch of Charles de Longueval

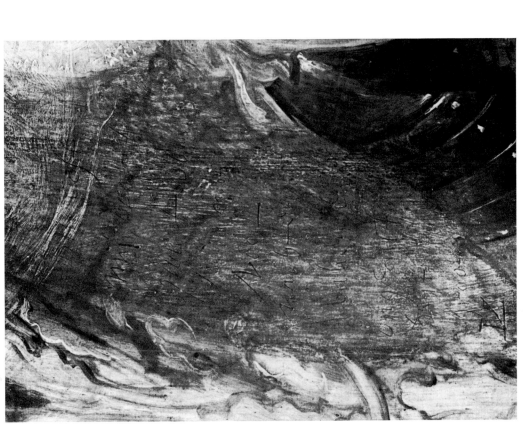

X.2 Inscription by Lucas Vorsterman
on Rubens' *Portrait of Charles de Longueval* (infra-red)

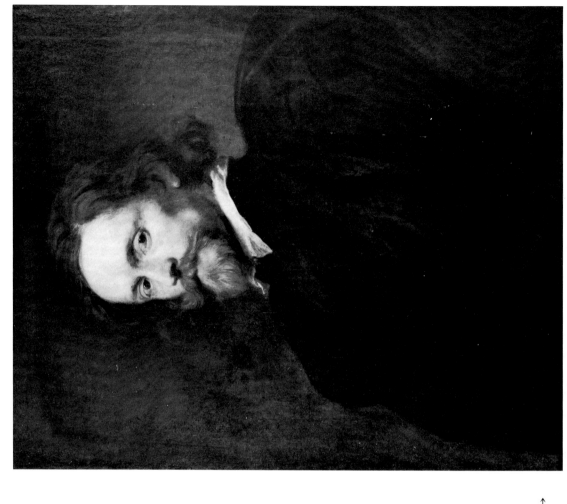

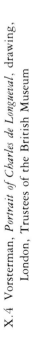

X. 4 Vorsterman, *Portrait of Charles de Longueval*, drawing,
London, Trustees of the British Museum

X. 5 Anthony van Dyck, *Portrait of Lucas Vorsterman*, →
Lisbon, Museu Nacional de Arte Antiga

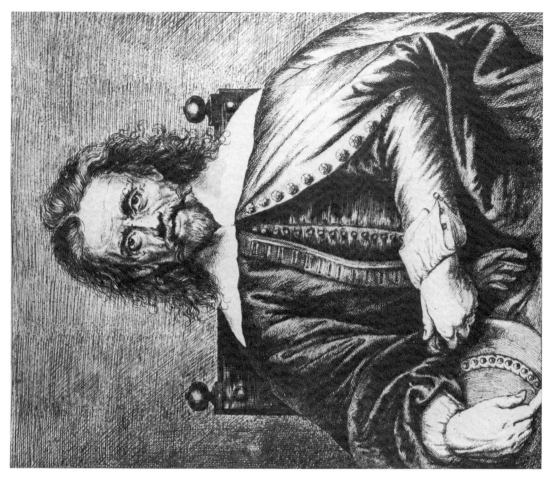

X.7 Frans van den Wijngaerde, etching after Jan Lievens, *Portrait of Lucas Vorsterman*

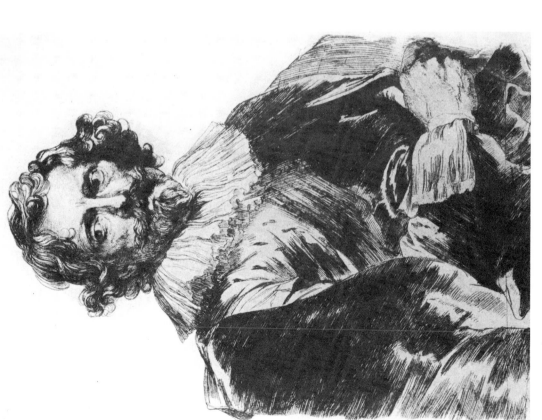

X.6 Van Dyck, *Portrait of Lucas Vorsterman*, etching

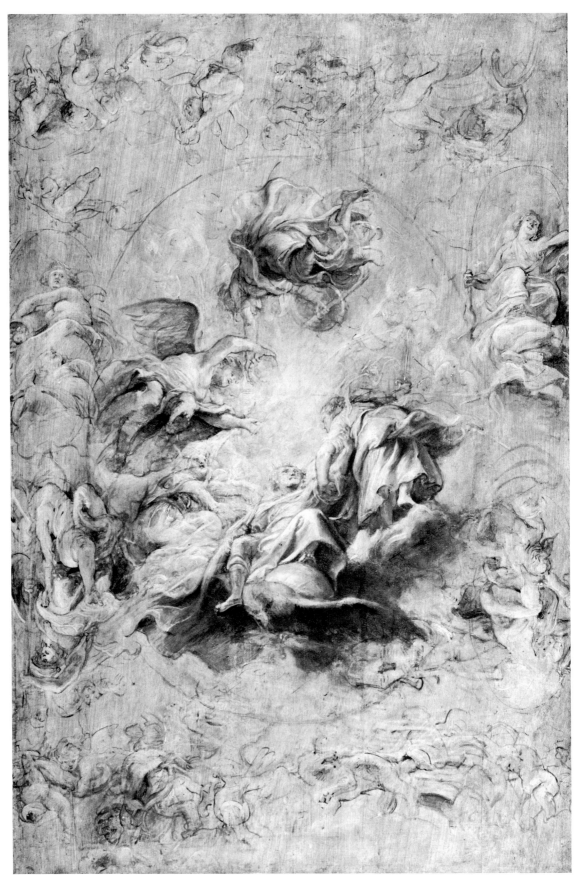

XI.1 Peter Paul Rubens, *The Apotheosis of James 1 and other sketches for Whitehall*,
Glynde, Sussex, collection of Viscount Hampden

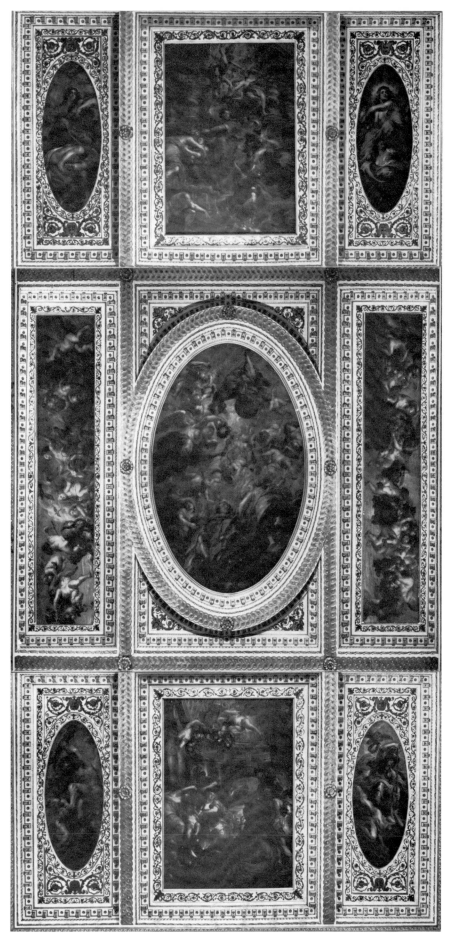

XI.2 The present installation {1970} of Rubens' ceiling
in the Banqueting House at Whitehall

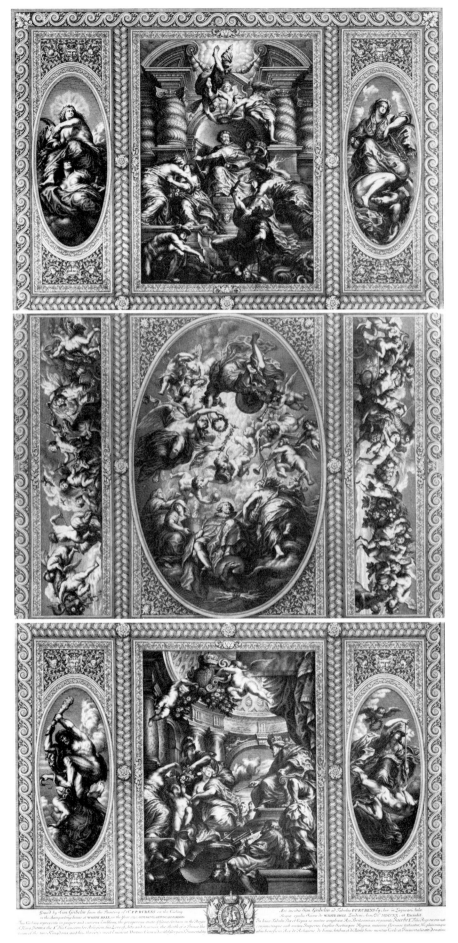

XI.3 Simon Gribelin, *Rubens' ceiling in the Banqueting House at Whitehall*, 1720, engraving in three parts, London, Trustees of the British Museum

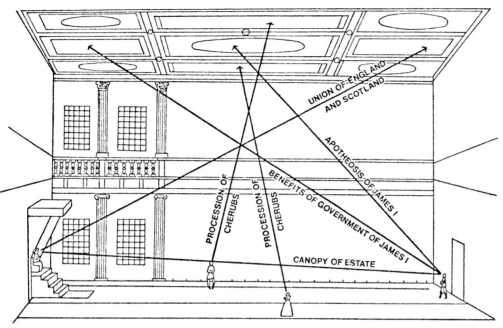

XI.4 Diagram of the lines of vision of the installation as planned by Rubens

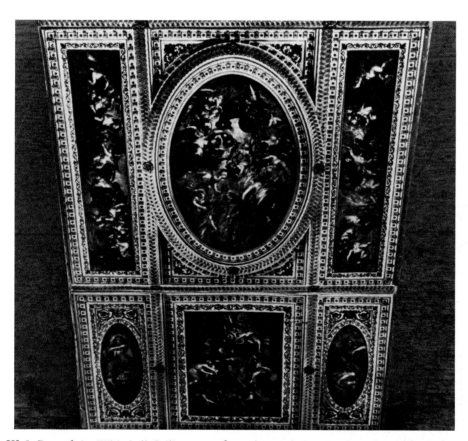

XI.5 Part of the Whitehall Ceiling, seen from the north (entrance) as planned by Rubens

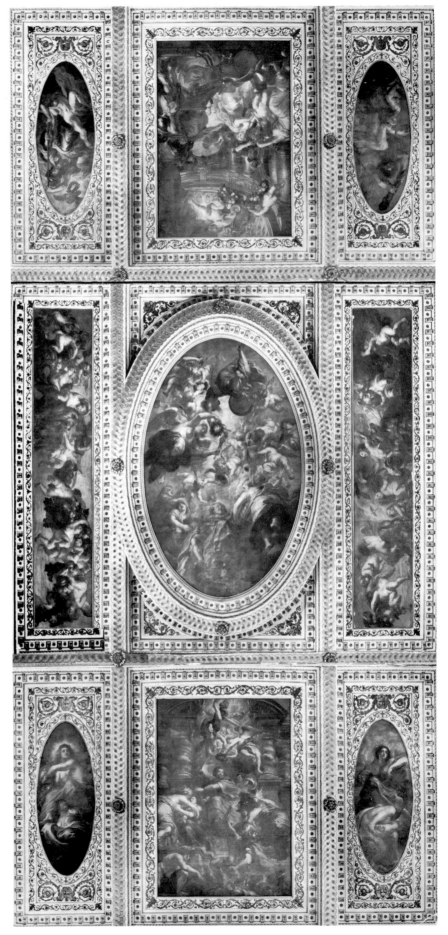

XI.6 Proposed arrangement of the Whitehall Ceiling, in accordance with Rubens' plan. British Crown Copyright.
Reproduced with permission of the Controller of Her Britannic Majesty's Stationery Office

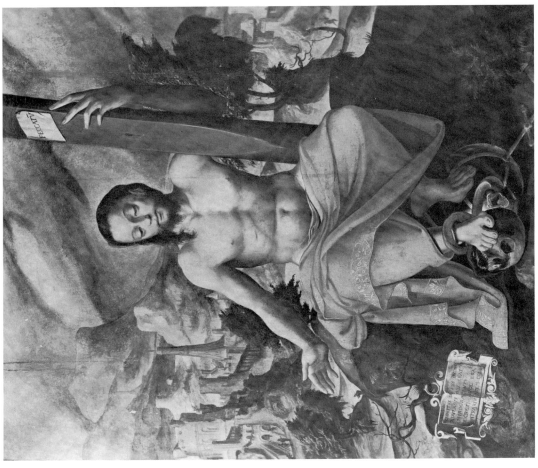

XII.7 Unknown Flemish Master, about 1540, *Christ as Victor over Sin and Death*, Antwerp, S. Harrveld (1928), copyright A.C.L., Brussels

XII.6 Lucas Cranach the Younger, *Allegory of the Old and New Testaments*, woodcut (detail)

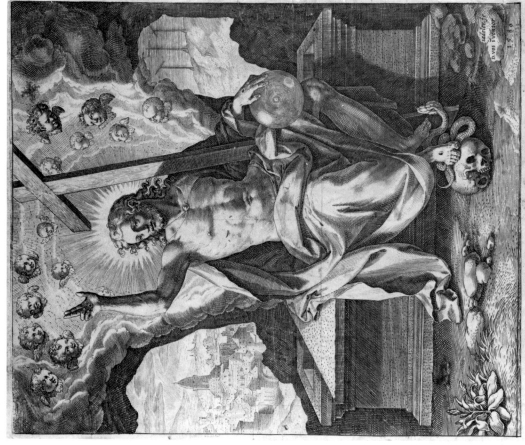

IN CHRISTO OMNES VIVIFICABVNTVR. 1.co.15.

XII.9 Jan Sadeler after Marten de Vos, *Christ as Victor over Sin and Death,*
engraving

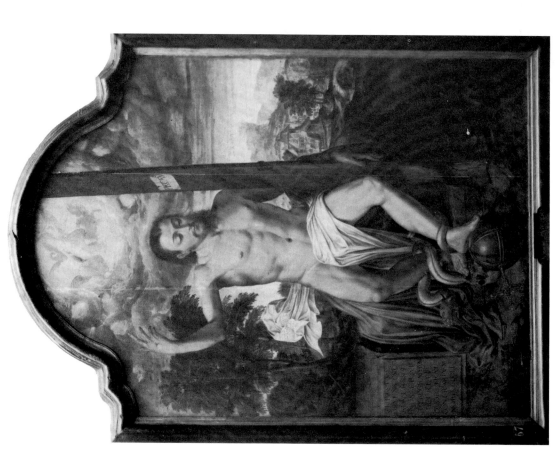

XII.8 Unknown Flemish Master, late 16th century, *Christ as Victor
over Sin and Death,* Bruges, Memling Museum, copyright A.C.L., Brussels

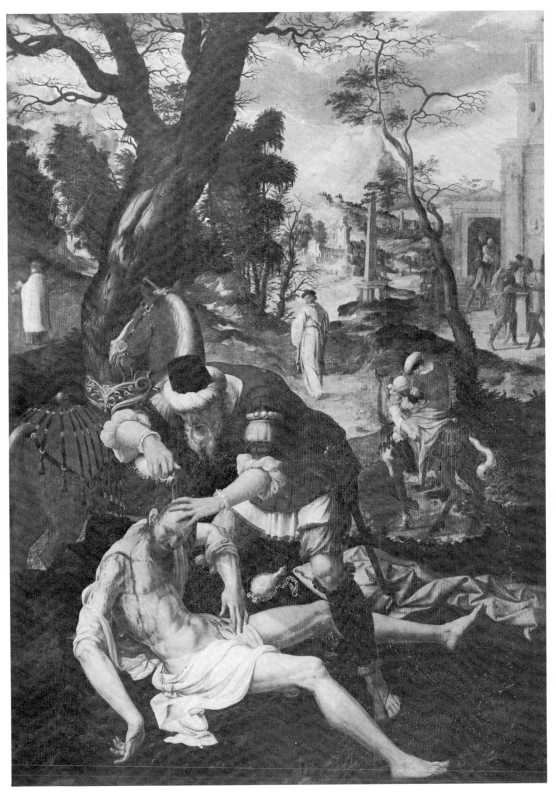

XII.10 Unknown Flemish Master, mid-16th century, *The Good Samaritan*,
Bruges, Memling Museum, copyright A.C.L., Brussels

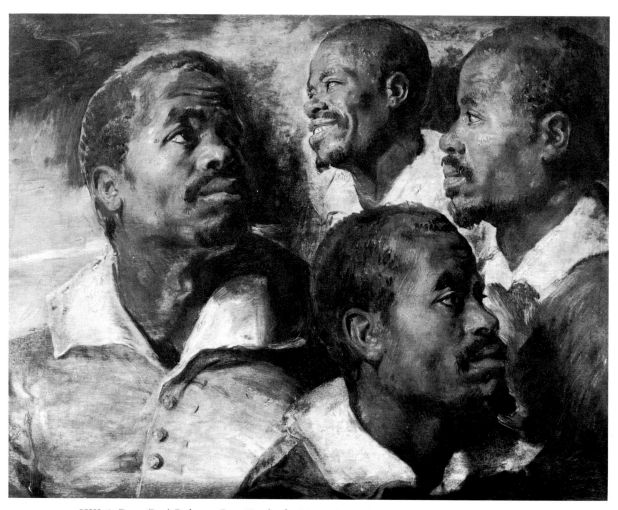

XIII.1 Peter Paul Rubens, *Four Heads of a Negro*, Brussels, Musées Royaux des Beaux-Arts

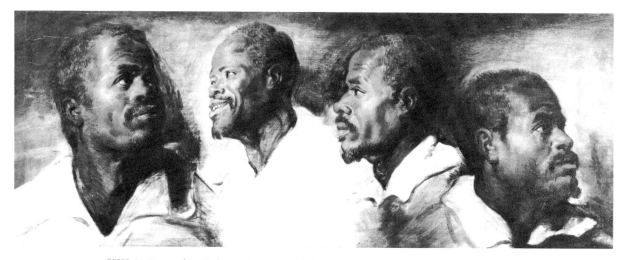

XIII.2 Copy after Rubens, *Four Heads of a Negro*, Malibu, J. Paul Getty Museum

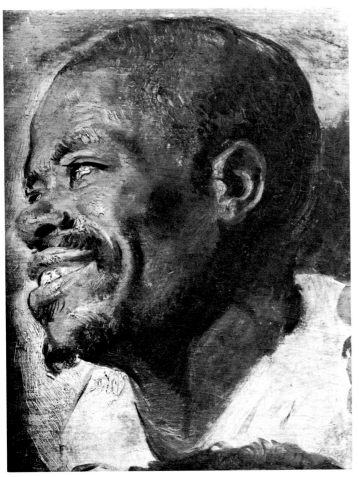

XIII.3 Detail of Fig. XIII.1, copyright A.C.L., Brussels

XIII.4 Anthony van Dyck, *The Martyrdom of St. Sebastian* (detail), Edinburgh, National Gallery of Scotland

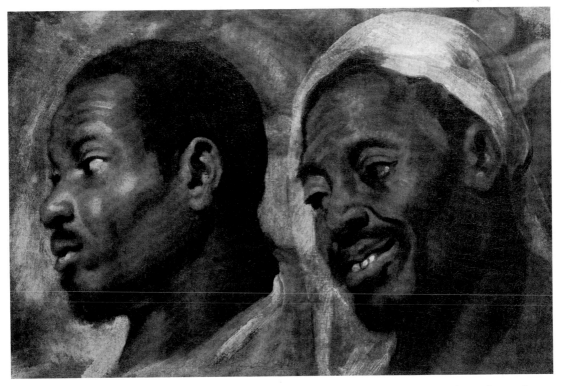

XIII.5 Jacob Jordaens, *Study of a Negro's Head*, formerly New York, Estate of Jacob Goldschmidt

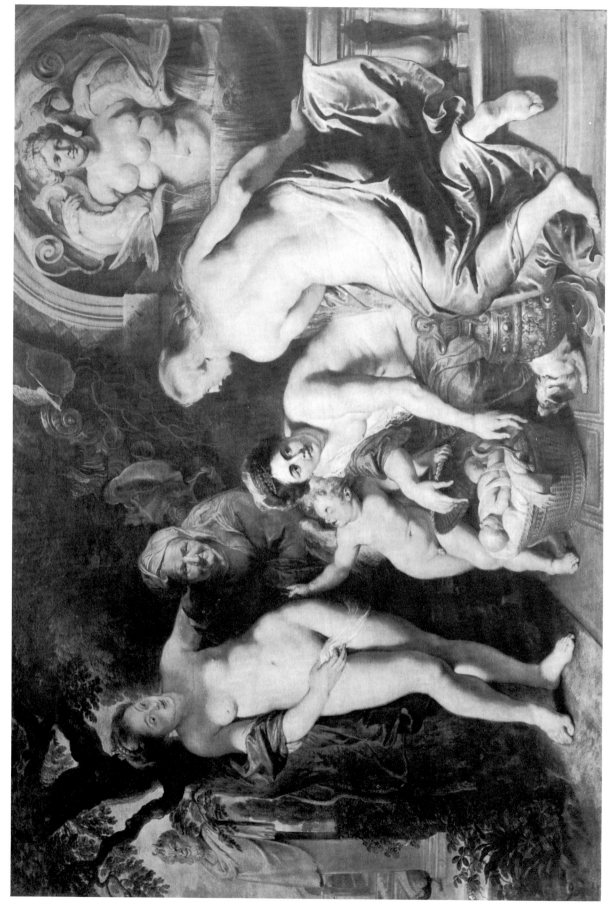

XIV.1 Peter Paul Rubens, *The Daughters of Cecrops Discovering the Young Erichthonius*, Vaduz, Liechtenstein collection

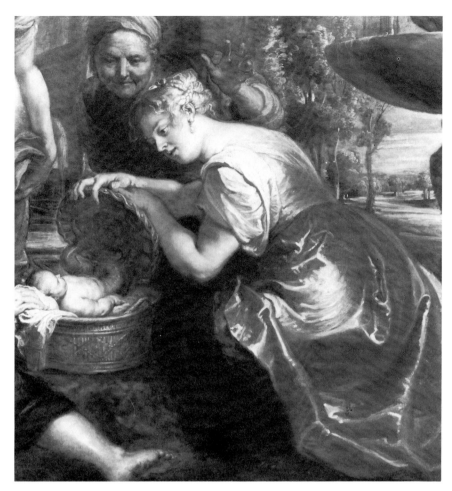

XIV.2 Rubens, *The Daughters of Cecrops Discovering the Young Erichthonius* (fragment), Oberlin College, Allen Memorial Art Museum, R. T. Miller, Jr., Fund, 44.96

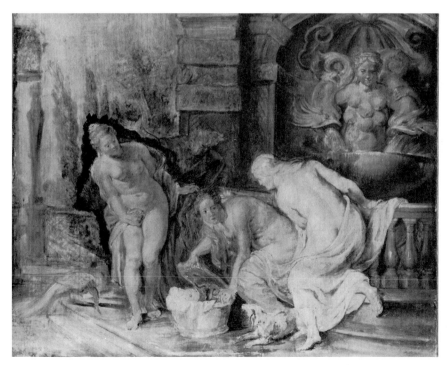

XIV.3 Rubens, *The Daughters of Cecrops Discovering the Young Erichthonius*, oil sketch, London, Home House Trustees Collection

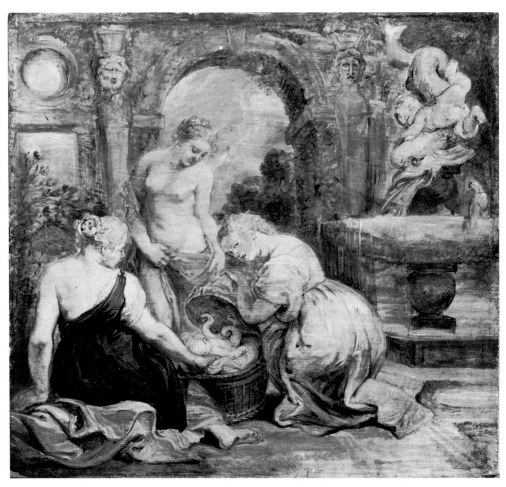

XIV.4 Rubens, *The Daughters of Cecrops Discovering the Young Erichthonius*, oil sketch, Stockholm, Nationalmuseum

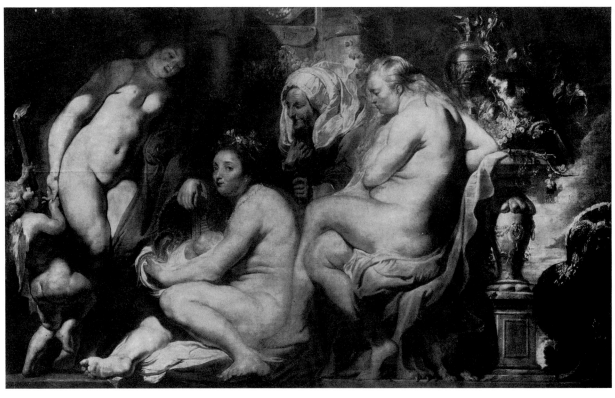

XIV.5 Jacob Jordaens, *The Daughters of Cecrops Discovering the Young Erichthonius*,
Antwerp, Musée Royal des Beaux-Arts

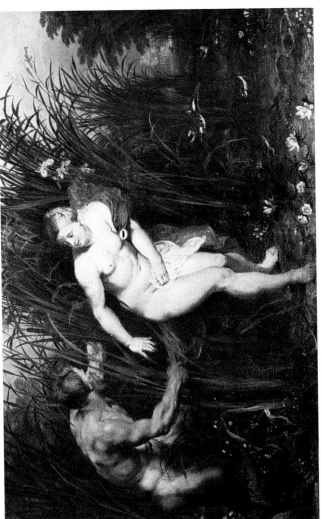

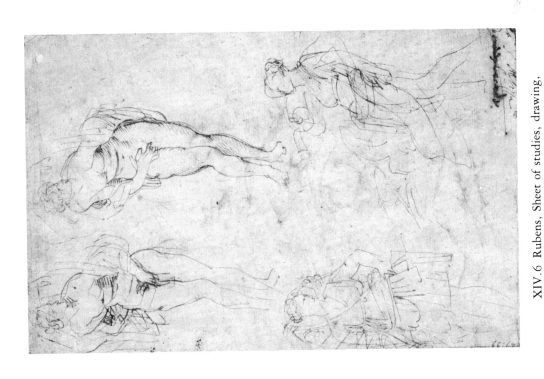

XIV.7 Rubens, Sheet of studies (verso of Fig. XIV.6), Amster-
dam, Rijksprentenkabinet →

XIV.6 Rubens, Sheet of studies, drawing,
Amsterdam, Rijksprentenkabinet

XIV.8 Rubens and Jan Brueghel, *Pan and Syrinx*, present
location unknown →

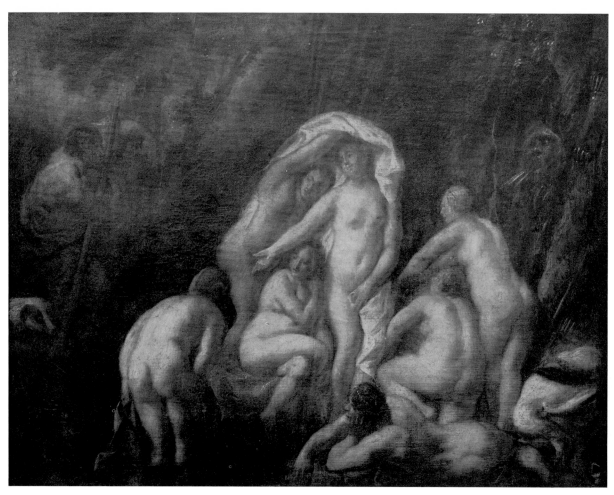

XIV.9 Jordaens, *Diana and Actaeon*, Besançon, Musée des Beaux-Arts

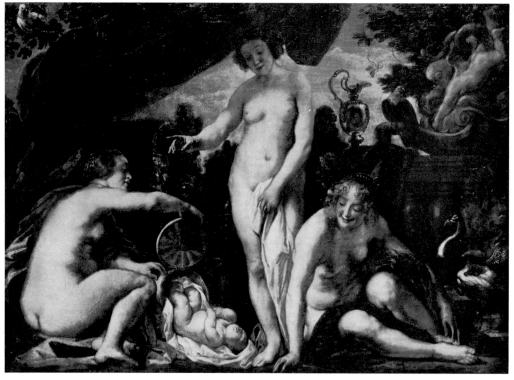

XIV.10 Jordaens, *The Daughters of Cecrops Discovering the Young Erichthonius*,
Vienna, Kunsthistorisches Museum

XV.2 Rubens, *De Luminoso et Opaco*, vignette in Aguilonius' *Opticorum libri sex*, →
engraved by Theodor Galle

XV.3 Rubens, *De Projectionibus*, vignette in Aguilonius' *Opticorum libri sex*,
engraved by Theodor Galle

XV.1 Peter Paul Rubens, *The Last Supper*,
drawing for the *Breviarium Romanum*, private collection

XV.4 Rubens, Design for a Plantinian Printer's Mark, drawing,
Antwerp, Museum Plantin-Moretus, copyright A.C.L., Brussels

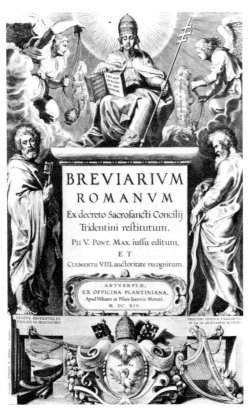

XV.5 Rubens, Title page of the *Breviarium Ro-
manum*, Antwerp, 1614, engraved by Cornelis
Galle

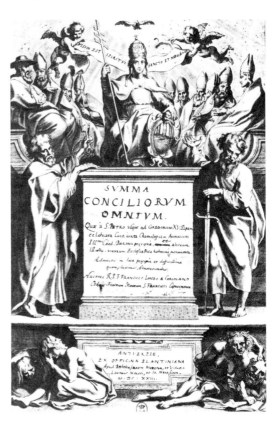

XV.6 Rubens, Title page of Francisco Longo a
Coriolano's *Summa Conciliorum omnium*, Antwerp,
1623, engraved by Cornelis Galle, proof print, Paris,
Bibliothèque Nationale

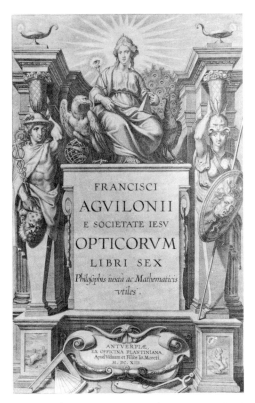

XV.7 Rubens, Title page of Franciscus Aguilonius' *Opticorum libri sex*, Antwerp, 1613, engraved by Theodor Galle

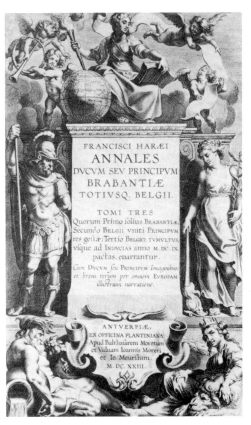

XV.8 Rubens, Title page of Franciscus Haraeus' *Annales Ducum seu Principum Brabantiae*, Antwerp, 1623, engraved by Cornelis Galle

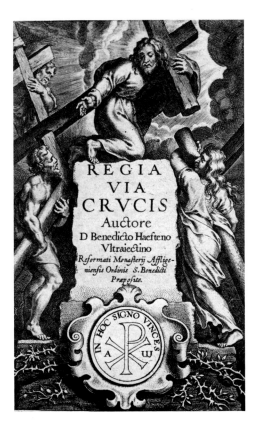

XV.9 Rubens, Title page of Benedict van Haeften's *Regia via crucis*, Antwerp, 1635, engraved by Cornelis Galle

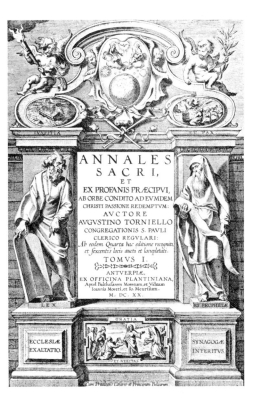

XV.10 Rubens, Title page of Augustinus Torniellus' *Annales sacri, et ex profanis praecipui*, Antwerp, 1620, engraved by Theodor Galle

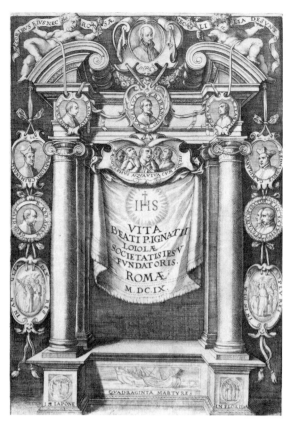

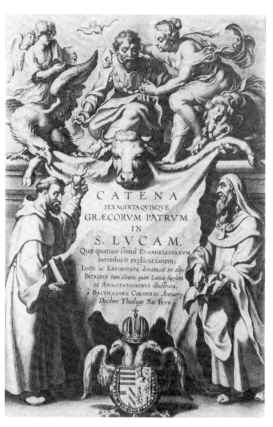

XV.11 Rubens, Title page of *Vita Beati P. Ignatii Loiolae*, Rome, 1609, engraver unknown

XV.12 Rubens, Title page of Balthasar Corderius' *Catena sexaginta quinque Graecorum patrum in S. Lucam*, Antwerp, 1628, engraved by Cornelis Galle

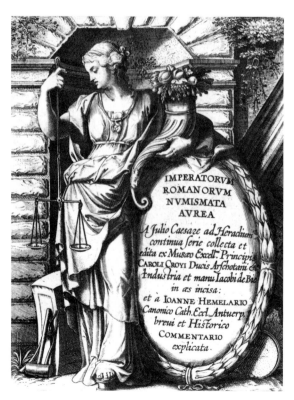

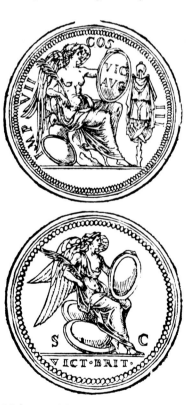

XV.13 Rubens, Title page of Jacob de Bie's *Imperatorum Romanorum numismata aurea*, Antwerp, 1615, engraved by Jacob de Bie (?), here reproduced from the 1627 edition

XV.14 Unknown Master, Victory, woodcuts of Roman coins, illustration from Guillaume du Choul's *Discours de la religion des anciens Romains*, Lyon, 1581, p. 189

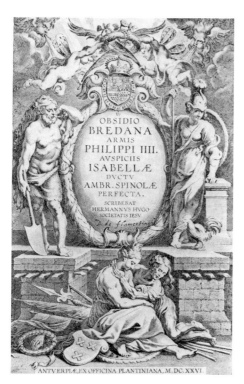

XV.15 Rubens, Title page of Hermannus Hugo's *Obsidio Bredana . . .* , Antwerp, 1626, engraved by Cornelis Galle

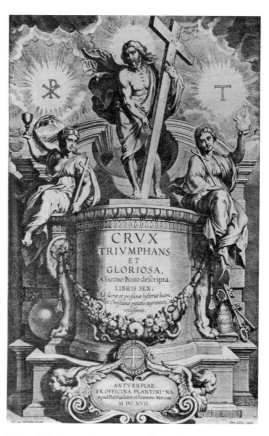

XV.16 Rubens, Title page of Jacobus Bosius' *Crux triumphans et gloriosa*, Antwerp, 1617, engraved by Cornelis Galle

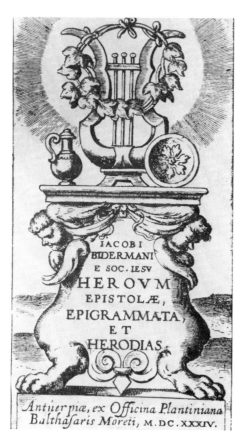

XV.17 Rubens, Title page of Jacobus Bidermanus' *Heroum Epistolae, Epigrammata, et Herodias*, Antwerp, 1634, engraved by Karel de Mallery

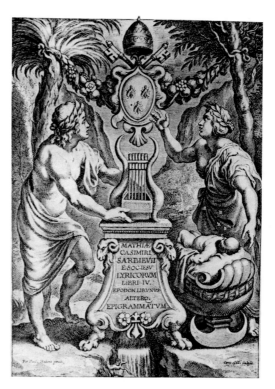

XV.18 Rubens, Title page of Mathias Casimir Sarbievius' *Lyricorum libri IV*, Antwerp, 1632, engraved by Cornelis Galle

XV.19 Rubens, Design for title page of Jacobus Bidermanus' *Heroum Epistolae, Epigrammata, et Herodias*, drawing, copyright Antwerp, Plantin-Moretus Museum

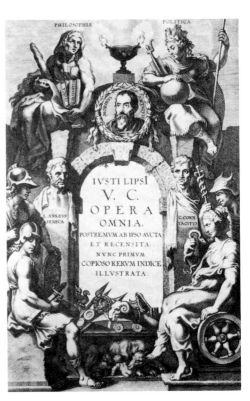

XV.20 Rubens, Title page of *Opera omnia* of Justus Lipsius, Antwerp, 1637, engraved by Cornelis Galle

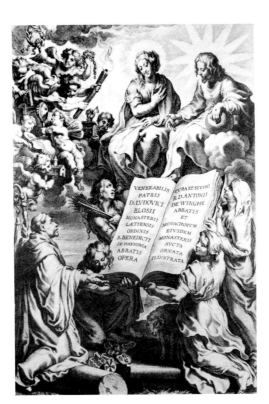

XV.21 Rubens, Title page of Ludovicus Blosius' *Opera*, Antwerp, 1632, engraved by Cornelis Galle

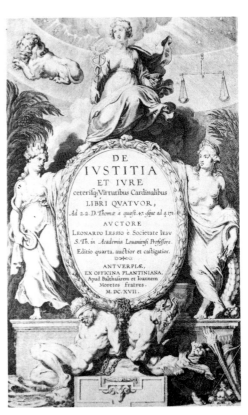

XV.24 Rubens, Title page of Leonard Lessius' *De iustitia et iure*, Antwerp, 1617, engraved by Cornelis Galle

XV.22 Rubens, Design for the printer's mark of Jan Meursius, oil sketch,
Antwerp, Museum Plantin-Moretus, copyright A.C.L., Brussels

XV.23 Rubens, Design for title page of Bernard Bauhusius' and Baudouin Cabillavius'
Epigrammata, drawing, copyright Antwerp, Museum Plantin-Moretus

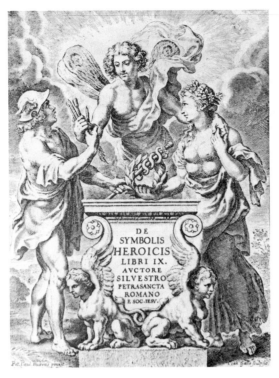

XV.25 Rubens, Title page of Silvester Petrasancta's
De symbolis heroicis libri IX, Antwerp, 1634, engraved
by Cornelis Galle

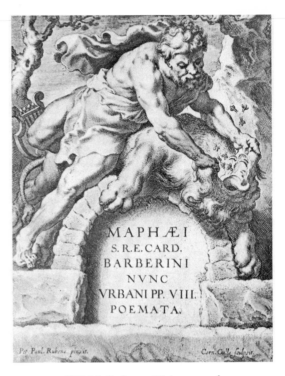

XV.26 Rubens, Title page of
Maffeo Barberini's *Poemata*, Antwerp, 1634,
engraved by Cornelis Galle

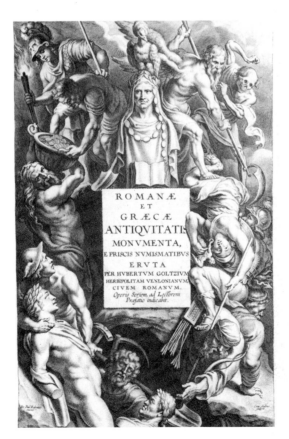

XV.27 Rubens, Title page of Hubert Goltzius' *Ro-
manae et Graecae antiquitatis monumenta*, Antwerp,
1645, engraved by Cornelis Galle

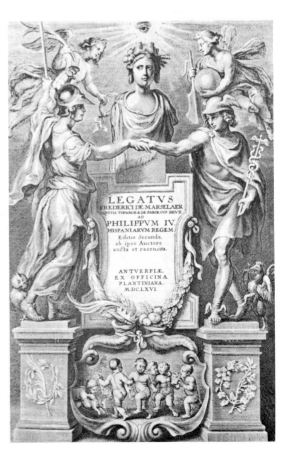

XV.28 Rubens, Title page of Frederic de Marselaer's
Legatus, Antwerp, 1666, engraved by Cornelis Galle
the Younger